Abandoned Italy

Robin Brinaert

JONGLEZ PUBLISHING

The decadence of a forgotten heritage

The scourge of time seizes deserted places, mold infiltrates the walls and the debauchery of objects of all kinds scattered here and there brings to mind the daily lives of those who passed through.

Villas and palaces, churches, abandoned monasteries, spinning mills, disused power stations and industrial plants, schools, hospitals, deserted sanatoriums ... All these places hiding treasures are a playground to me, and the ideal image to capture with my camera lens.

Light creeps through a crack, and the sun invading a chapel gives the place a magical glimmer. The world is a theatre and I've chosen to look behind the curtain. The feeling of being the first to walk on new ground is unique and very exciting.

This activity, though clandestine, is redolent of less legal practices, such as infiltration. But explorers like me who have been practising it for many years all share a more demanding vision. We do not touch anything, we do not degrade anything. We just take a few shots ... then we go.

Urban wandering is a unique emotional experience.

About

I was born in 1988 and I live in the province of Hainaut in Belgium. Through urban exploration I combine my different passions: graphic design and amateur photography.

I have spent some years walking with my Canon 5D along the roads of Belgium and neighbouring countries in search of the unusual and the strange. When I discover a wasteland, the decrepitude of the abandoned place is a welcome break from the frenzy of everyday life. What a fantastic adventure in a world out of the ordinary!

I would like to share my discoveries with you, through images sometimes one more surprising than the next. Through this book, I hope you will enjoy discovering the places I have had the opportunity to explore.

Robin Brinaert

Contents

Cinema Nazionale – *Liguria*

Every neighbourhood has its own point of reference, a place that lives in people's hearts, "a place where we left a part of us", according to a passer-by who had frequented the place.

"I remember the images of the movies, barbarian warriors who raised the dust in bloody battles, cowboys who rode their horses and made the enemies smell the powder of their rifles ... You could still smoke in closed public places and when we went out, we brought home the smell of nicotine and the adrenaline of the film."

Many love stories were born in this magical place that was the old national cinema, a true symbol of the neighbourhood.

Converted first into a supermarket then into a car dealership, and finally into a meeting place for young people from "good families" of the region, the old cinema cinema with its neoclassical façade, built in 1937, was finally closed in 1970. So began a battle between the municipality and those who wanted to conserve the original structure, especially the façade.

Despite a fire in 2017, the façade remained intact. Inside, the balconies are large, the wooden seats are covered with brown fabric and the curtain has disappeared.

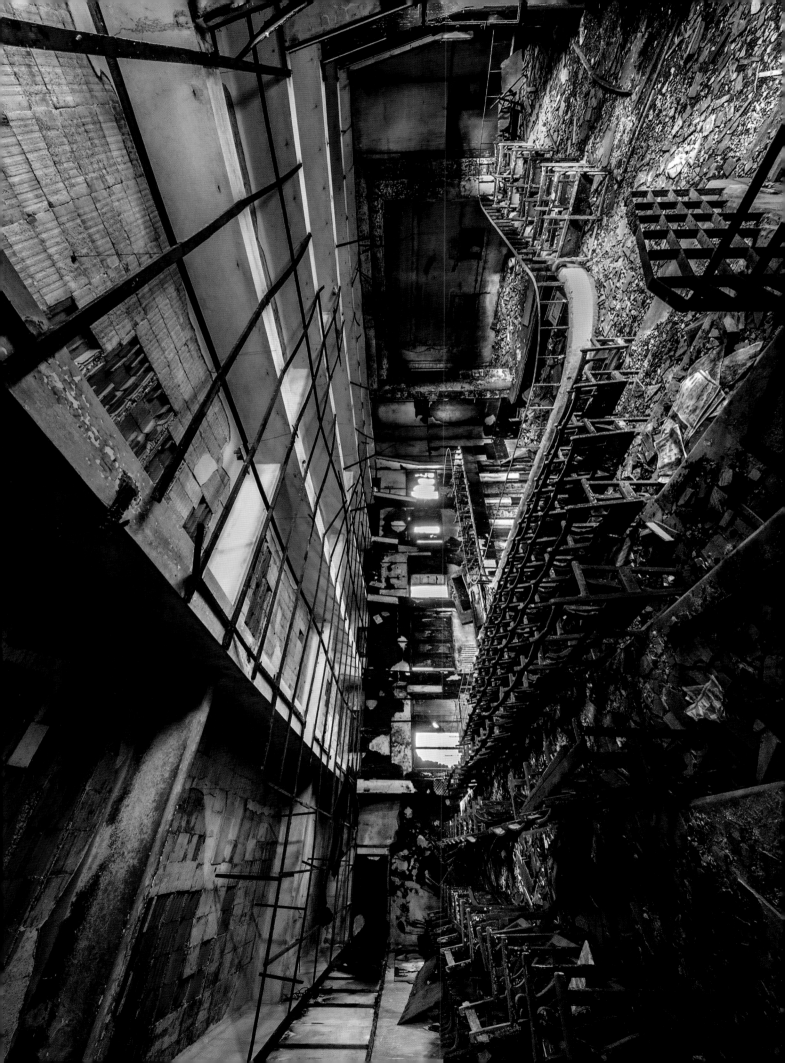

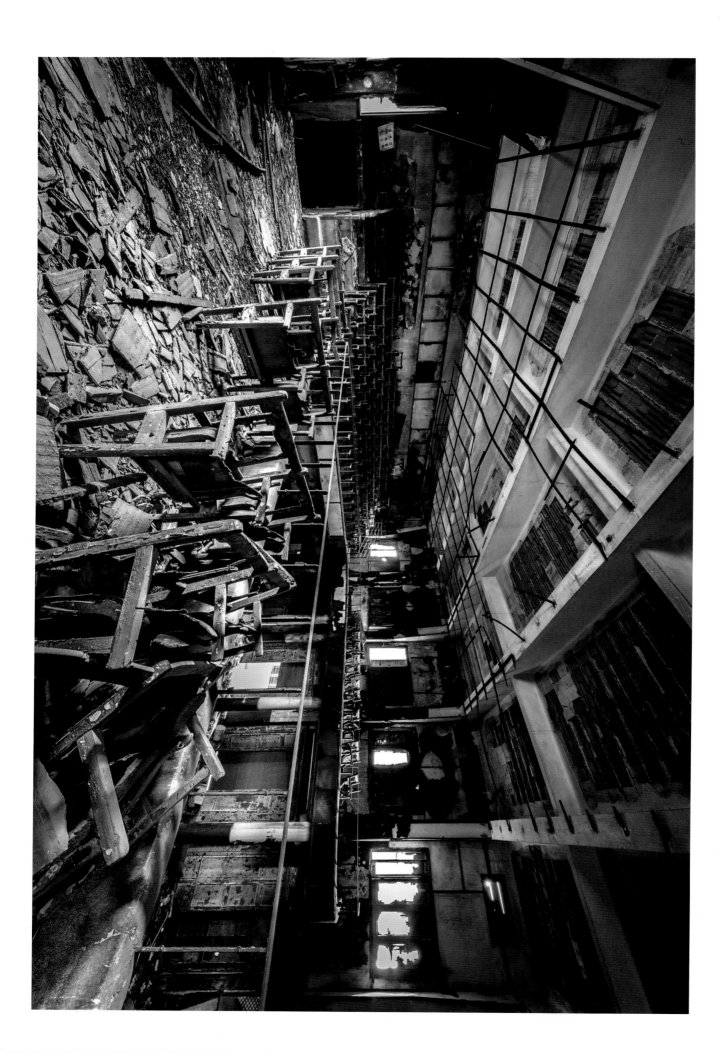

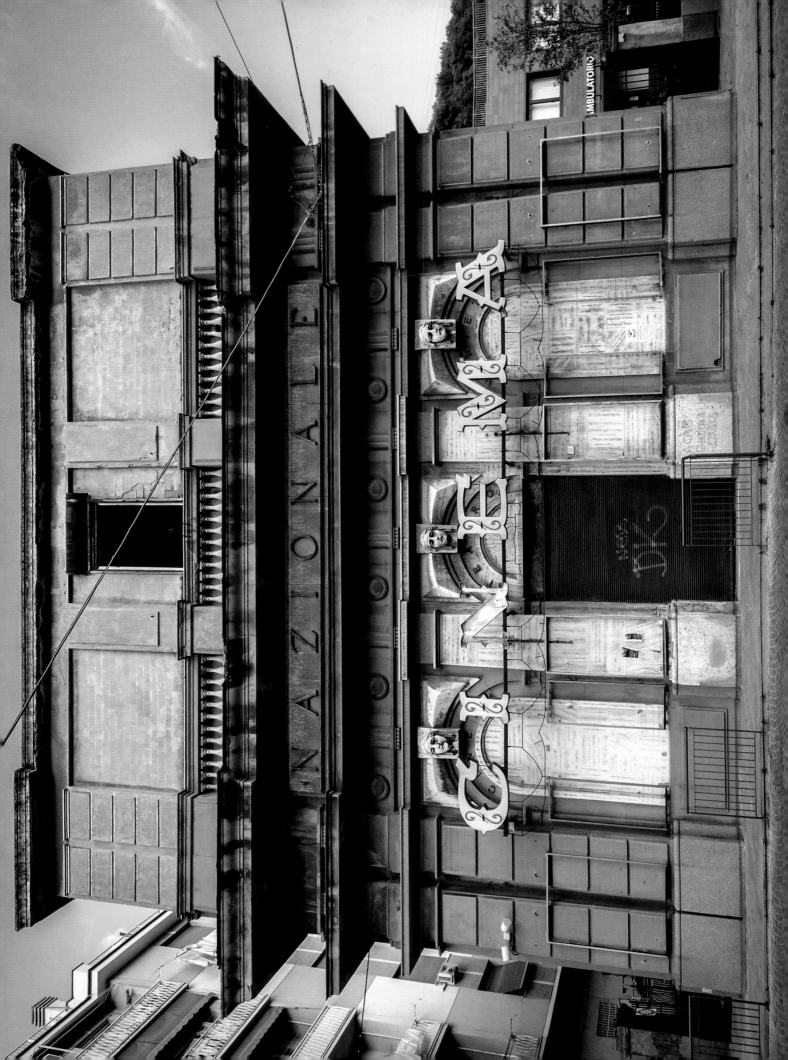

Manicomio di Q – *Liguria*

In the 19th century, a public order law defending the society "against the supposed violence of fools" facilitated the confinement of anyone considered dangerous to himself or others. Anyone could report an act of violence or a public scandal. It was enough to warrant a medical certificate being issued against the supposed perpetrator. With the stamp of a court, and after a month of observation, they were irremediably locked in a mental asylum.

The mental asylum of Q is one such institution. Opened in 1895, it could accommodate more than 700 patients, who were mainly treated with electroshock therapy. Experimental operations on the nervous system and trepanation were also widely practiced in rooms adjoining the clinical research and radiology laboratories.

According to the records, however, the quietest patients could be taken to the movies or allowed to walk around the gardens. The hospital even had a theatre in which patients mocked the staff! The asylum was closed in the early 1980s following the Basaglia Act, which comprehensively reformed the psychiatric system. Mould has since invaded the rooms and corridors, but the place remains remarkably preserved.

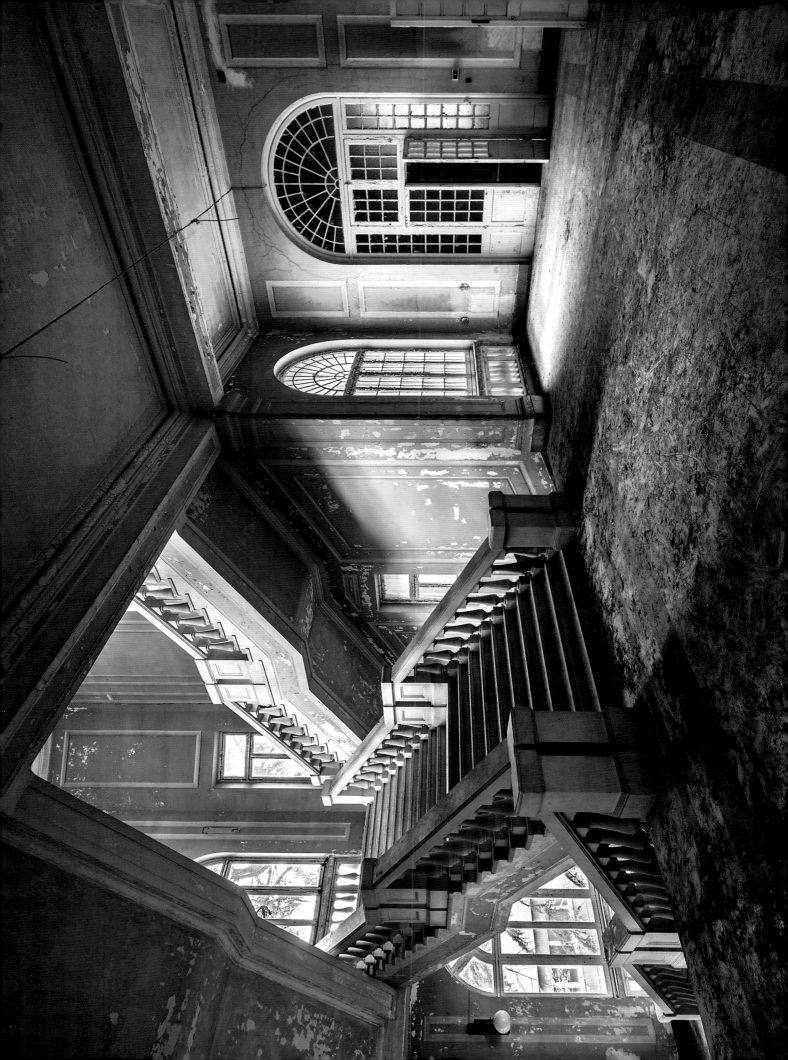

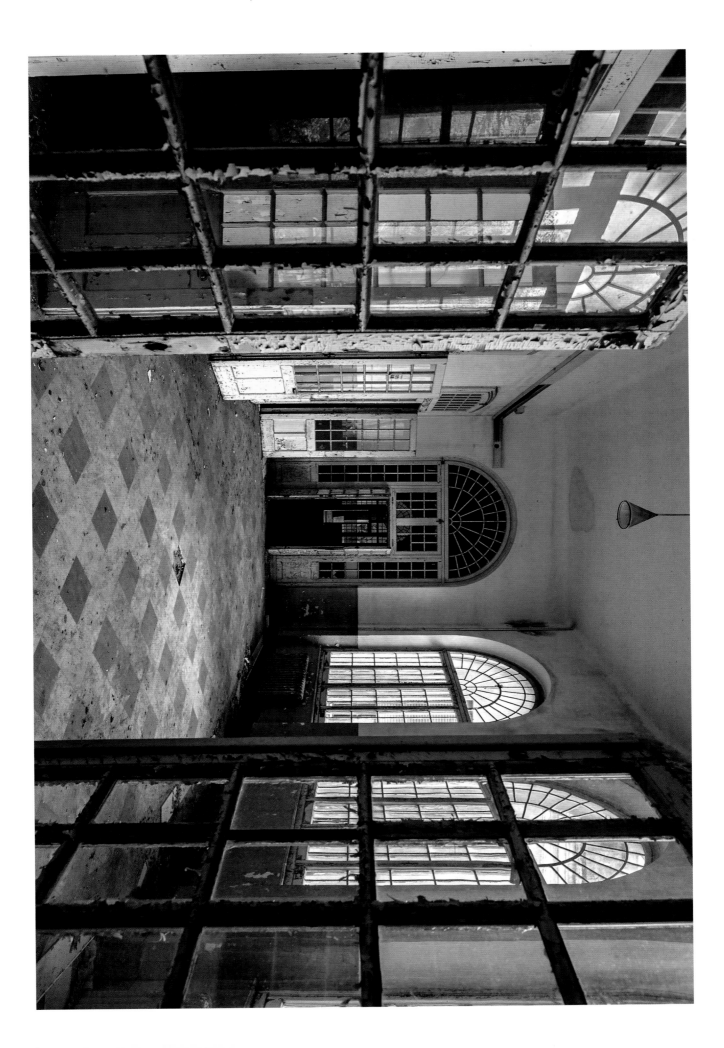

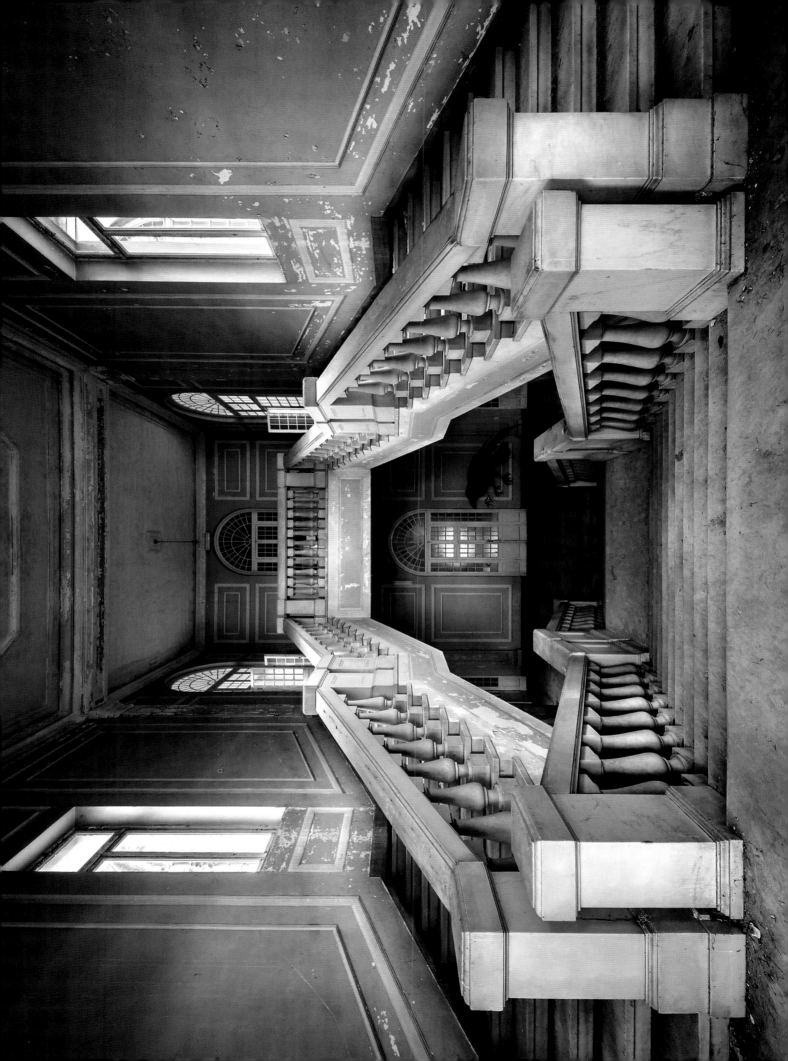

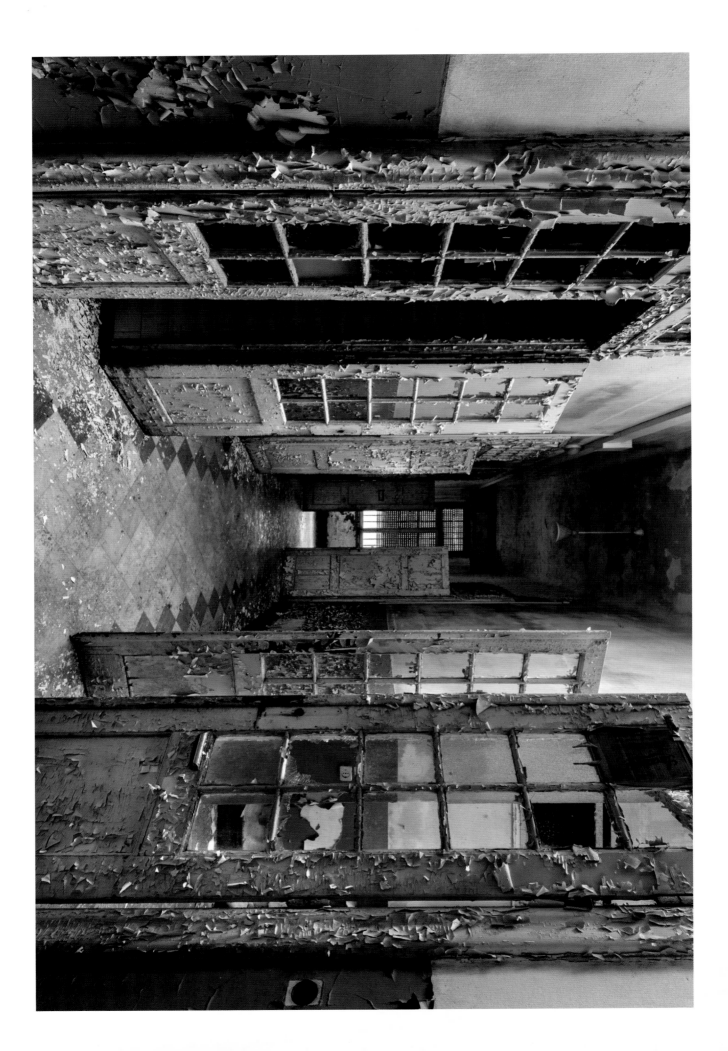

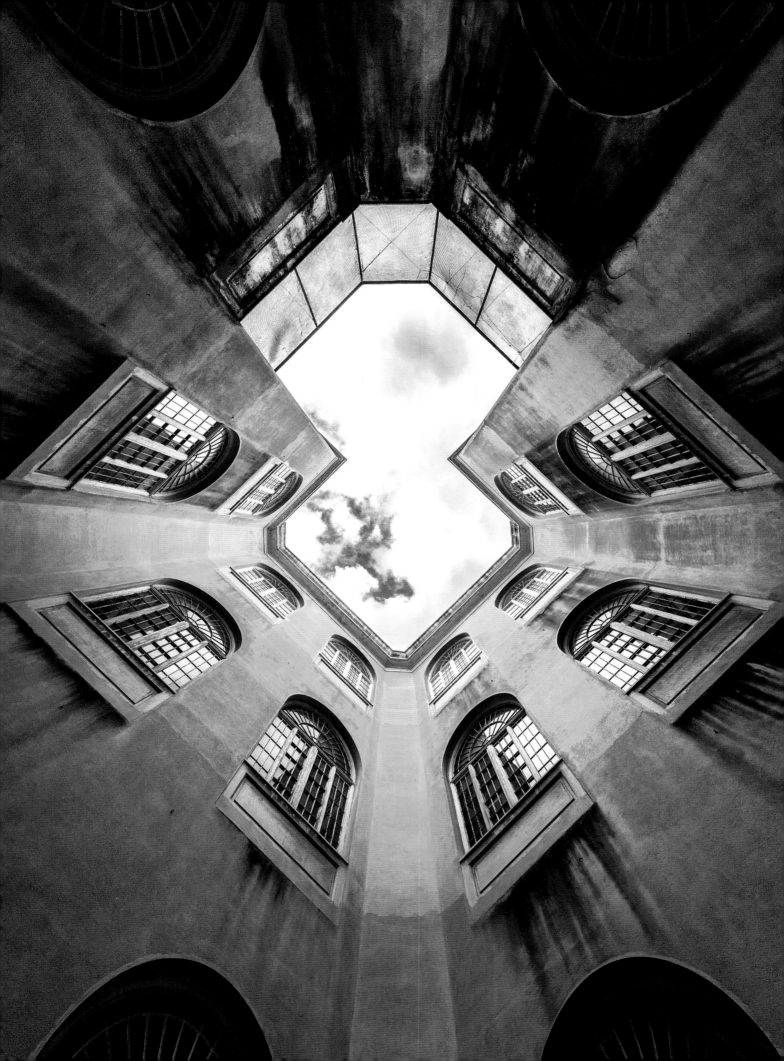

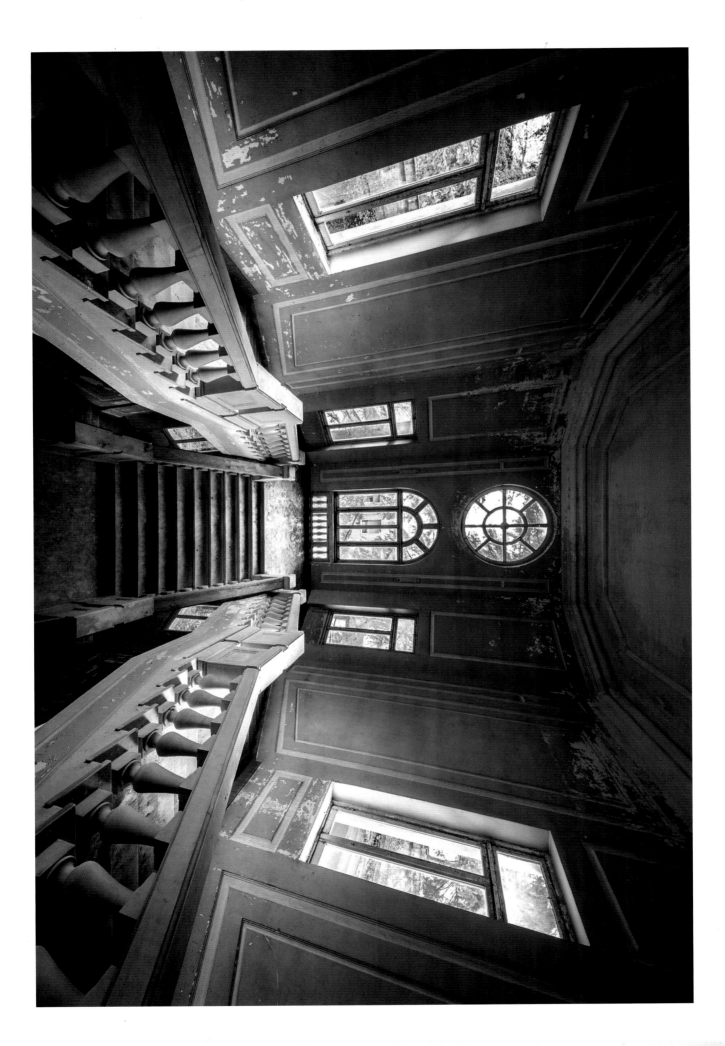

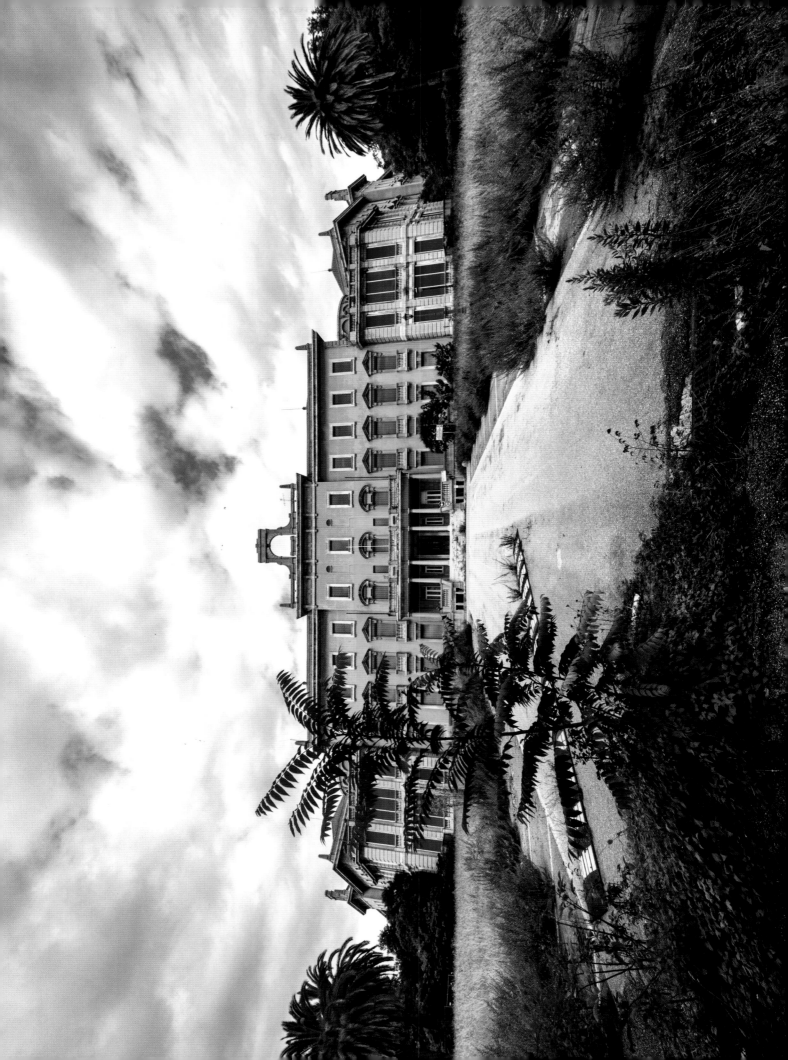

Villa Zanelli – *Liguria*

Commissioned in 1907 by Captain Nicolò Zanelli, the house was built by the architect Gottardo Gussoni, a student of the famous Fenoglio, a master of Italian Liberty style.

The Zanelli villa, with its low wall complemented by stylised wrought iron gates and its refined, undulating decorations, can be considered a masterpiece. Some ornaments are inspired by the motifs of the famous Belgian Victor Horta.

The property was sold in 1933 to the municipality of Milan, which made it an international camping site and summer camp. It remained so until 1967, with a short interval during the Second World War when it was used as a field hospital (as evidenced by the cross painted on the turret). It was converted again and until 1998 it was a centre for the treatment of heart disease.

Despite its elegant architecture and beautiful garden leading directly to the Ligurian Sea, the house was closed, deteriorating as time passed. Part of the first floor has since collapsed.

However, it should soon regain its former splendour. On the initiative of the President of Liguria, Villa Zanelli, a historical and cultural jewel, should see its ground floor converted into a museum, while the other floors will become a hotel offering seven deluxe rooms and a panoramic rooftop restaurant.

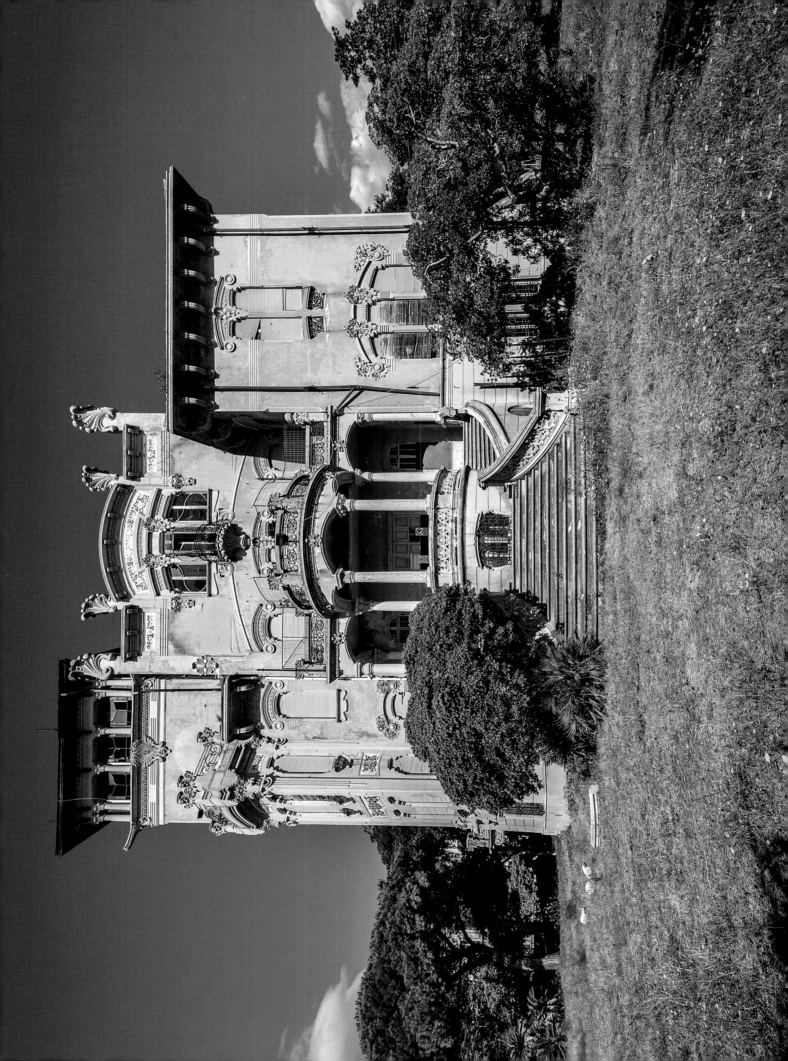

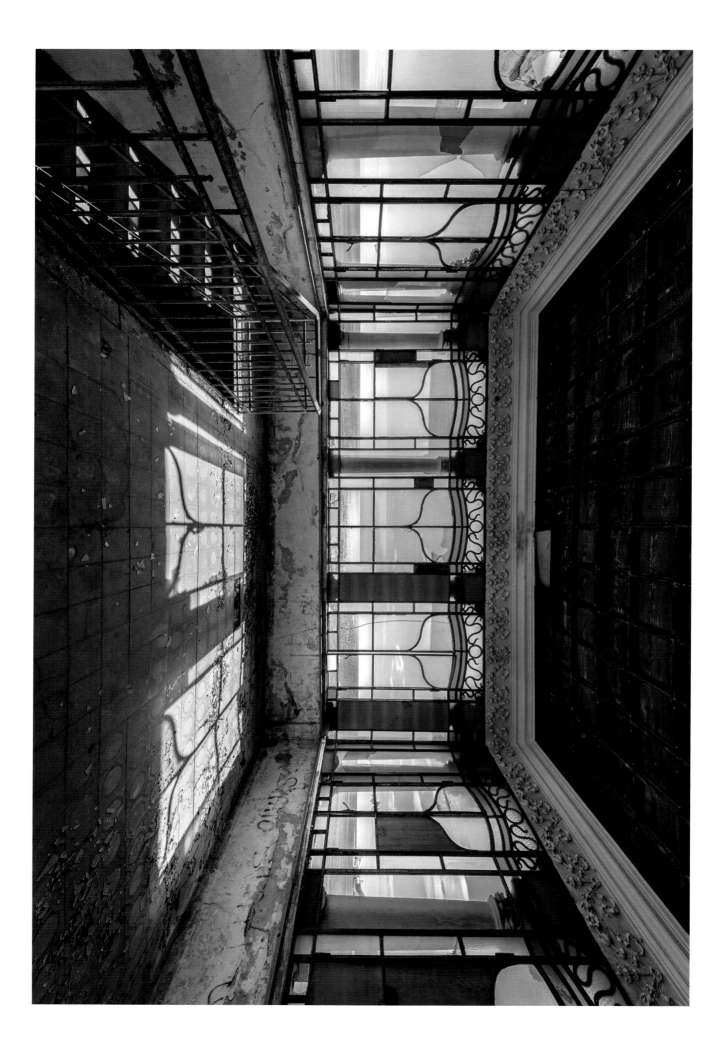

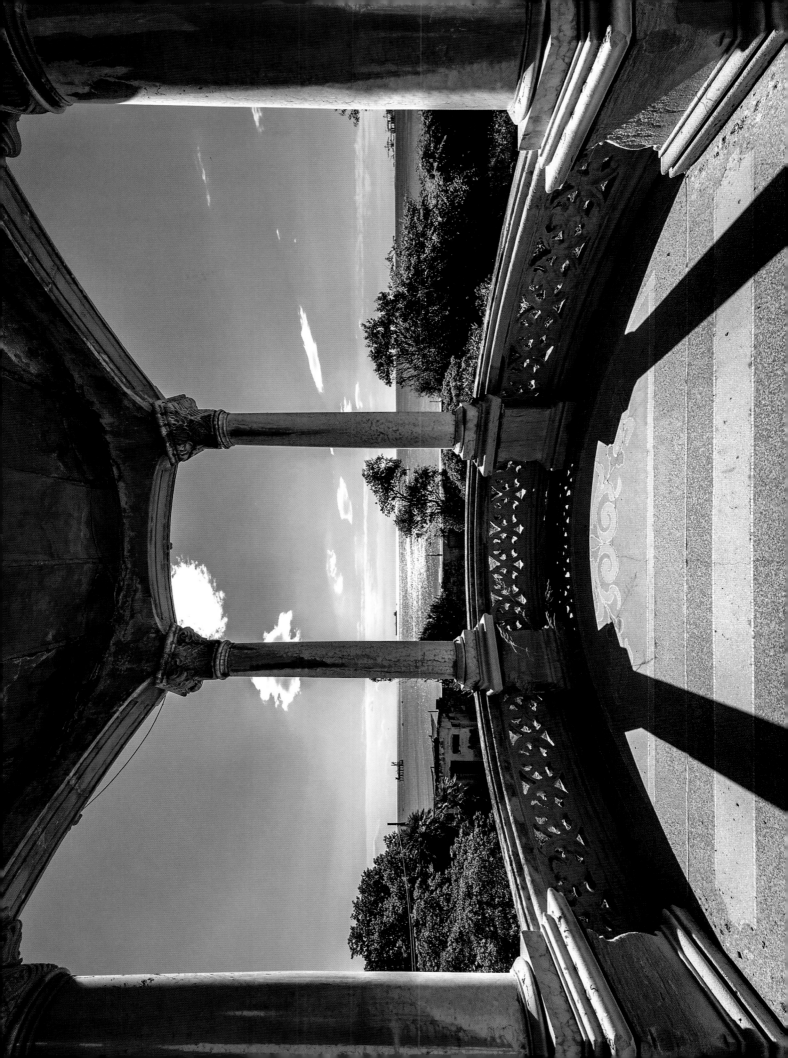

Chiesa di Verde – *Liguria*

The chapel of the Villa Durazzo Cataldi is all that remains of the magnificent 18th-century villa demolished in the 1960s to make room for a refinery. It is a little Baroque gem that negligence and industrialisation have unfortunately damaged extensively. The decrepit chapel is the last witness to the splendour of yesteryear.

Despite the advanced state of decay, it is still possible to distinguish the stained glass windows of the rosette and contemplate the incredible altar supported by two female busts.

A recovery plan has been developed as part of the "Adopt a Monument" initiative, but to date it has not been put into action.

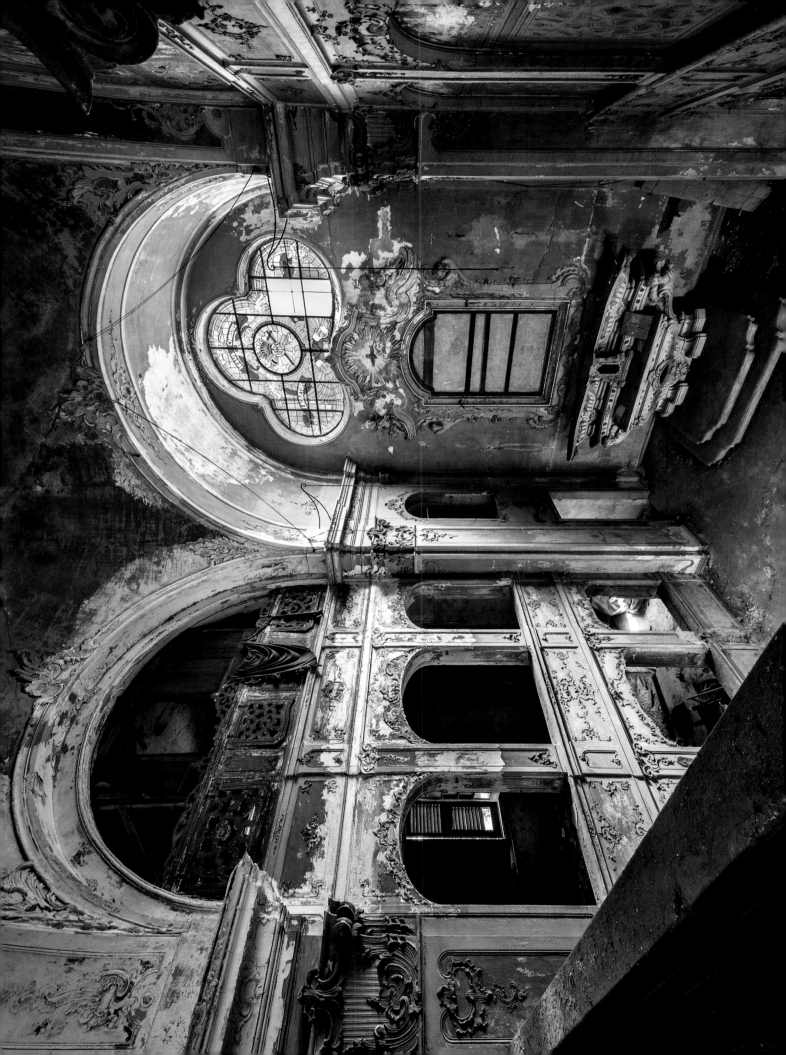

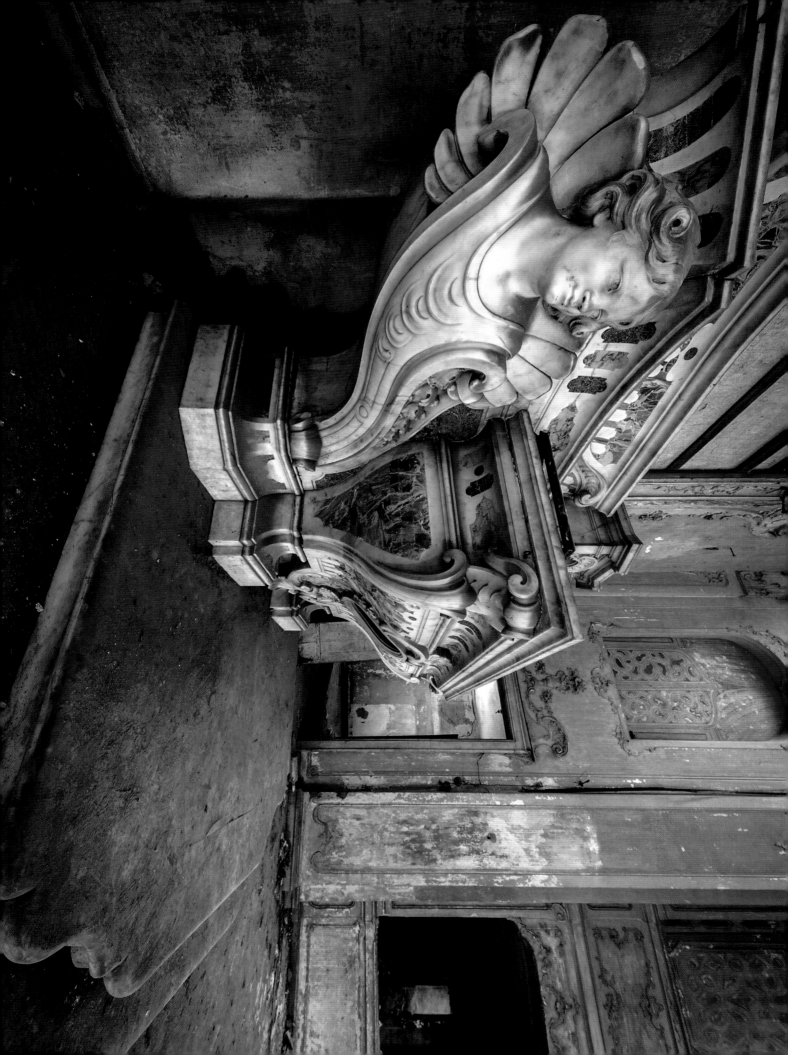

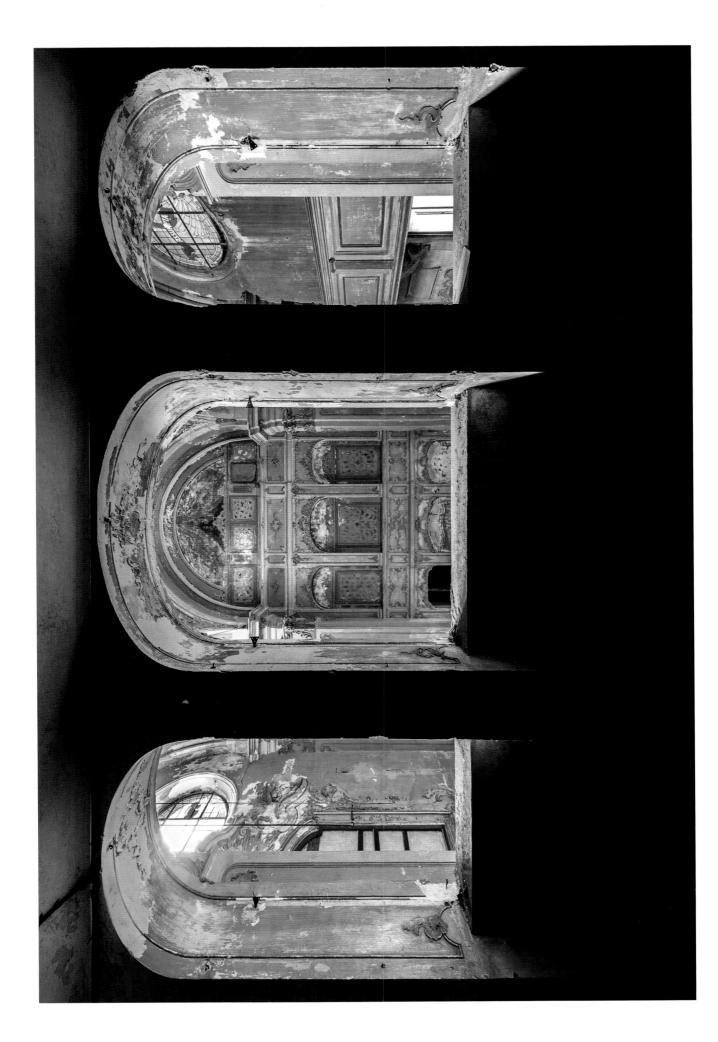

Old Salesian college – *Piedmont*

The immense structure of this former Salesian boarding school and boarding house ranges across eight floors of reinforced concrete, typical of the big constructions of the 1960s. It is a maze of corridors and stairways serving dormitories that can accommodate at least 200 children — children who, we imagine, would fill the space with an excited din.

Everything is designed for autonomous living: the large, fully-equipped kitchen, the laundry, classrooms with wooden benches, the music room with a desk and sheet music scattered on the floor, the infirmary and medical equipment, the gym and typical wooden vaulting horse, the colourful stained-glass chapel, the theatre with chairs still intact, and in the locker room, stage costumes ready to be worn.

The building was clearly designed according to megalomaniac criteria. Strongly criticised and considered an economic burden for the province, it closed in 1981.

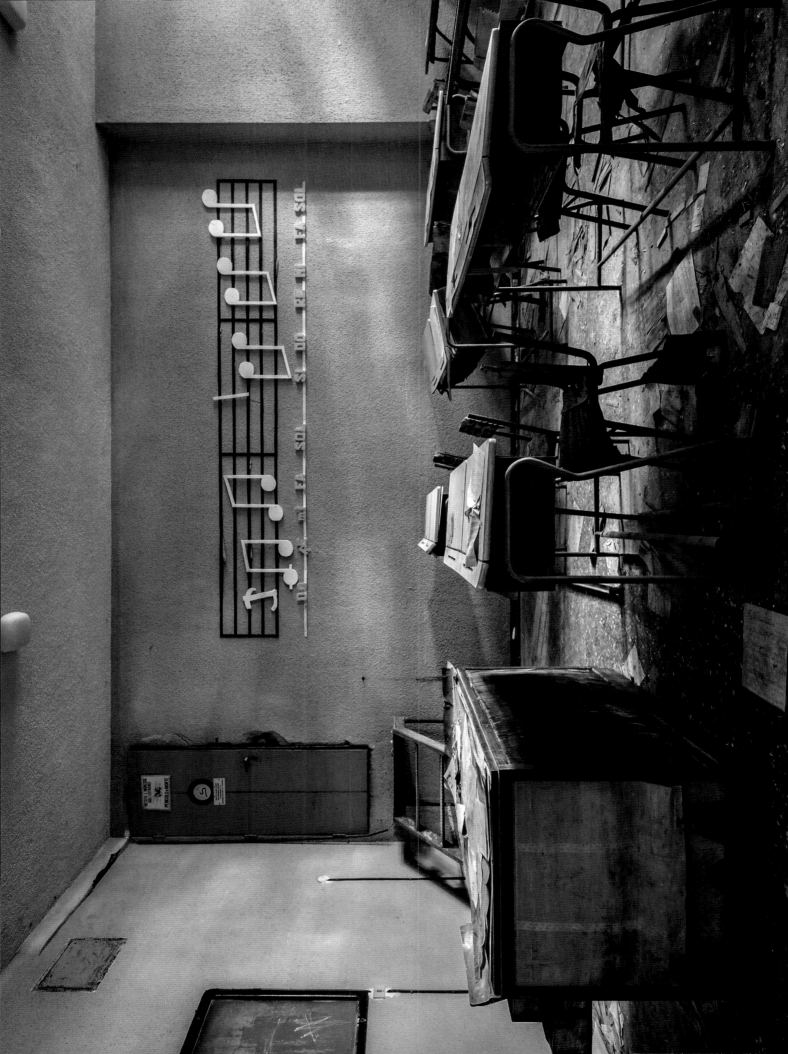

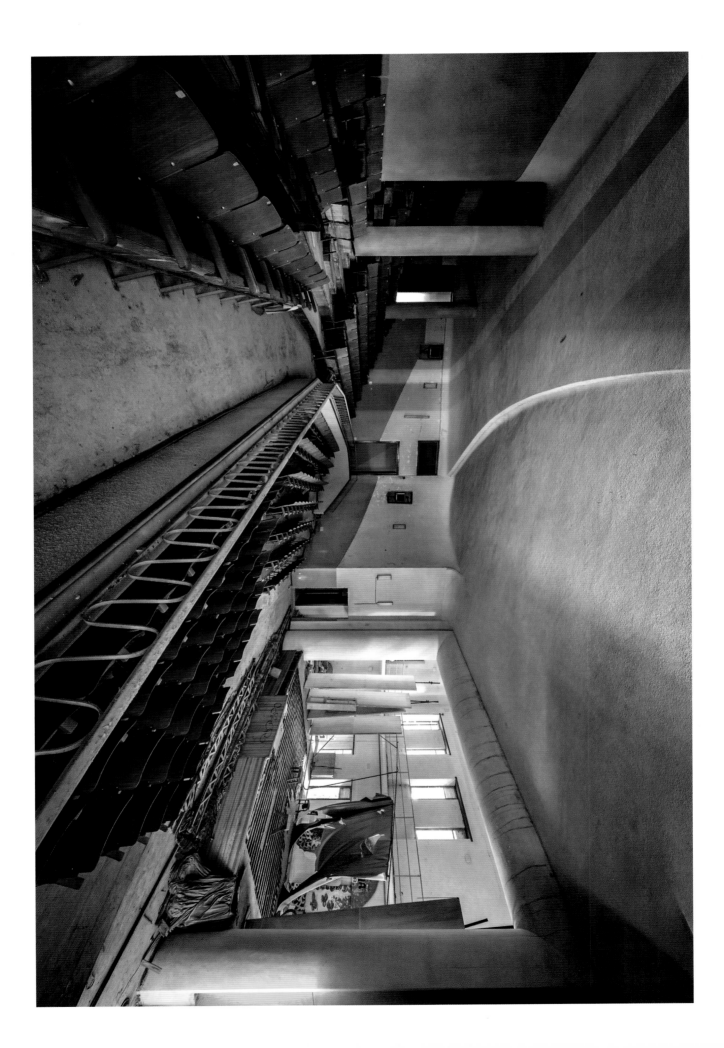

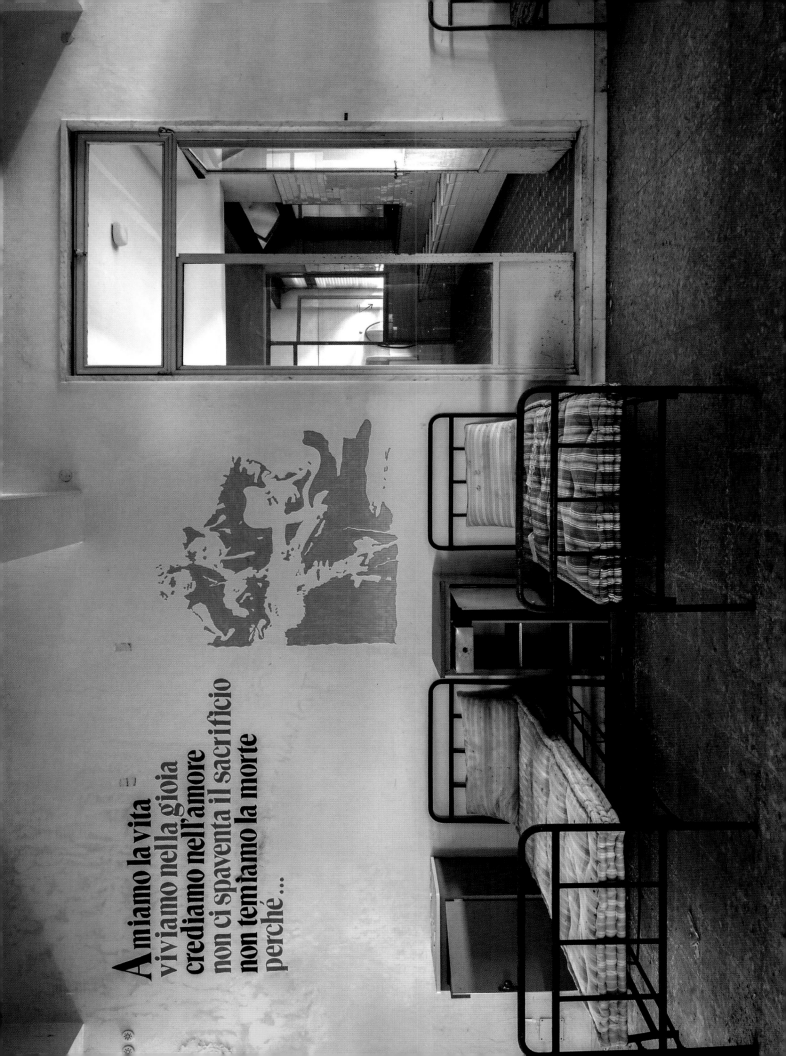

Amiamo la vita
viviamo nella gioia
crediamo nell'amore
non ci spaventa il sacrificio
non temiamo la morte
perché…

Orfanotrofio SG – *Piedmont*

The construction of this immense building, intended to welcome orphaned children, began in 1877.

The ground floor immediately impresses with its monumental marble staircase, richly decorated with enormous spheres.

In a bedroom on the first floor there are metal beds, complete with oil-painted headboards and old spring mattresses stubbornly resisting decay. And though the cast-iron sinks dating back to the 1930s are still intact, the faucets have been stolen.

The most beautiful surprise lies on the second floor: a chapel with an altar surrounded by two painted angels, all still in good condition. Alas, the ceiling decorations have faded over time.

There was talk of restoring the building to make it a home for disabled youths, but due to a lack of funds the project was shelved.

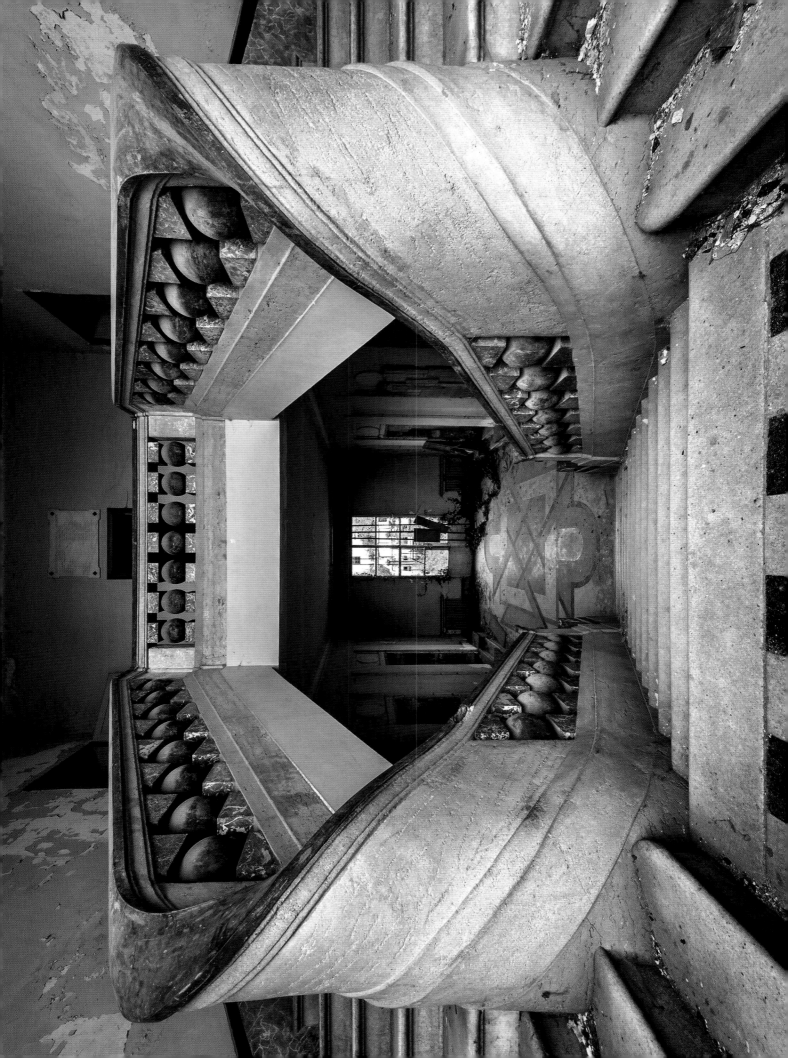

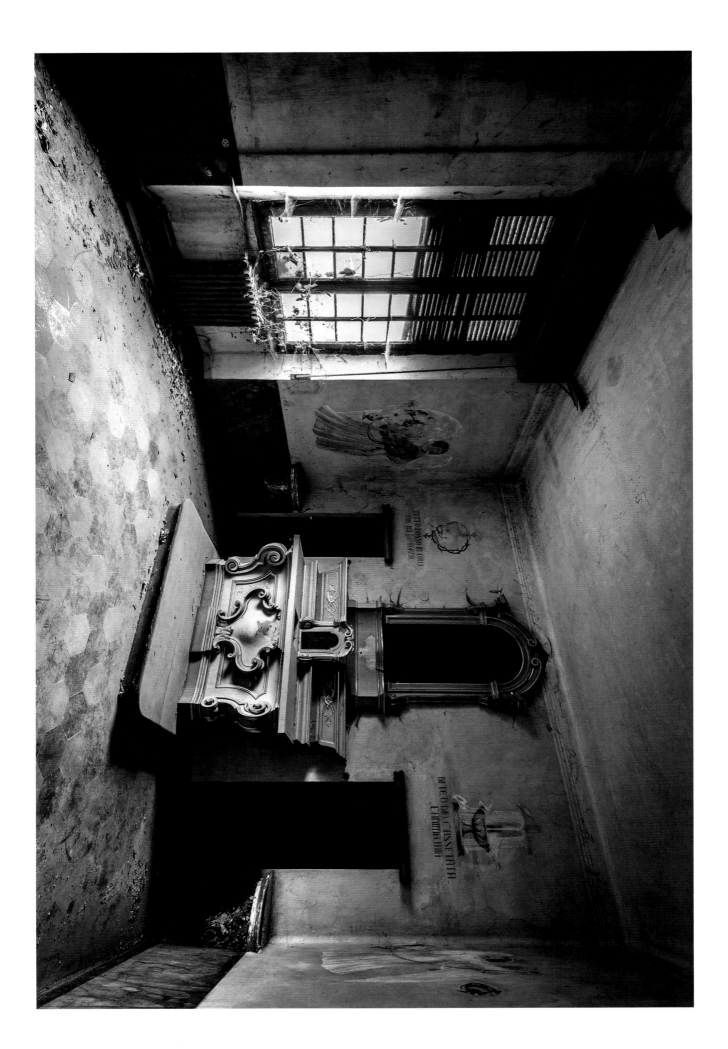

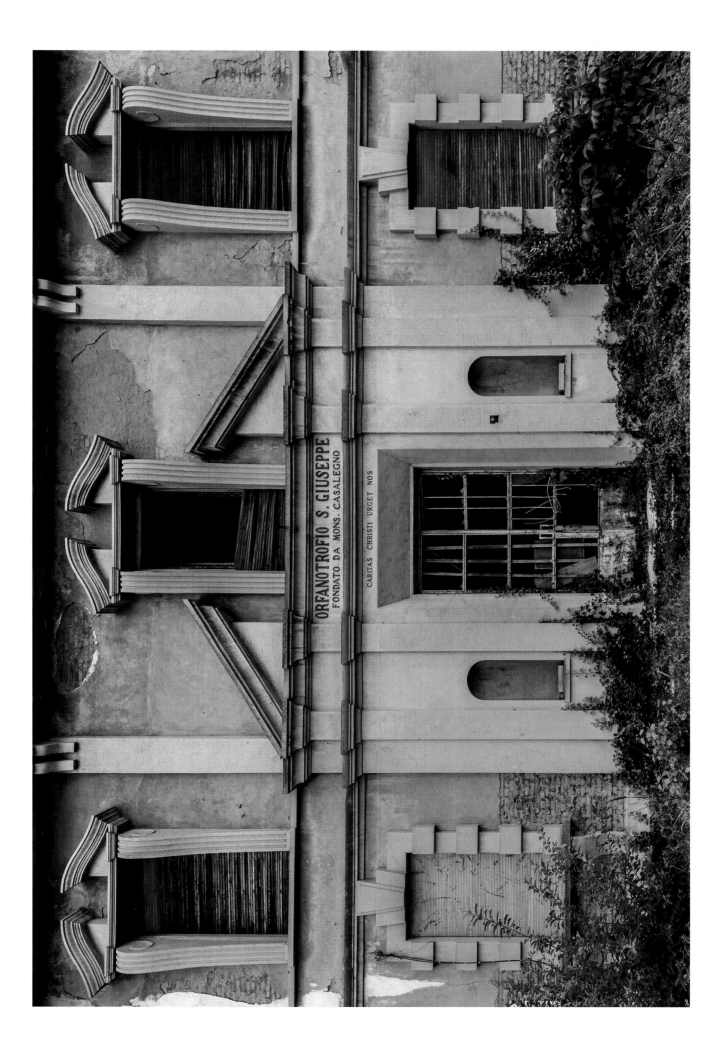

Ceramic factory – *Piedmont*

Built in the early 20th century, this ceramic plant produced stoves and flowerpots, but soon expanded to other sanitary items that were in great demand. The industry prospered, responding to the needs of a fast-changing society.

During the two world wars, production ceased; clay was no longer imported from France and the workers were sent to the front.

In the 1950s and 1960s, as demand for ceramic products took off again, the company employed up to 1,300 workers. But unable to adapt to the technological developments of the 1980s and 1990s, the factory finally closed.

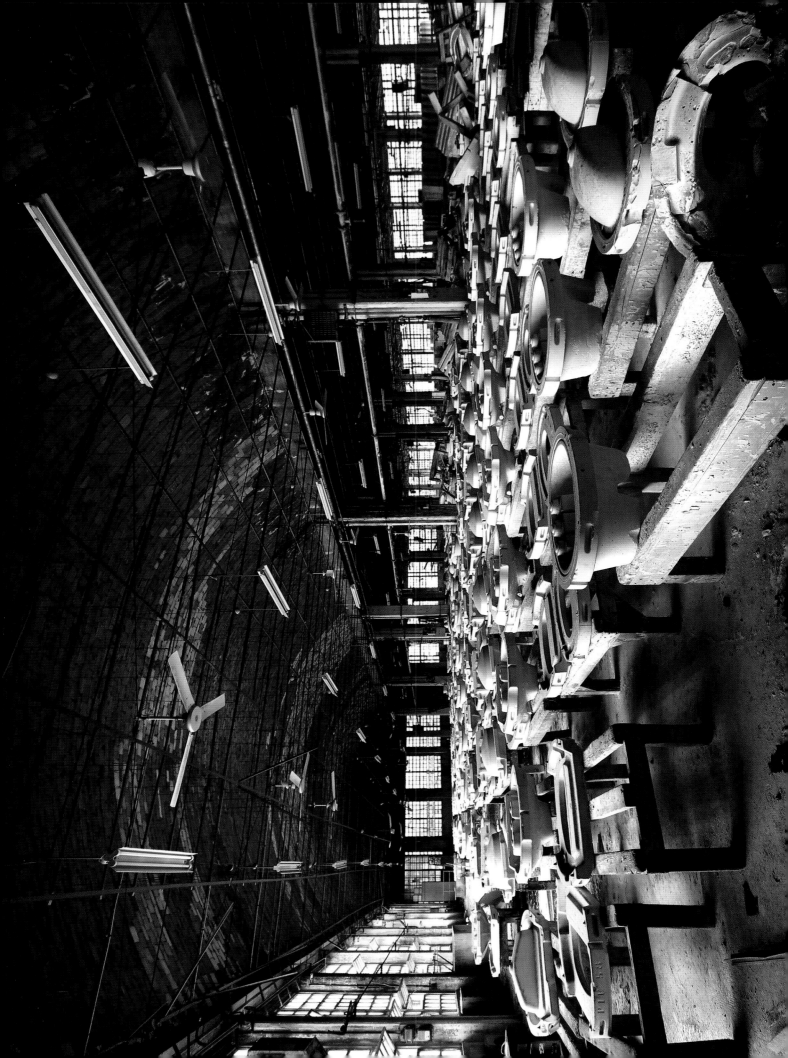

Teatro Mosquito – *Piedmont*

The vast psychiatric hospital "Tompeo Benedetto", named after a medical doctor famous for his research on mental illnesses, also had a church and a theatre.

Squeaky doors, broken glass scattered on the floor, greenery colouring the walls, burnt wooden chairs, stairs full of debris, and a balcony on the verge of collapse …. All that remains since the hospital closed in 1978 — as a result of the great reform of the psychiatric system — and the subsequent fire that ravaged the building. The only remaining inhabitants are mosquitos which attack anybody who ventures in the theatre.

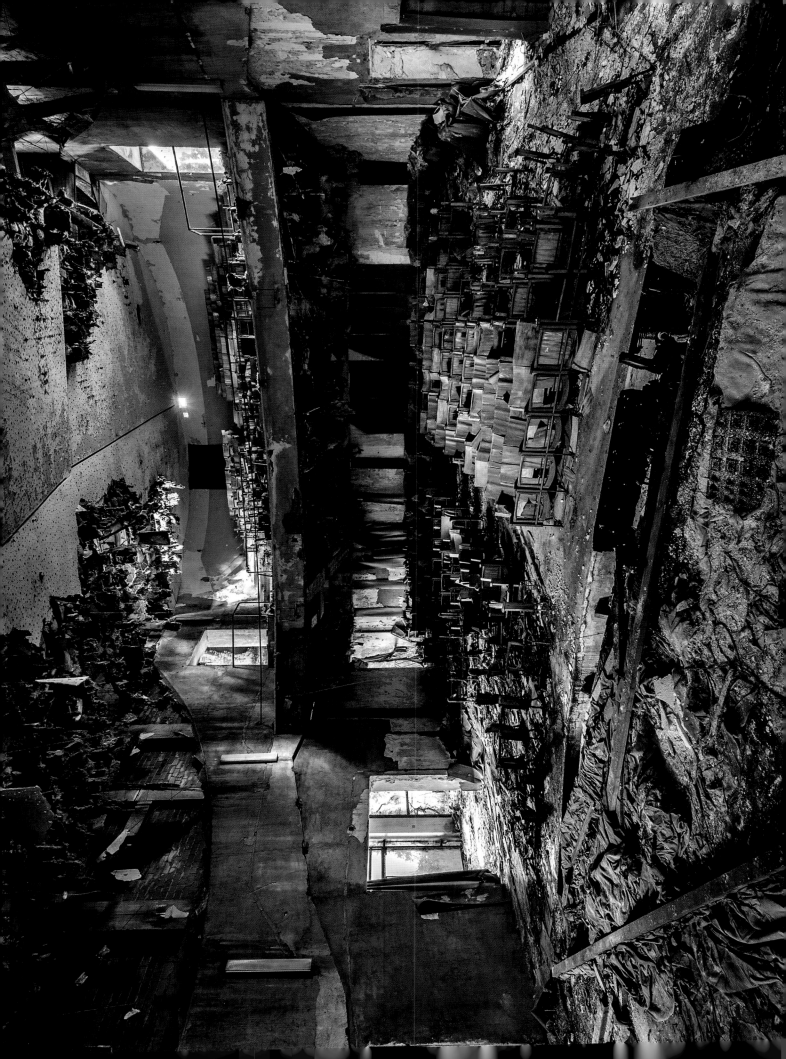

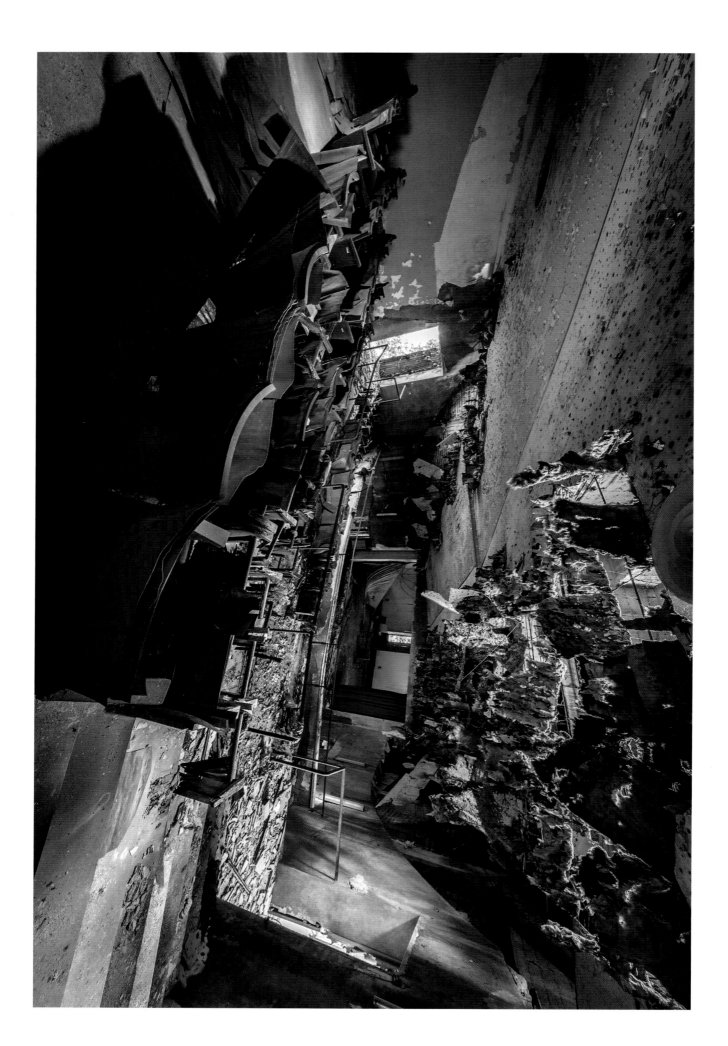

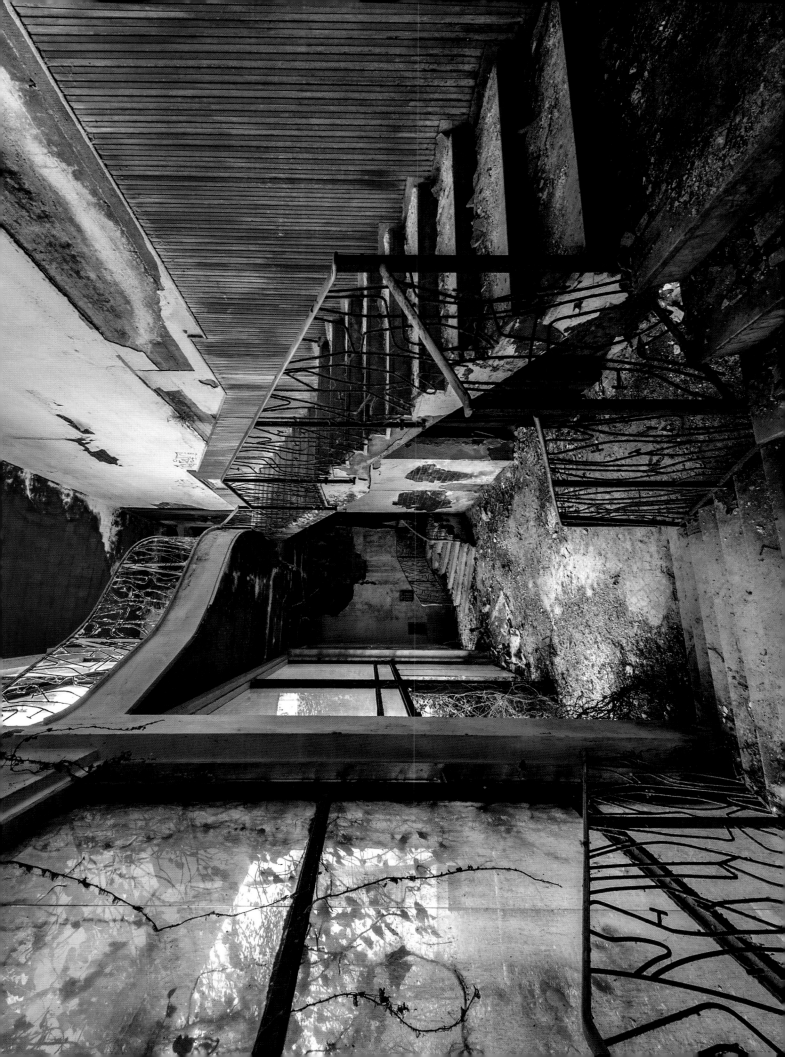

Castello di R – *Piedmont*

The story behind the twin castles is unbelievable. Though the oldest of the two dates back to 1170, the second was built at the very beginning of the 20th century. This copy — its vacant corridors decorated with family crests — was the brainchild of Count Lancelot, who, having been denied the original, which he thought he would inherit, decided to have an identical one built just 200 metres away. He requested the architect provide all the modern comforts. Thus the castle was fitted with a heating system, toilets and even private sewers, a rare luxury for the time. Descendants of the count could not continue living there, so this unique clone is now abandoned, its colourful frescoes and medieval turrets falling into disrepair.

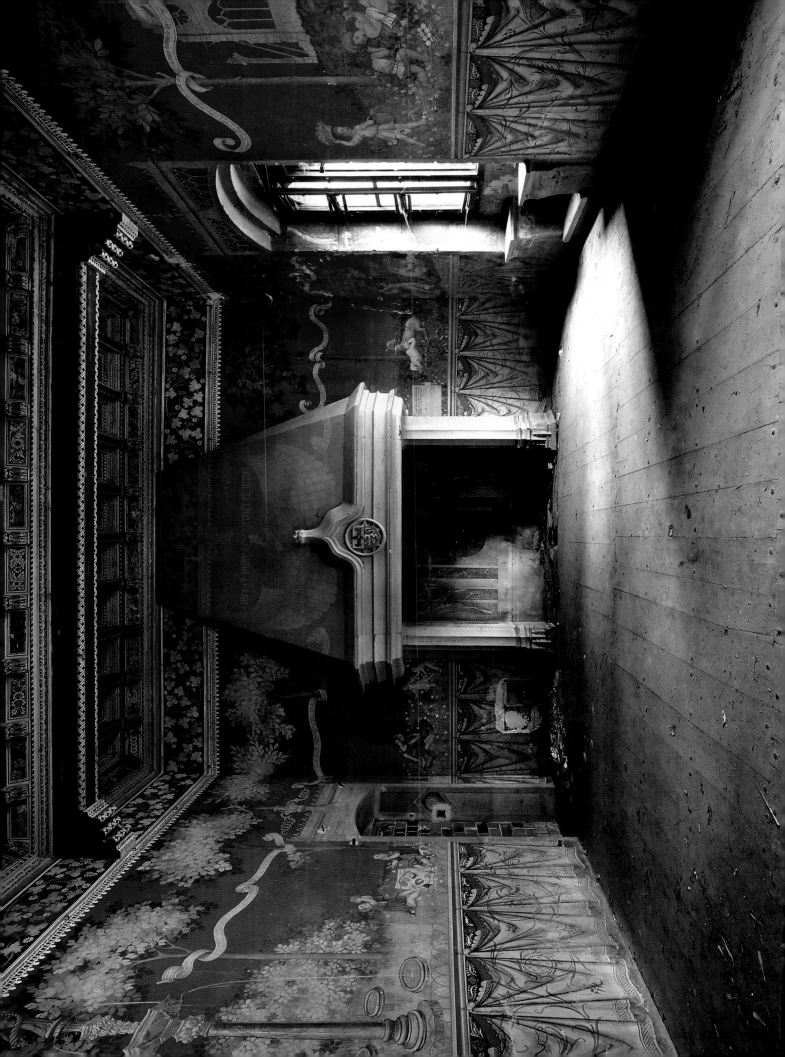

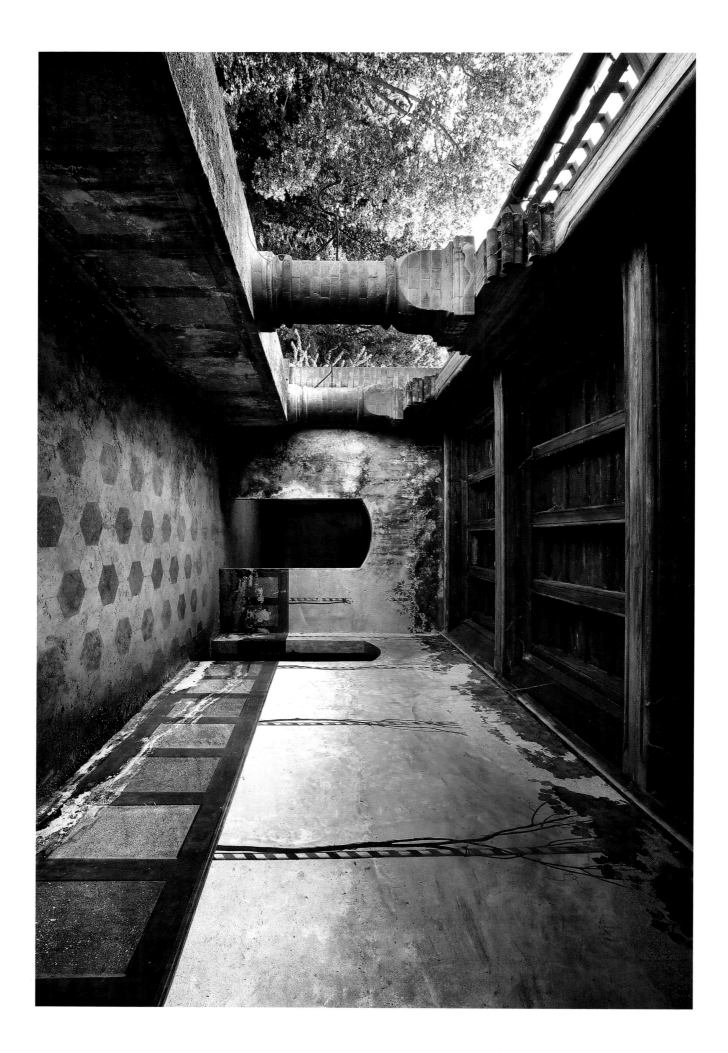

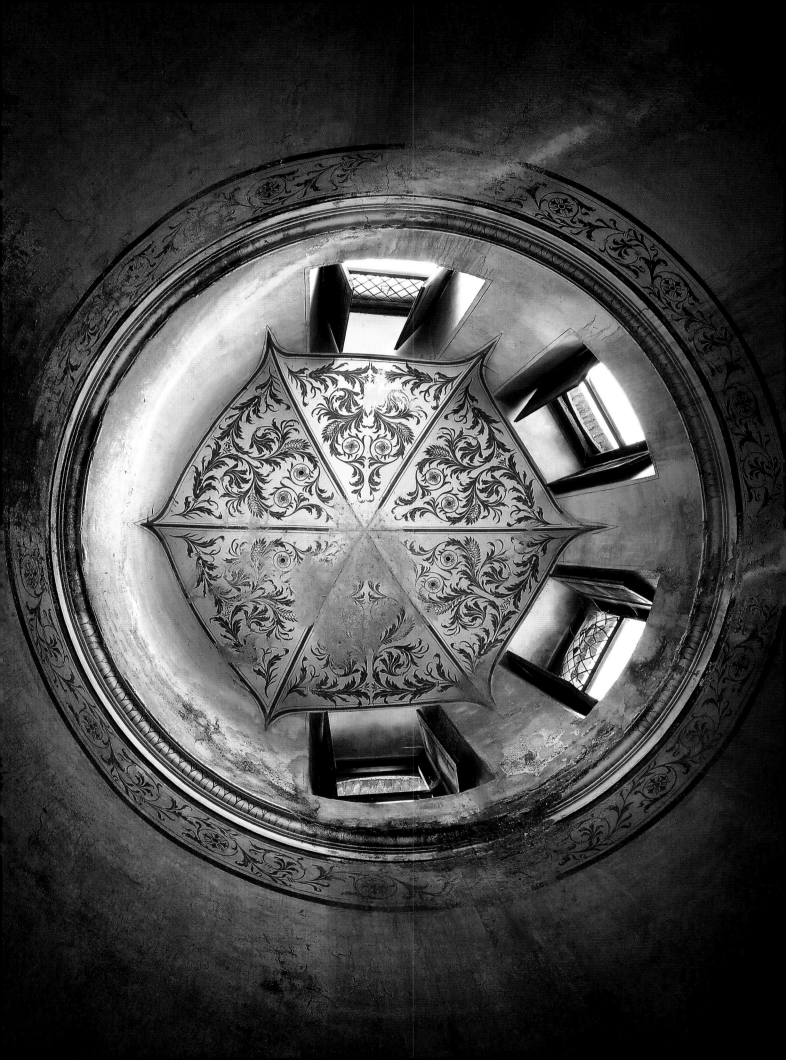

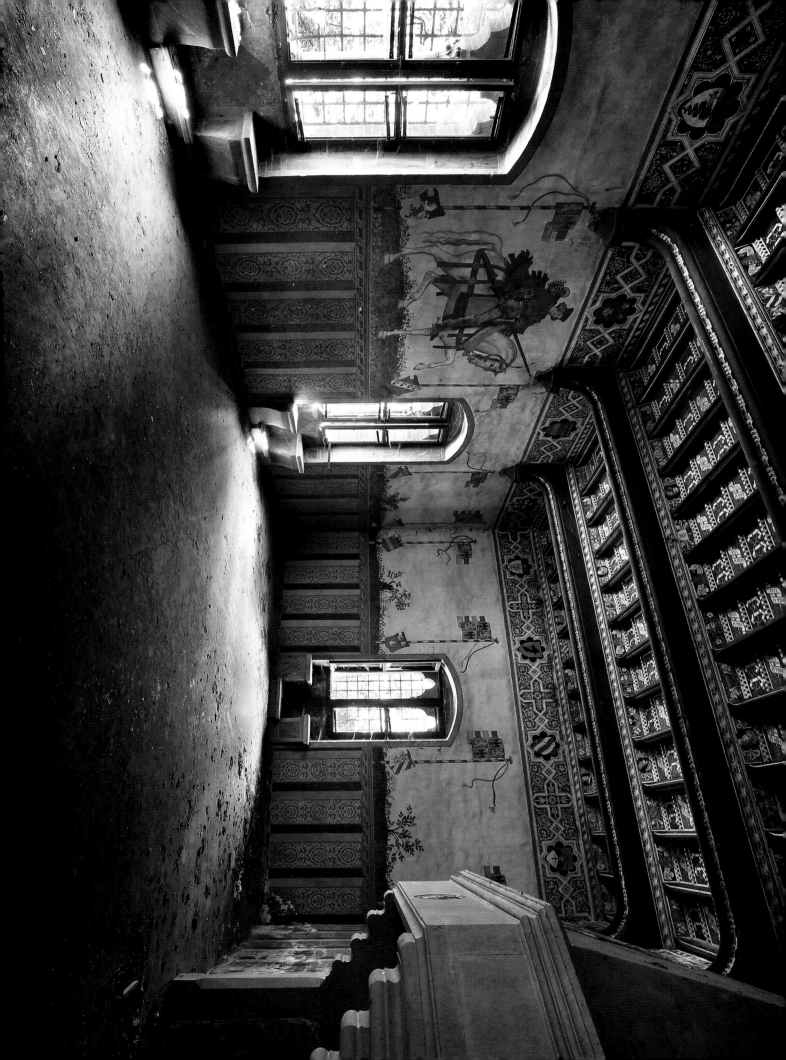

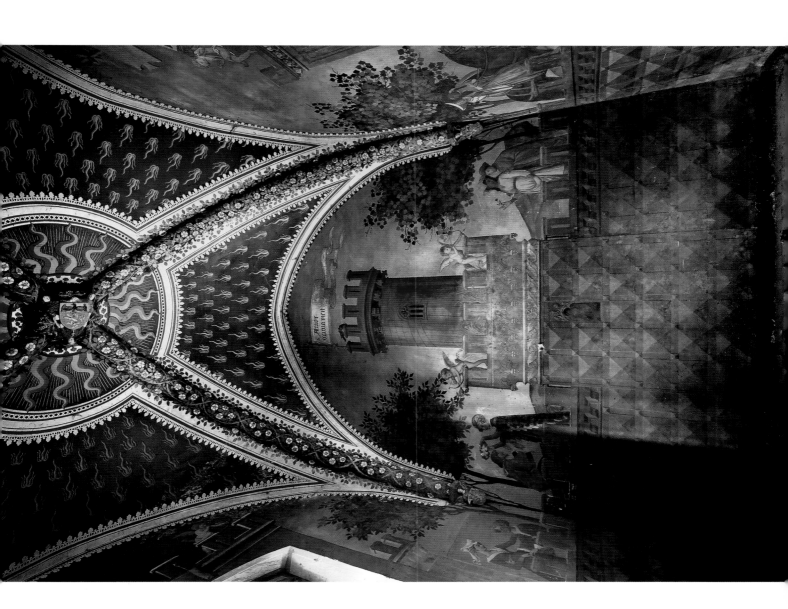

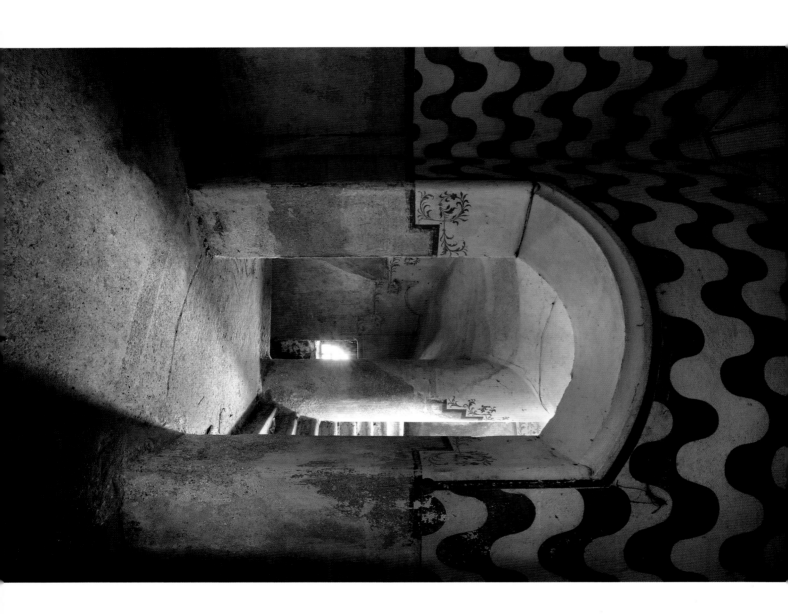

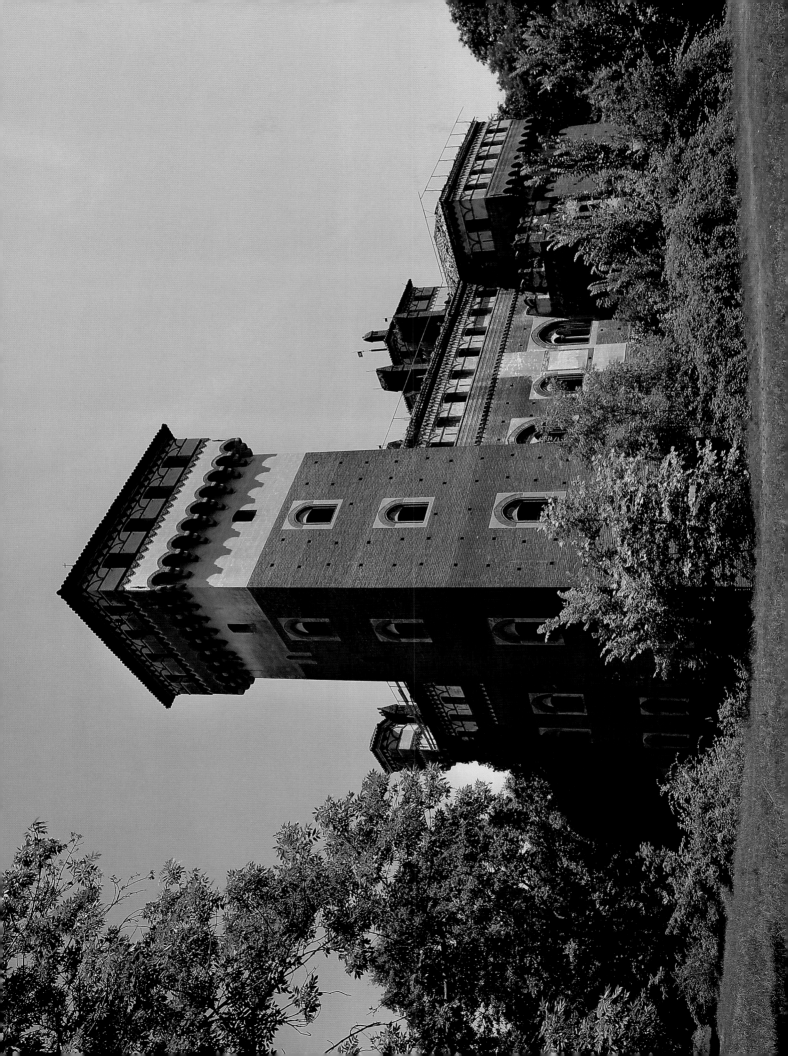

Palazzo di L dei conti M – *Piedmont*

This grand and majestic palace, built in the 18th century, was the summer residence of the Counts of Morra, who included in their ranks one of the pioneers of Piedmont archeology. This magnificient residence is a true work of art; from the colourful coffered ceilings and painted basements to the fireplace decorations and the trompe l'œil of the stairwell that gives the impression of overlooking beautiful gardens, the visit is breathtaking.

At the time of its first occupancy, the villa was, it is said, furnished with taste and refinement, enhanced by an impressive art collection. Following some financial setbacks, the property changed hands several times until in 1930 an architect bought it and undertook to renovate it over two decades.

It was sold once more to a company at the end of the 1950s. Uninhabited since then, it has gradually been invaded by humidity and dust.

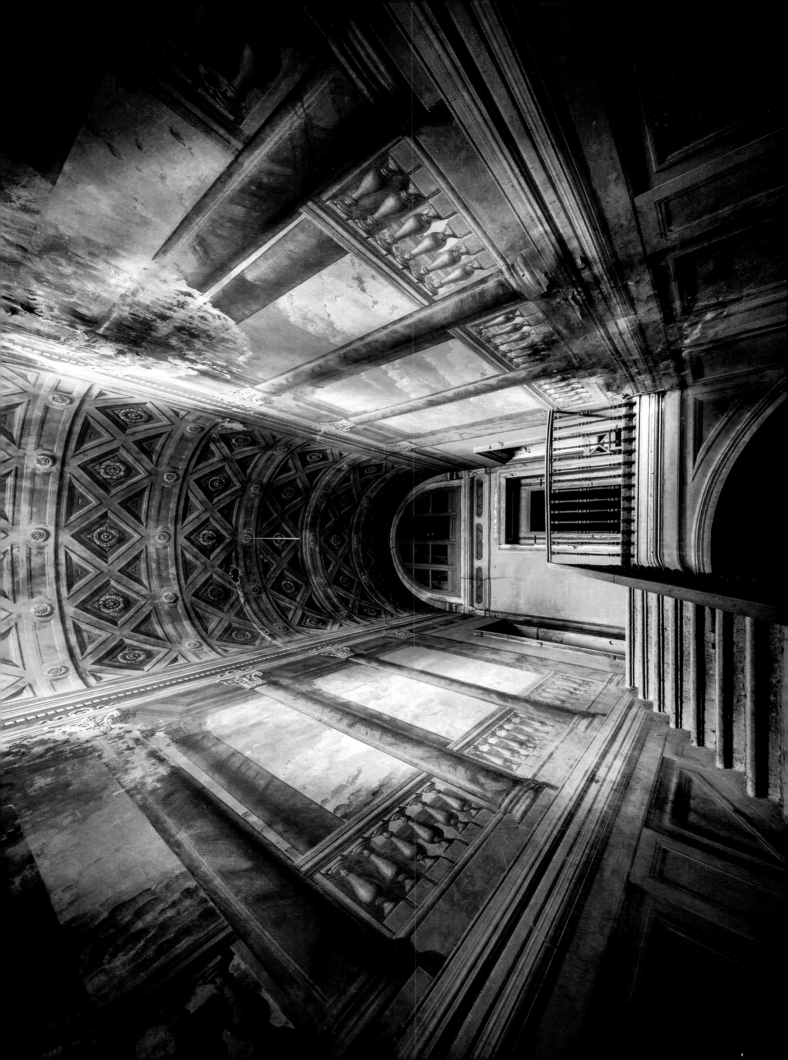

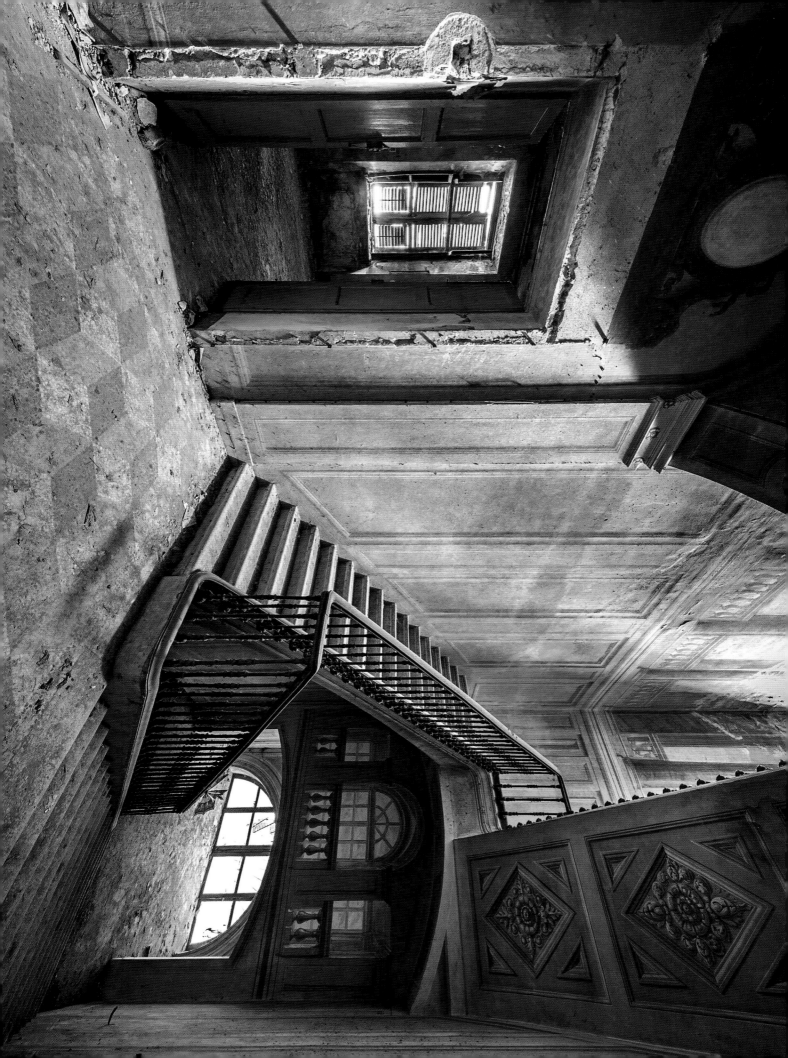

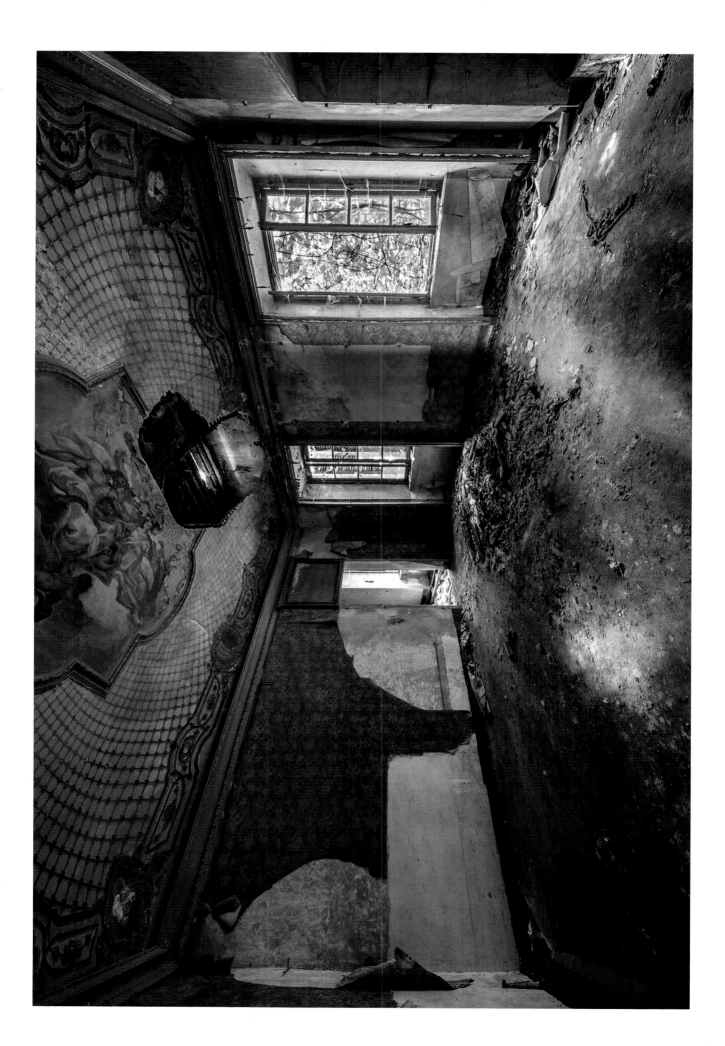

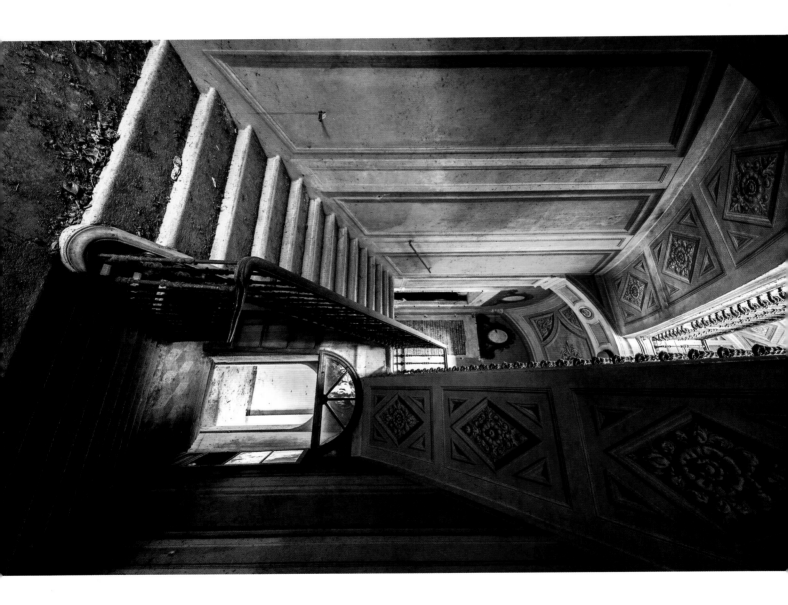

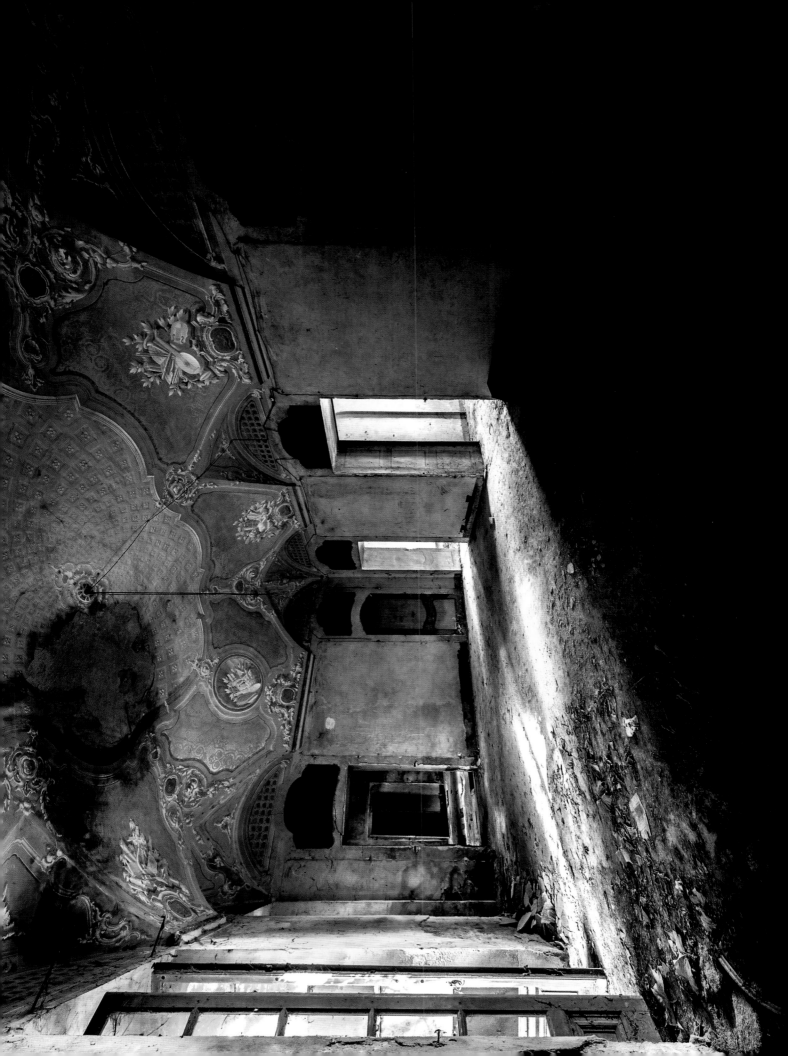

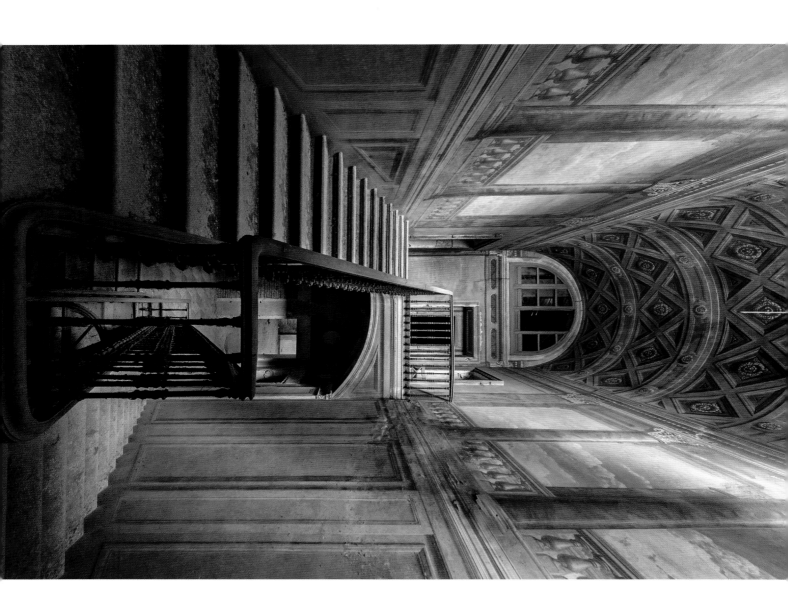

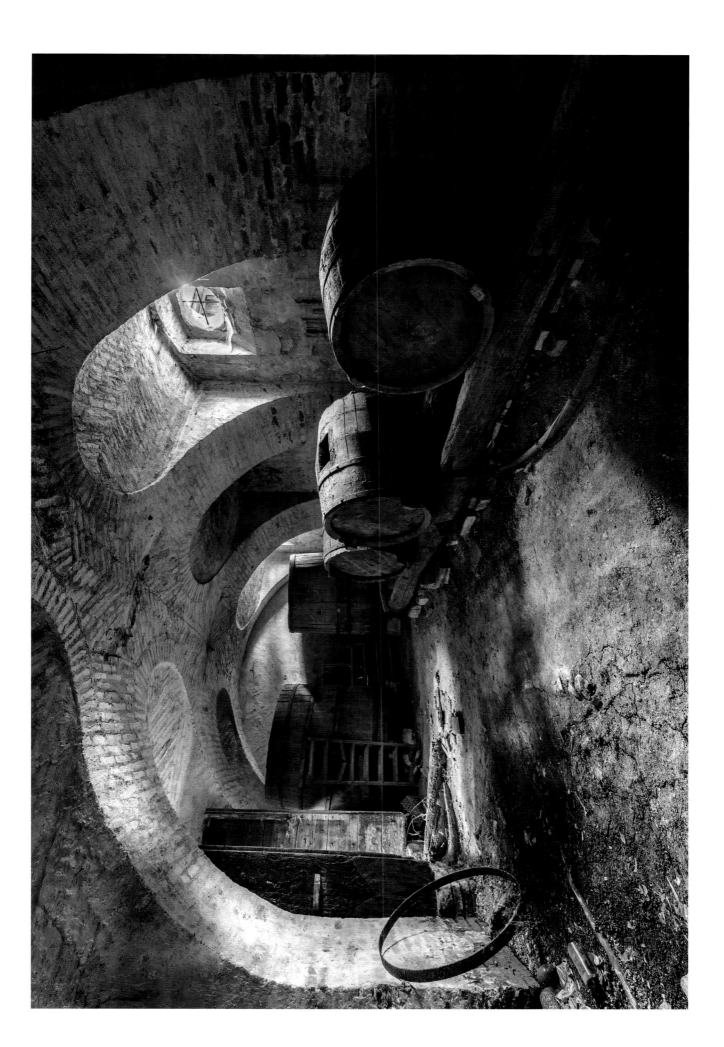

Red Cross Hospital – *Piedmont*

The Red Cross Hospital formerly hosted a summer camp for sick children who also enjoyed the great outdoors. The two dormitories are still in excellent condition, though the collective bath next to the first one is now home to a small tree that has taken advantage of the shade to inhabited the deserted space.

Despite the austerity of the ground floor room, with its bare school offices and the fading cross of the chapel ceiling, the atmosphere of summer camp still pervades; one can almost hear the laughter of the children floating in the air ...

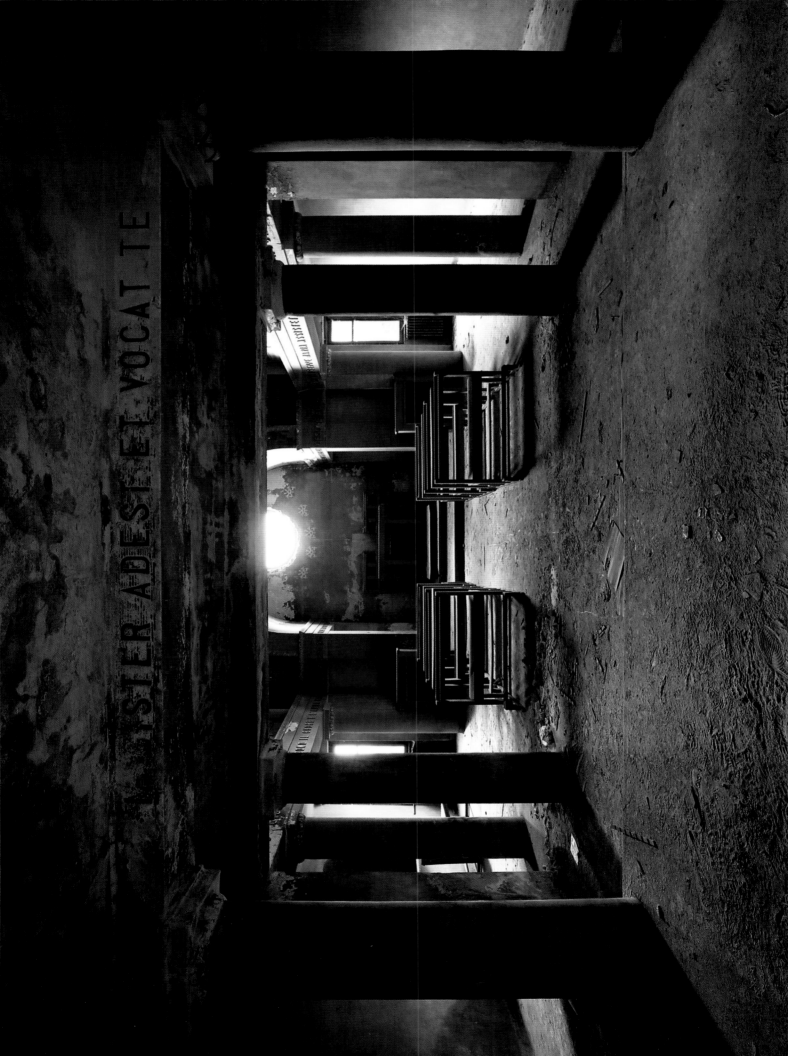

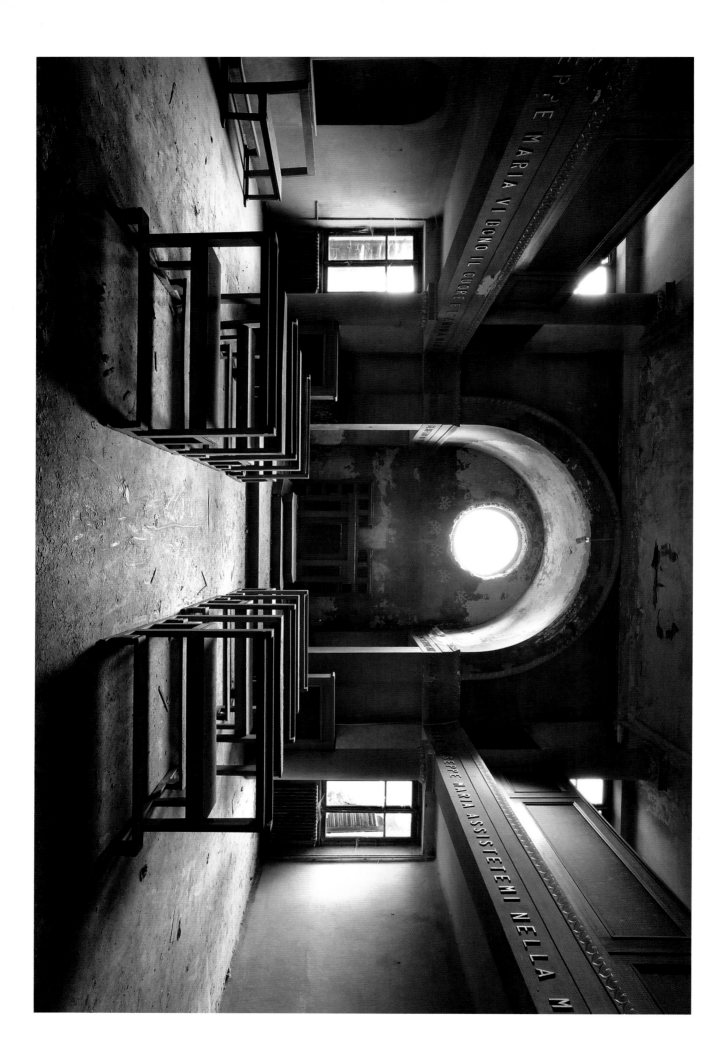

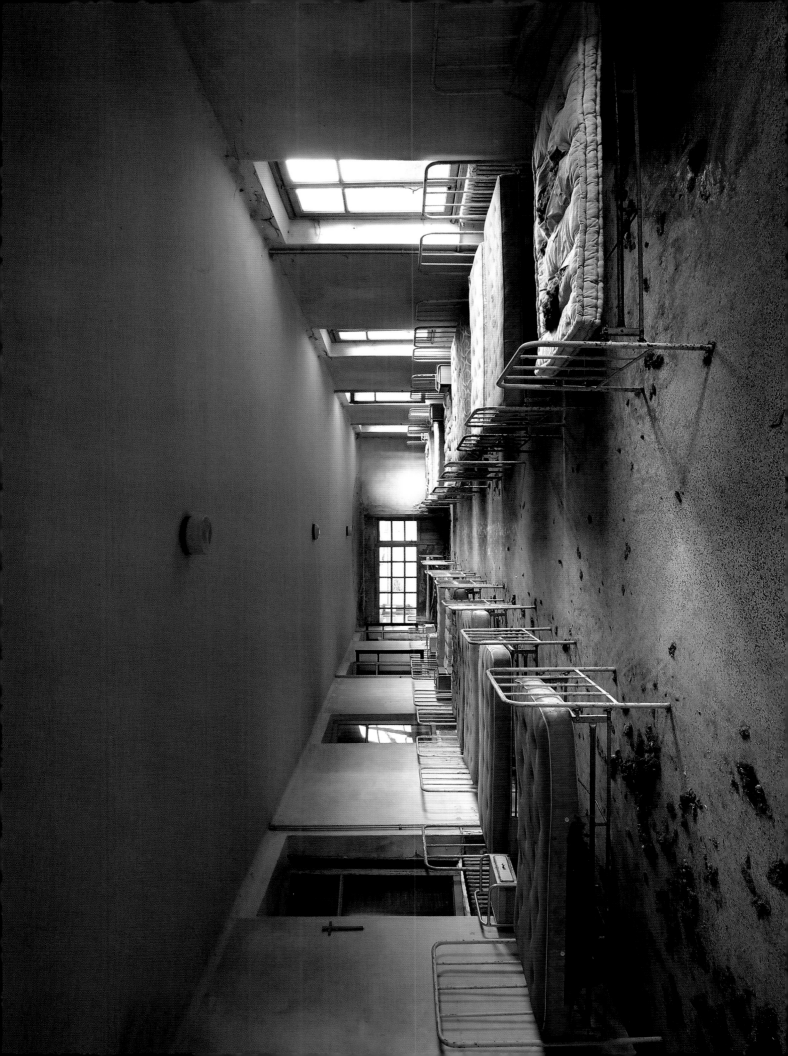

Villa Curva – *Piedmont*

Villa Curva is one of those places typical of an agro-residential area. An avenue flanked with towering plane trees leads to this beautiful and noble residence. The 17th-century neoclassical façade is decorated with a large triangular tympanum, while at the back, facing a once charming park, its pond dotted with water lilies, a majestic four-flight staircase leads to a loggia with three arches.

With its large hall decorated with gold, and its curved staircase culminating in an extraordinary rose window, the interior of the villa is just as remarkable.

The property witnessed the particularly active social lives led by its various owners, sometimes politicians, sometimes aristocrats. During the war, the villa became a clandestine warehouse for alcohol, suffering some damage after a raid by partisans, before the owners returned to take possession of it and restore its former splendour.

Today uninhabited, the house and its 96 rooms seem empty and in need of renovation.

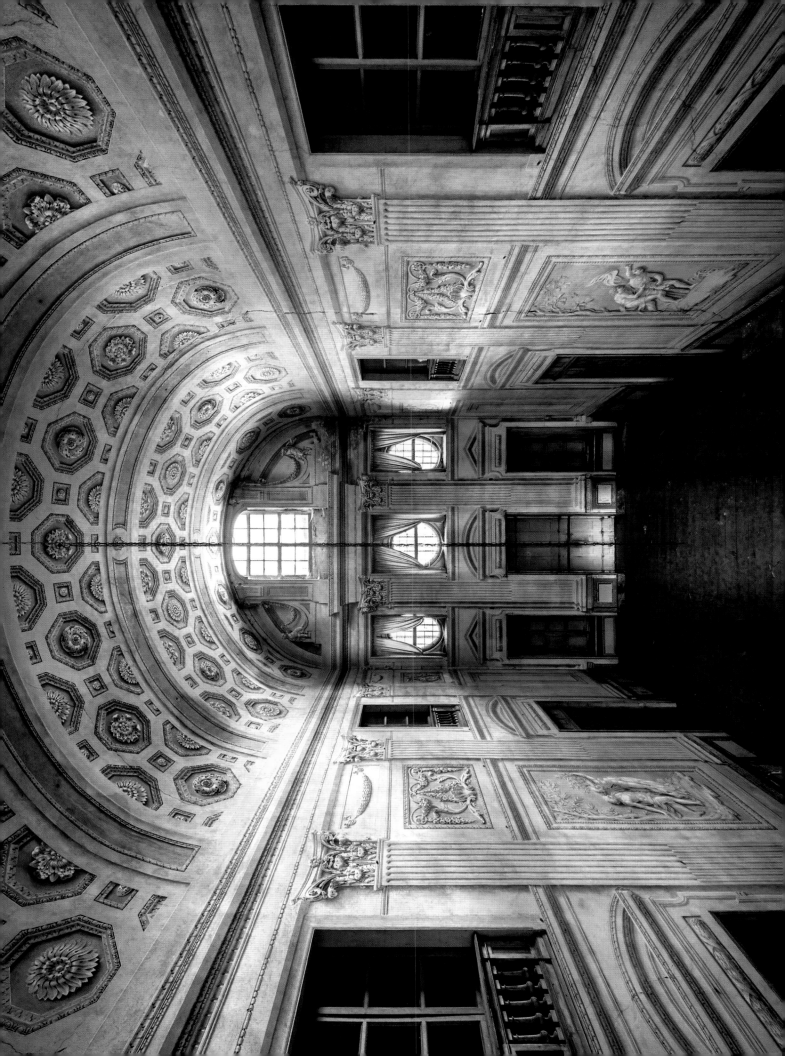

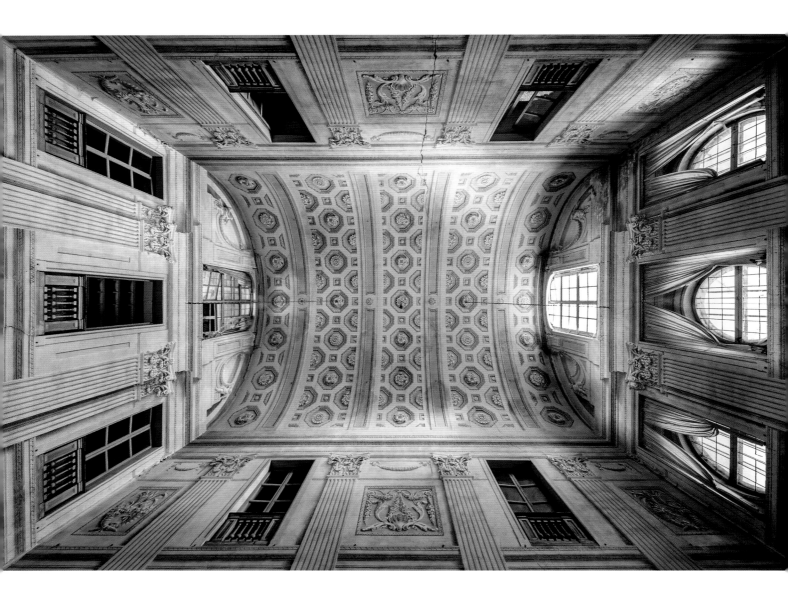

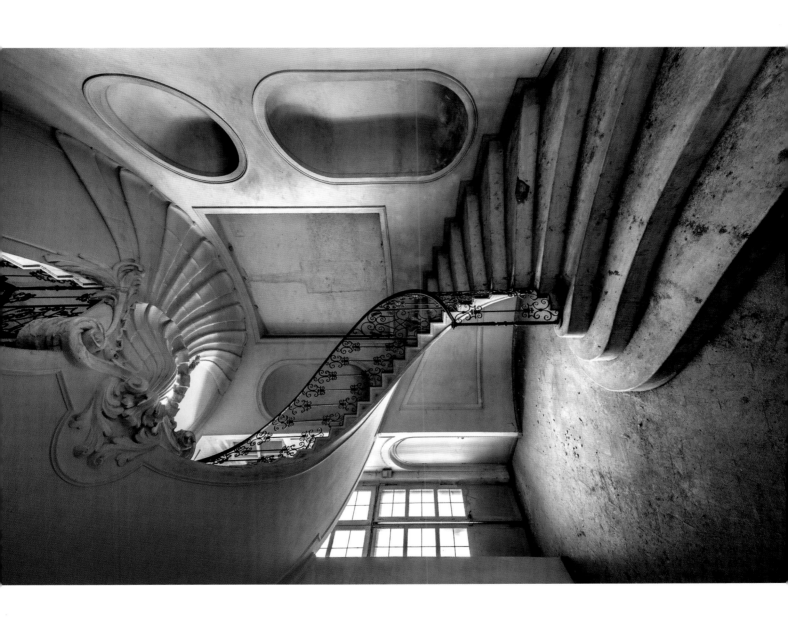

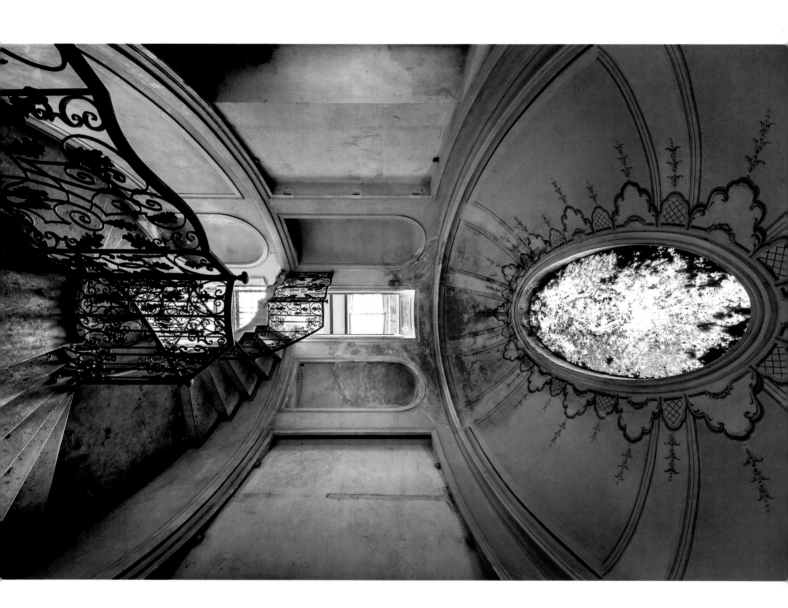

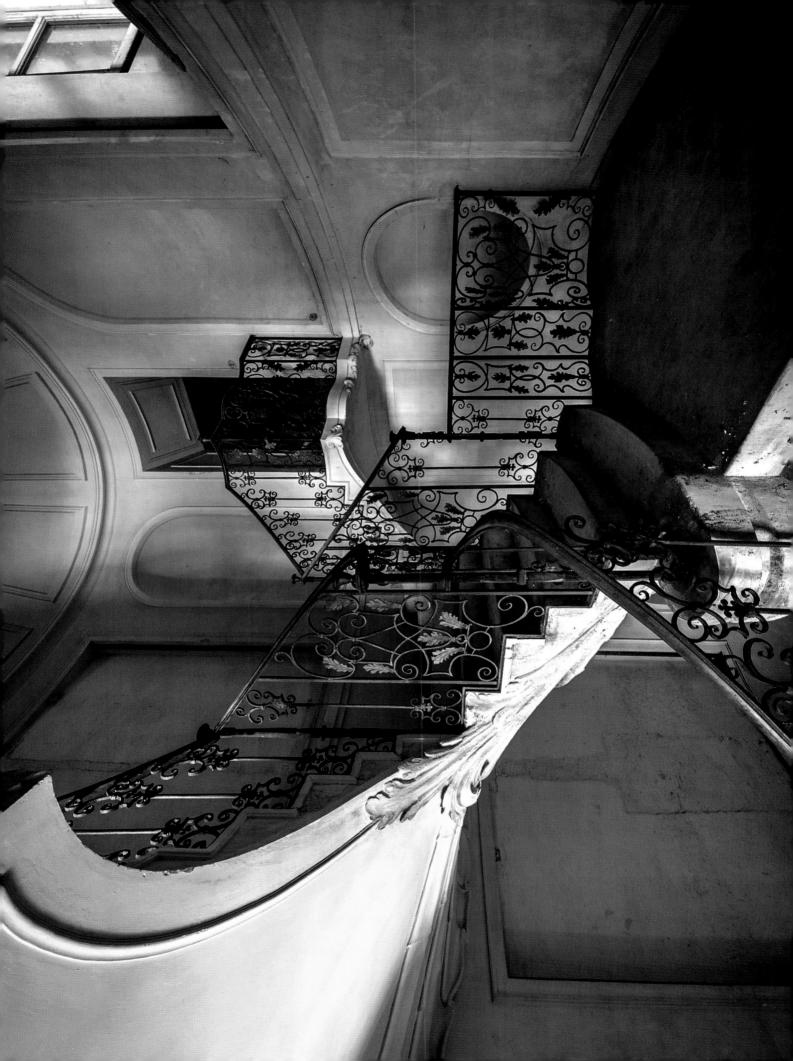

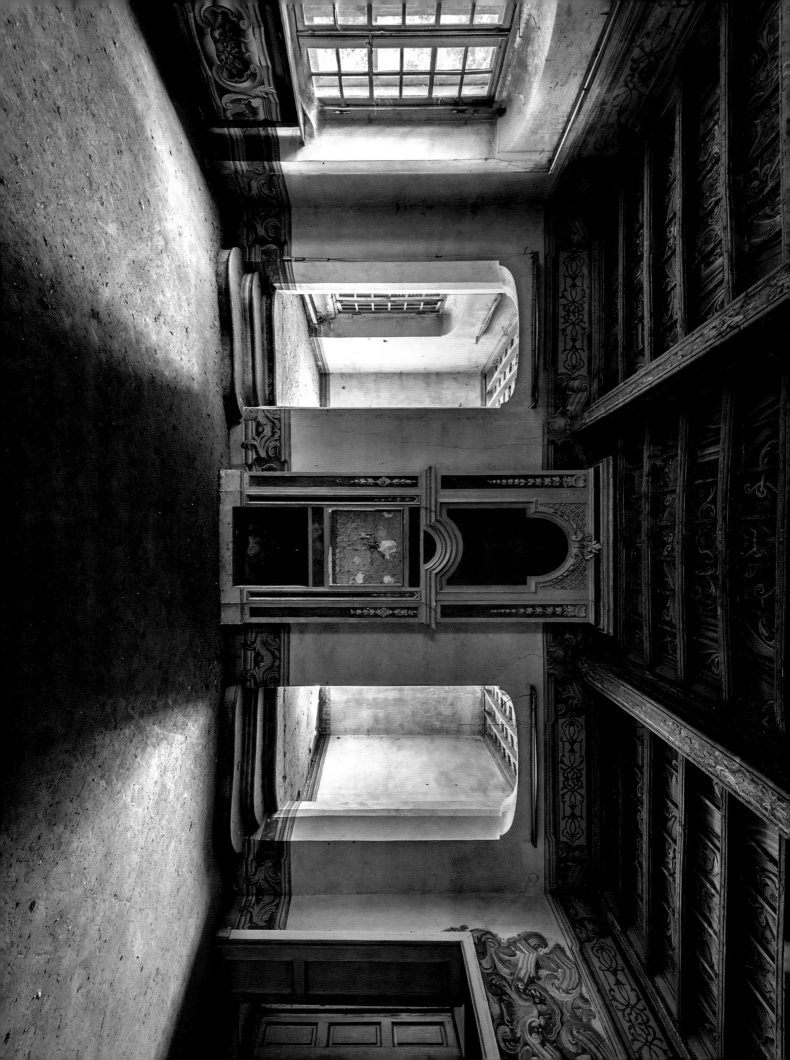

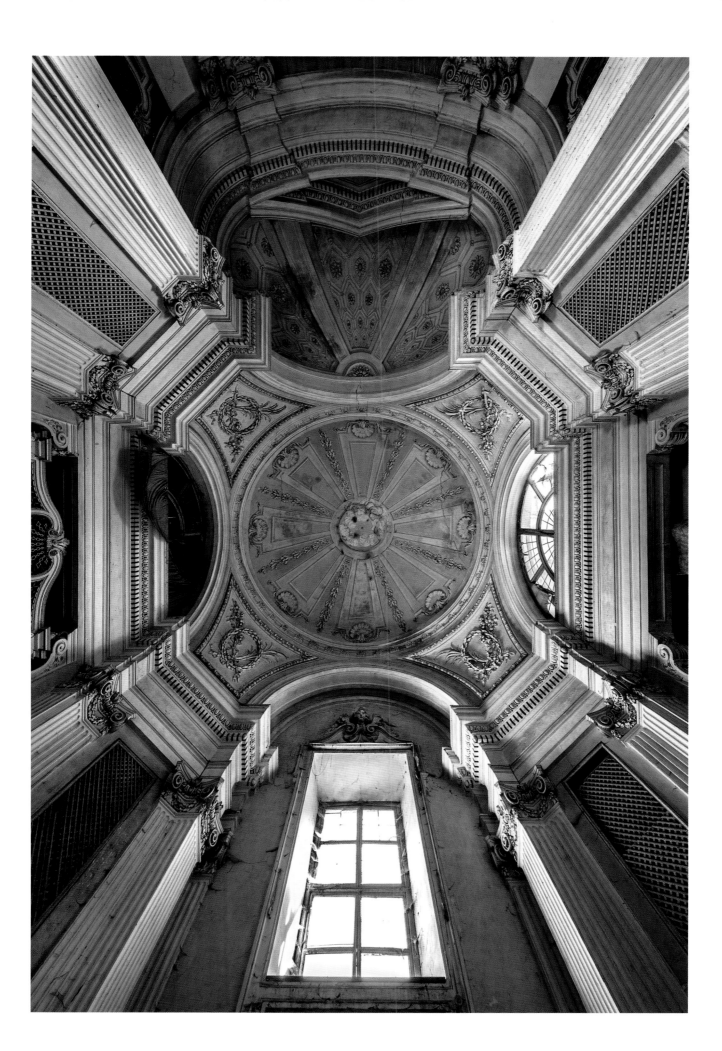

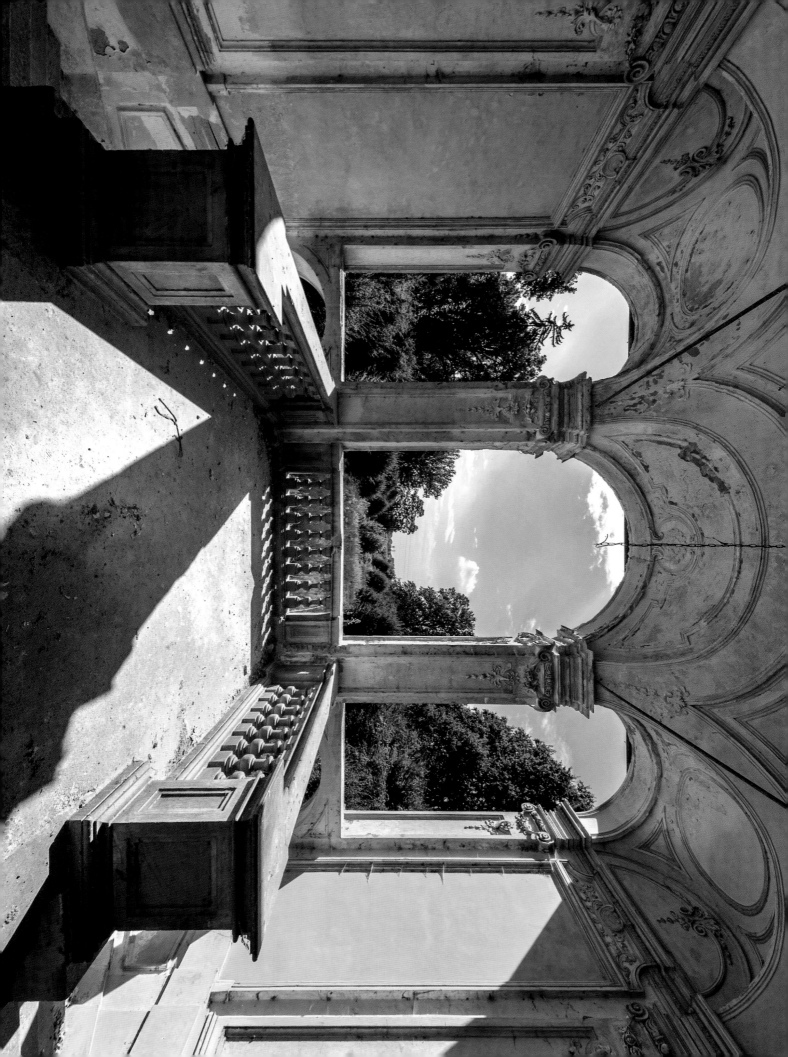

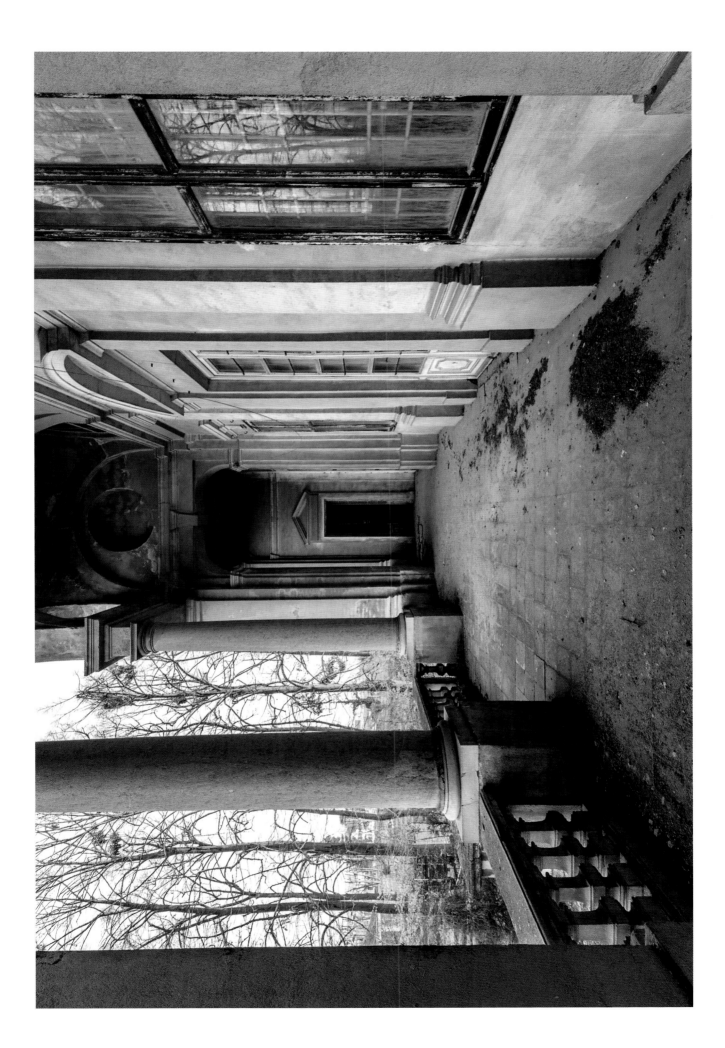

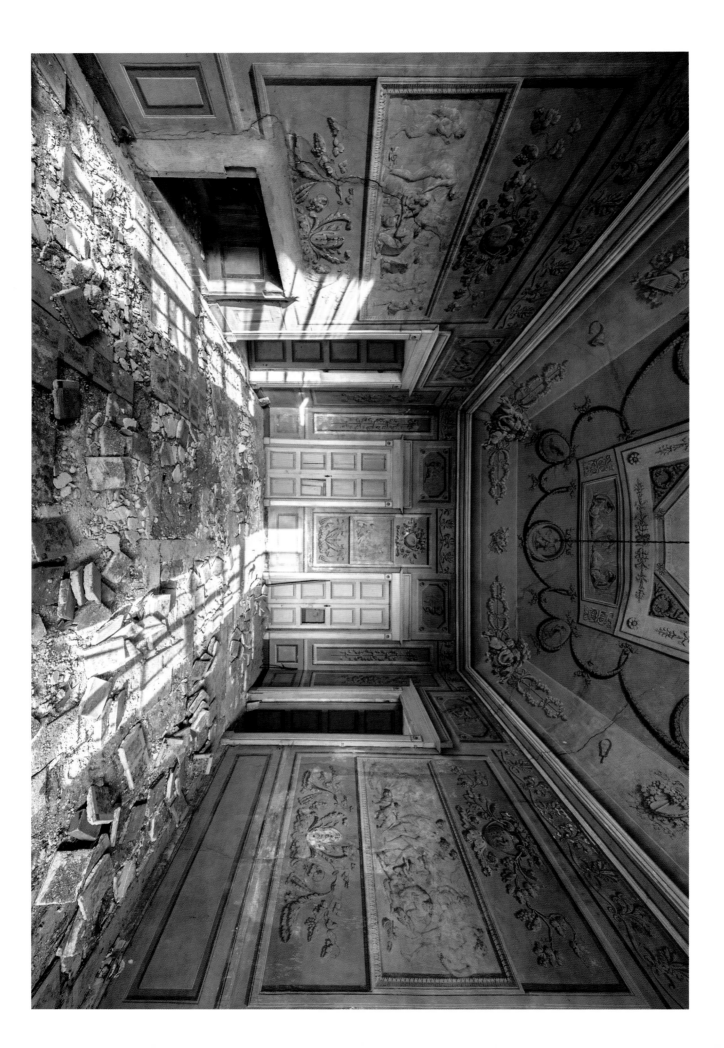

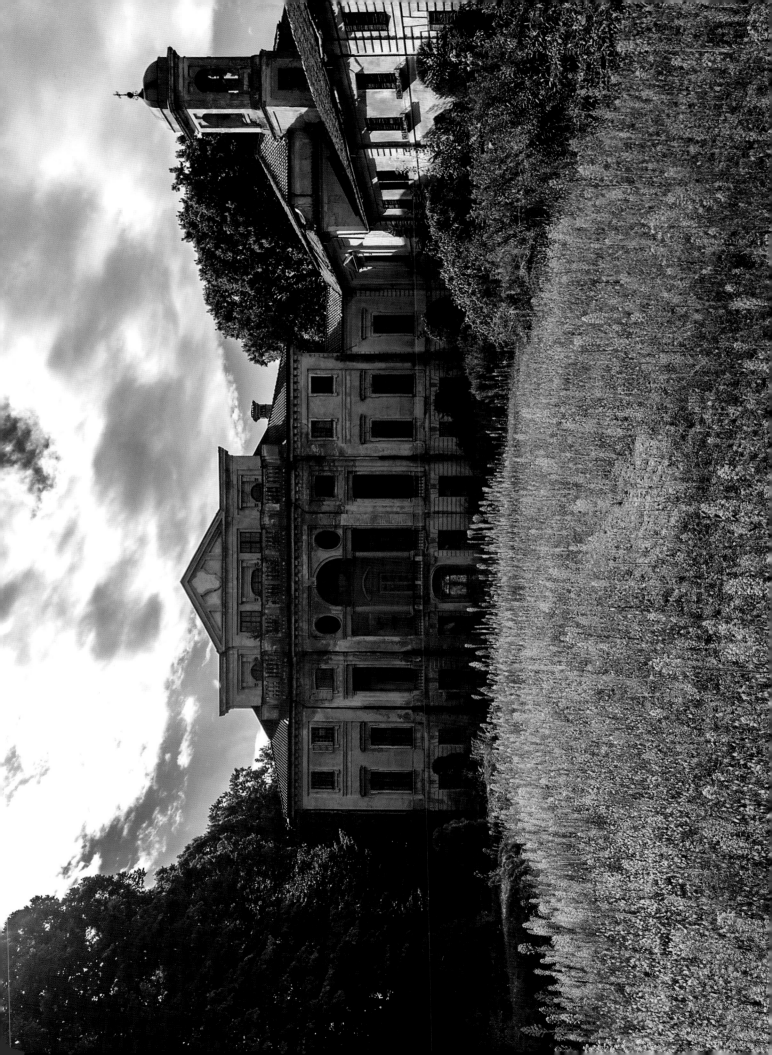

Villa Garibaldi – *Piedmont*

The two towering buildings overlooking the Deer Valley were built in 1950. Offering breathtaking views of the Alps in the distance, the main villa is a holiday resort designed for the House of Savoy. This illustrious family, which obtained royal dignity in the 18th century, is one of the oldest dynasties in Europe and boasts some 700 members.

The building has three floors and many salons, all decorated with beautiful frescoes depicting peaceful landscapes, while a beautiful vaulted terrace allows hosts and guests to enjoy a fresh atmosphere despite the southern exposure.

The outhouse in the neighboring building accommodates servants, stables and a hunting lodge — essential leisure requirements for the aristocratic elite.

This beautiful property, a victim of its size, is now struggling to find a new buyer.

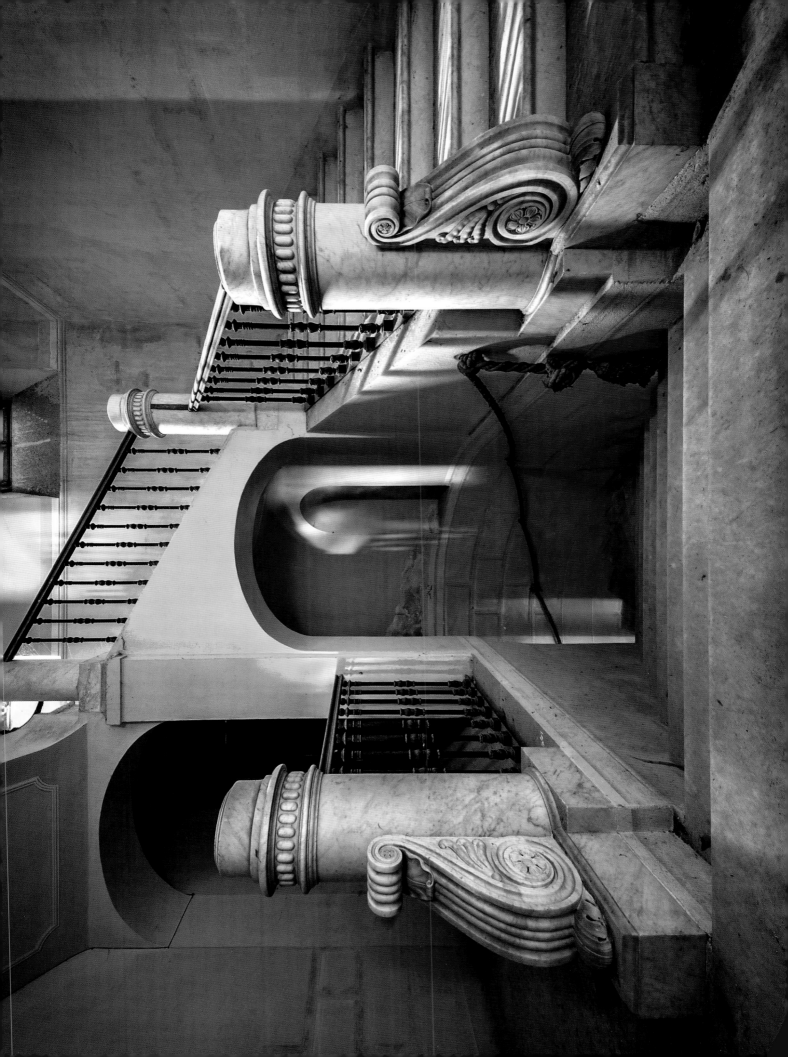

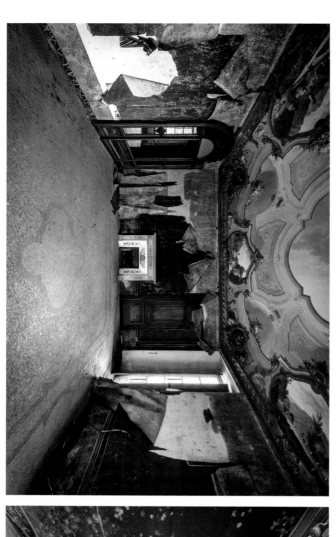
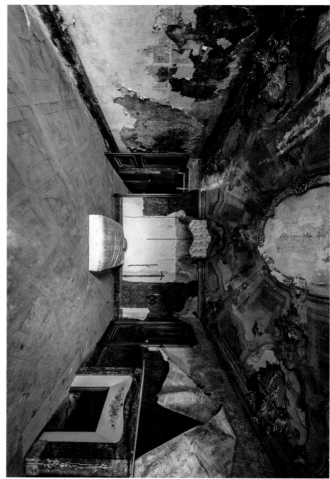
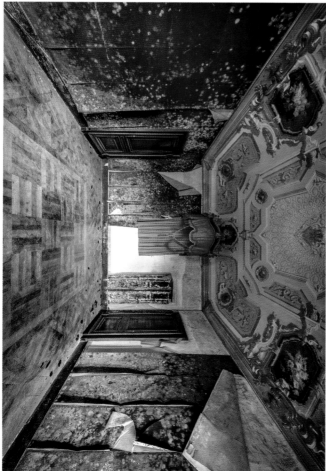
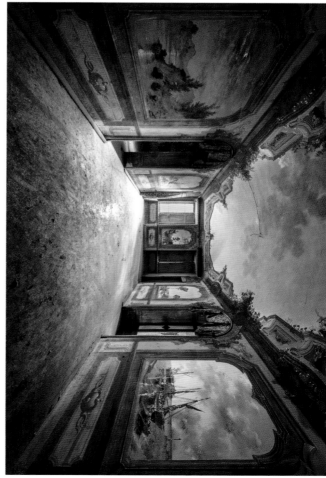

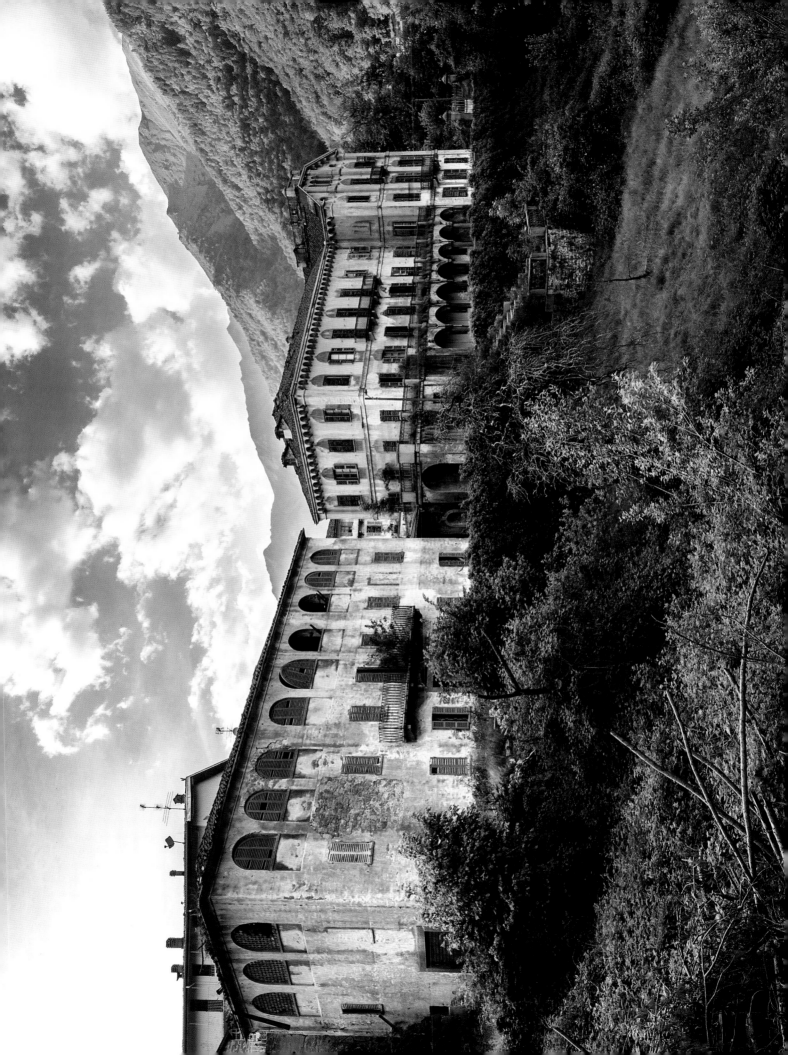

Villa Poss – *Piedmont*

Villa Poss was one of the most famous residences in the Lake District of northern Italy. It enjoys a privileged location overlooking a magnificent panorama of the lake and its intense blue waters. The status of the property is due as much to its remarkable architecture as it is to the importance of its residents and the variety of its botanical collections.

On a stretch of land purchased at the end of the 18th century, the Marquis Poss built the house in several stages. Most notably, he erected a characteristic medieval tower that was later called Villa La Torre. During the following decades, prestigious guests of this private villa followed one after another: a Napoleonic minister, a countess of the region, two industrialists, a Polish prince, and in the 20th century, a rich entrepreneur.

Although the building is heavily damaged, some elements, such as the majestic staircase flanked by a beautiful wrought iron banister, still exude an atmosphere of evaporated luxury.

The gardens were once a special attraction; the beautiful six acre-park consisted of greenhouses, caves, valleys, bridges, a gazebo, stables, and many trees and shrubs of rare and imported species.

The park, just like the villa, has been abandoned for years. In 2000 the municipality suggested it could be renovated and transformed into a museum, but donors interested in safeguarding this precious heritage are yet to be found.

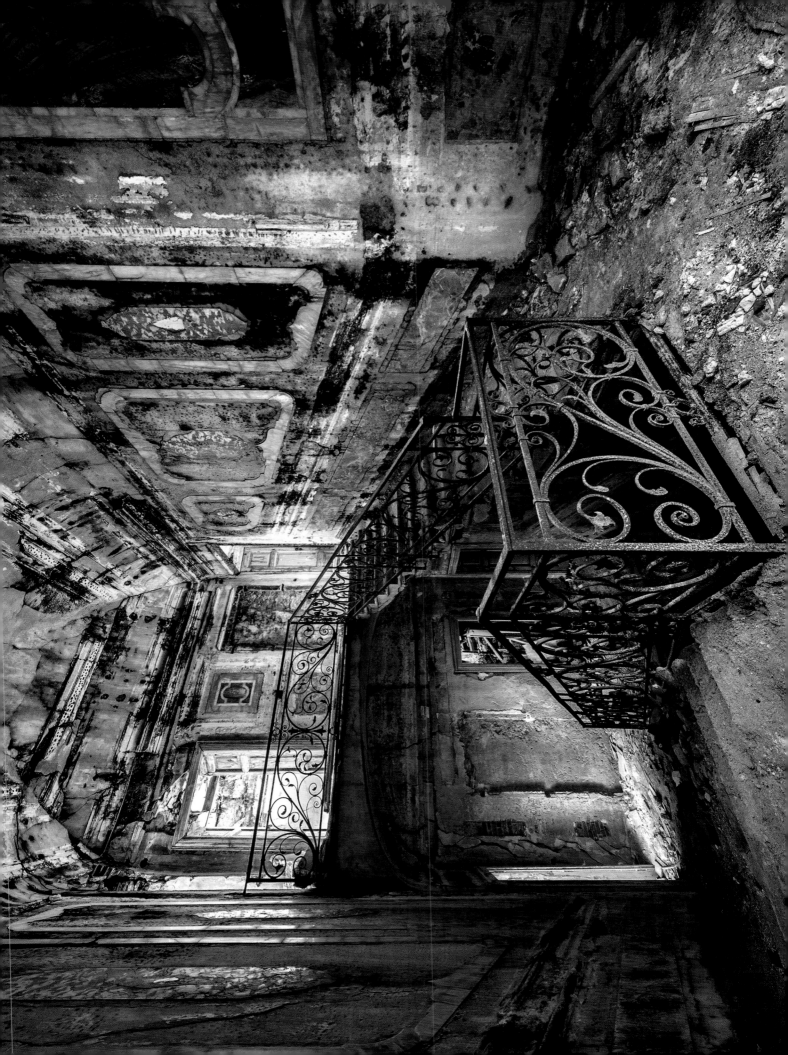

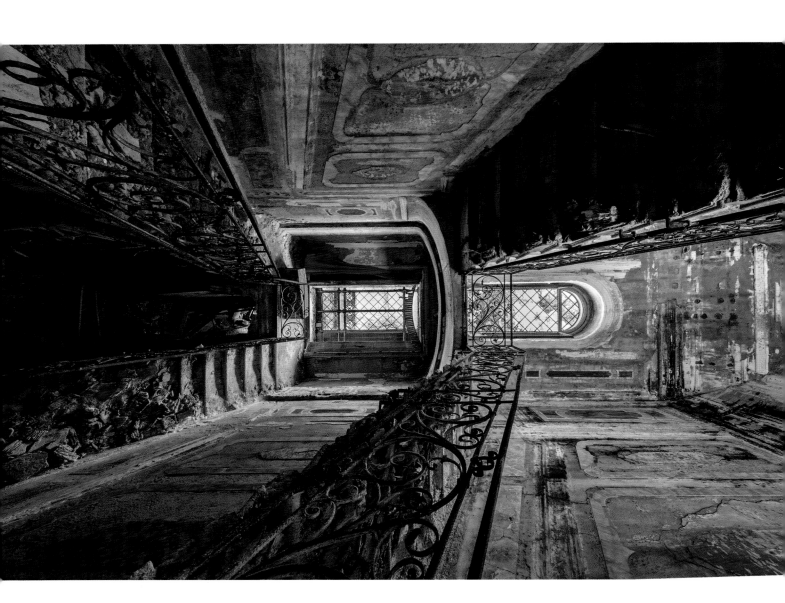

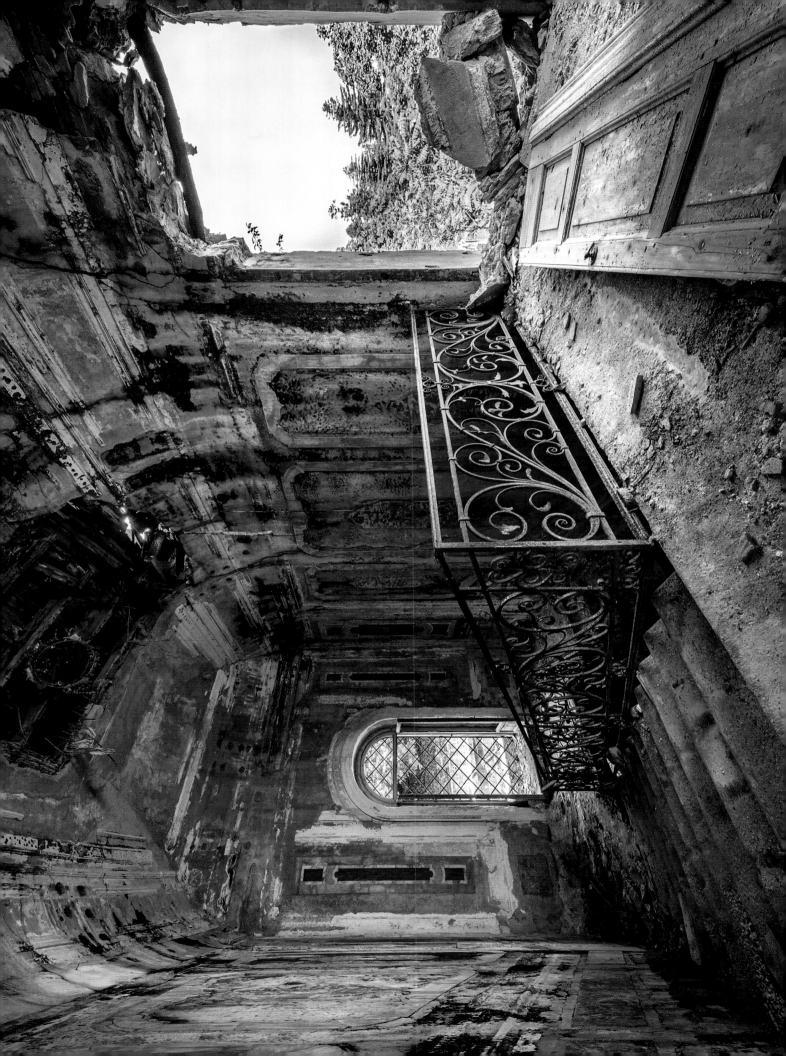

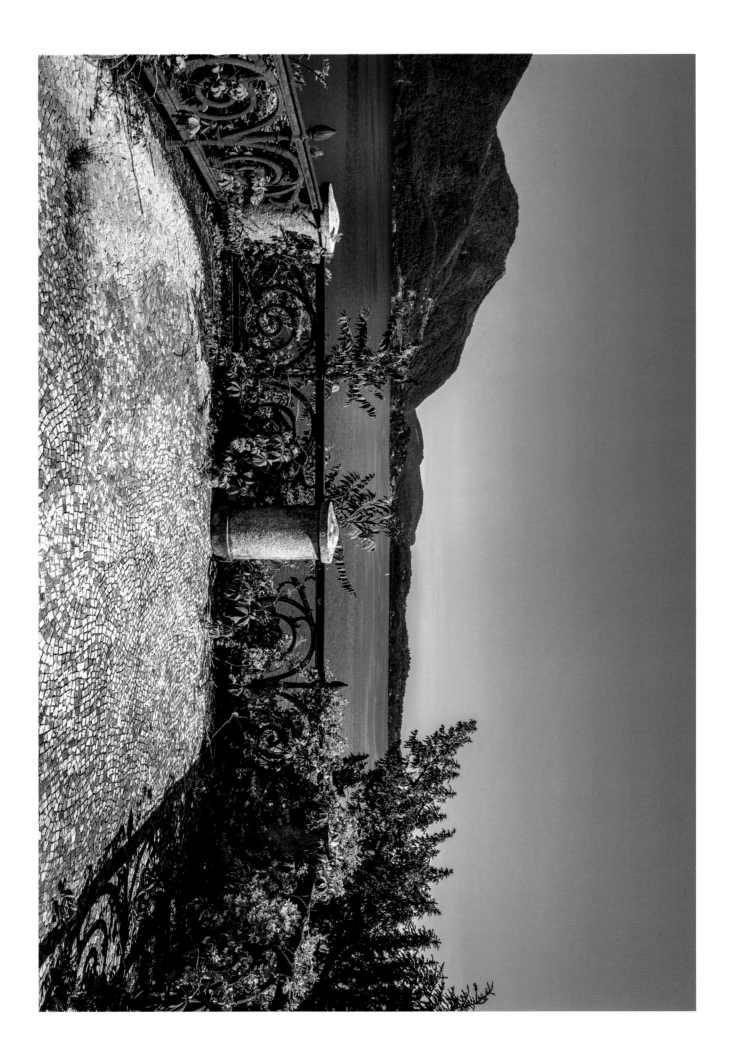

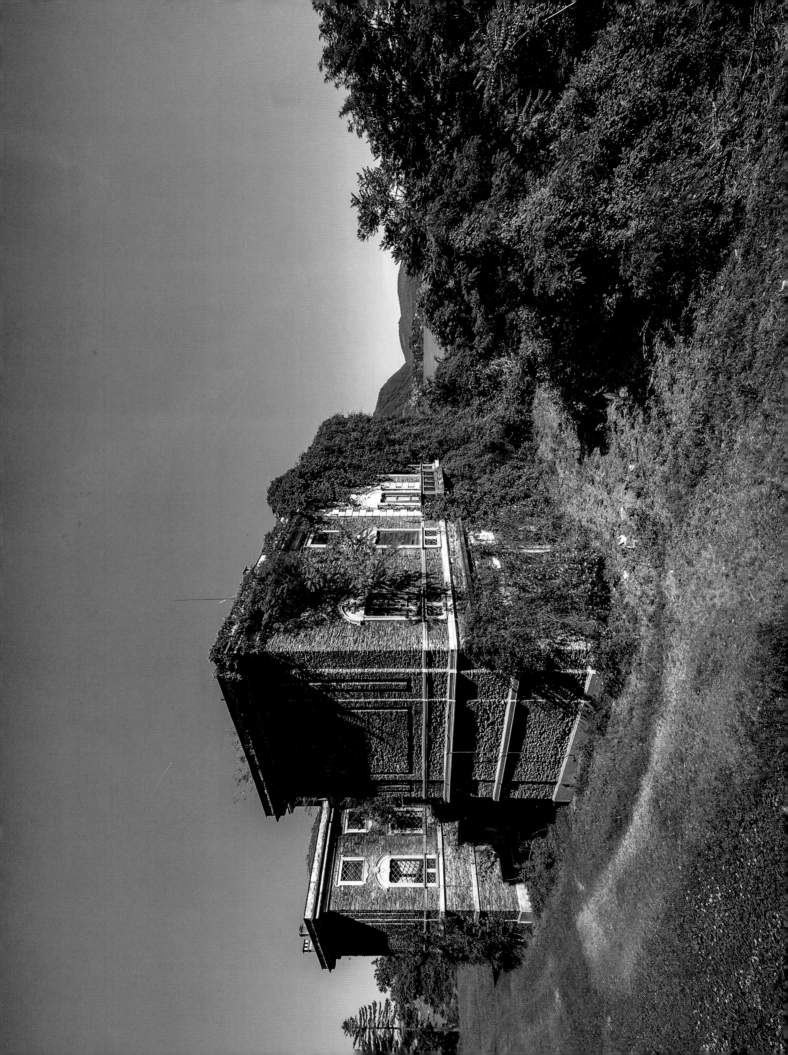

Villa Romana – *Piedmont*

Commonly called "the house with a hundred windows", this huge and luminous residence enjoys a breathtaking view of the surrounding hills and the valley of the River Po. Designed by the Count of Viarengo (a famous architect of the time), it was built in the second half of the 18th century for the Marquis of Cereseto, a Piedmontese aristocrat.

According to the wishes of the owner, the villa followed an elegant Baroque style and is very harmonious in its proportions. It was once surrounded by vast gardens and a park. The entrance hall, which occupies the full height of the building, is very impressive. Its decoration, in pastel green on a white background, is composed of stucco, medallions and inserts. The walls are covered with frescoes depicting armoured knights, coats of arms with shields, helmets and spears. A balcony running through the hall provides access to the other rooms of the property.

Was it a family home? A headquarters? This beautiful example of architectural heritage is for sale and awaits a new owner ...

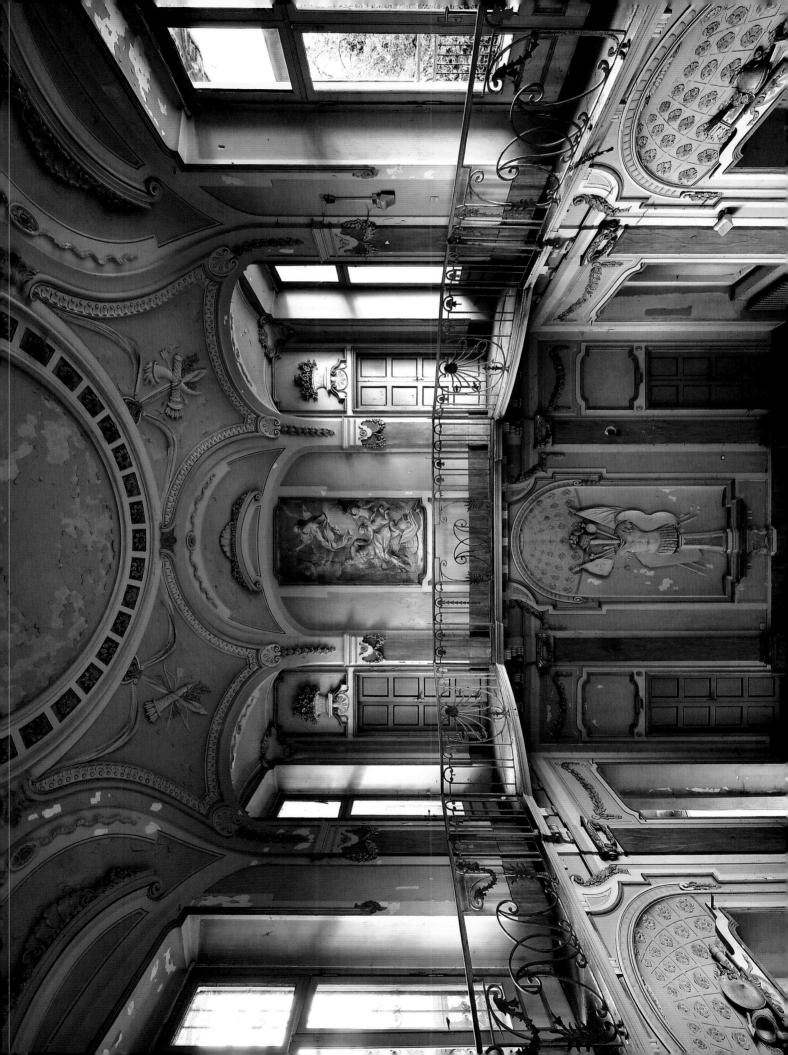

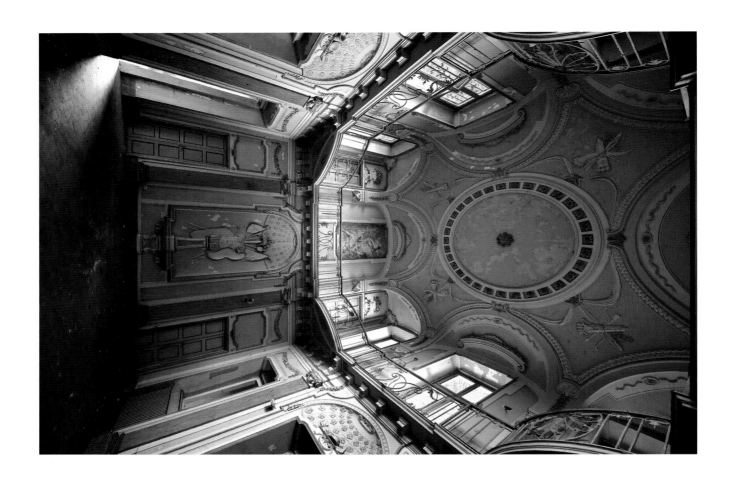

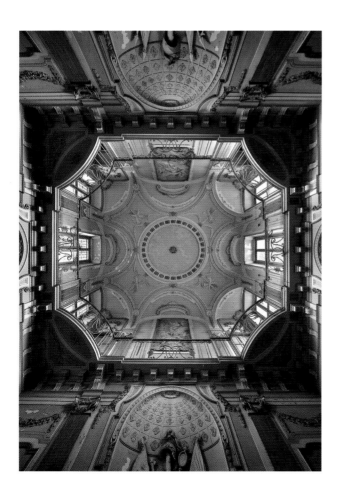

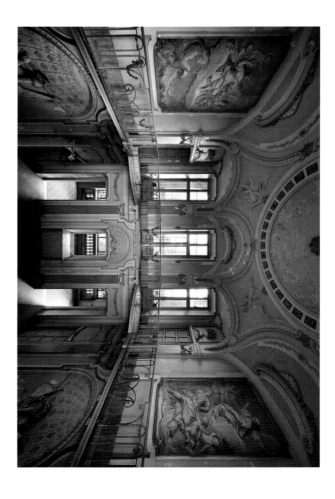

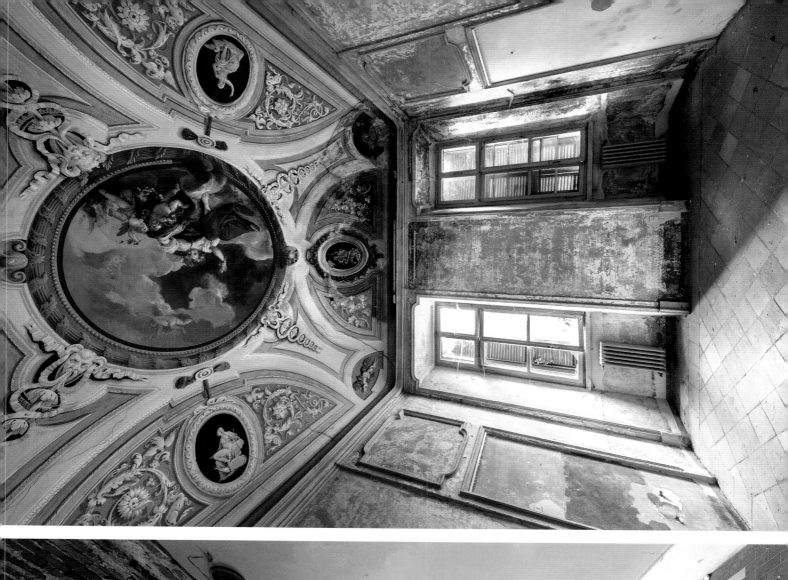
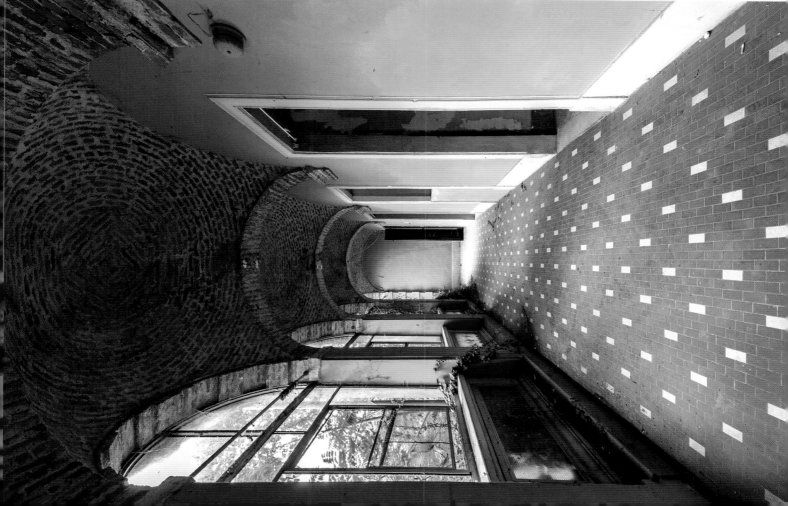

Villa SG – *Piedmont*

Wealthy families of Turin had summer residences built to enjoy the cool breeze coming down from the surrounding hills. A grain merchant began the construction of this villa in 1697. The weather vane on the skylight of the central body bears the inscription "1767", indicating when the property was completed.

A succession of eminent residents has allowed the villa to be preserved in good condition over the centuries. Among the residents, Count Lajolo, mayor of the municipality and the creator of a recognised agricultural foundation in the region.

The central body rises under an astounding rose ceiling. The main hall is decorated with frescoes depicting life-size figures, including women — undoubtedly courtesans — and men, along with the coats of arms of the various families who lived in the villa. From here a staircase climbs to a balcony overlooking the room, and its prestige becomes apparent.

During the First World War, the villa hosted the Marist Fathers, who cultivated aromatic herbs from all over the country to distil liquors, which they aged in oak barrels.

Due to a lack of funds needed to maintain it, the residence is now vacant.

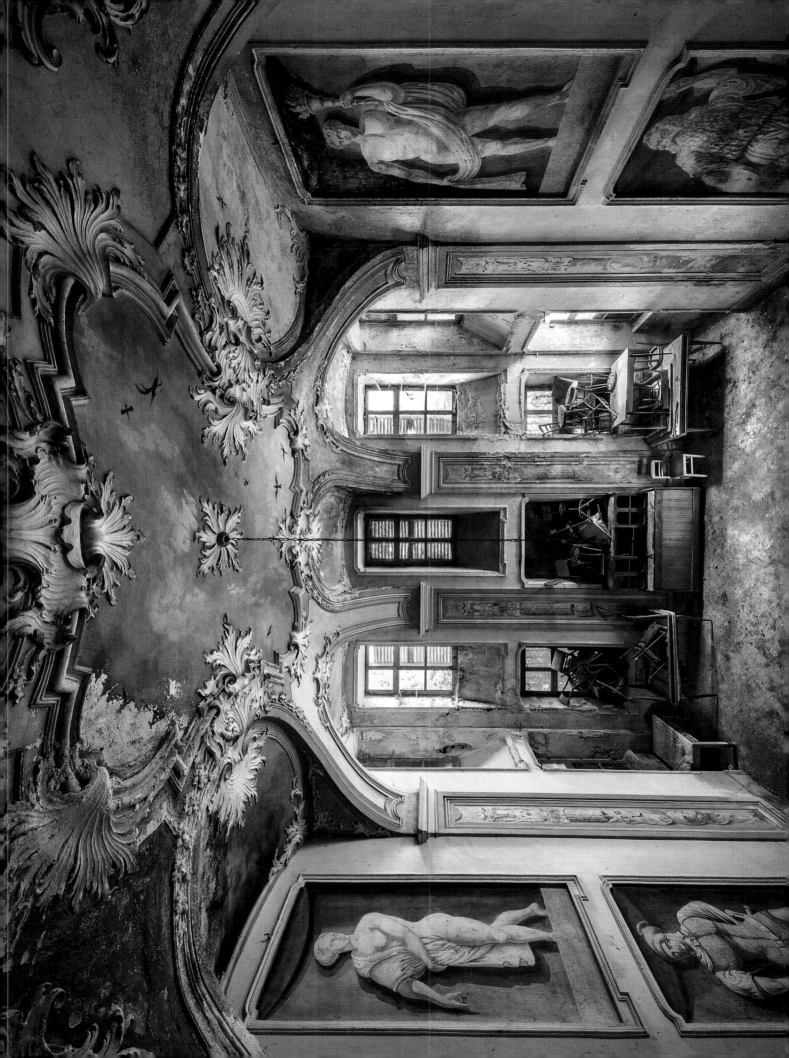

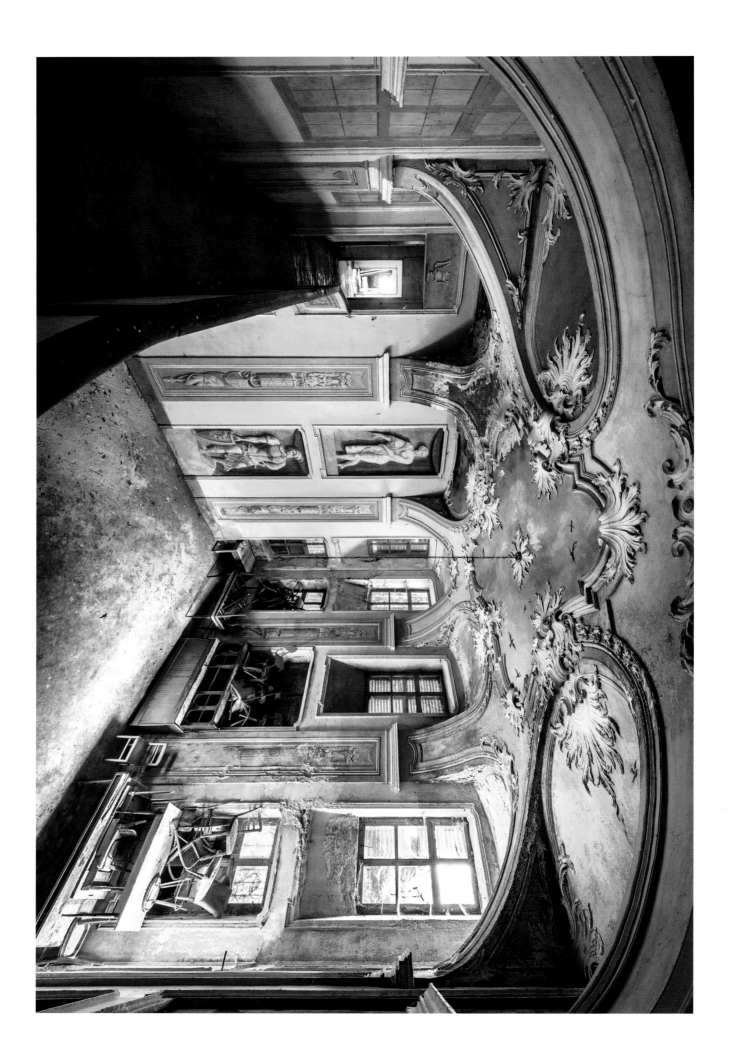

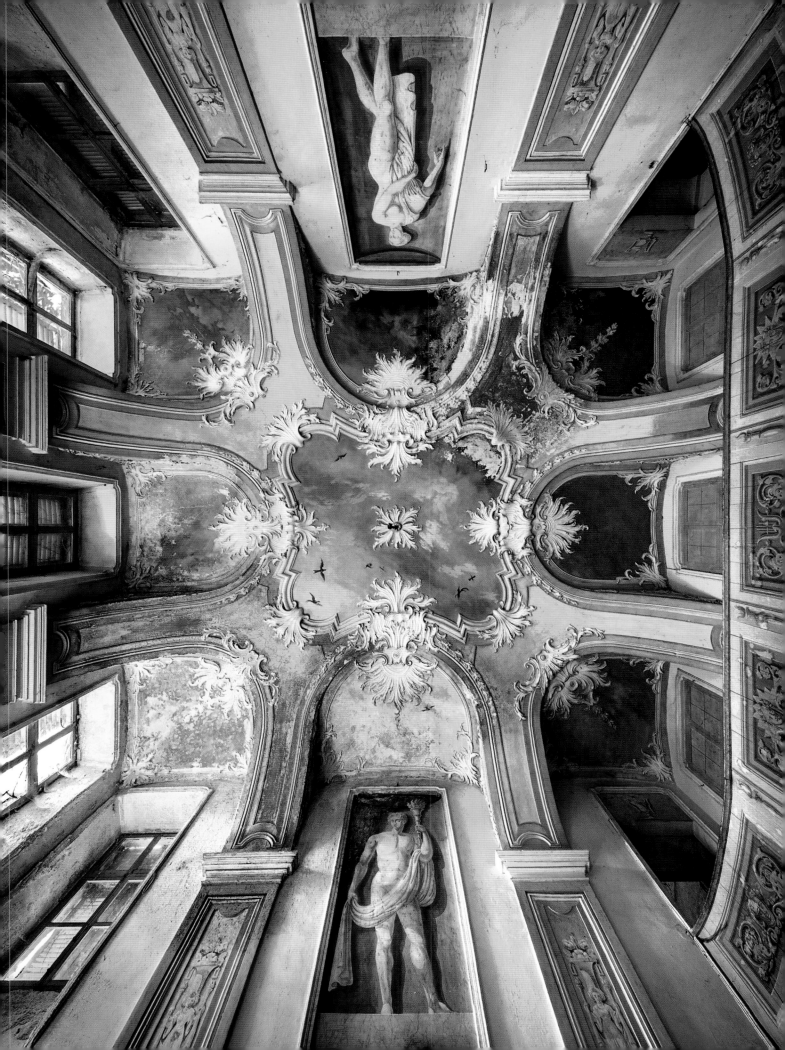

Chiesa Santa Cascia – *Piedmont*

This church was one of the four Camaldolese hermitages built in Piedmont in the 17th century on a wooded area of 175 hectares. The Benedictine monks lived here in cells, in solitude and prayer.

In 1918 the hermitage was transformed by the Italian Red Cross into a sanatorium for veterans of the First World War, and was subsequently used to treat women with tuberculosis.

A presbytery and a church with rather sober decorative stuccoes, whose façade deliberately faces towards the big city, were later joined to the rudimentary buildings.

The hermitage, closed since 2013, is in a state of complete abandonment, slowly but inexorably deteriorating.

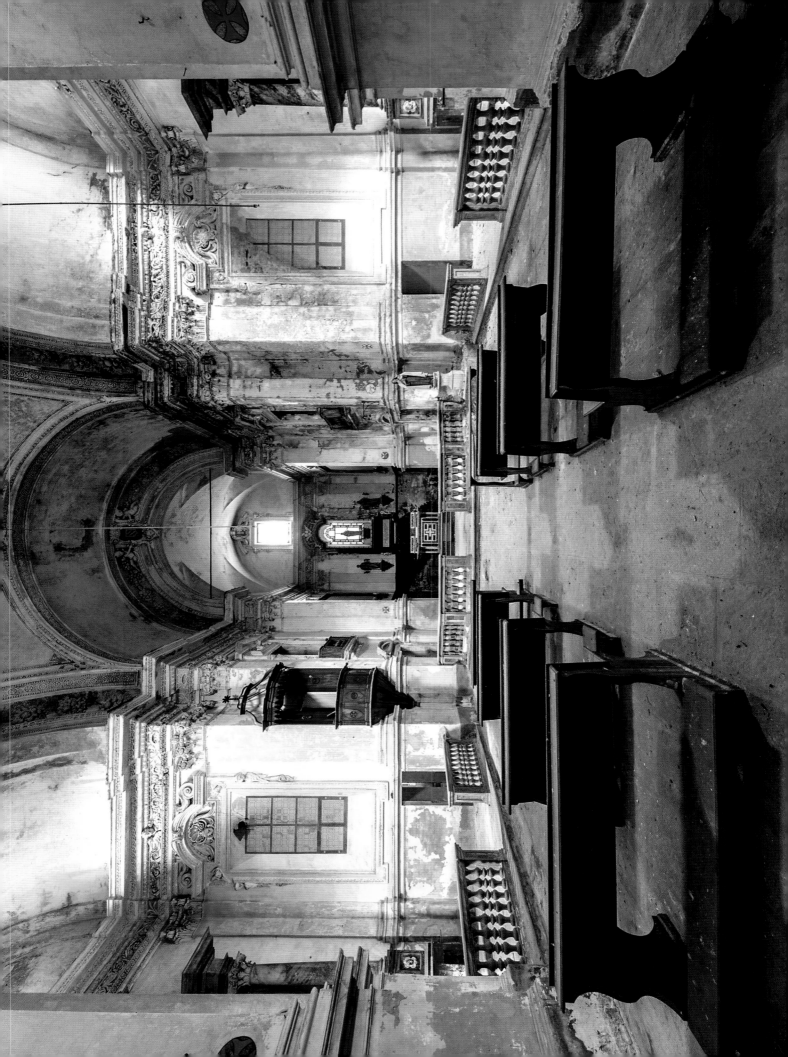

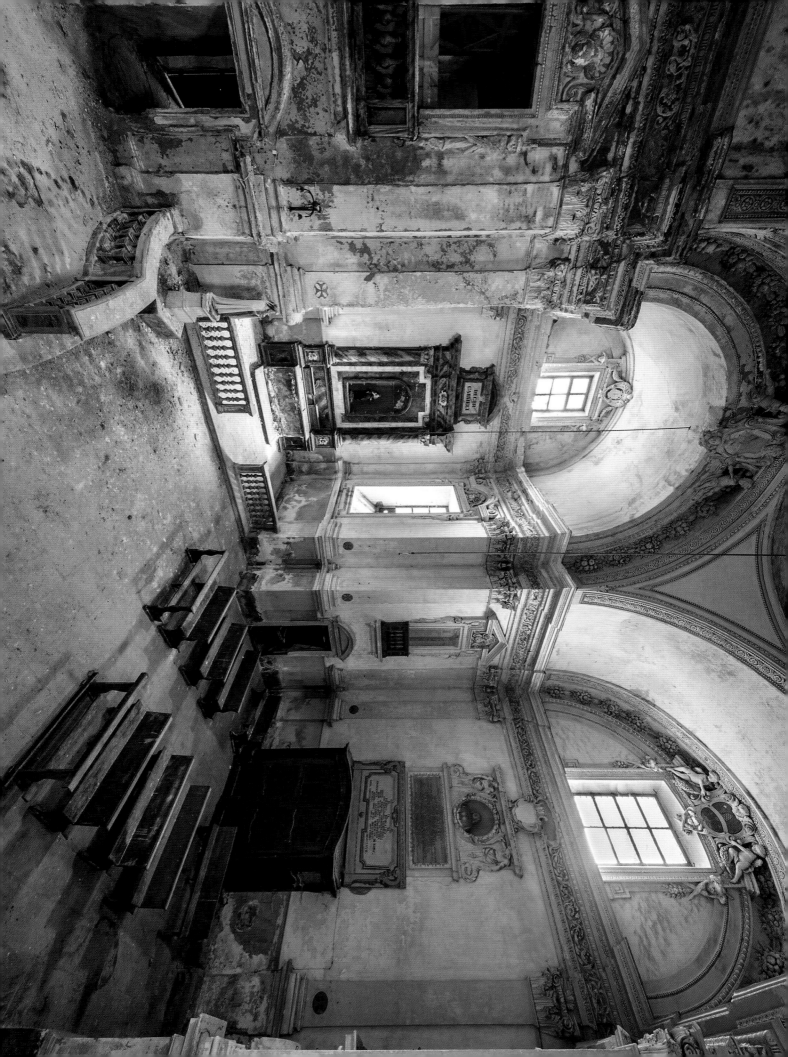

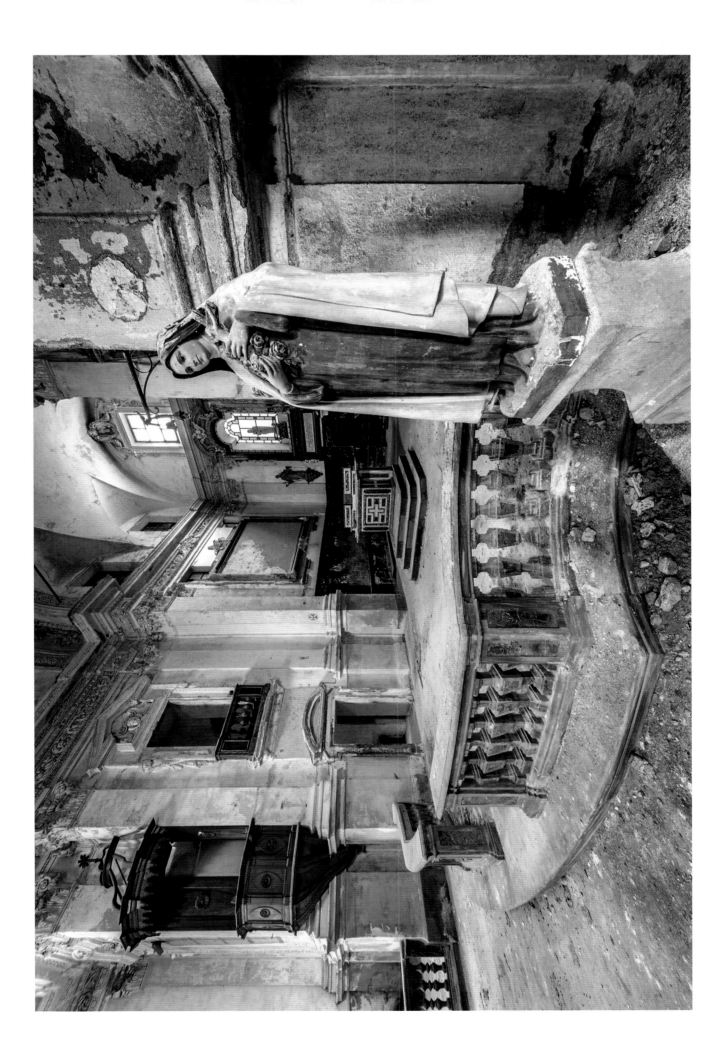

Teatro Guido – *Lombardy*

Inaugurated in 1895 on the occasion of the September festival with a performance of Faust, this theatre in Lombardy was designed by the architect Francesco Piazzalunga.

In 1905 it was the turn of La Traviata, The Barber of Seville and Don Pasquale. In 1938, after some restoration works, it took the name of Teatro Guido and began a very profitable season with a series of well-known shows, including Carmen and La Bohème.

In the mid-1950s, film screenings alternated with theatrical performances. But all activity ceased in 1982 and the theatre closed, leaving it without maintenance or conservation.

After years of abandonment, there is rubble and cobwebs; the smell of mould and pigeon droppings taints the air; dotted around, clear evidence of overnight bivouacs; mountains of soaked manuscripts crumble when touched. There are also posters, strips of old film reels, ticket price signs and many documents related to theatre and film activities. The Civic Center is now inviting the municipality to contact fundraising experts to save the theatre.

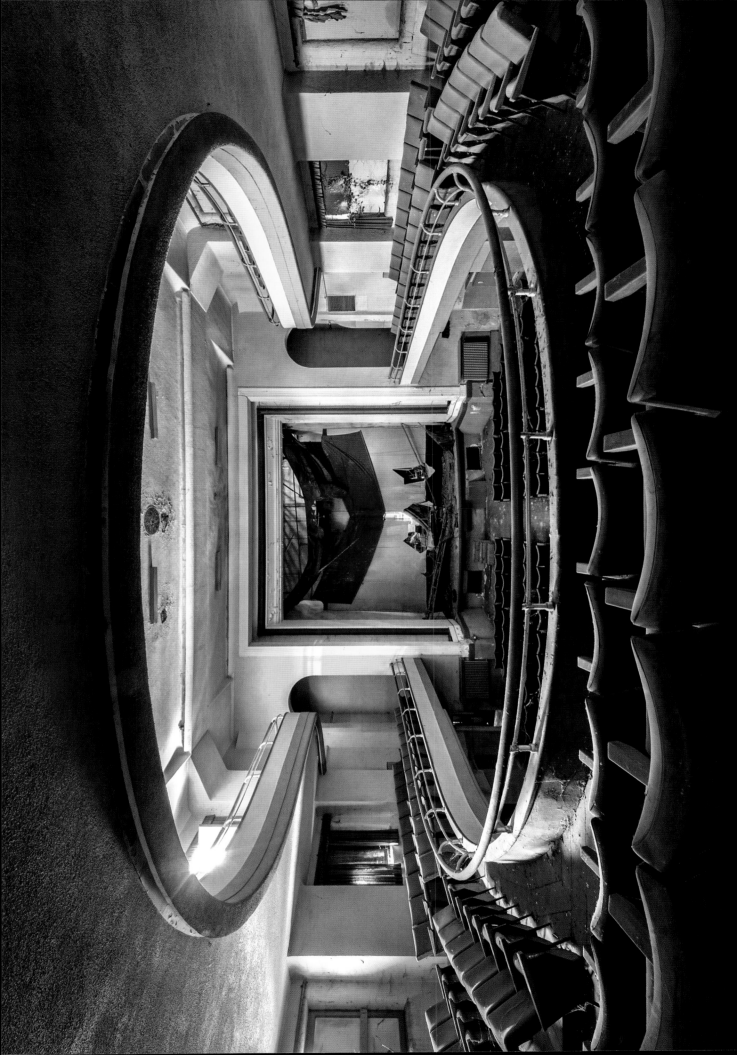

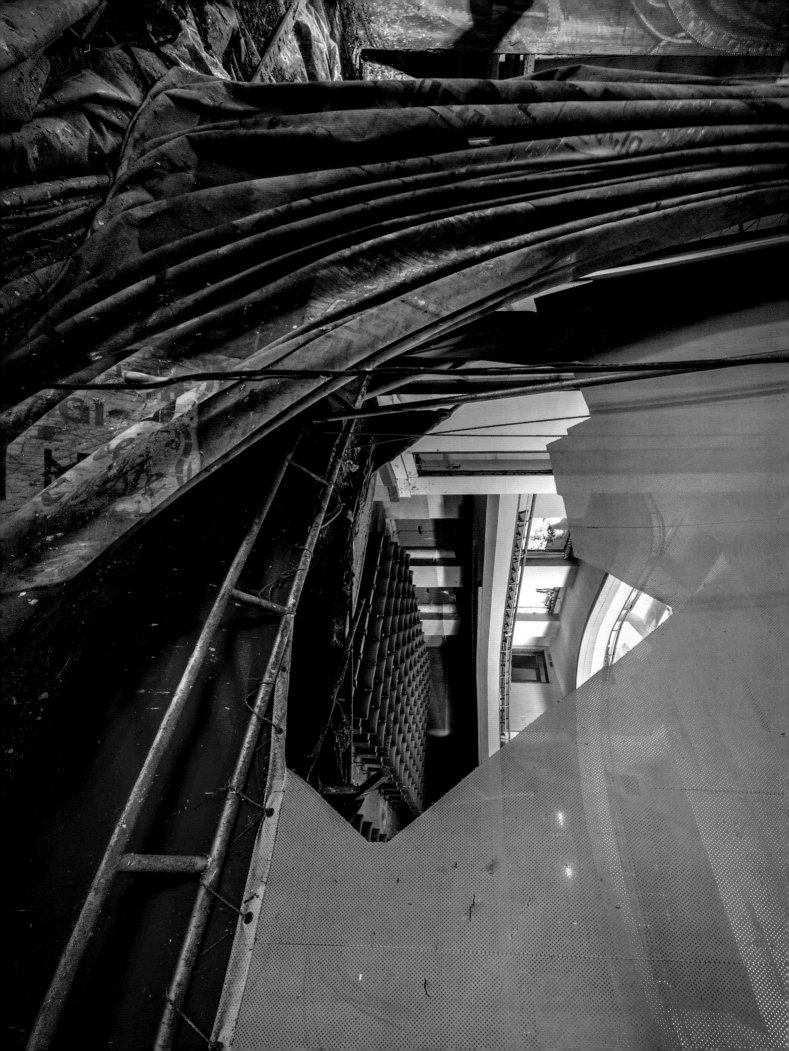

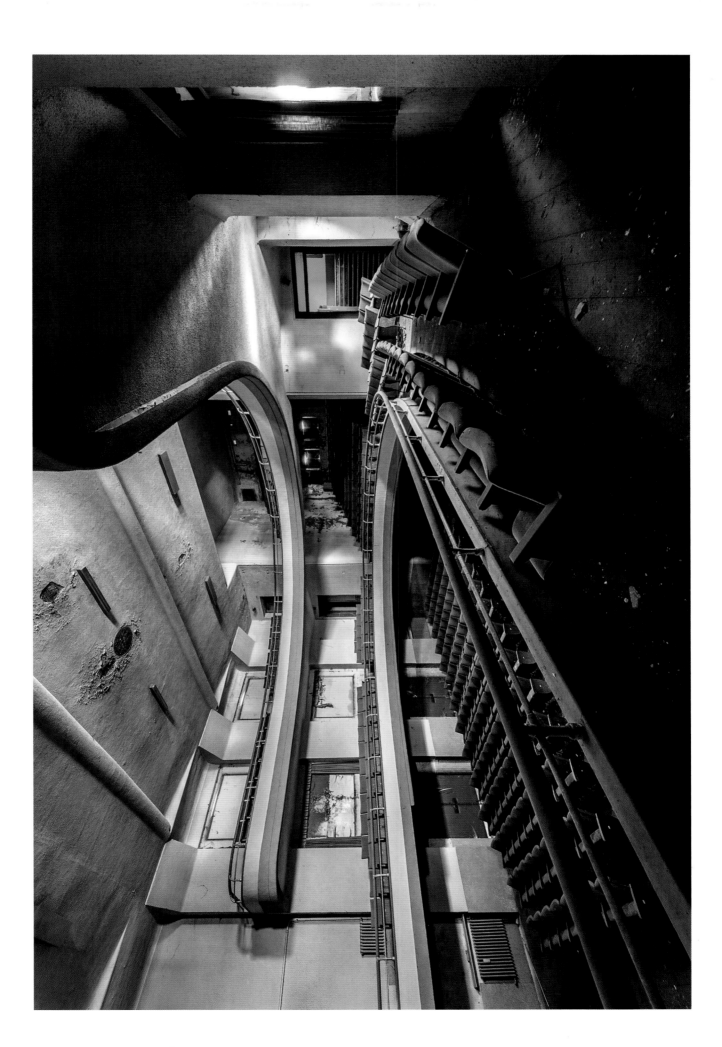

Castello dell'Artista – *Lombardy*

The manor and its fortified court with its annexes were built in the early 1600s by the Marquis Gonzaga, who belonged to one of the most famous aristocratic families in Europe. The building, a true symbol of the power of the family, was inhabited by successive generations, each modifying and restructuring it over the years.

In 1661 Prince Octavio transformed the central body of the building and equipped it with a loggia that can still be admired today. It is to him that we owe the creation of the sumptuous gardens.

On the walls, sepia photographs typical of the early 20th century augment family portraits, creating a warm atmosphere in the house, despite its state of abandonment. In the two-level salon the walls are decorated with busts, while each of the doors is surmounted by a majestic golden eagle. The other rooms of the palace, with their coffered ceilings decorated with rural scenes, bouquets of flowers and rosettes, are no less impressive.

The castle was abandoned in 2005 when the last heir died … at the age of 108!

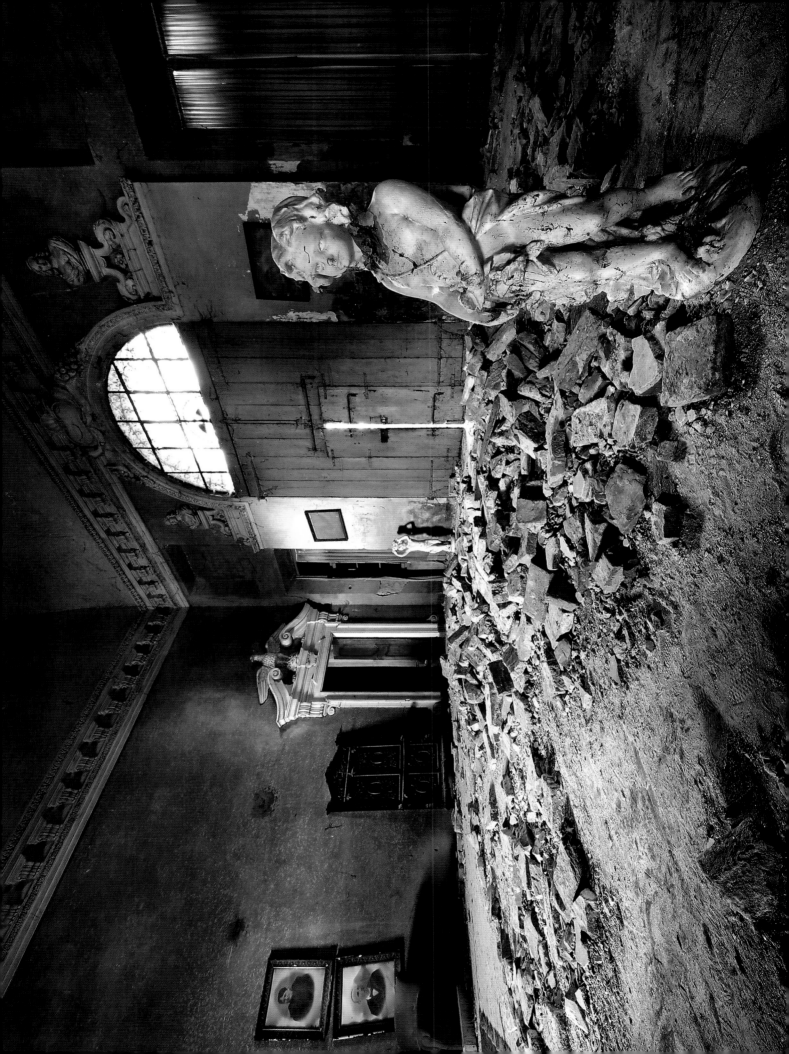

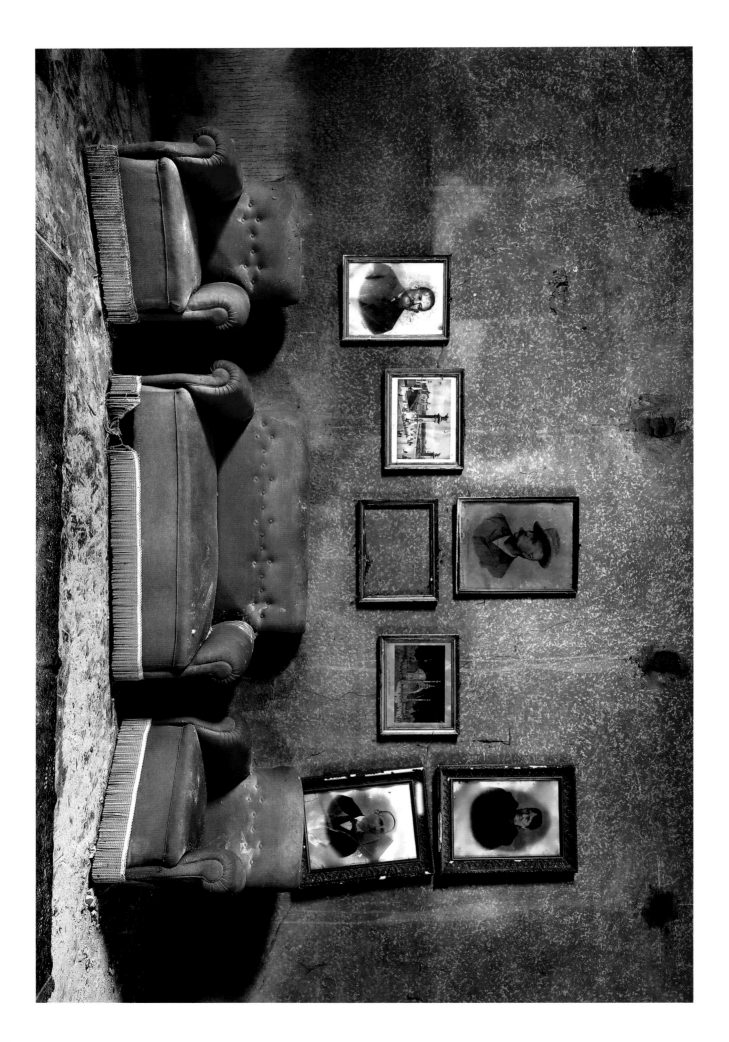

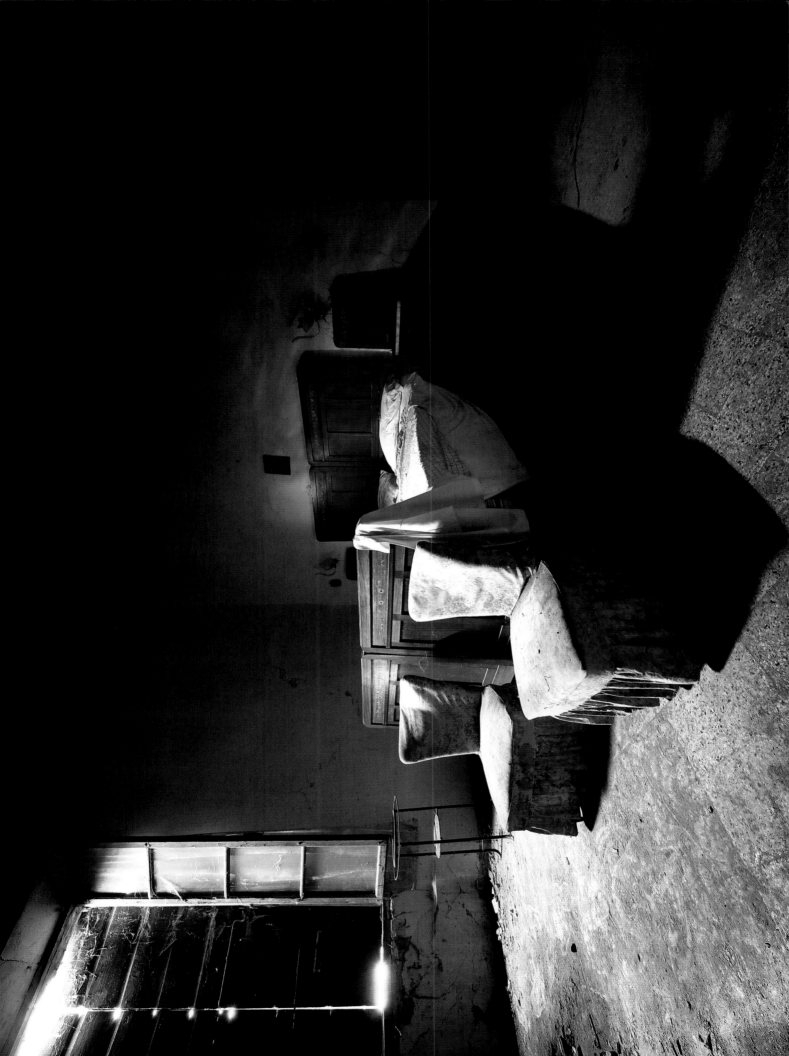

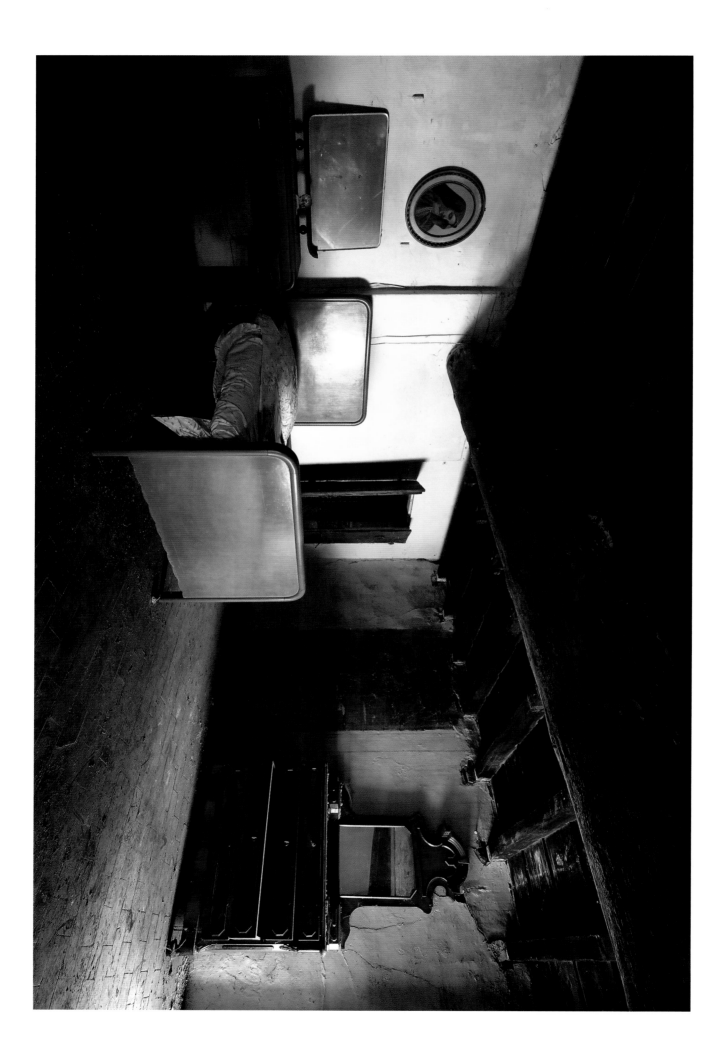

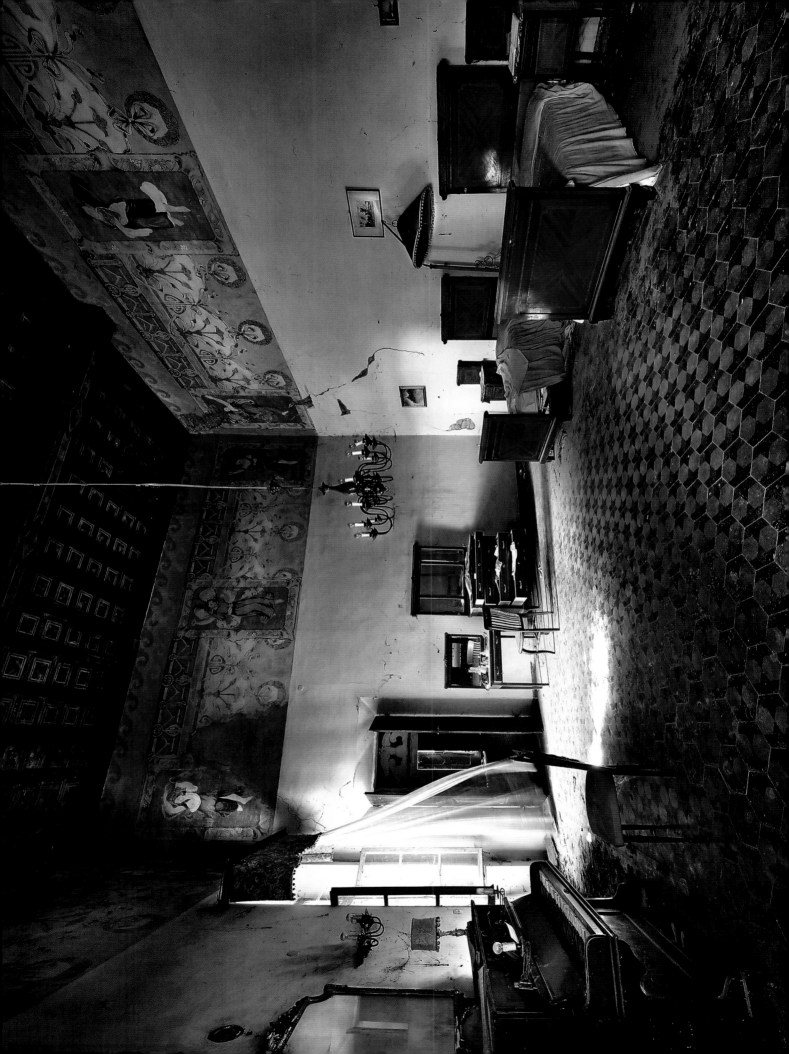

The Crespi d'Adda power plant – *Lombardy*

In 1869 a wealthy Italian textile manufacturer named Crespi bought a piece of land near the Adda River and set up a production plant: spinning, weaving, dyeing and administration.

A hydroelectric plant was built in 1909 to facilitate the operation of the growing business.

It was the time of enlightened industrialists and philanthropists who, inspired by the current social doctrine, wanted to satisfy the needs of their workers by taking care of their living conditions both inside and outside the factory. A complete city was built around the plant; as well as houses it included a hospital, church, school, cultural centre, theatre, stadium, public baths, a washhouse, fire station, and a cemetery.

Unfortunately, in 1929 the Great Depression hit Italy and the plant slowed down until it closed.

Today the magnificent «black turbines» are still there, overhung by their old control desk. A Francis turbine and two other powerful Kaplan turbines provided a total power output of 858 kW. They occupy the entire hall.

The power plant is the smallest of those created along the Adda River, but certainly the most beautiful: the Liberty Lombard-style decorations, the original wooden floor, the marble control panel, and the head of the turbines make it a real jewel of industrial archeology.

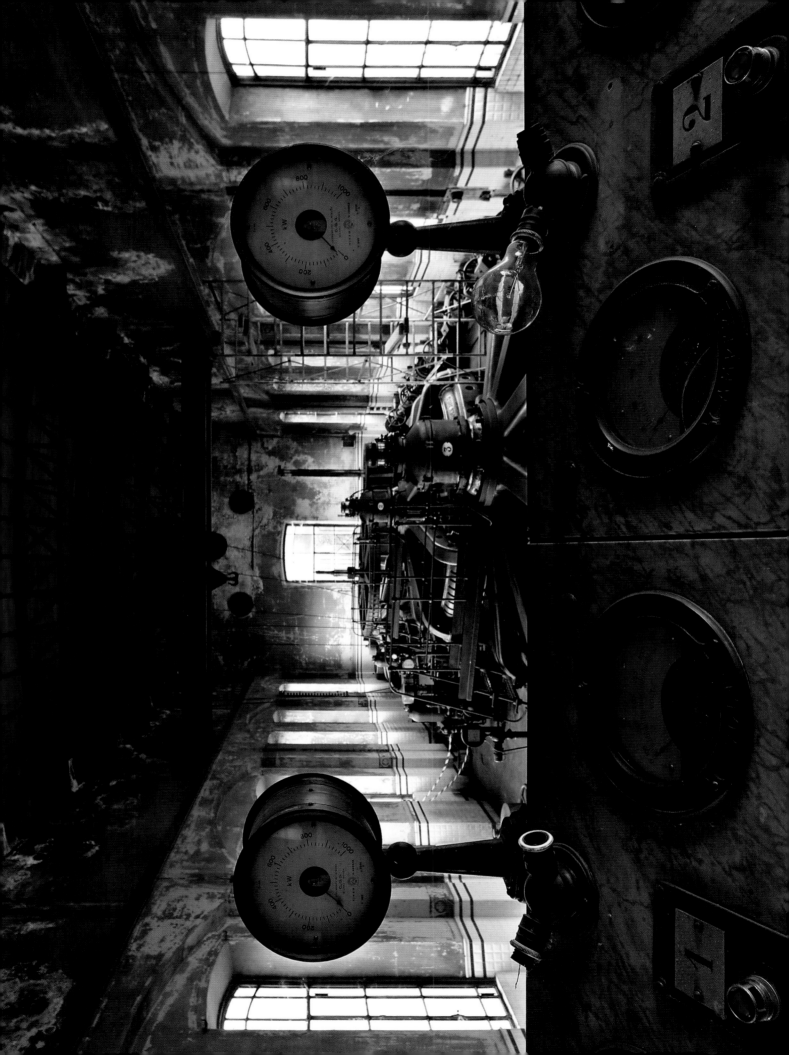

Animal laboratory – *Lombardy*

In 2013 Italy took the courageous decision to ban farms for animal experiments throughout its territory. Since implementing the European law outlawing animal experimentation and vivisection, all breeding of laboratory animals has ceased. A revolution in the field of animal welfare and a great ethical progress.

To date, no other European country can claim such progress.

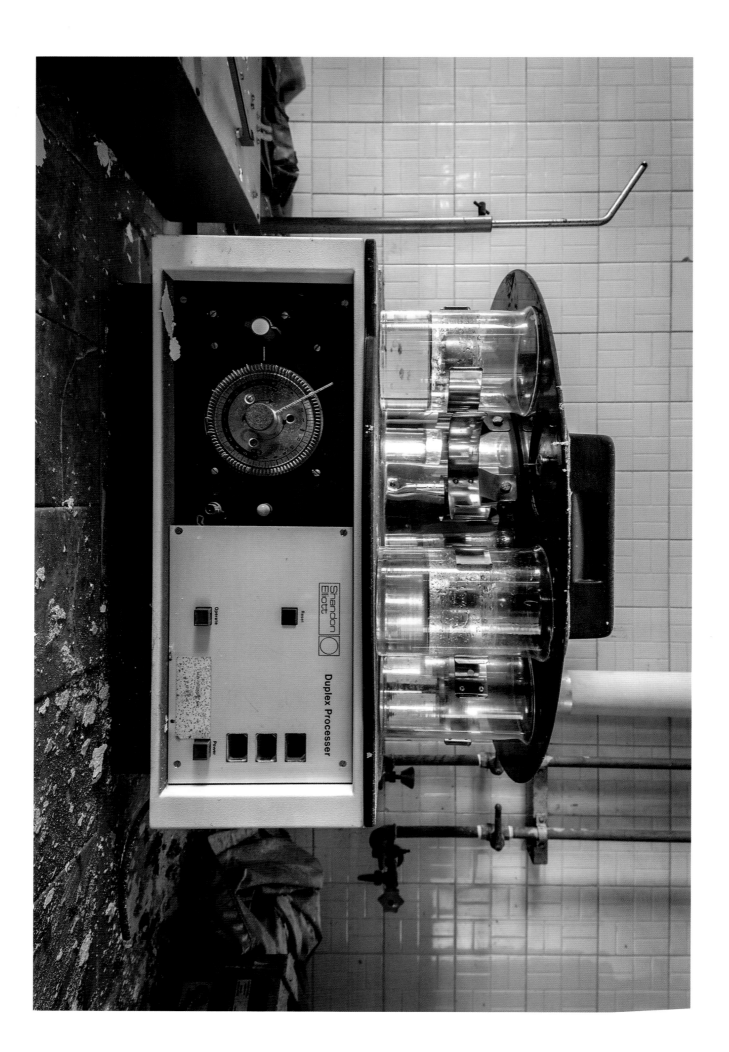

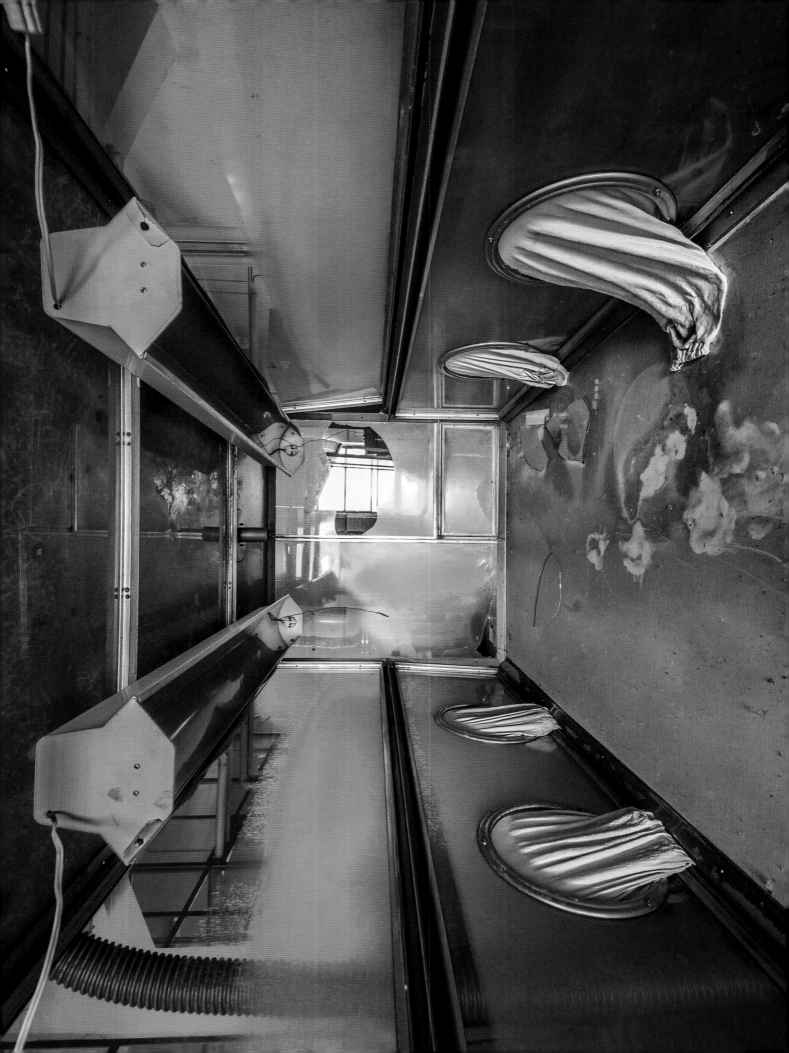

Palazzo Athena – *Lombardy*

Purchased at the beginning of the 20th century by Silvio Strumia, an entrepreneur in the silk industry, this old neoclassical house is surprising. In the centre of the building a large elliptical room extends over two floors, crowned by a dome with a skylight. The dome is decorated with caryatids in white stucco and is supported by 16 Corinthian columns. Each column bears the insignia of an art or a profession … perhaps a subtle reminder of the workers the industrialist employed between 1920 and 1950.

Recognisable by its characteristic high chimney, the spinning mill that Strumia had built in the gardens adjacent to his palace also gave work to many women of the region.

The plant was destroyed by a fire in 1992, a few years after it closed.

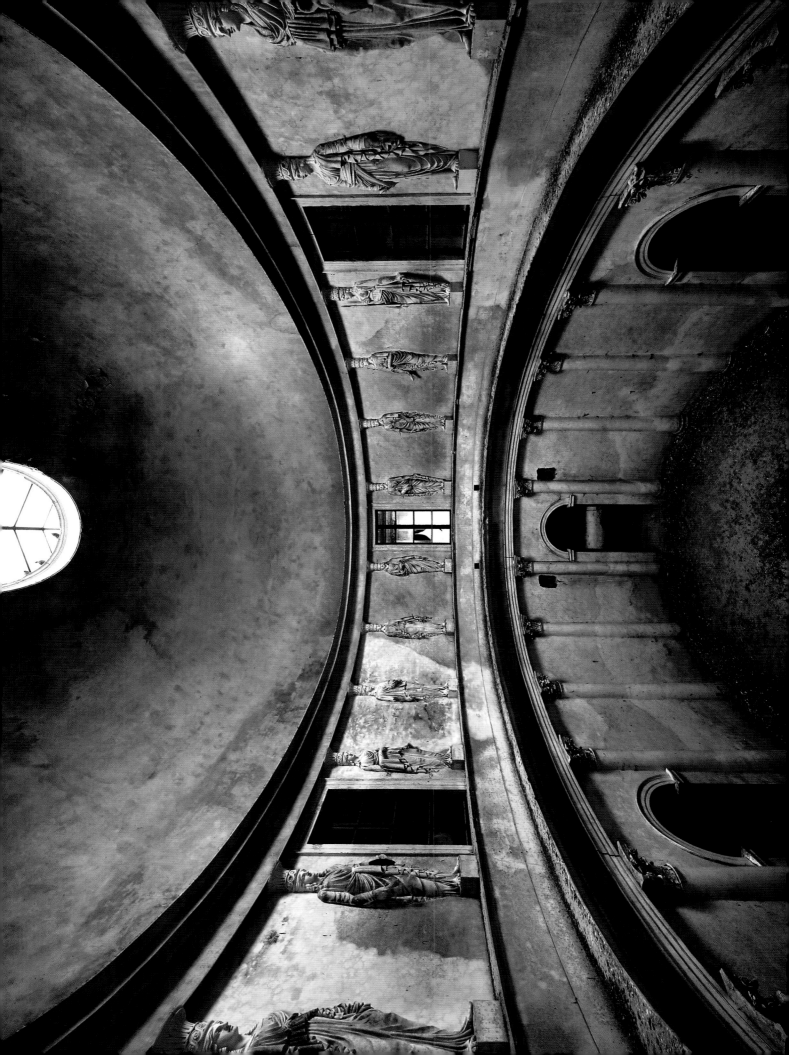

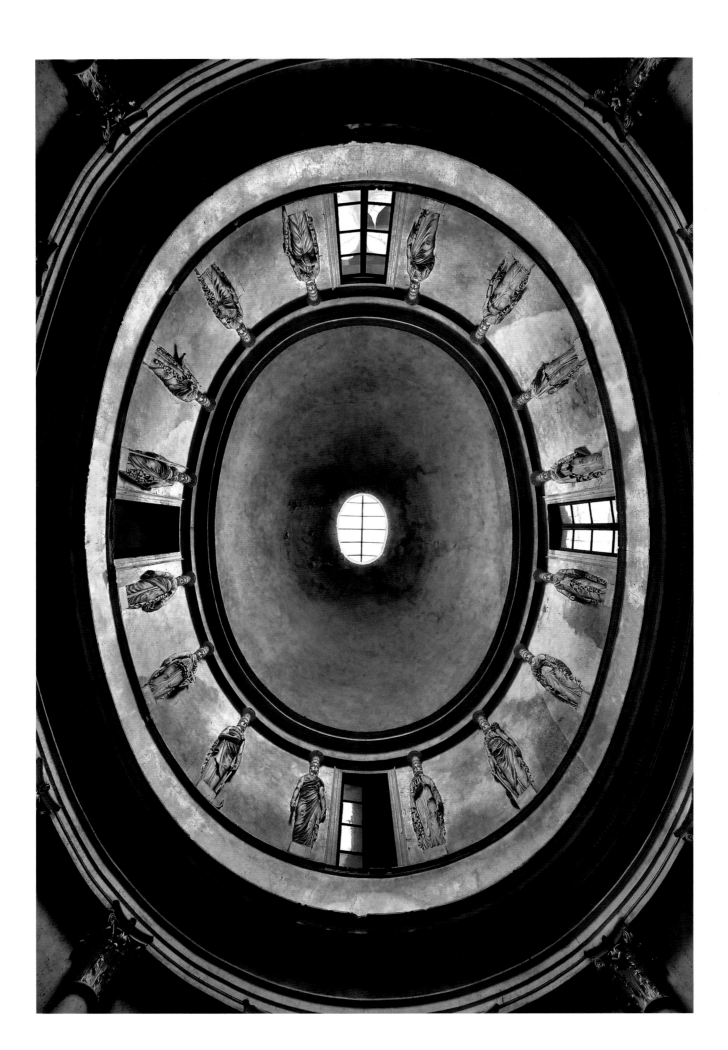

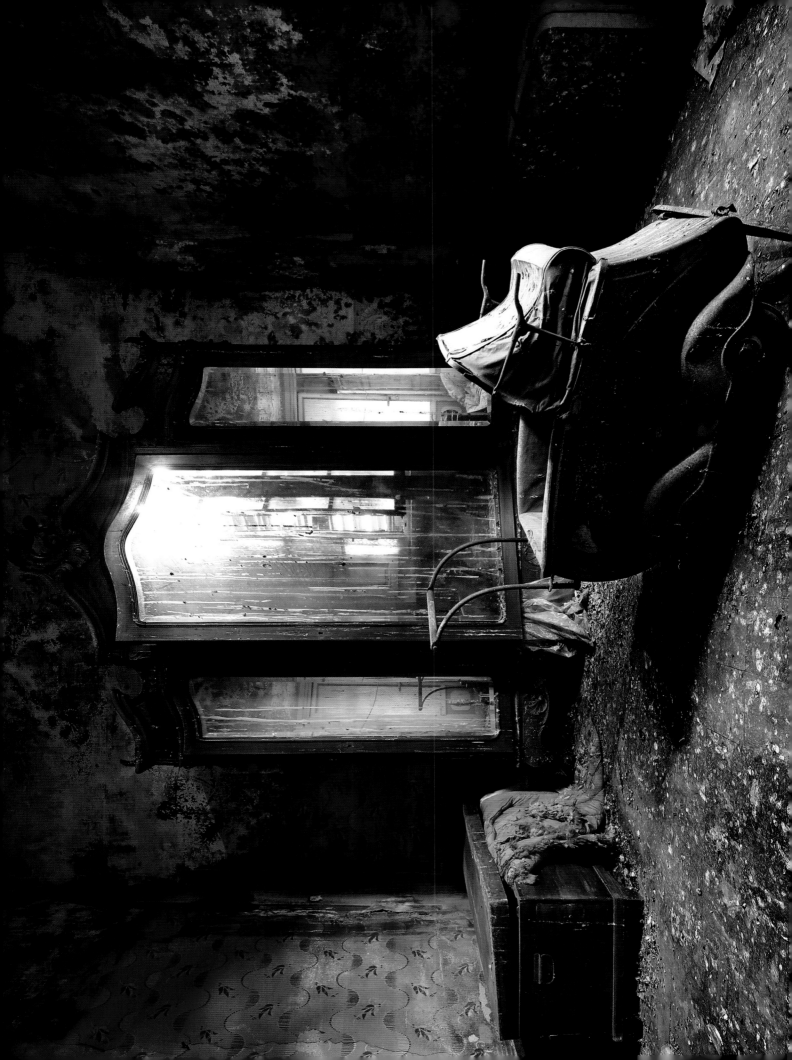

Villa Camilla – *Lombardy*

Built in 1895, Villa Camilla, with its turrets and refined decorations, is a true demonstration of the prosperity of the entrepreneur who built it. It is also an advertisement for the white cement that made his fortune - in the 1920s, his company produced up to 200 tonnes of cement a day and employed more than 1,500 employees in 12 factories.

Offered as a wedding gift to his wife Camilla, this elegant property in neo-classical style, with stables and a large greenhouse, was equipped with all modern comforts: toilet, running water, radiator heating system ... a real luxury for the time!

Since the couple had seven children, expansion was necessary, but neither the two wings with Corinthian columns nor the third floor adversely affect the harmony of the whole. Small touches of Art Nouveau throughout highlight the taste of the family for this style, which was very popular at the time.

Now deserted, this jewel that witnessed the story of a family, as well as that of a whole region, is gradually falling victim to the ravages of time.

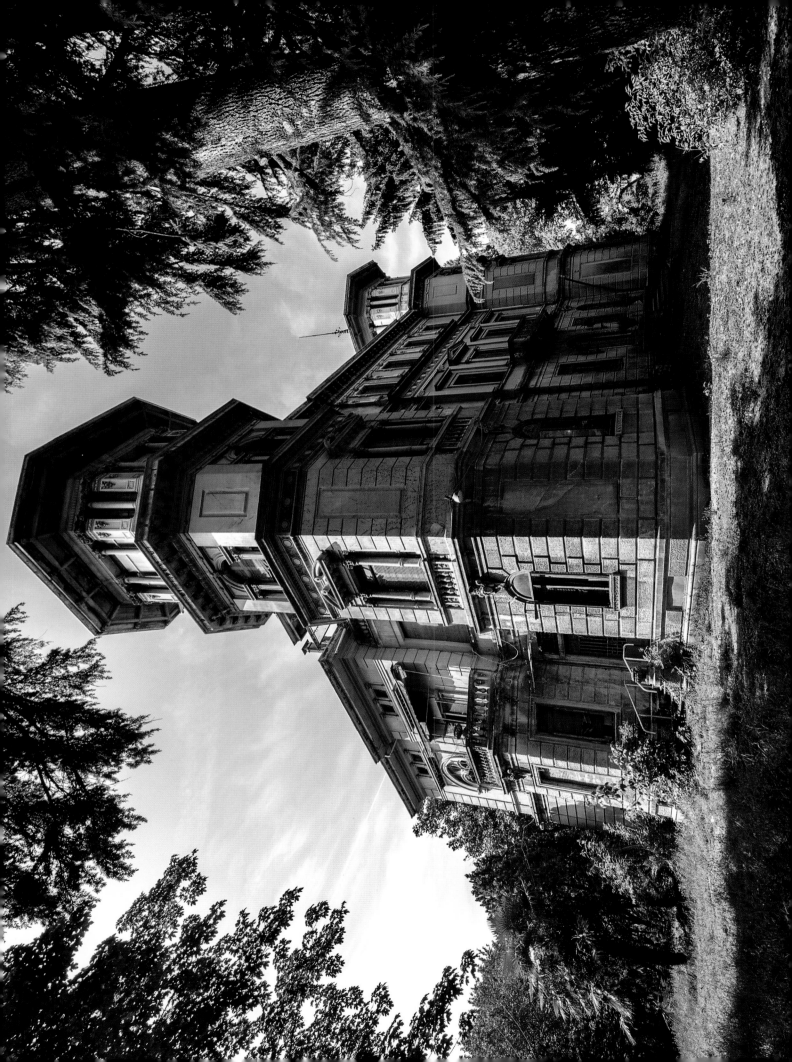

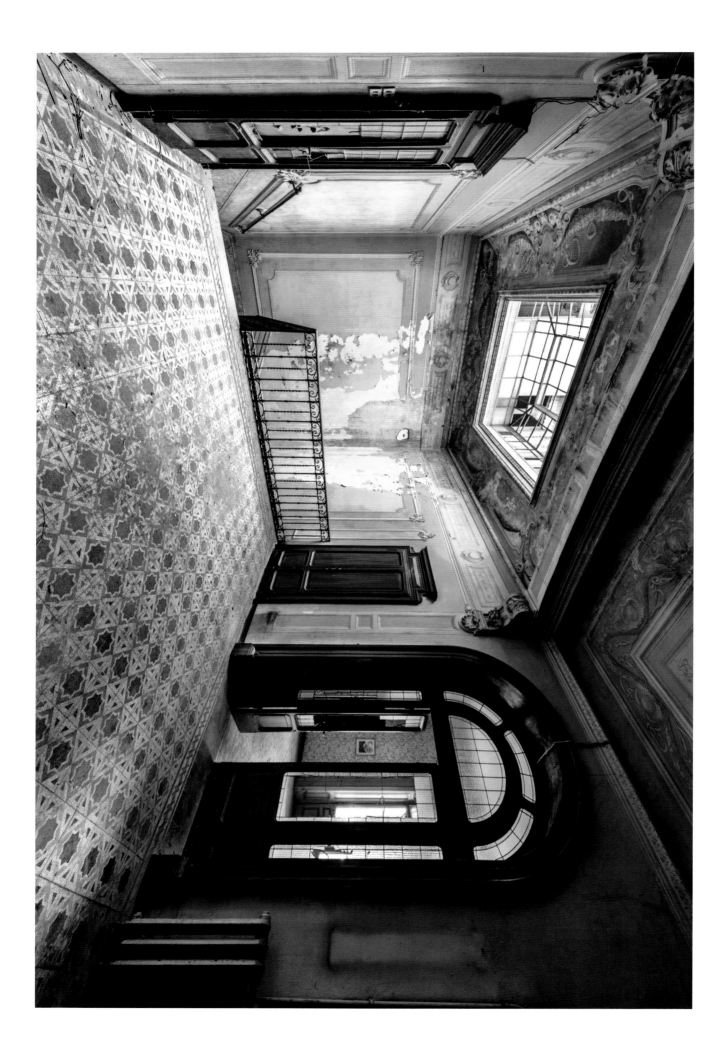

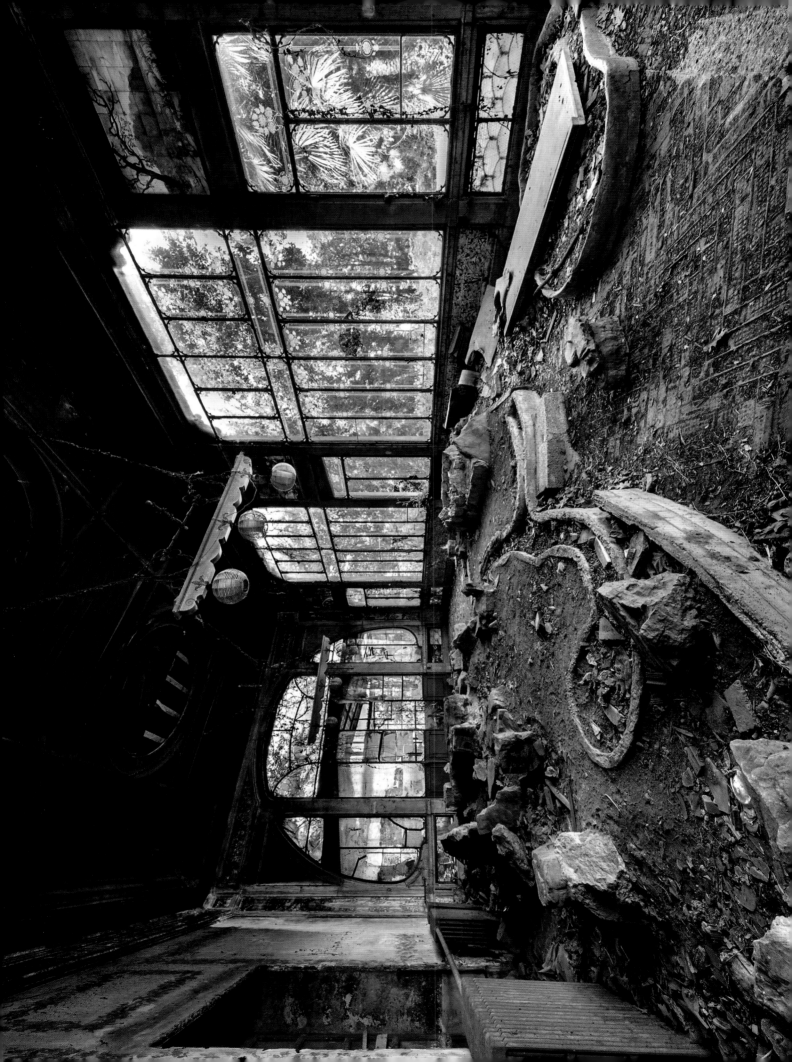

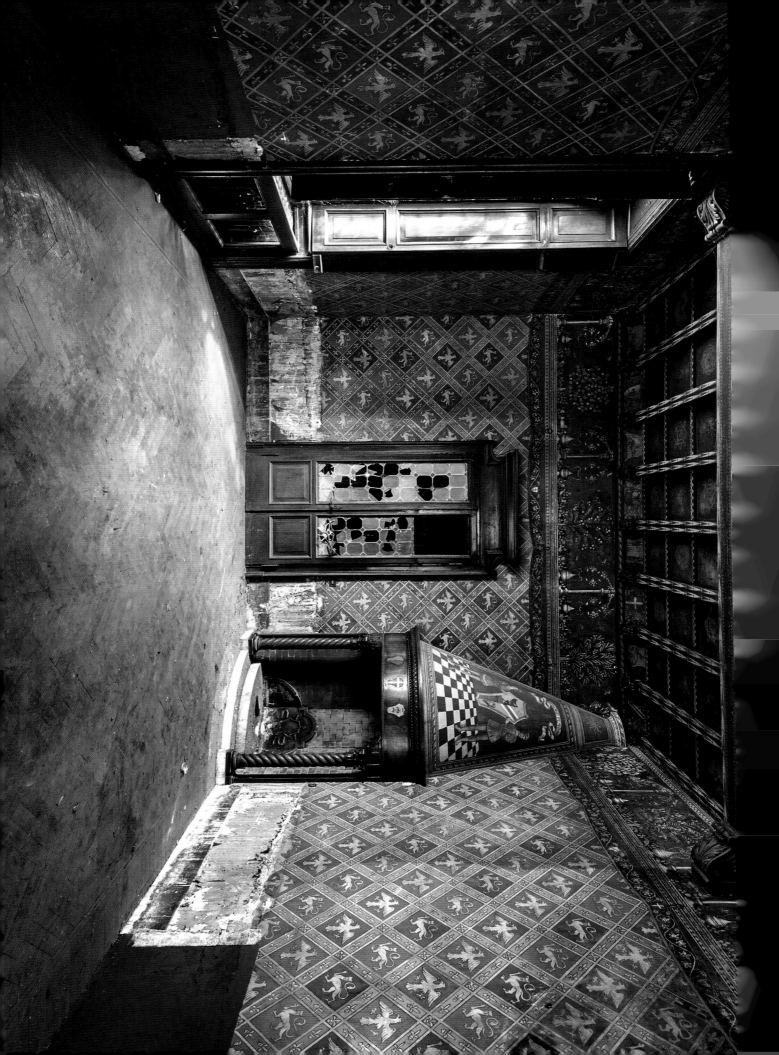

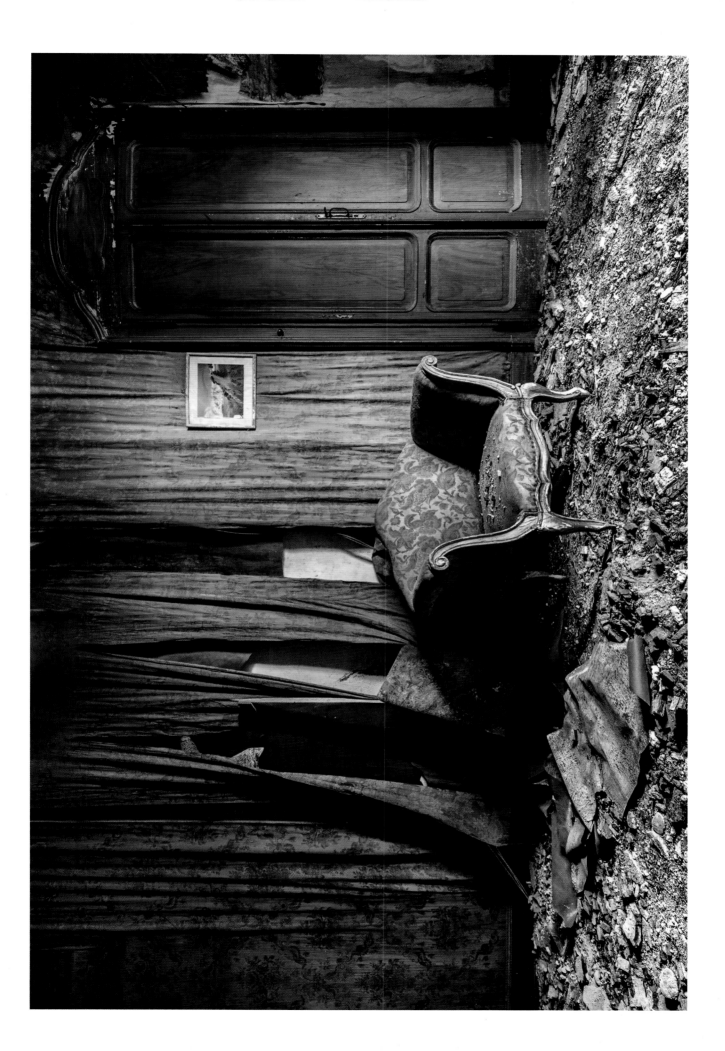

Villa Molinari – *Lombardy*

The Molinari, a powerful merchant family of 18th-century Milan, commissioned Giuseppe Bianchi, one of the best architects of the court of the Governor of Milan, to build this architectural jewel.

The works, which lasted from 1760 to 1764, transformed a group of existing houses into a beautiful U-shaped building — a design typical of Milanese villas of the time — with two symmetrical wings and a central body supported by a triple-arched portico. At the top of the façade is the emblem of the Molinari family: two corners on a mill wheel.

Though the villa had been closed and abandoned since 1950, the Municipality of Limbiate initiated a recovery plan in 2008 to restore the building. Sadly, the plan failed. An investigation uncovered a series of false invoices and tax evasion to the tune of 300 million euros, bringing the project to a halt.

The final nail in the villa's coffin came two years later when a fire devastated most of the property, destroying the old roof beams and making the walls, already weakened by decades of abandonment, even more fragile.

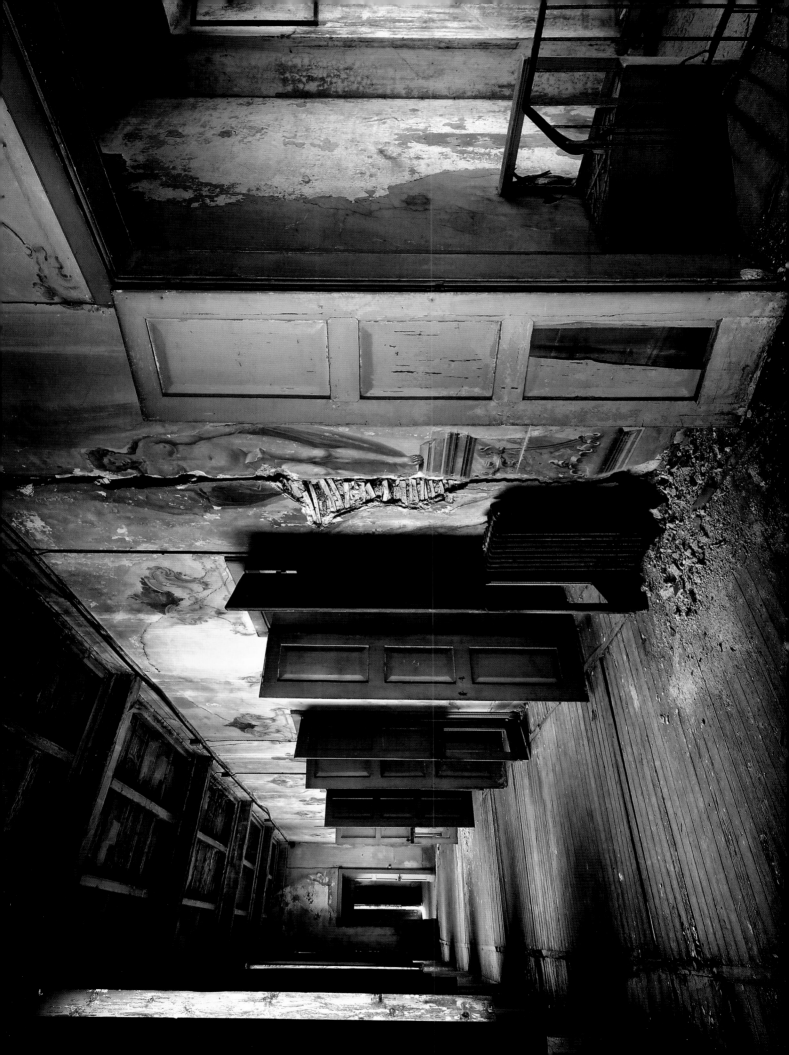

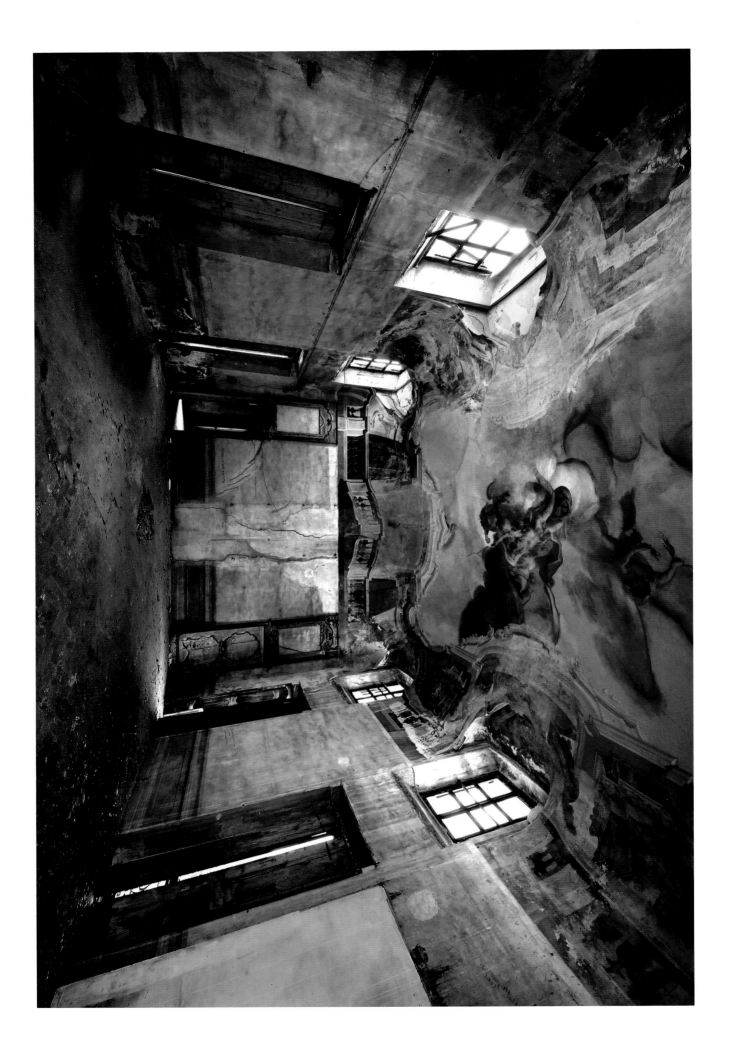

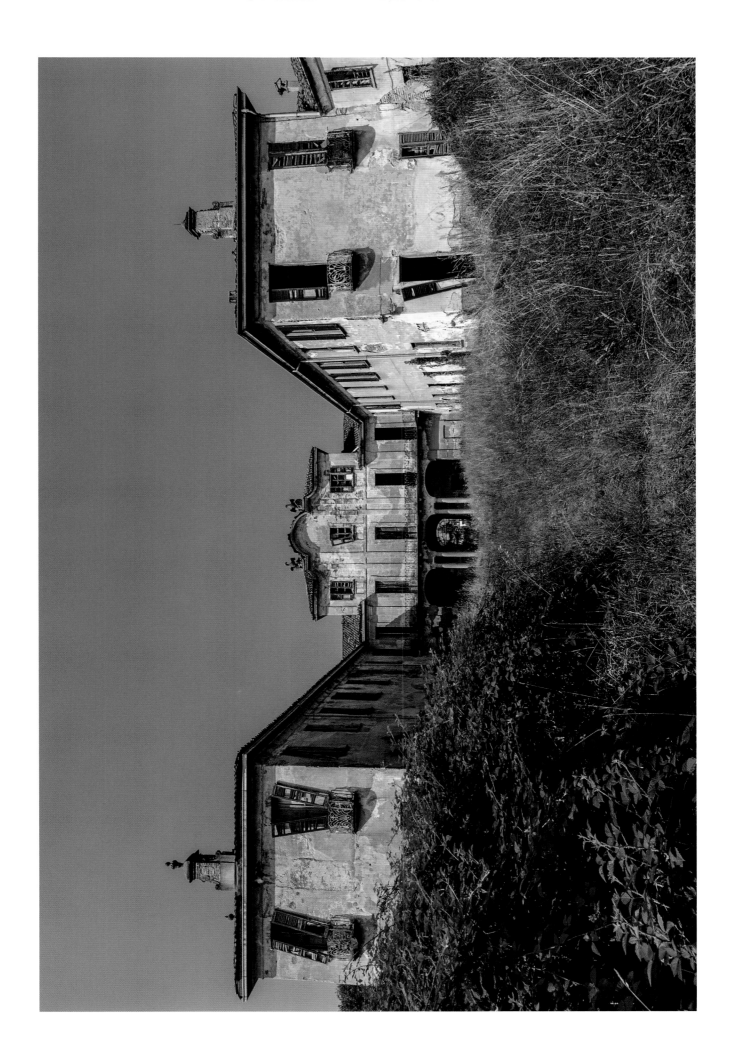

Chiesa di MG – *Lombardy*

The parish church of a village in Lombardy was shaken violently by the earthquake of 29 May 2012; its walls and roof did not survive. The town hall and neighbouring houses suffered a similar fate. Pigeons, now the sole inhabitants of this magnificent building, have soiled the ground and everything within their reach.

The church was built with a single nave, two side chapels, a bell tower, a sacristy and a presbytery. The Baroque-Renaissance style makes it a bright and welcoming space. The consecration of the church took place in 1609, and a century later some major extension works provided the church with three naves. In the following century, it was further augmented by an external staircase, and in 1920 its interior was entirely decorated by the famous painter Ettore Pizzini.

Behind the red marble altar, surprising for its height of at least three metres, the fresco depicting the baptism is splendid. Other scenes are equally remarkable, including the birth of Jesus and the Last Supper. However, the organ buried under dust and rubble would definitely need tuning.

In recent years, the roof has been completely rebuilt and extensive consolidation and restoration works have been undertaken, giving back to the parish church some of its former splendour.

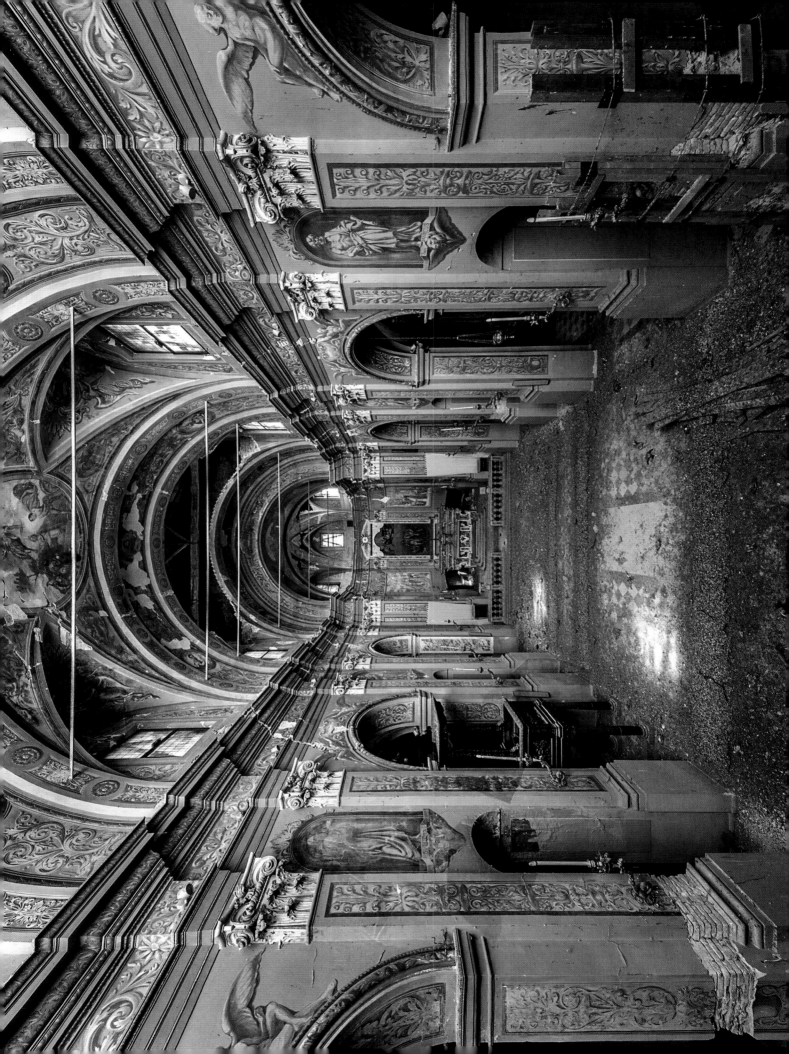

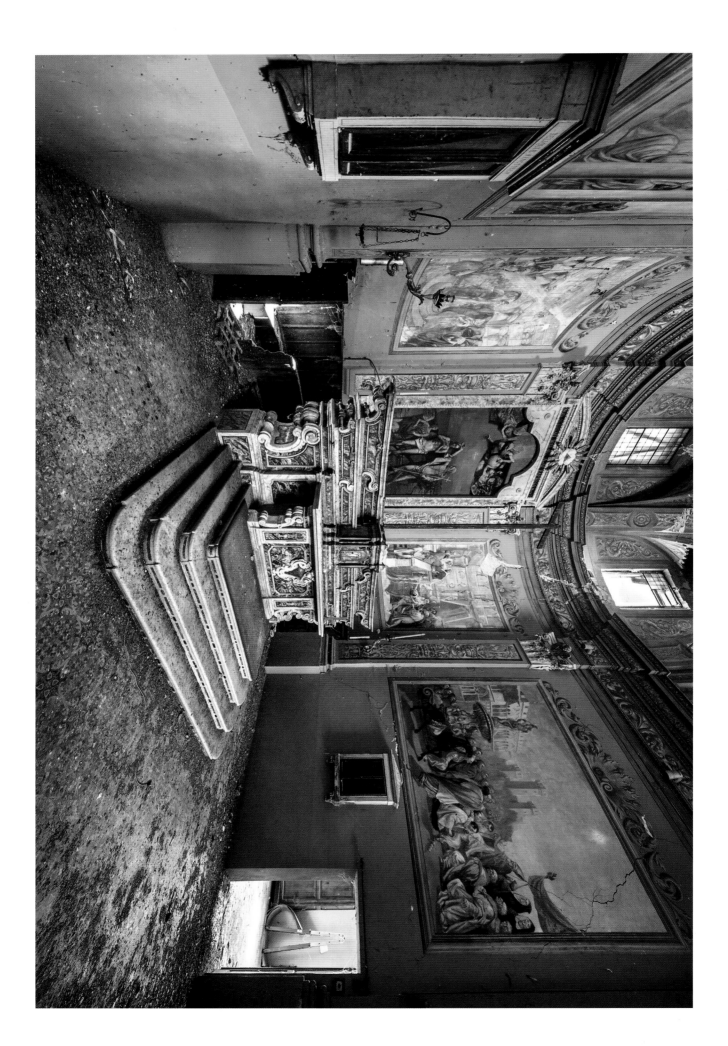

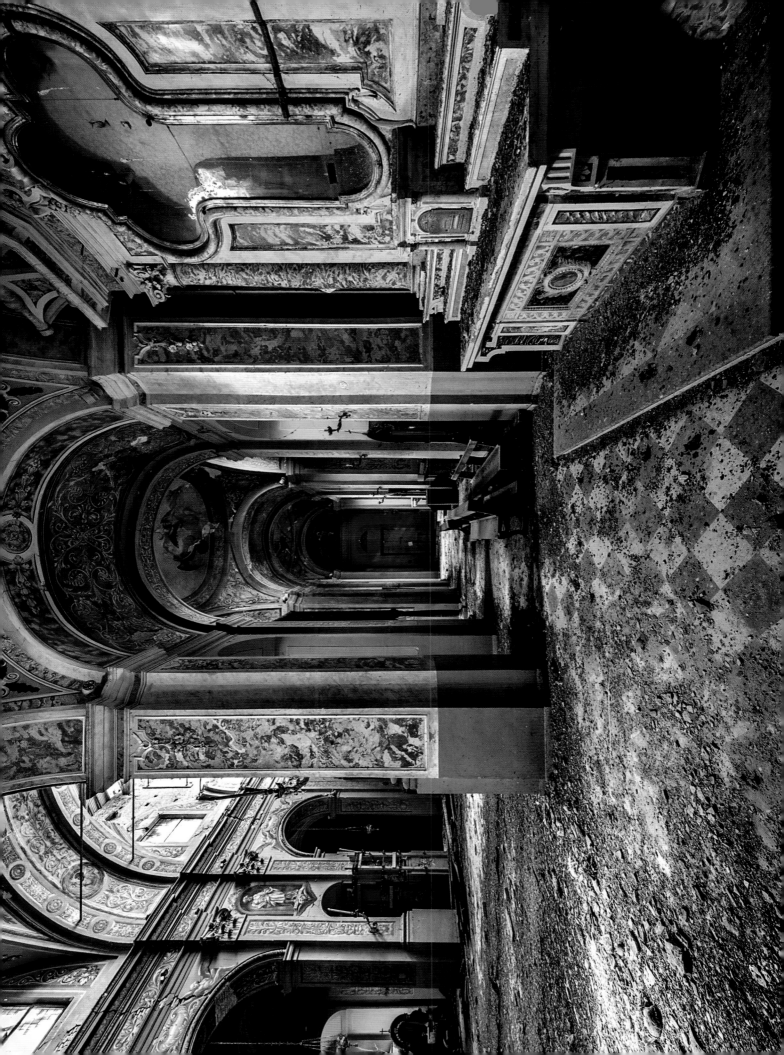

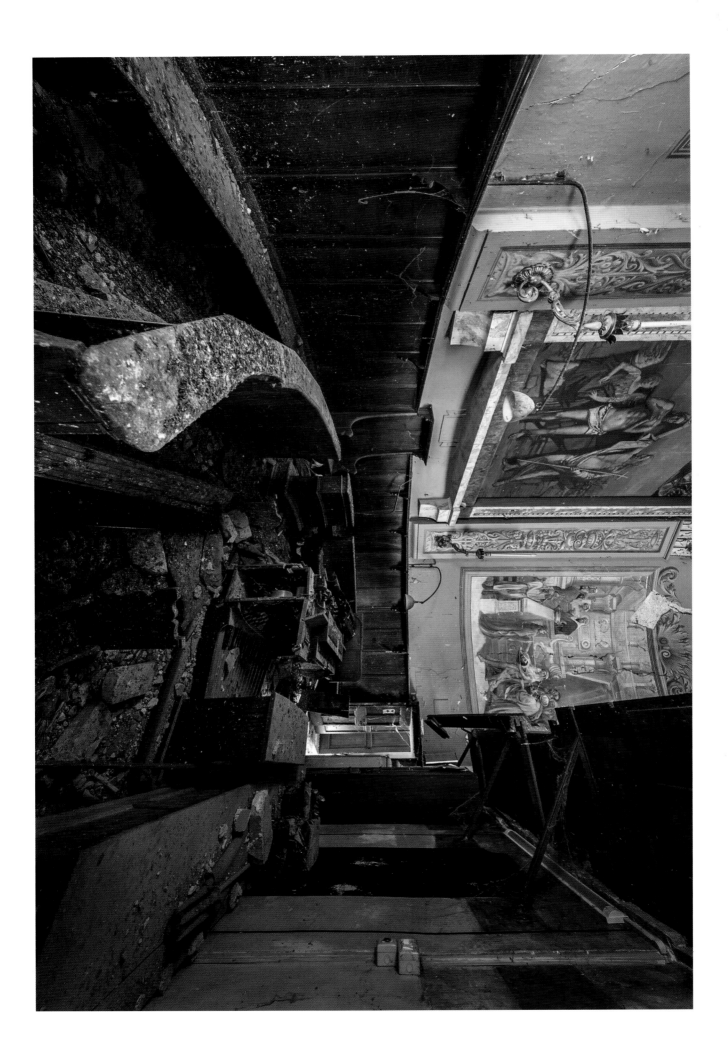

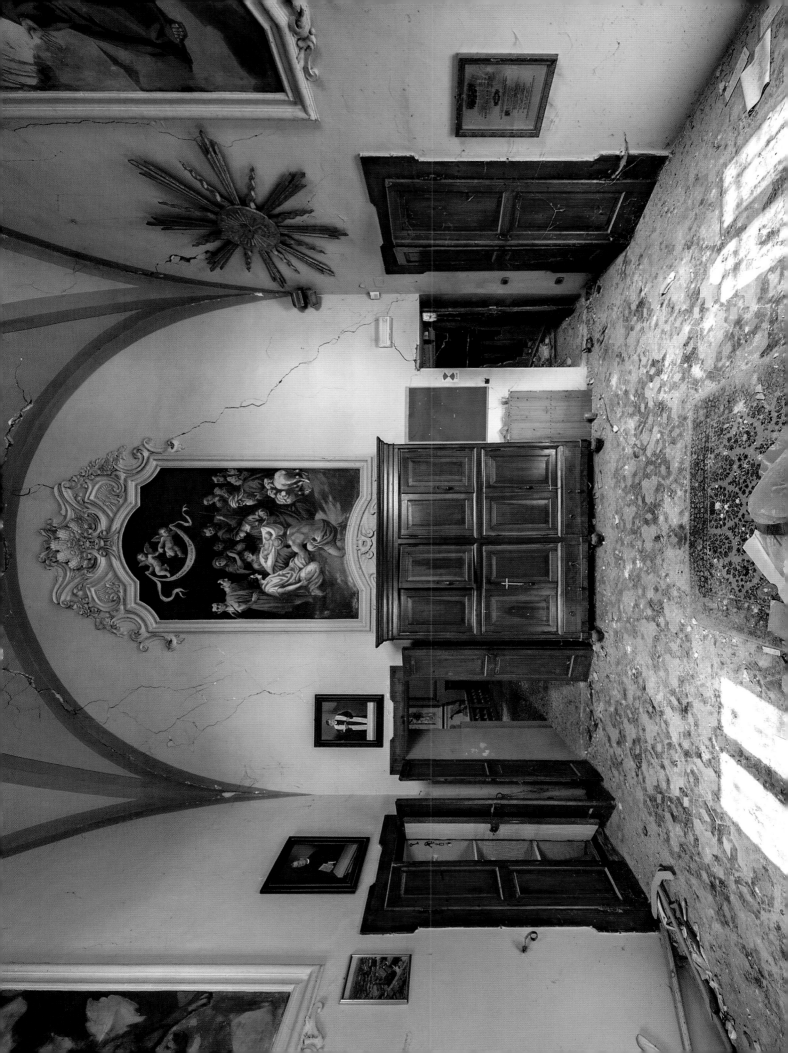

Villa Zenobio – *Veneto*

Built in 1717, this elegant villa was the property of the Zenobio family from Trento, which was part of the highest nobility in Veneto. The coat of arms of the family, displaying a winged lion surmounted by a crowned eagle flanked by two caryatids, is engraved on the pediment of the house to inform visitors of the importance of those living here. Inside, the rich decoration of white and gold stucco is still impressive, as is the Baroque courtyard, which was renovated in 1928 following a fire. However, the villa, like many others, has since been abandoned; the descendants of the families that built them often had no means to maintain such properties.

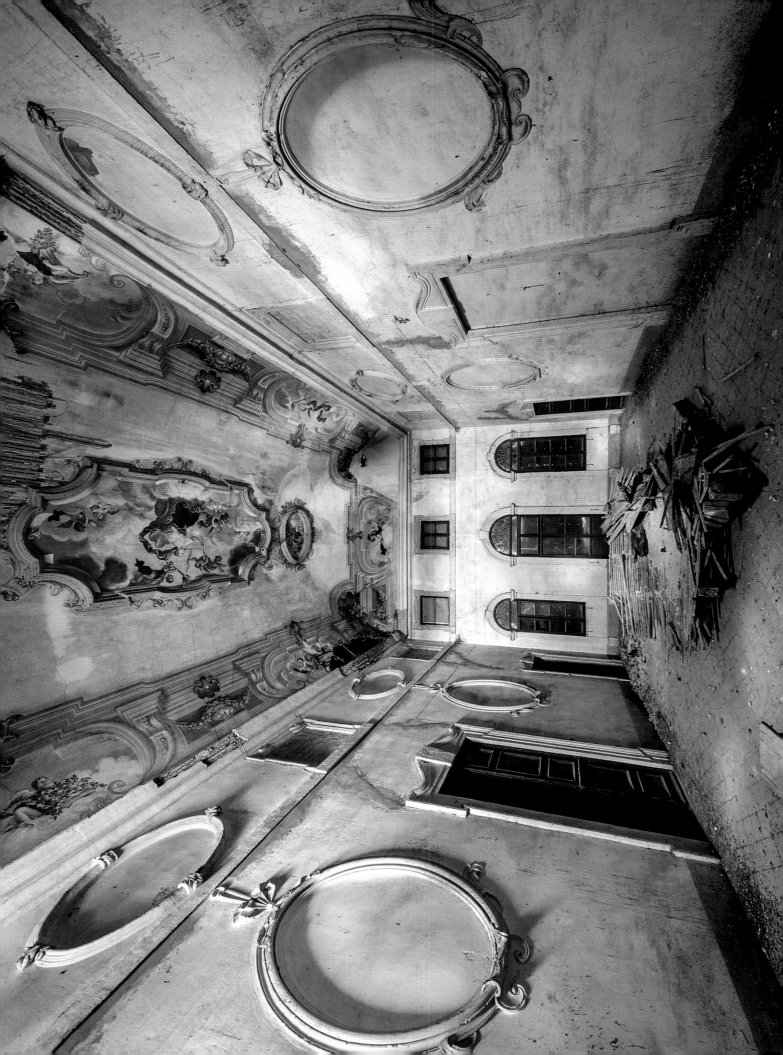

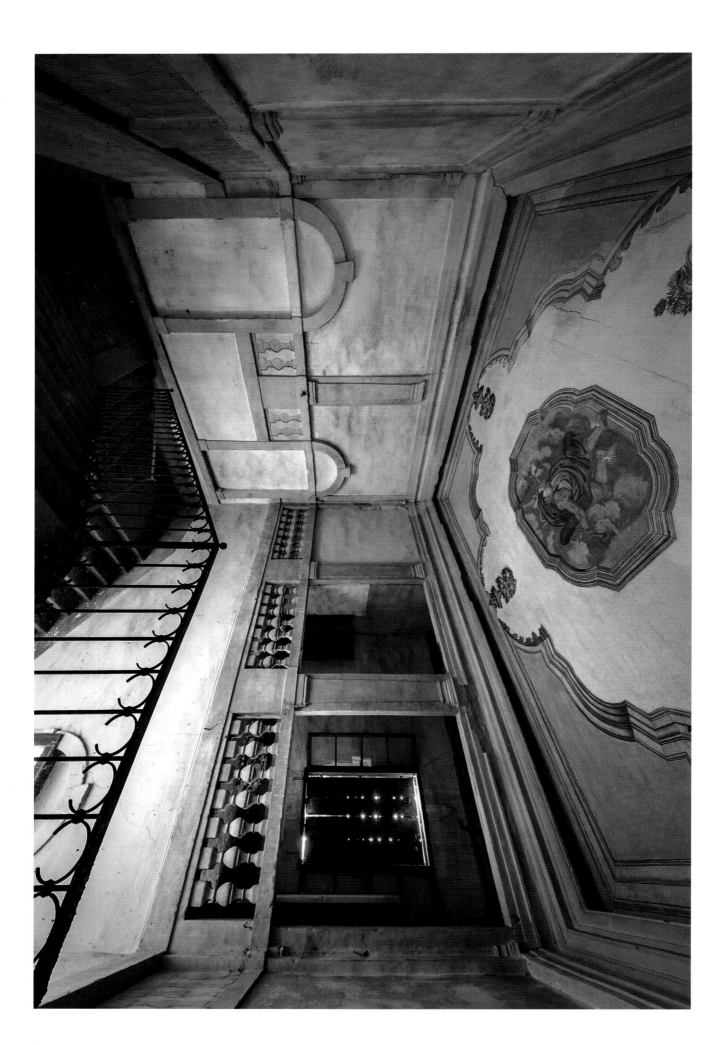

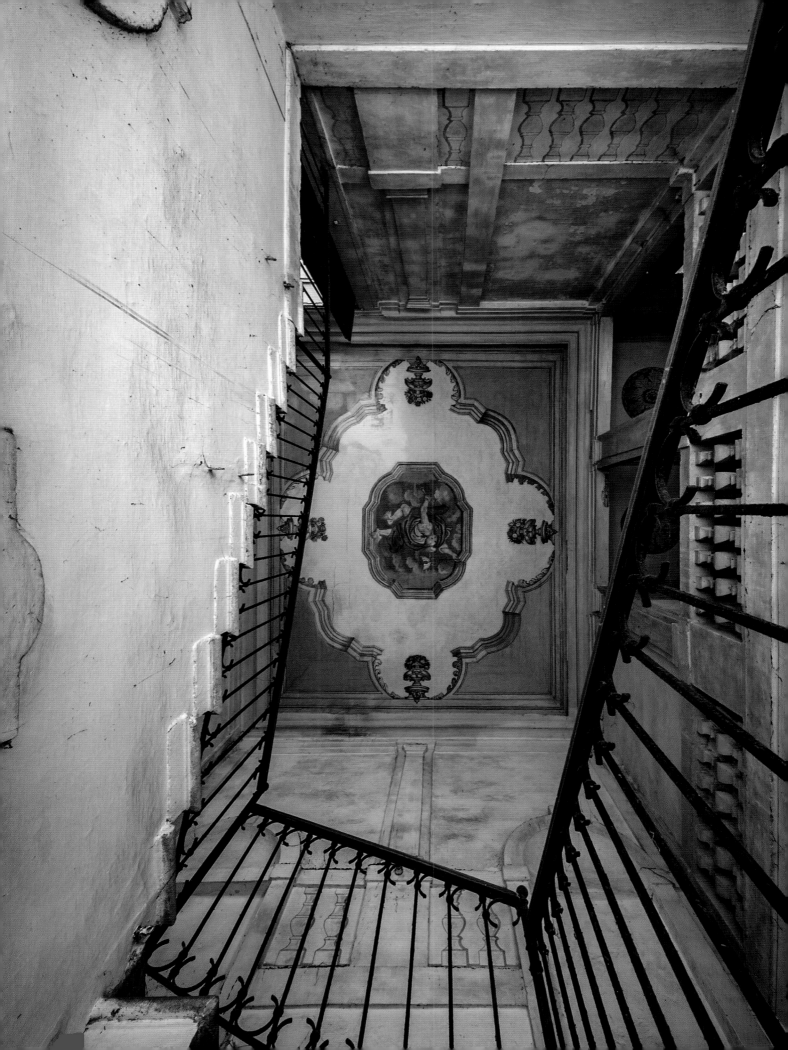

Cappella del contadino – *Veneto*

In a large park in the middle of nowhere rise several rustic buildings built in 1917. Among them is a graceful private hexagonal chapel; the interior decoration in orange tones lends it a spectacular luminosity.

Embossed ornaments representing garlands of plants remain in good condition. The table of the sumptuous altar is supported by two beautiful caryatids, enhancing its beauty; the frescoes surrounding it date back to 1968. The peaceful atmosphere makes you want to stop, meditate, or simply relax.

Fortunately, this wonder is protected from vandalism thanks to the presence of a guardian living in the property.

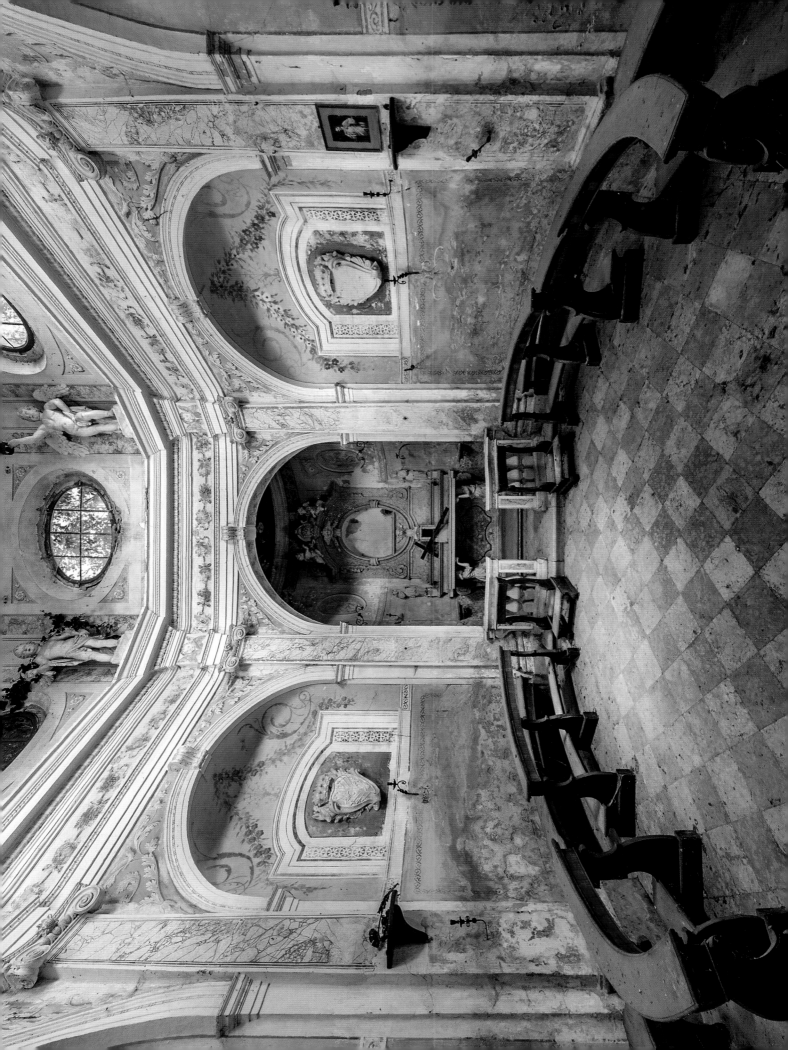

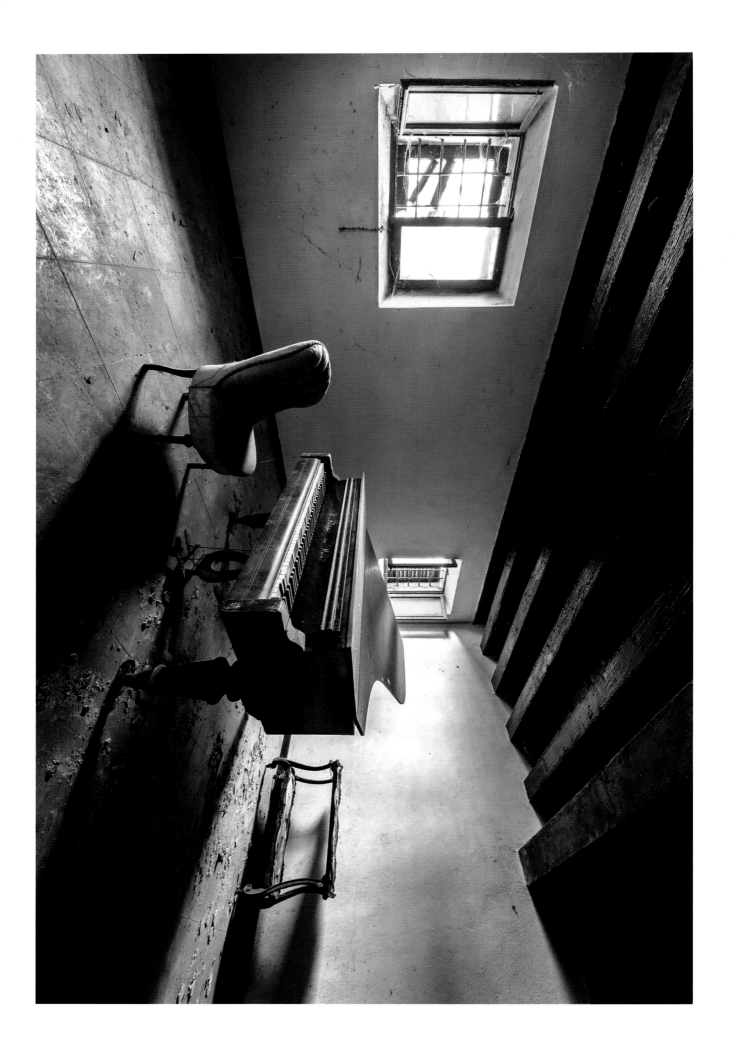

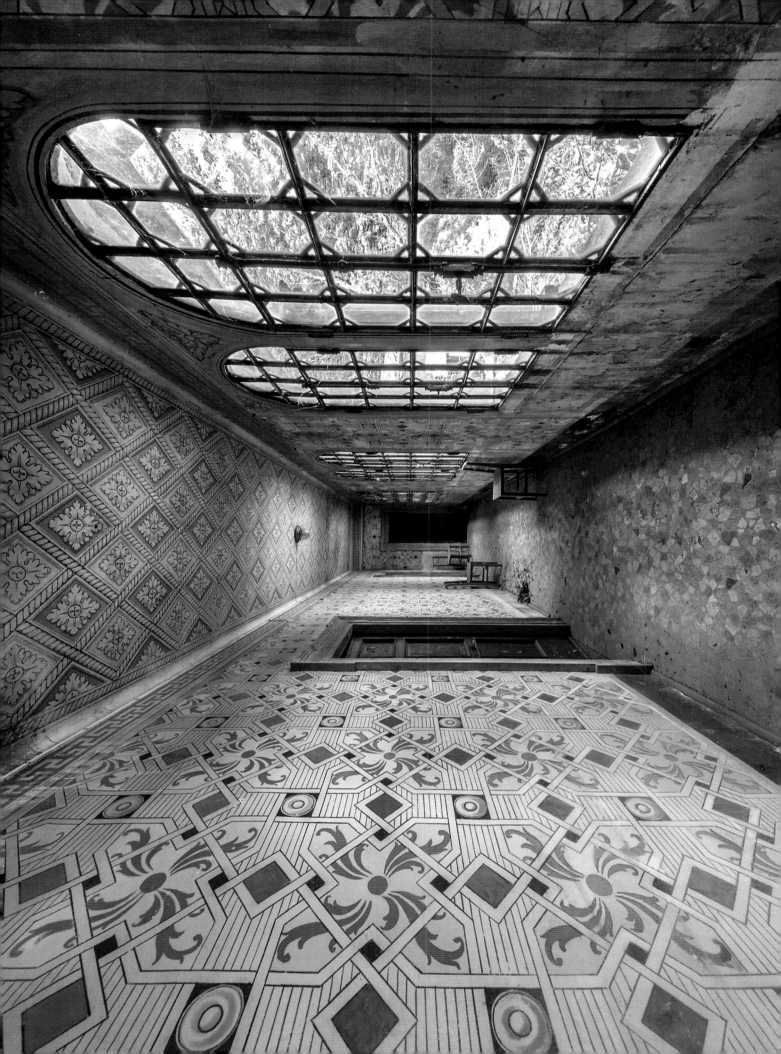

Hotel Paragon – *Emilia-Romagna*

Built in the late 19th century, this five-star hotel has hosted many diplomats, doctors and celebrities from around the world.

In addition to the neoclassical façade, you can admire the splendid dining room with its stained glass windows and elegant skylight, set among an enchantment of mirrors and stuccoes that has witnessed more than a hundred years of refinement and tradition.

The hotel had 110 rooms, but it is only in the most luxurious of them we find the feature that attracted the wealthy customers: direct access to thermal water. Here they could enjoy all the health benefits of the water without leaving the comfort of their apartments.

It was in 2008 that the five-star fairy tale came to an end.

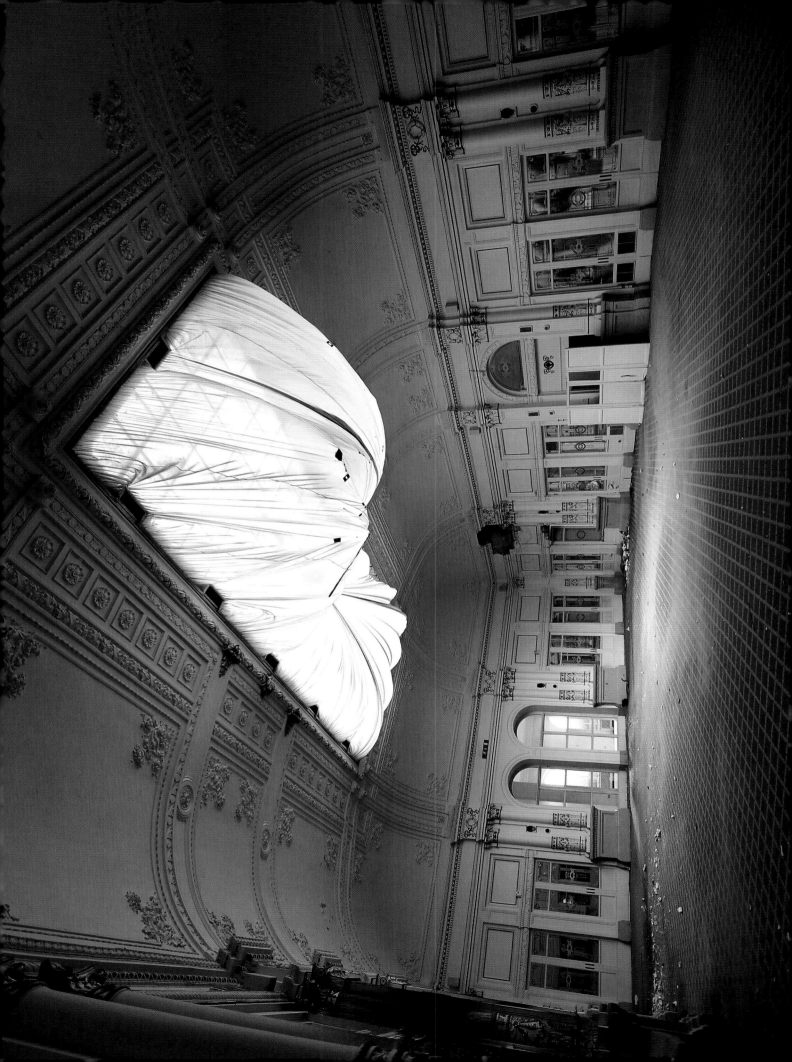

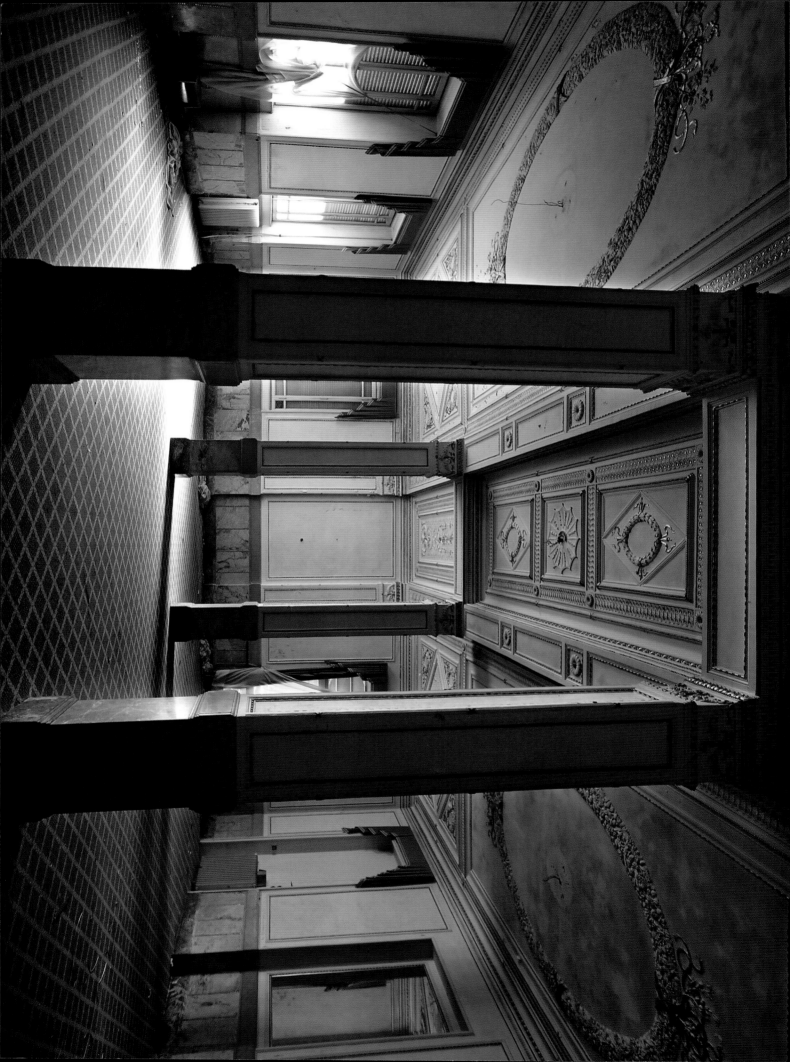

Hotel Thermal T – *Emilia-Romagna*

On the gentle green slopes of the Apennine mountains, far from the big industrial centres, a thermal town was built and became famous for its salso-bromo-iodic waters. Although these were already known to the Romans and Celts, their healing properties were again discovered in 1839 by Dr. Berzieri. The thermae, which offered a wide range of treatments thanks to its mineral-rich waters, became very popular and welcomed guests from all over Europe.

Built during the Belle Epoque, the thermal hotel has an elaborate façade that combines Liberty and Art Deco styles. The empty salon is lit by large windows, the light reflected on the beautiful marble columns. The dining room, where refined dishes of traditional Emilian cuisine were once enjoyed accompanied by fine local wines, also stands empty. The hotel closed in 2007.

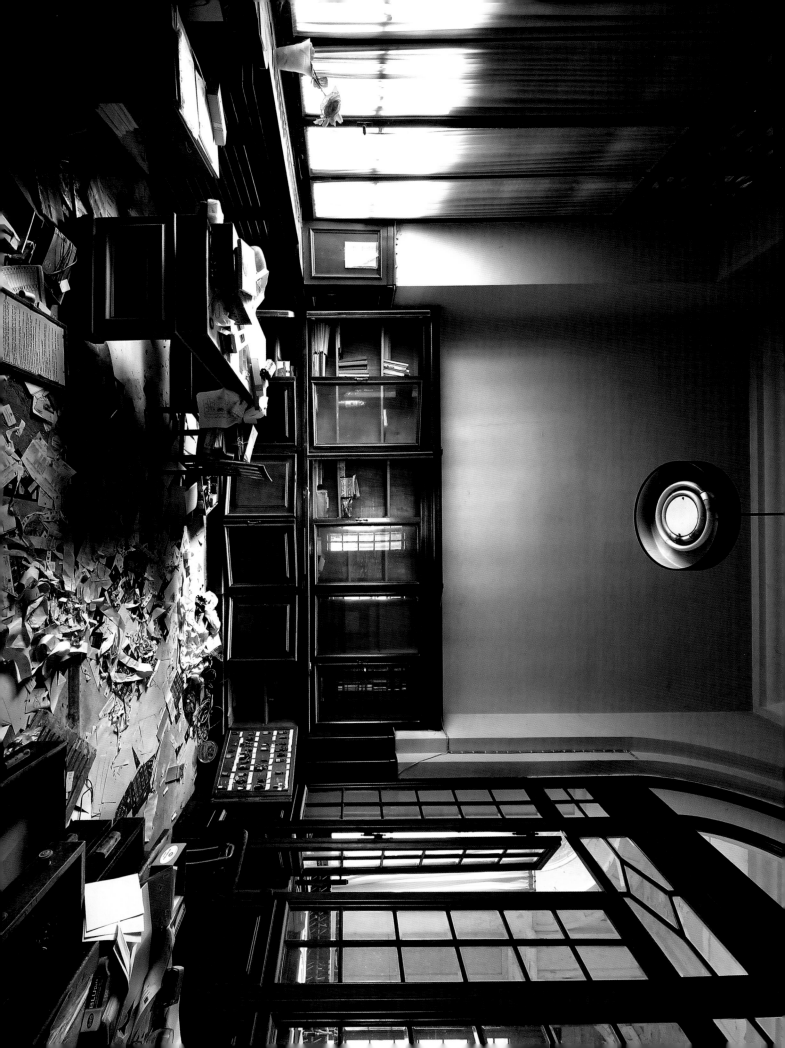

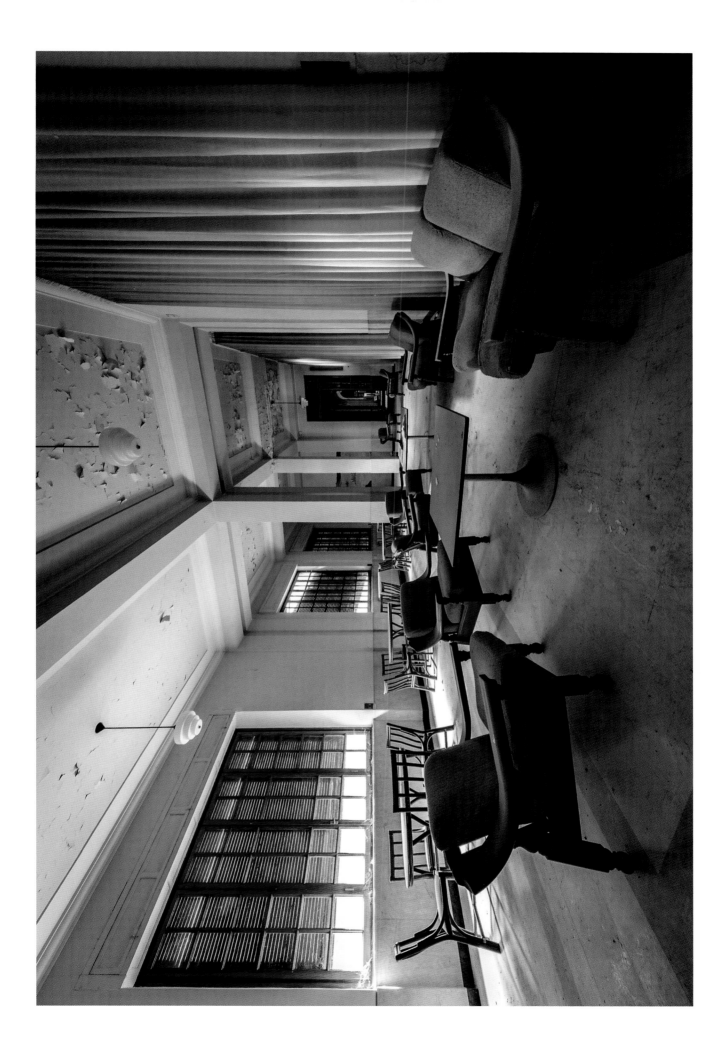

Palazzo di C – *Emilia-Romagna*

A charming atmosphere and warm hospitality are felt immediately on entering this majestic palace, which for years served first as an apartment for Queen Margaret of Savoy then the Empress Aleksandra Romanova.

In 1966 this beautiful Liberty-style building, built over four floors at the beginning of the century, became a prestigious palace of public utility for the municipality, with the facility to house dignitaries and academics from all over the world.

The walls of the reception and the atrium are covered with fine woodwork, while the walls of other rooms boast splendid frescoes. The rooms were heated by radiators — a particularly modern feature at the time. For several years the palace was left unused. But after some faithful restoration it can now accomodate up to 3,000 square metres of cultural and artistic exhibitions, conferences, happenings, shows and other events in its elegant salons and auditorium.

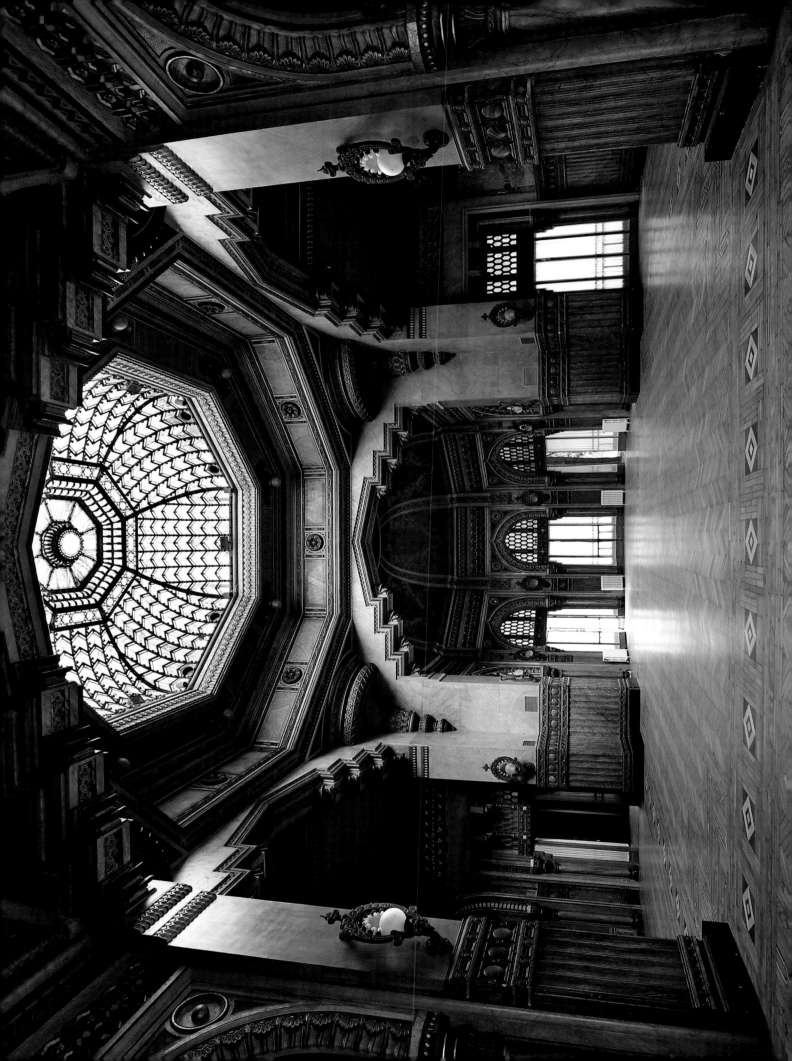

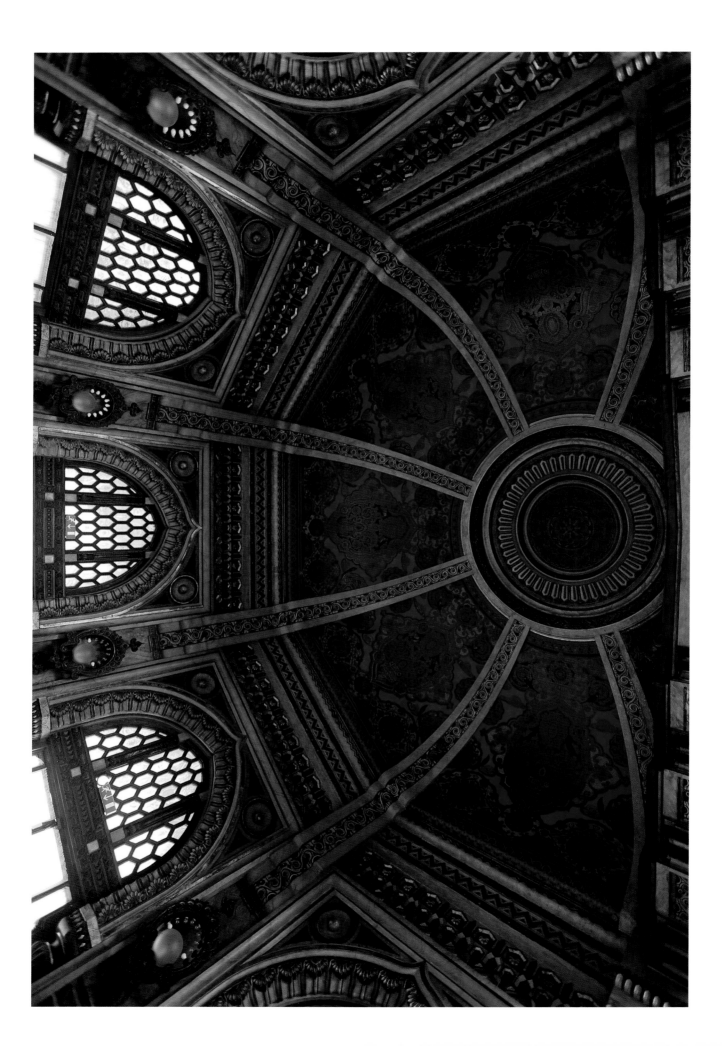

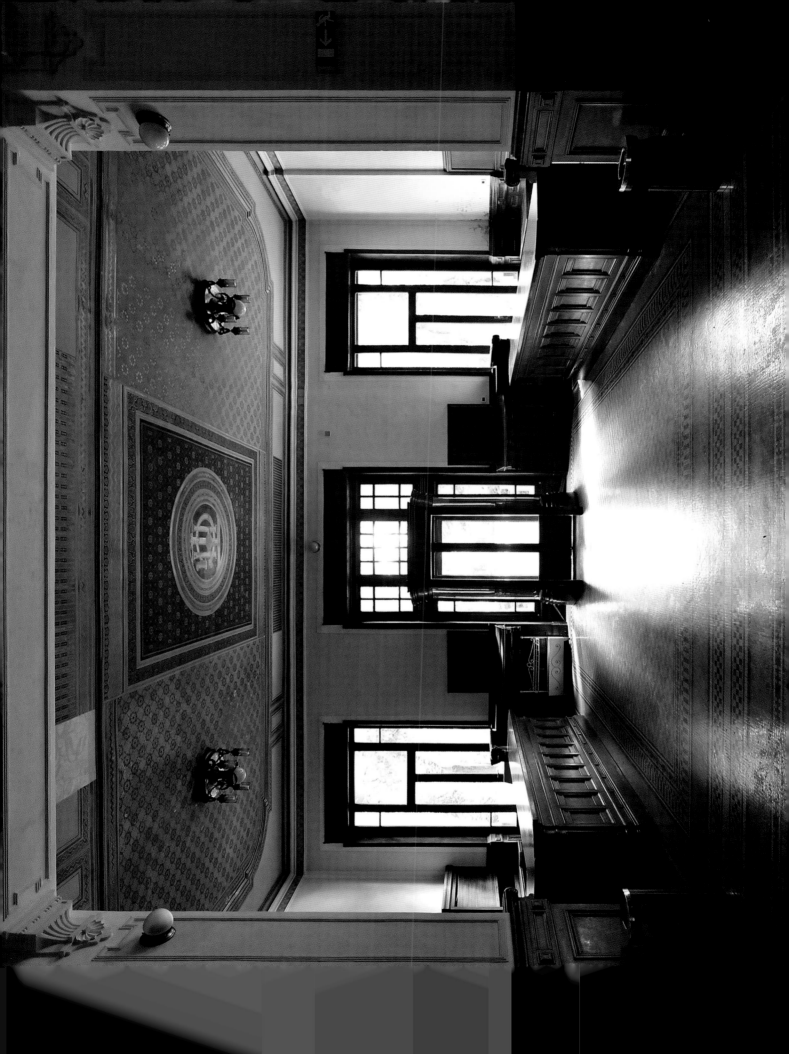

Manicomio di C – *Emilia-Romagna*

It was in 1873, after a devastating citywide cholera epidemic, that the Provincial Administration of Parma decided to temporarily transfer the psychiatric hospital to the premises of the former ducal palace and old convent of San Domenico.

Years passed by and this temporary solution became more and more permanent; so much so that the rear of the palace served as a psychiatric asylum for the province until its closure.

In the 1960s, Mario Tommasini, provincial councillor in charge of the psychiatric institution, met the eminent professor Franco Basaglia. Together they began the long battle to reformulate the very concept of a psychiatric hospital.

Consequently, in 1978 the Basaglia Law closed all psychiatric asylums. Patients were discharged, and many once lost souls returned to life.

The asylum is abandoned and left to the whims of the atmospheric agents who will suceed in erasing a whole section of history.

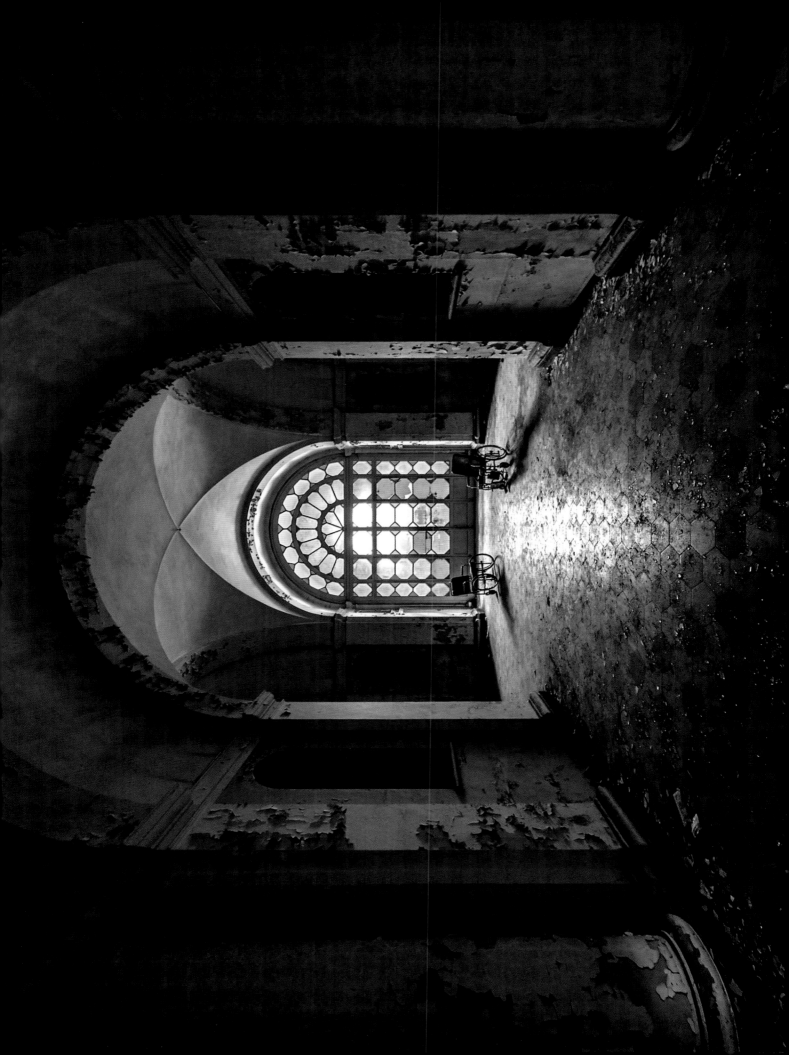

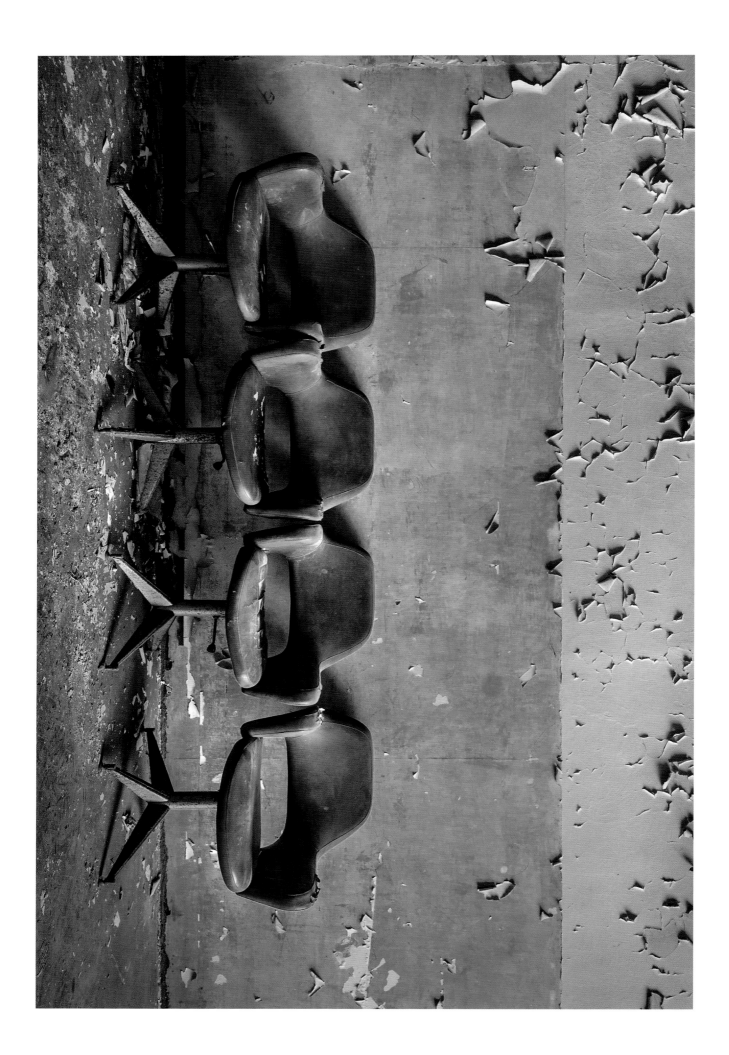

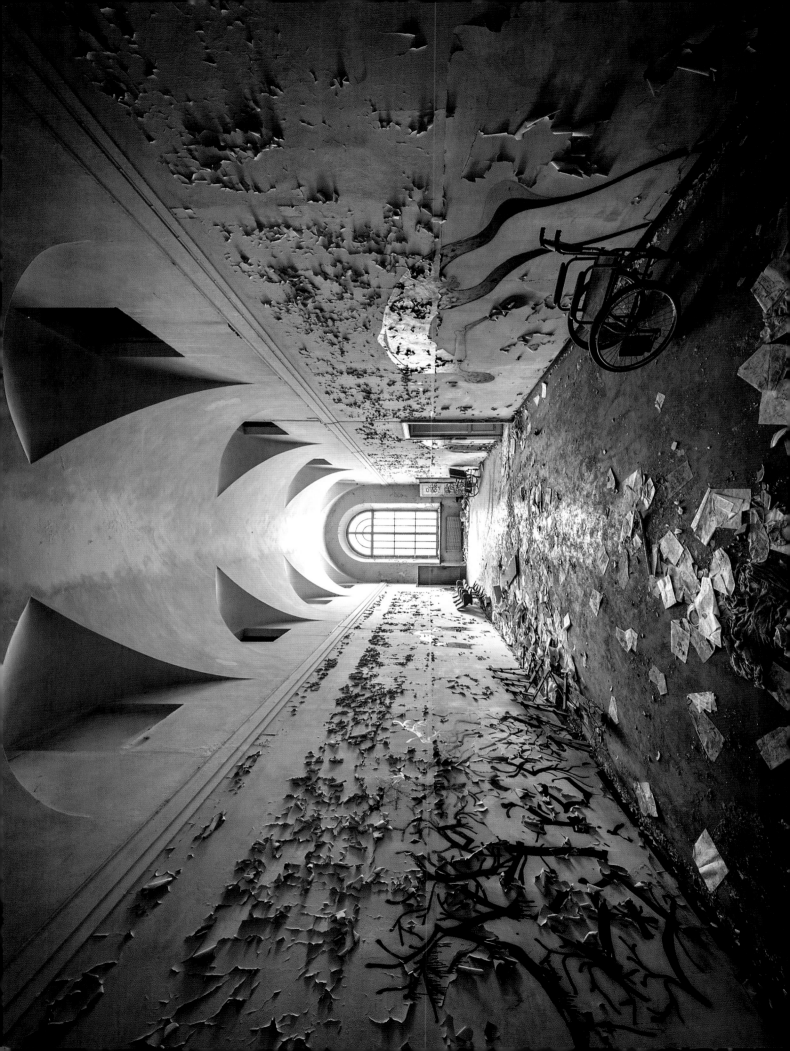

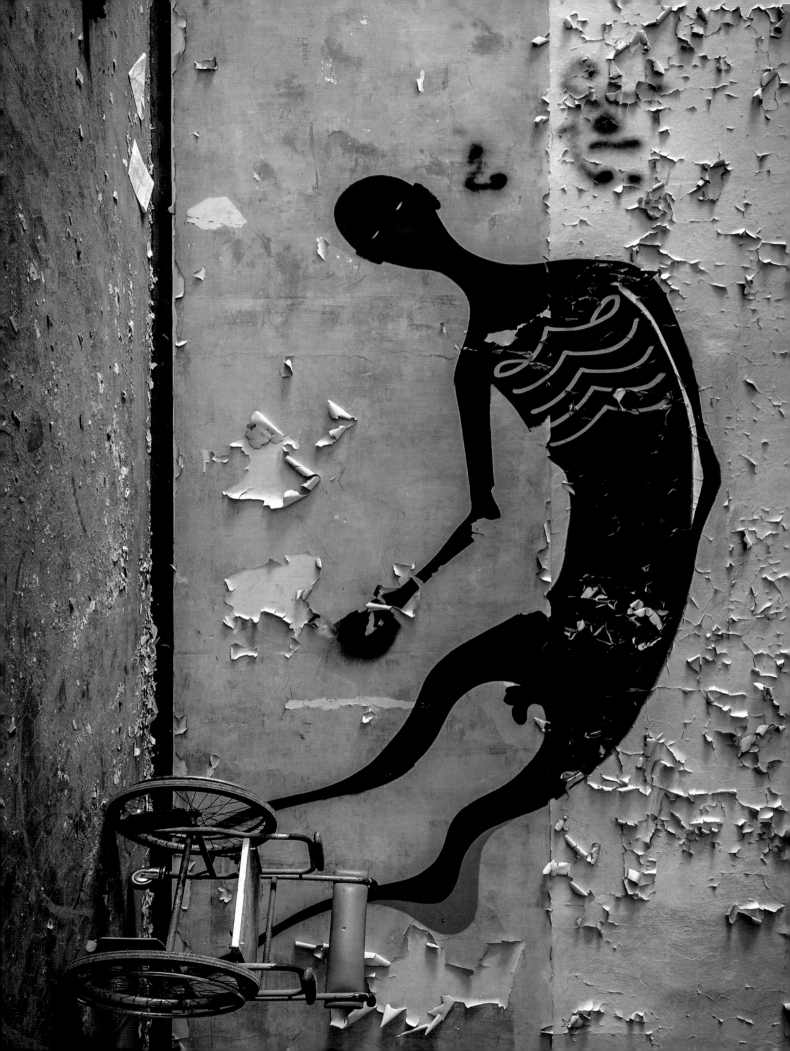

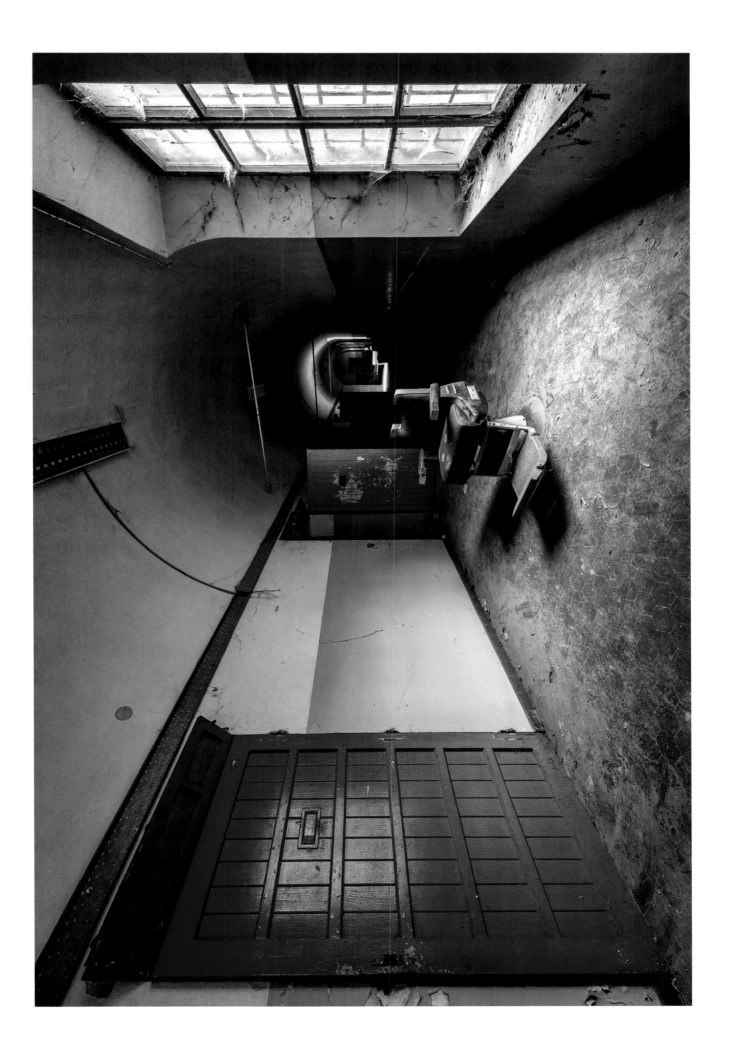

The Casa del Coach – *Emilia-Romagna*

Welcome to a villa in the heart of the Italian countryside where time has stopped. Everything is as it was: the furniture, the photographs, the newspapers, the football trophies and diplomas … It seems that the host of this place was a football coach!

Judging by the calendars, magazines and mail still found here, it is possible that the villa has been abandoned since 2006.

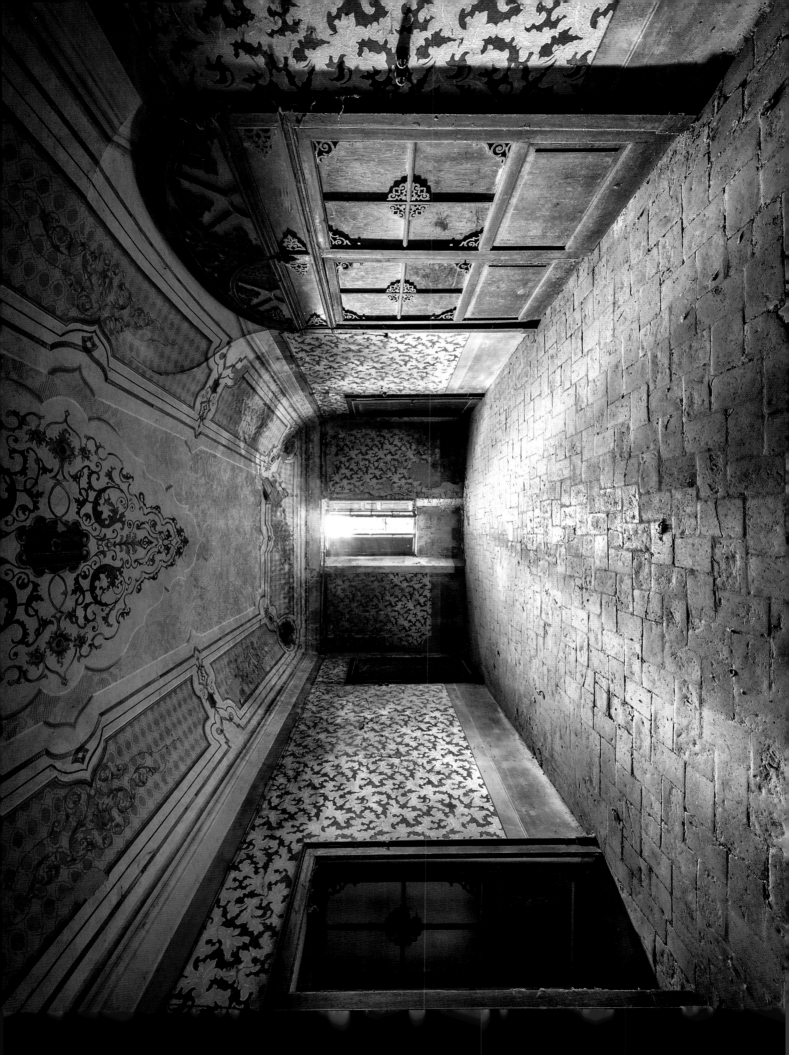

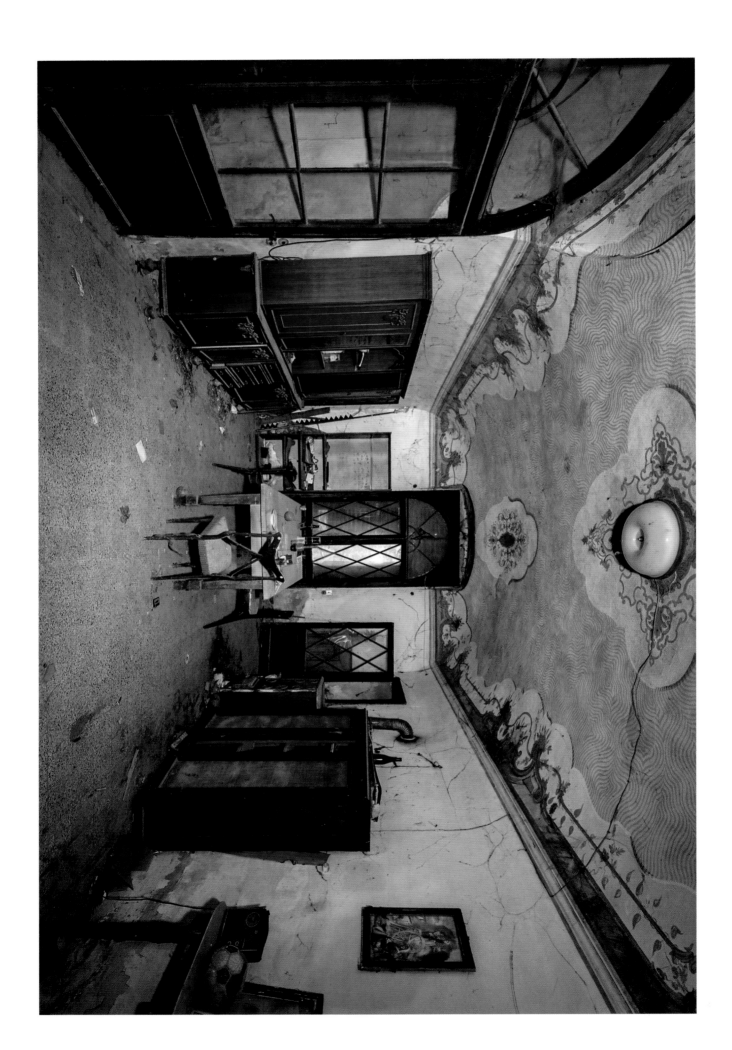

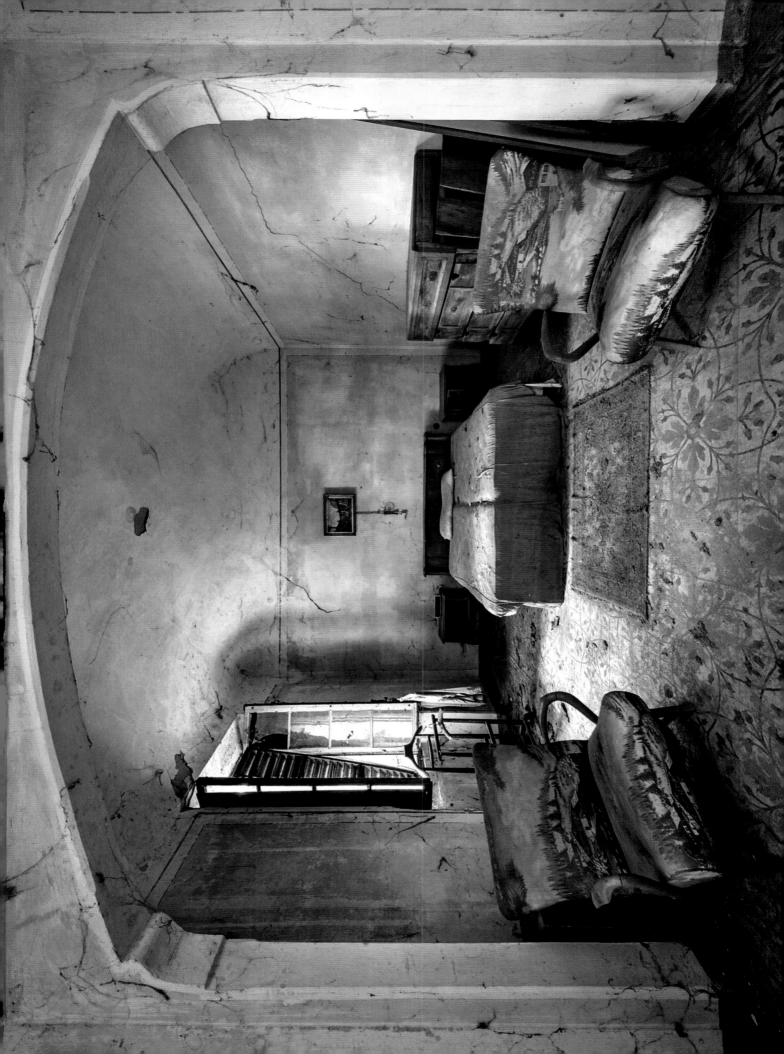

Casino Palace – *Emilia-Romagna*

It was in a former hunting lodge, nestled in the heart of the nine hundred hectares that were then the hunting grounds of the Duchy of Parma, that the Duchess Maria Amalia de Bourbon established her summer residence, erecting in 1789 a prodigious building.

Thirty years later the grand neoclassical structure was completed by a prestigious bell tower with a clock. It housed the Court Theatre and a casinetto, according to the wishes of Marie Louise of Austria, Duchess of Parma.

In the large entrance hall an imposing double-sweeping staircase that separates the hall from the main salon immediately catches the eye of anyone venturing in, before a short walk leads to the chapel, with its shimmering, but slowly fading colours … a reflection of the entire house.

Shamelessly abandoned, the building is deteriorating day by day, while none of the virtuous dialogue engaged in by the province to save this true work of art bears any fruit.

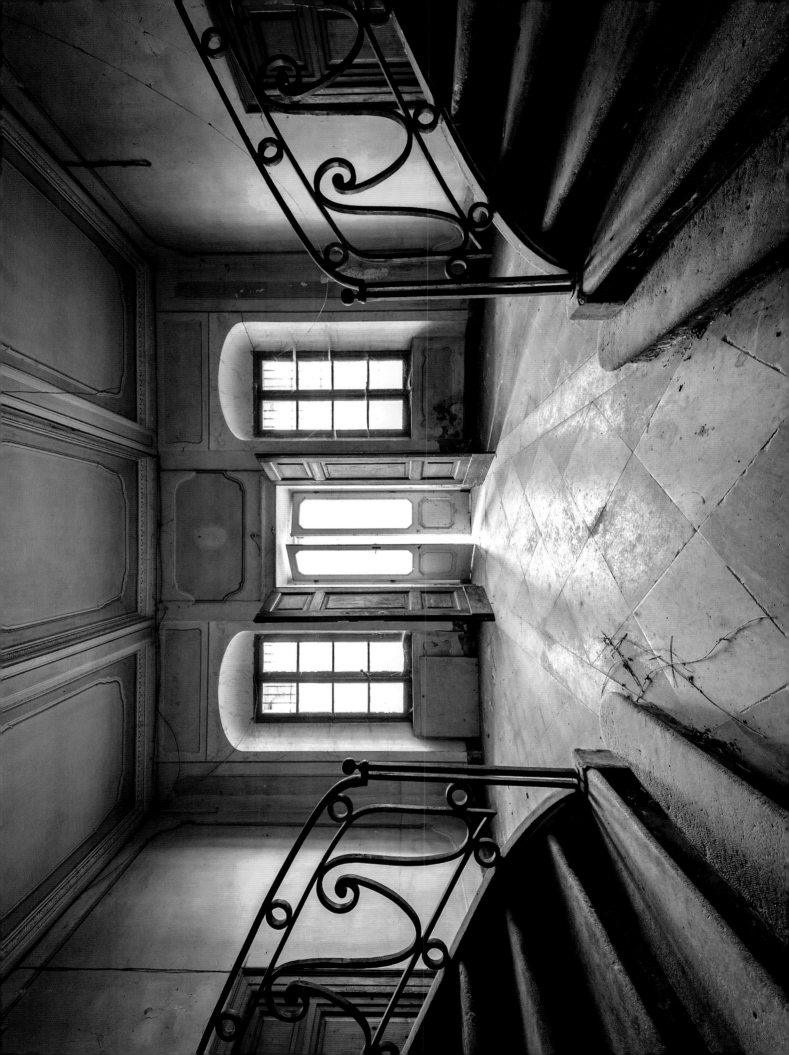

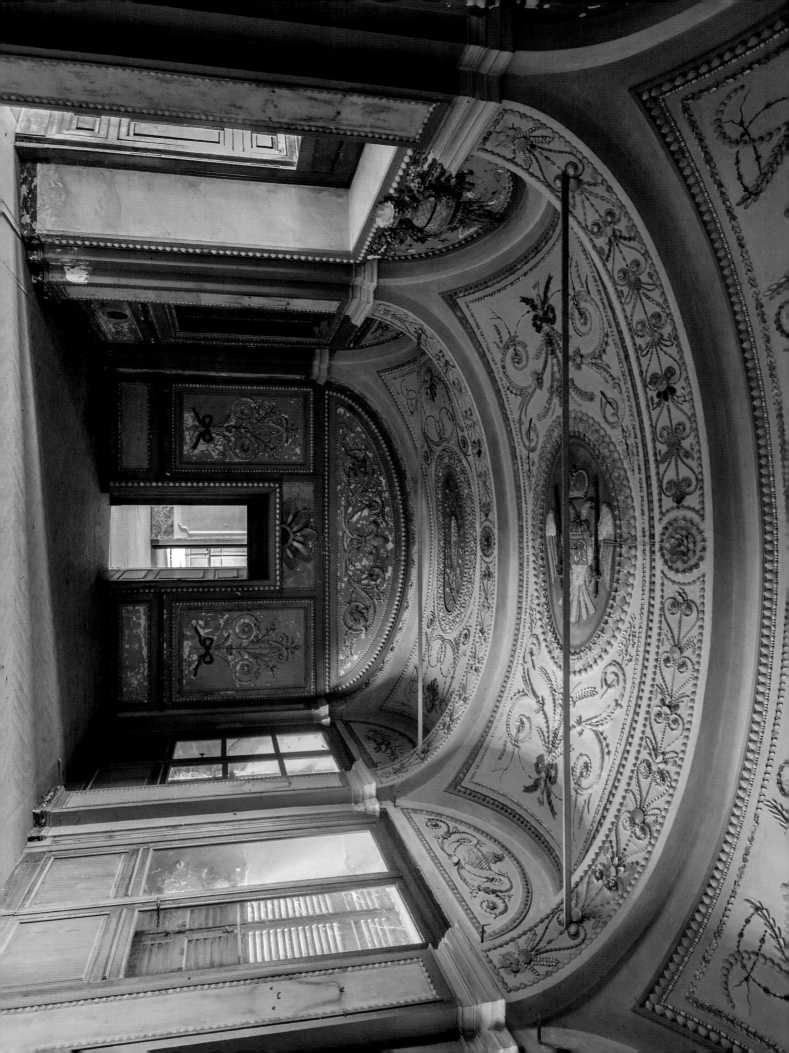

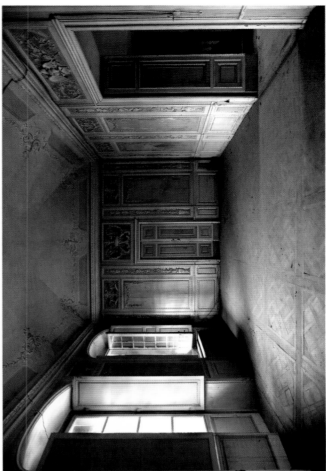
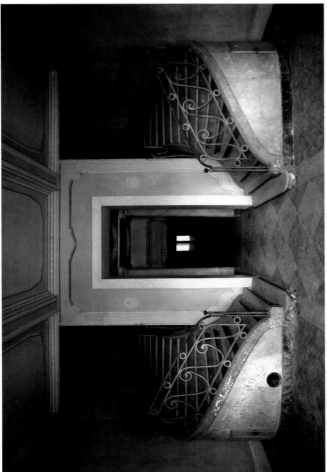
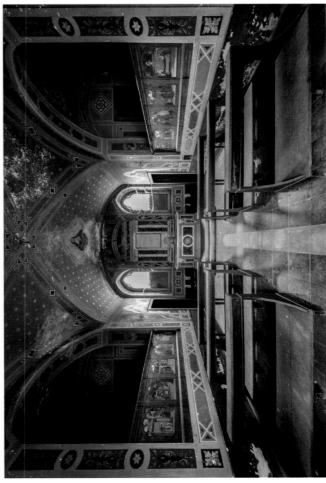

The ancient Oculus distillery – *Emilia-Romagna*

An imposing concrete industrial tower, its walls dotted with a hundred windows, forms the majority of the remains of an old abandoned distillery, codename: Oculus. This huge factory transformed sugar beets into products for use by other manufacturers, such as alcohol for Martini and industrial oils for Manutti.

Founded in 1889, the distillery has long been one of Europe's largest producers of alcohol and sugar. The quota system applied by the European Union in 1968 helped it to prosper by allowing it to benefit from the public intervention mechanisms put in place to manage surplus production. The situation changed when in 2005 the European Union decided on a drastic revision of regulations and the abolition of production quotas.

With no more EU aid, the increase in production led to a sharp fall in prices and a severe crisis for producers. Companies were strongly encouraged to modernise their facilities, forcing the closure of obsolete plants, including the Oculus distillery.

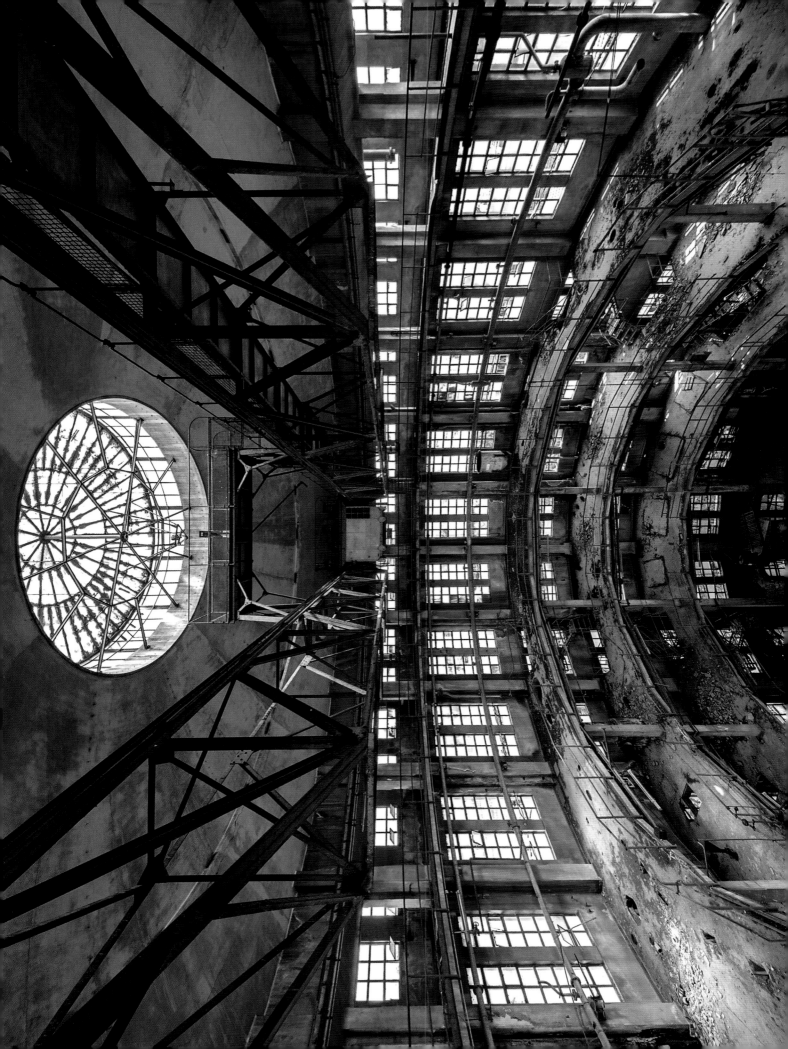

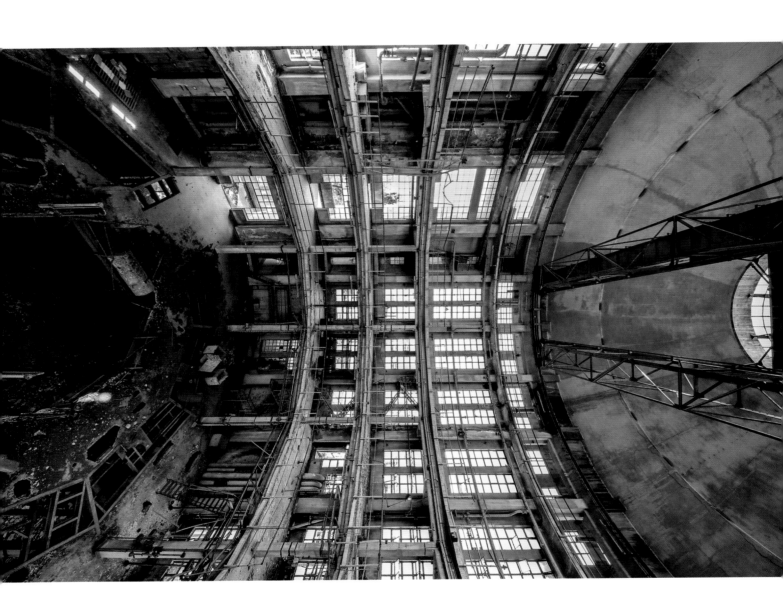

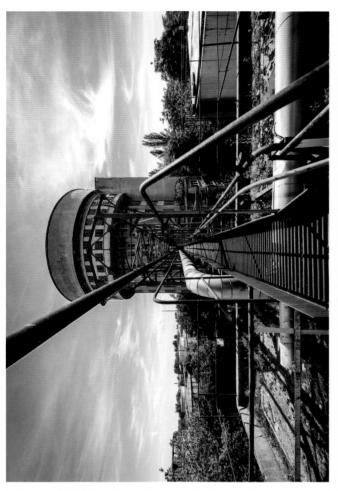
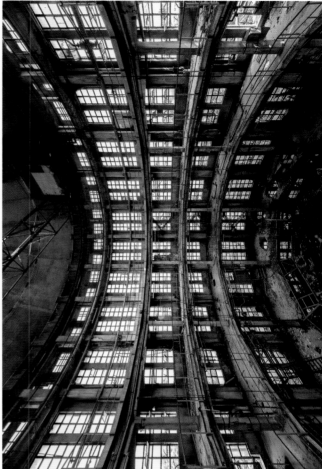
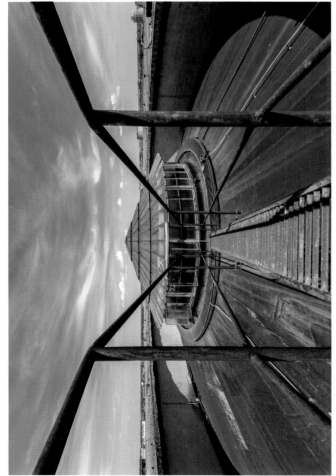
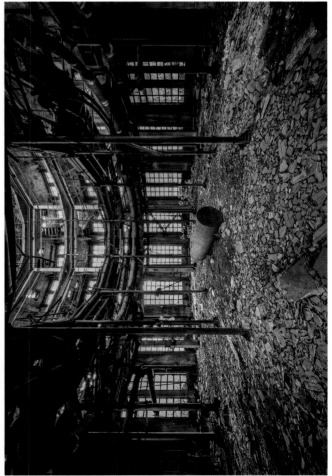

Palazzo di G – *Emilia-Romagna*

On the edge of a forest covering almost four hectares stands a castle that looks more like a fortress. Built in the middle of the 14th century, the castle retains a medieval touch, its crenellated fortifications and its keep witnesses to a time when the wars between Guelfs and Ghibellines tore the country apart.

The castle's transformation into a neogothic palace (as are called the villas of the Bolognese nobility) by the Pepoli family in 1870 somewhat changed its appearance, but it was the terrible earthquake of 2012 that irreparably disfigured it.

At a magnitude of 6.2 on the Richter scale, the earthquake caused the collapse of part of the roof and the medieval tower that once stood beside the keep. Inside, an apocalyptic vision awaits: cracks running through the remaining colourful walls join the broken windows and collapsed ceilings in sinister harmony.

Fortunately, the municipality is keen to preserve the region's historic monuments. Part of the palace has survived and remains in a reasonable state of preservation, such as this large room, its ceilings adorned with frescoes, and bookshelves holding over three thousand literary works.

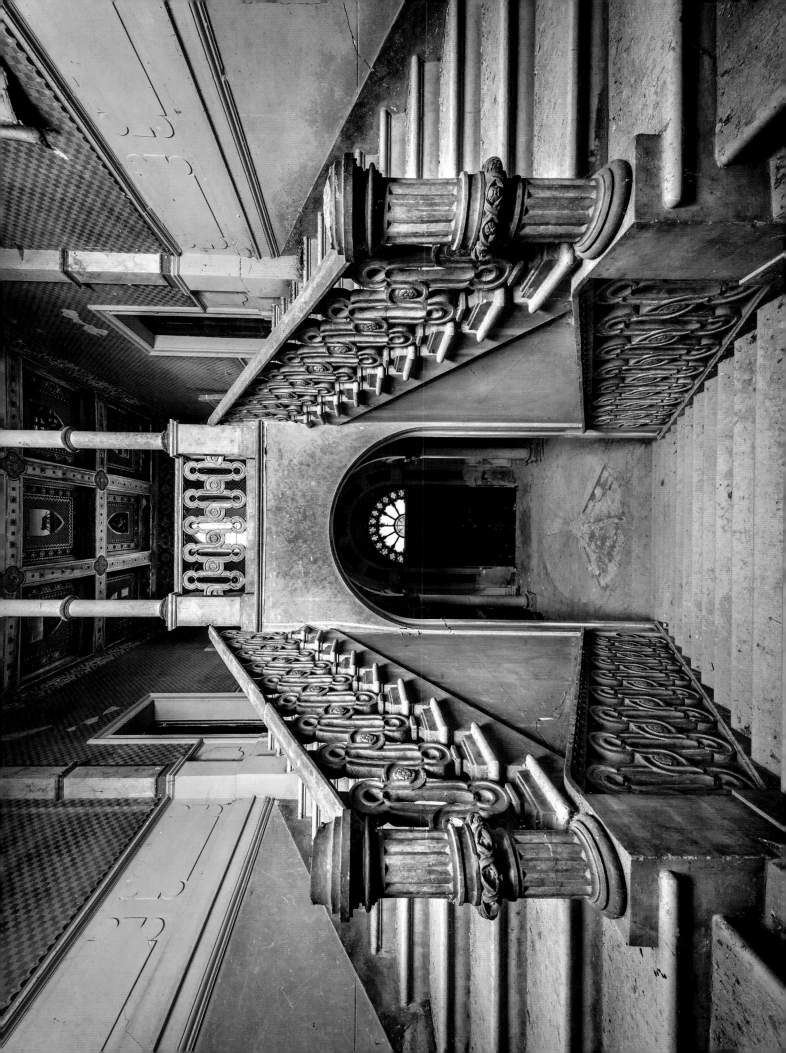

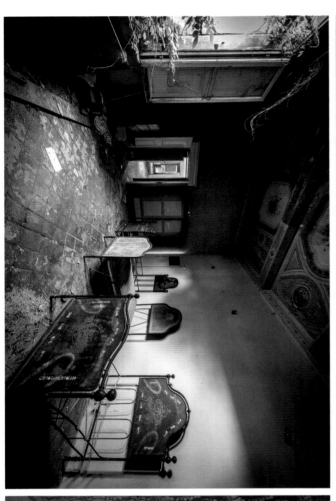
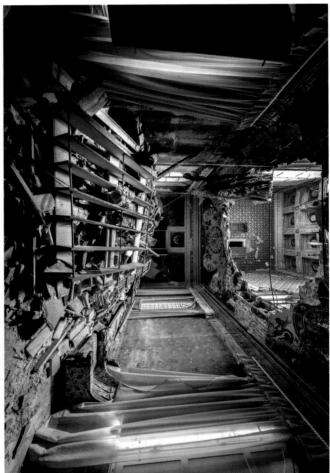
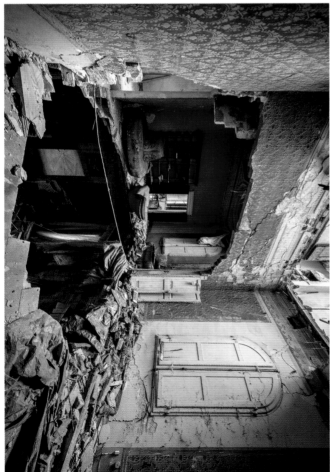
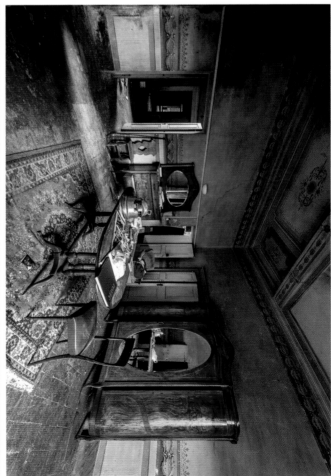

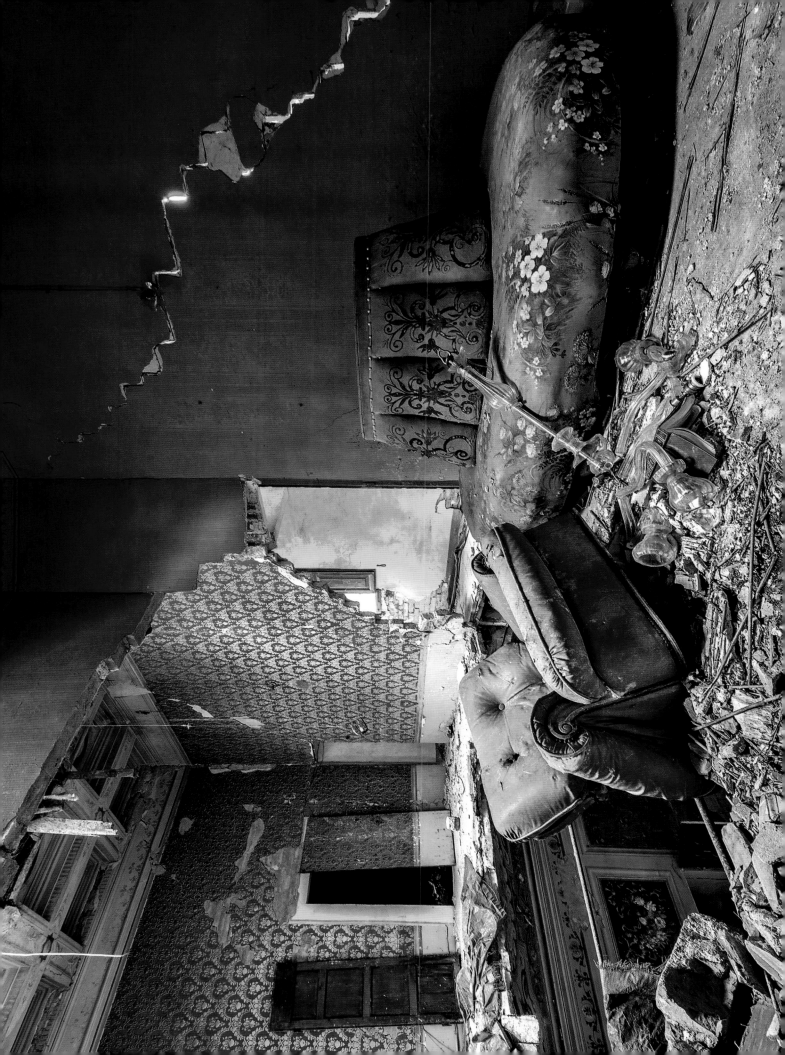

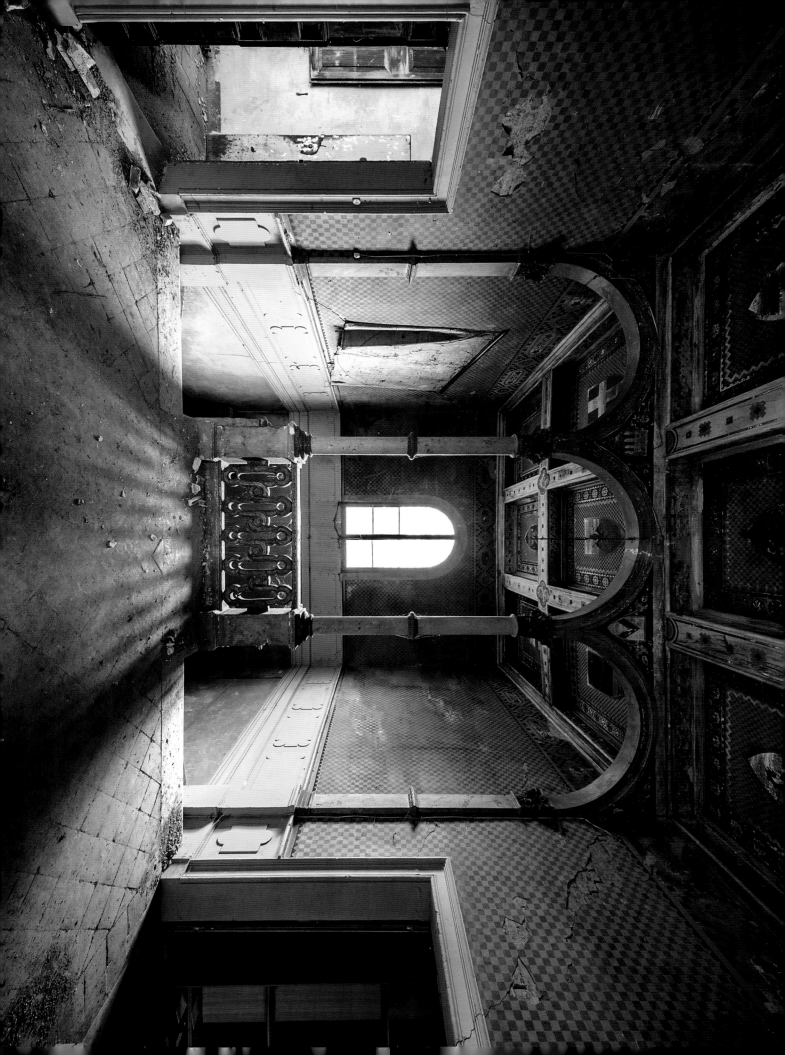

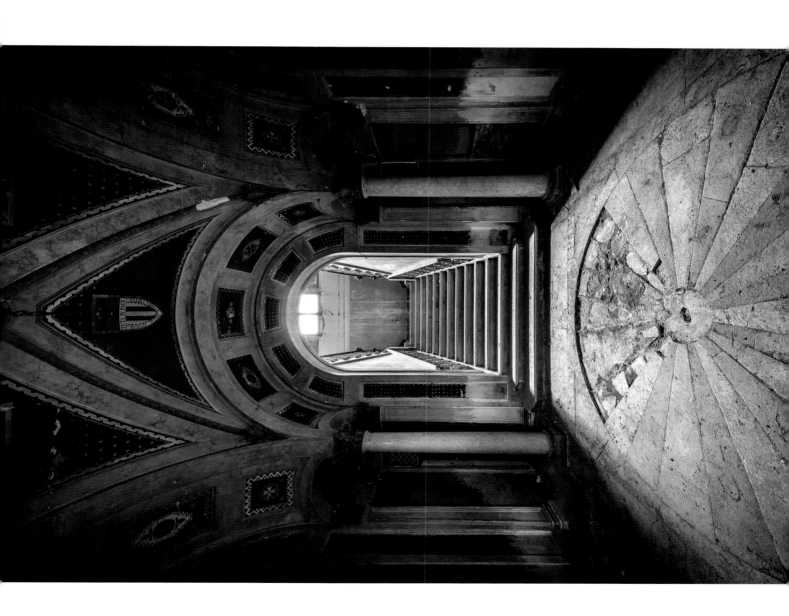

Palazzo di Gaia – *Emilia-Romagna*

Among the streets of a small village, the fascinating ruins of Gaia Palace do not fail to attract attention. Through the trees and brambles that have invaded the property, the beautiful stucco frescoes are still visible.

The history of the villa dates back to the 16th century; it was built by a family of senators from Bologna, before being occupied in the 18th century by the Savini, followed by the Polish general Grabinski during the period of French domination.

But it is the sumptuous and refined banquets given in the 1920s that still bring a sparkle to the eyes of the villagers, reminded of the elegant silk dresses and the illuminations that brightened up the palace.

Bombed between 1944 and 1945, the house is now too damaged to be inhabited, but the remains standing beneath the wild vegetation are of unaltered beauty.

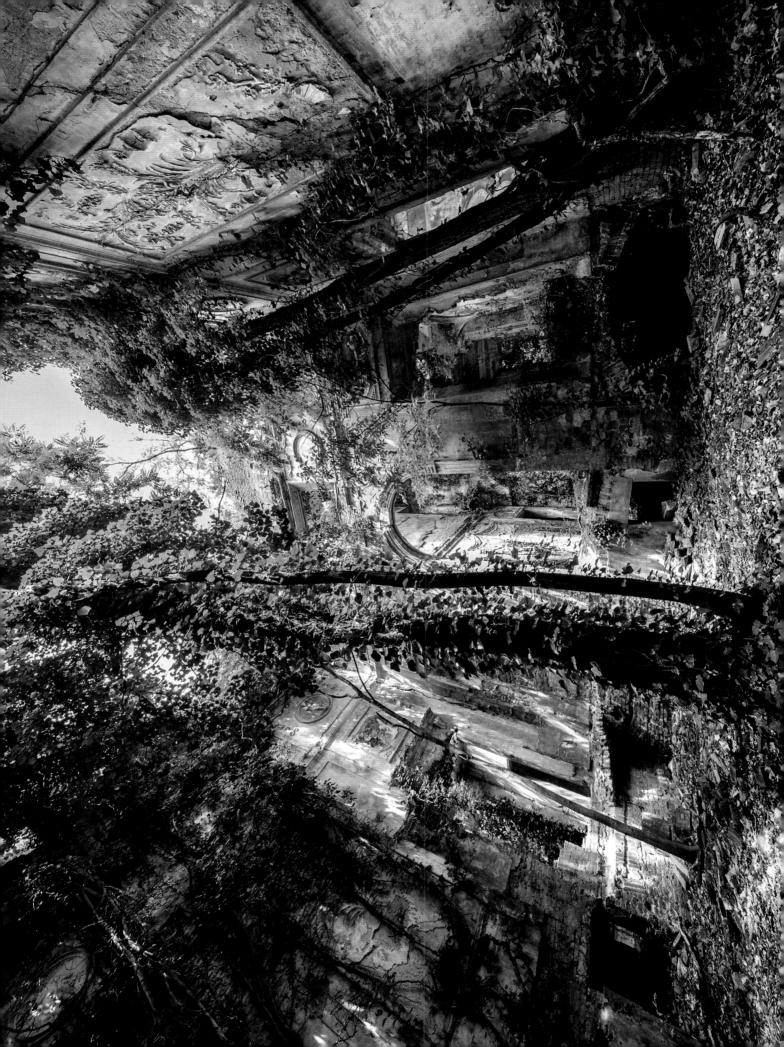

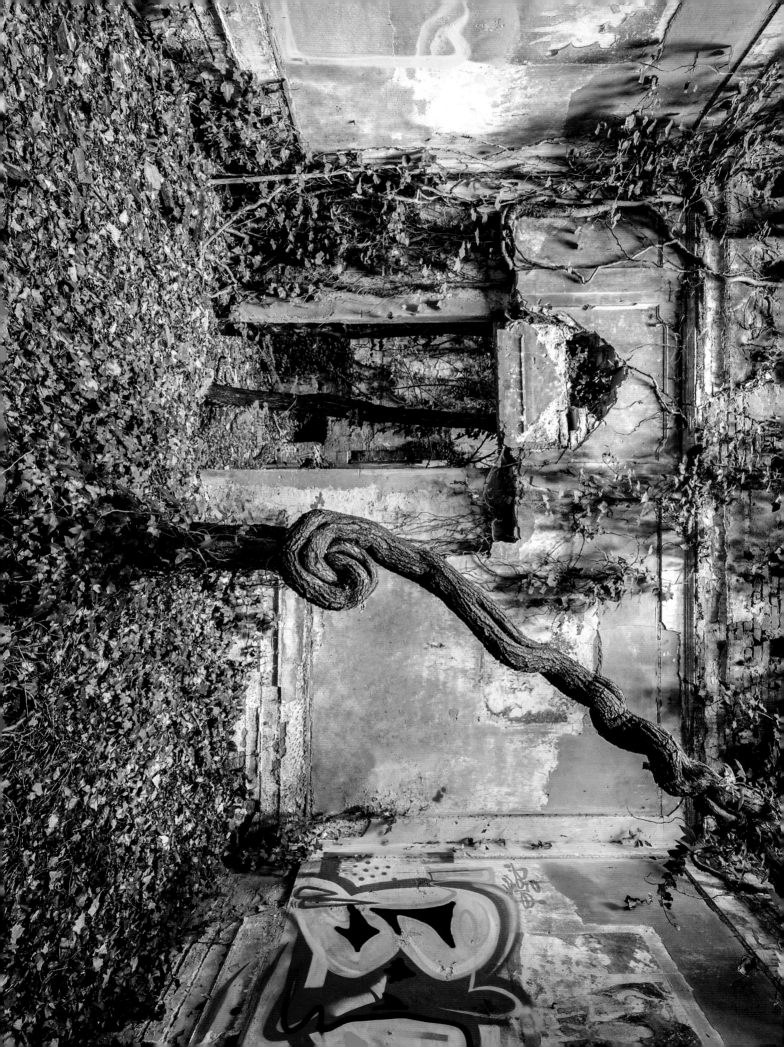

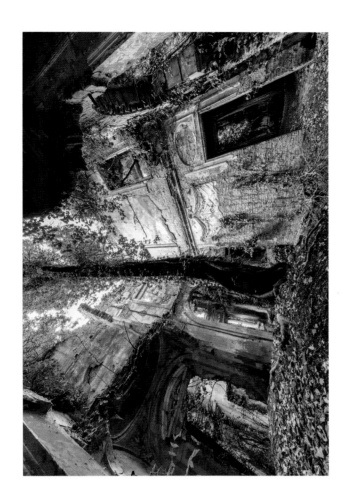

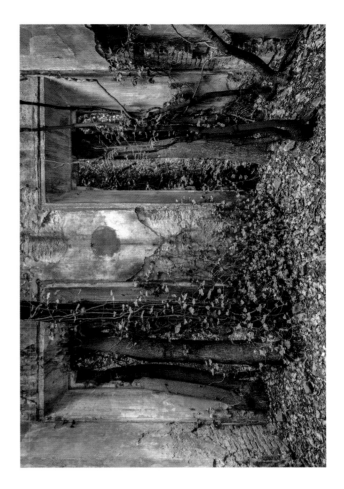

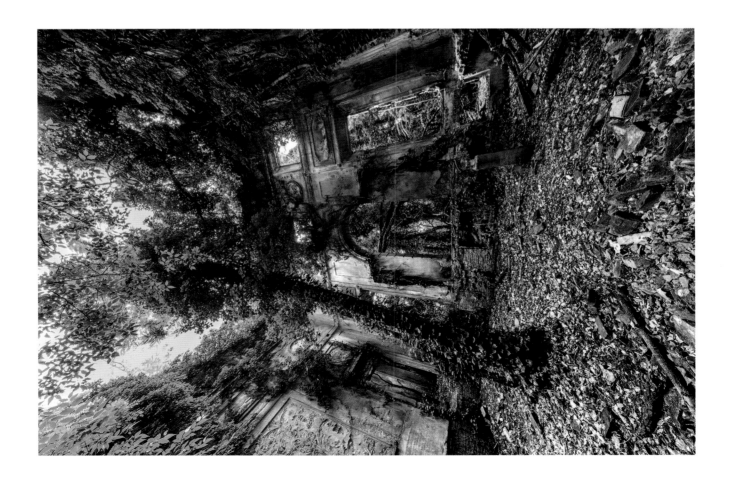

Villa L – *Emilia-Romagna*

At the foot of the Apennines, in the midst of hills covered by vineyards and silvery olive groves, stands a beautiful farm-villa. Built in the late 17th century on the ruins of a castle dating back to 1186, it was inhabited for three centuries by the same family from local nobility. The villa had previously been transformed many times: in the hands of Galvano, a politician under the command of the Roman German emperor; the musician Lodovico Fogliani; and the family of Manfredo L.

At the death of the last marquis, his grandchildren decided not to live in the villa. In 1921, the Duchess Clelia Sforza Fogliani donated it to be used as a kindergarten and it remained as such for several years. But the villa is now abandoned and open to all ... and what a surprise when we get there!

From walls to ceilings the house is entirely painted, giving it a surreal and slightly oppressive atmosphere. The entrance hall is a whirlwind of colours and characters, where knights, angels and winged horses roam among beautiful flower basins. The trompe l'œil invites visitors to rest in an equally admirable patio. The paintings have remained in an excellent condition, but for how long?

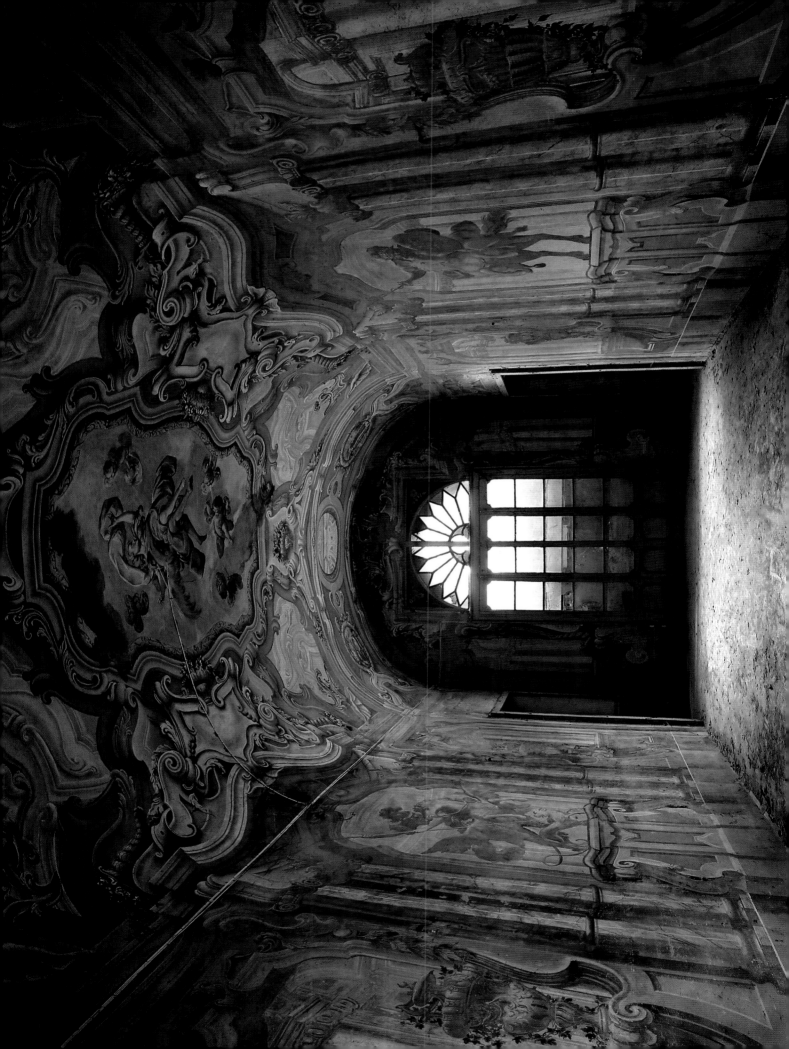

Villa Romantica – *Emilia-Romagna*

This beautiful villa, well hidden among trees and bushes overlooking the hills of Umbria, once belonged to the brother of Napoleon Bonaparte and was famous for being an elegant and joyful summer residence.

In its time it has belonged to many wealthy owners, but this romantic residence is now buried under its own rubble, its colorful frescoes, depicting country landscapes, are barely visible under the rubbles of a collapsed ceiling that has now reached the basement.

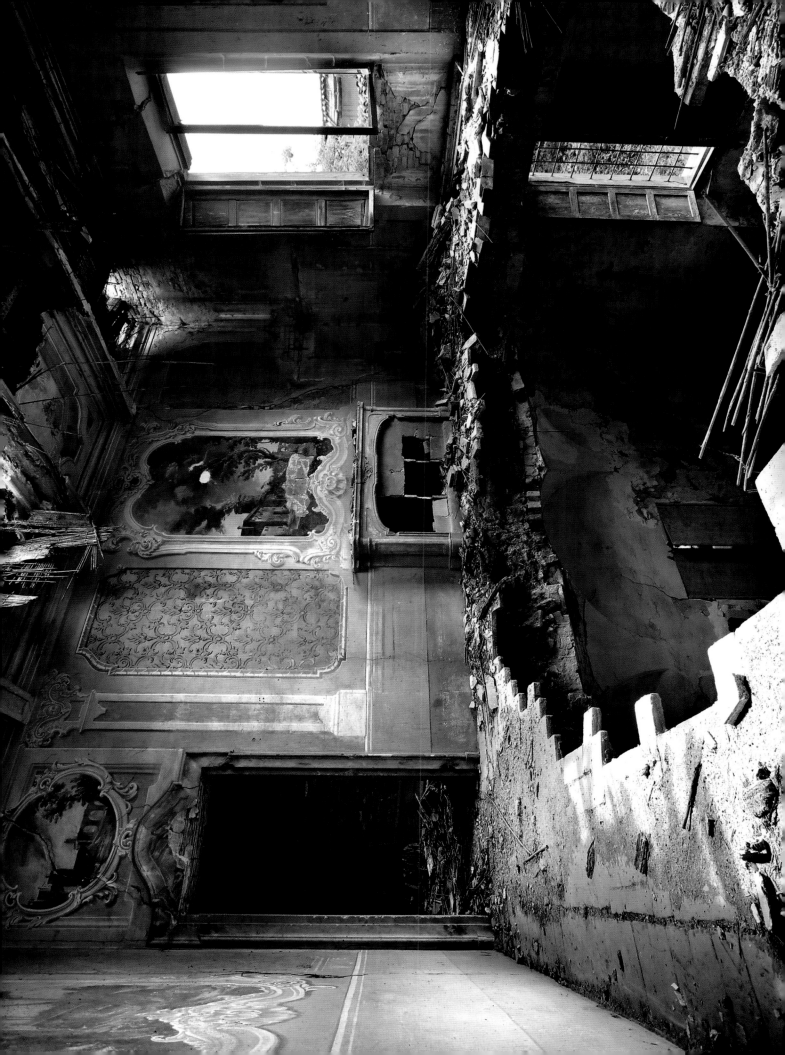

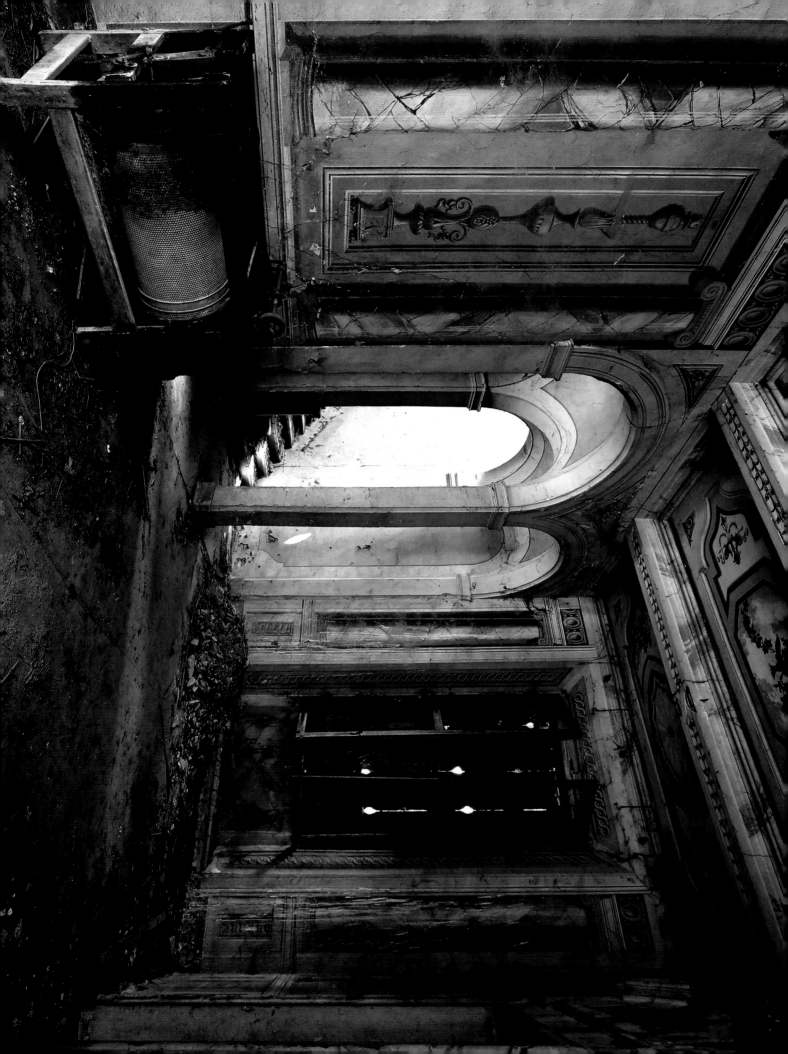

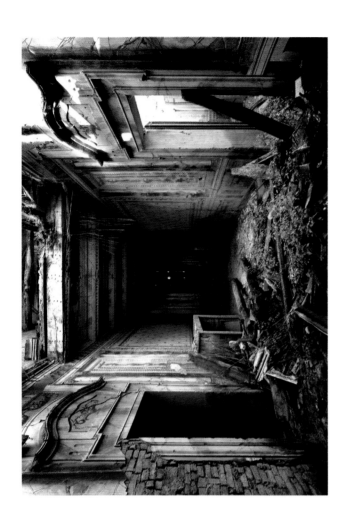
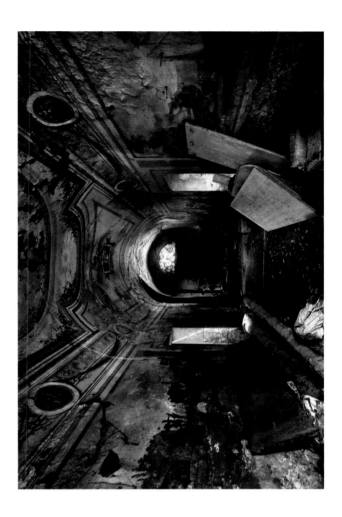
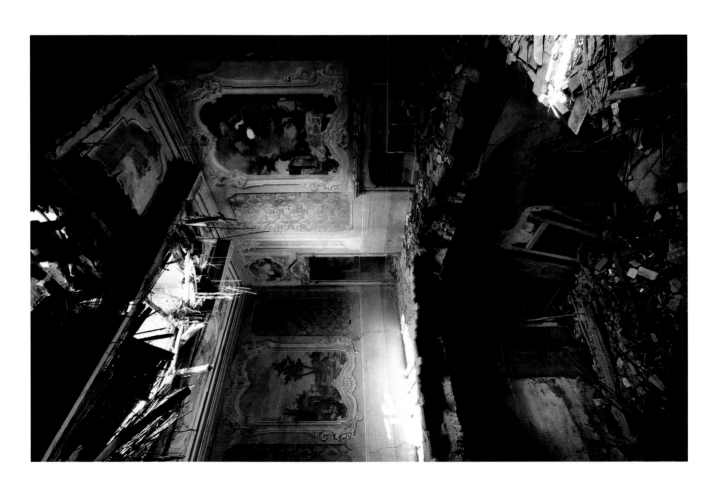

Discoteca medievale – *Tuscany*

After opening on the night of New Year's Eve 1993, this Tuscan disco was only active for four years. During this time, the club gained a good reputation and became the go-to place for night owls; thousands of people from the world of cinema and entertainment, such as Alain Delon and Alba Parietti (an actress, singer and Italian TV presenter), came to dance. Sadly, due to mismanagement, the club eventually closed.

For years the structure was neglected and degradation is well under way, but there are still some remnants of its fake medieval castle decor: flags at the top of the towers, murals depicting knights in armour, coats of arms with animal heads. Although all its copper wires have completely disappeared, the building retains a certain beauty in its rather flattering red seats.

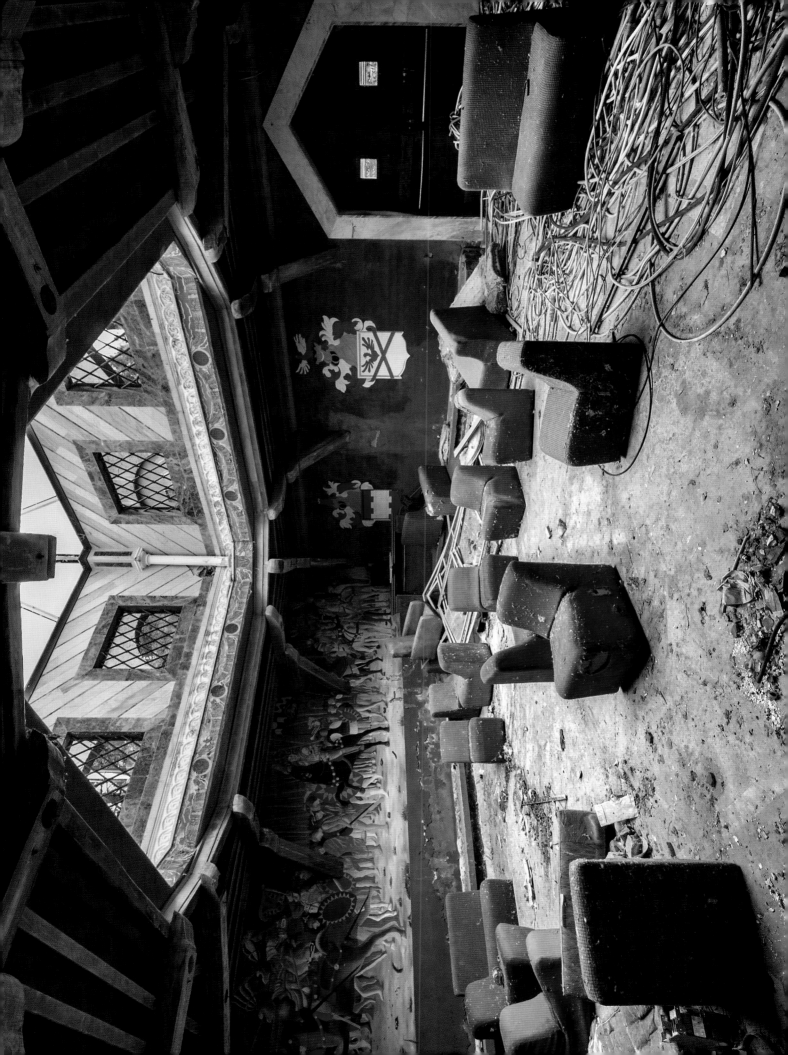

Cementificio Sacci – *Tuscany*

The former SACCI cement factory was created in December 1933 by the merger of several small local companies producing hydraulic binders and ready-mix concrete. The factory played a fundamental role in the economy and housing development of the surrounding area.

During the Second World War it suffered considerable damage. Reconstruction works began with a comprehensive programme to restore the potential for producing and distributing grey and white cement, concrete and aggregates.

In 1949 the company had nearly 300 employees.

Today the site is abandoned, but the company was absorbed by the Italian multinational Cementir Holding, with more than 40 concrete plants in Abruzzo, Marche, Tuscany, Lazio, Apulia and Molise.

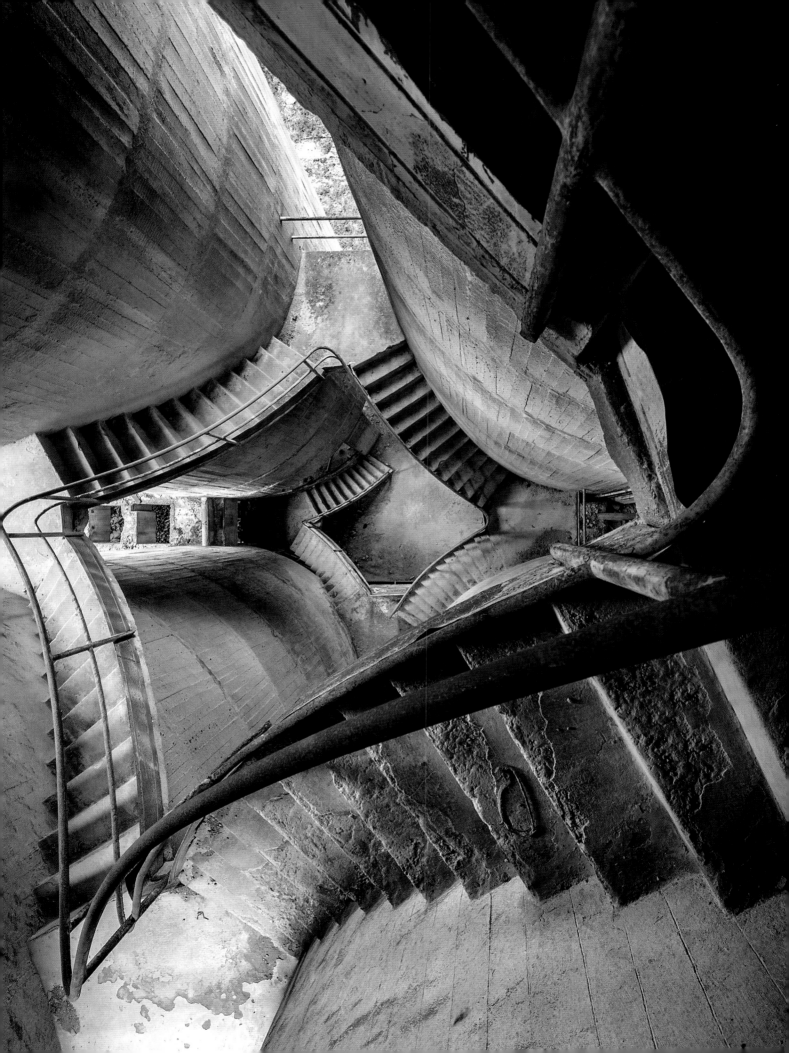

Castello Non Plus Ultra – *Tuscany*

The castle of Sammezzano is a masterpiece of excess and refinement. This proud place has hosted many personalities — Charlemagne himself stayed there while his son was baptised by the pope in 780 AD — but the one who had the most remarkable impact was Ferdinando Panciatichi Ximenes, the owner who transformed it between 1843 and 1889.

A politician, patron, lover of architecture, engineering and botany, this man of immense culture undertook to make the castle a true work of art reflecting his complex, tormented and megalomaniac personality. The magical atmosphere that permeates this labyrinth of myriad colours, the Moorish-inspired sculptures and grandiose salons (including the Peacock room, with its majolica-decorated walls), leaves no visitor indifferent.

The gardens are equally impressive: Ximenes conceived the "Historical Park" — 65 hectares of exotic plants, fountains and oaks that would prepare the visitor for the splendours waiting at the end of the path. But the castle was deserted by his descendants, looted during the Second World War, and transformed into a luxury hotel in the 1970s ...

Now awaiting the realisation of a project to transform it into a luxury resort with spa and golf courses, the building and its park remain once more abandoned.

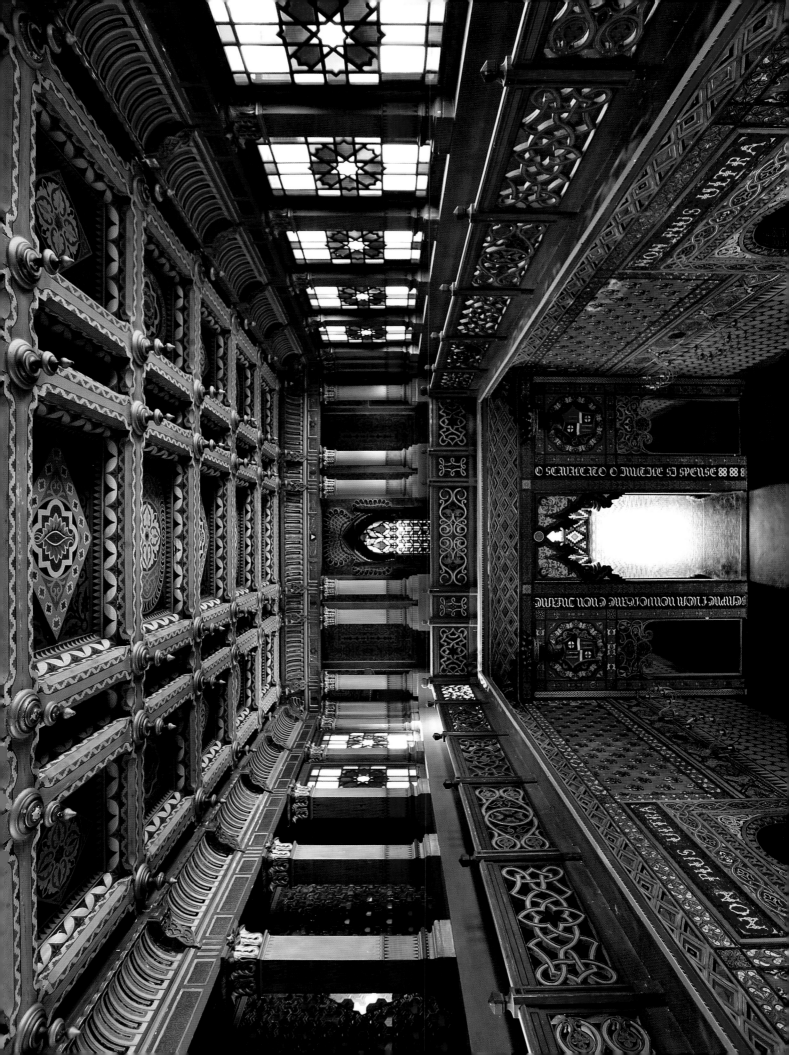

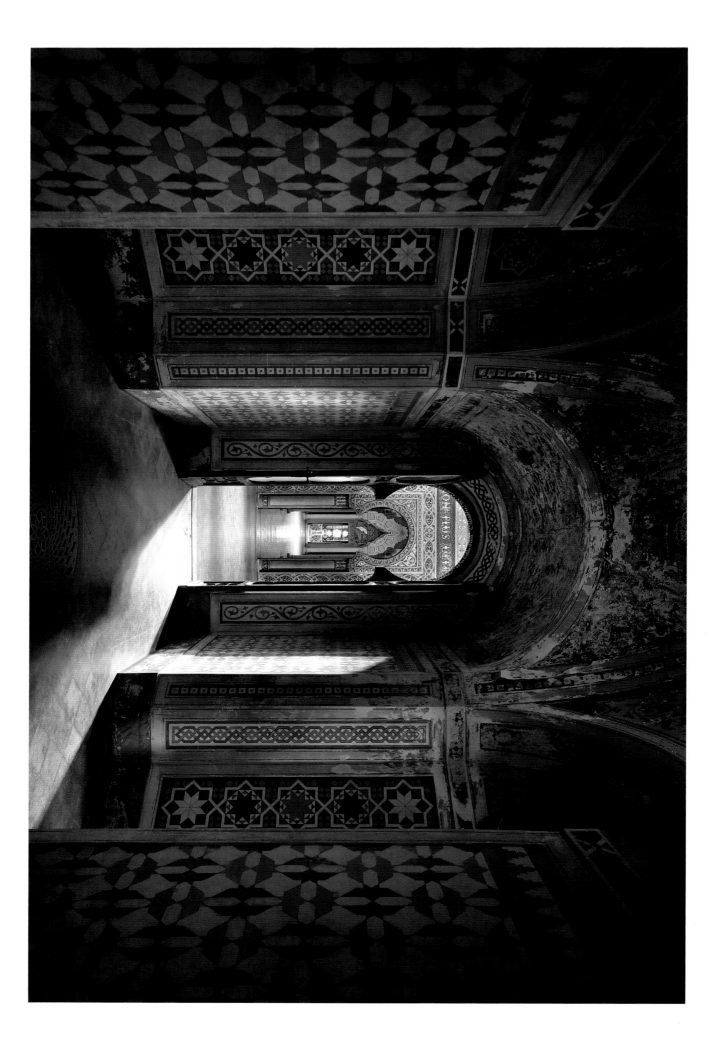

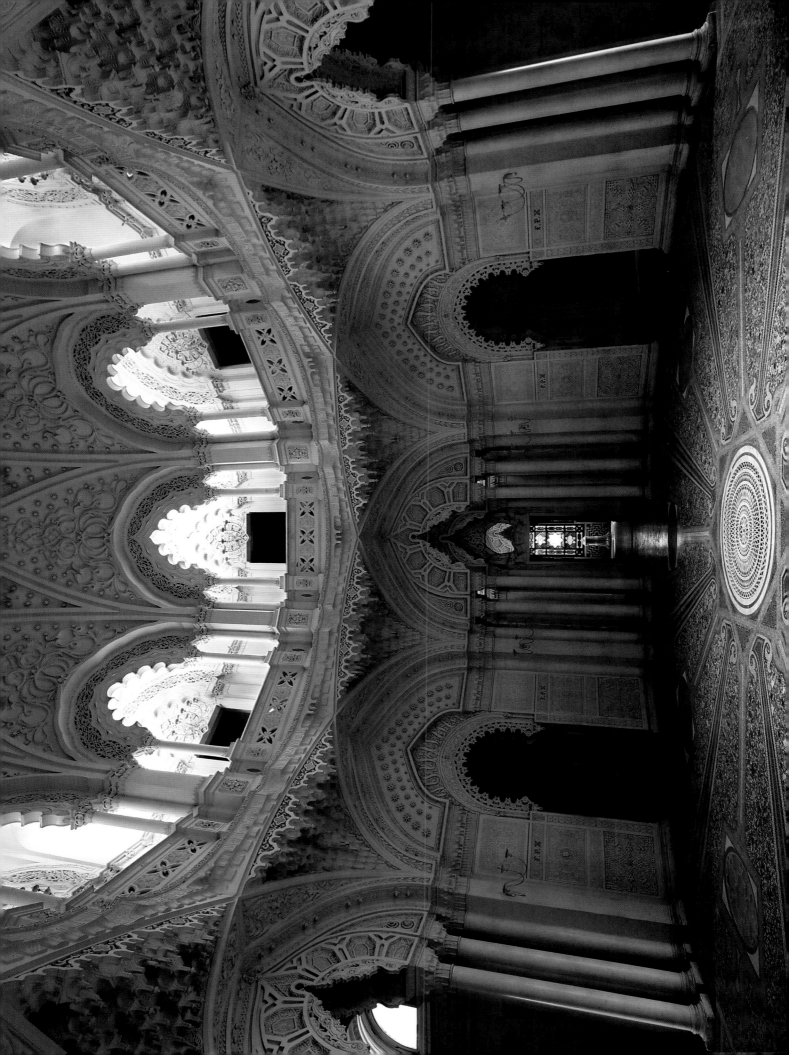

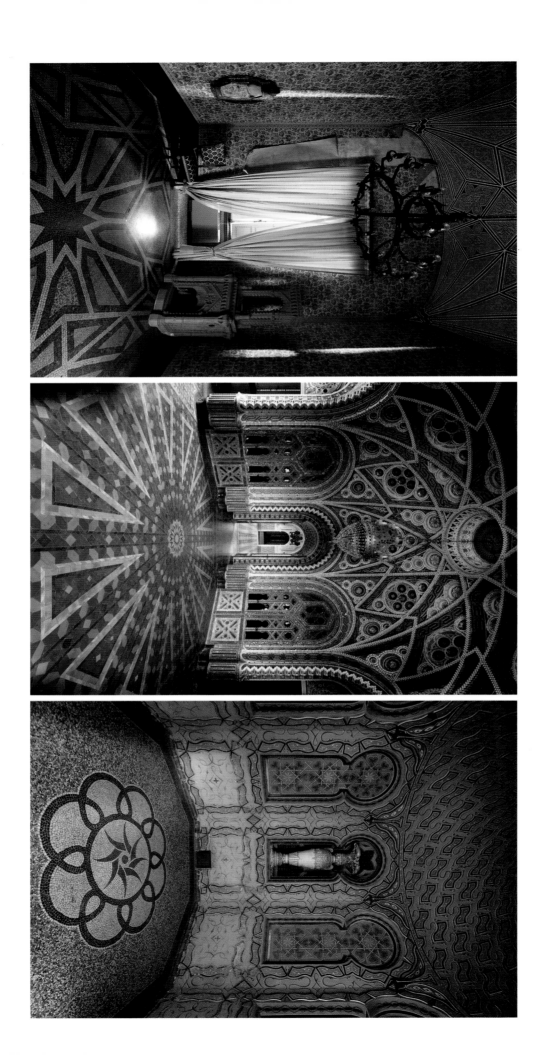

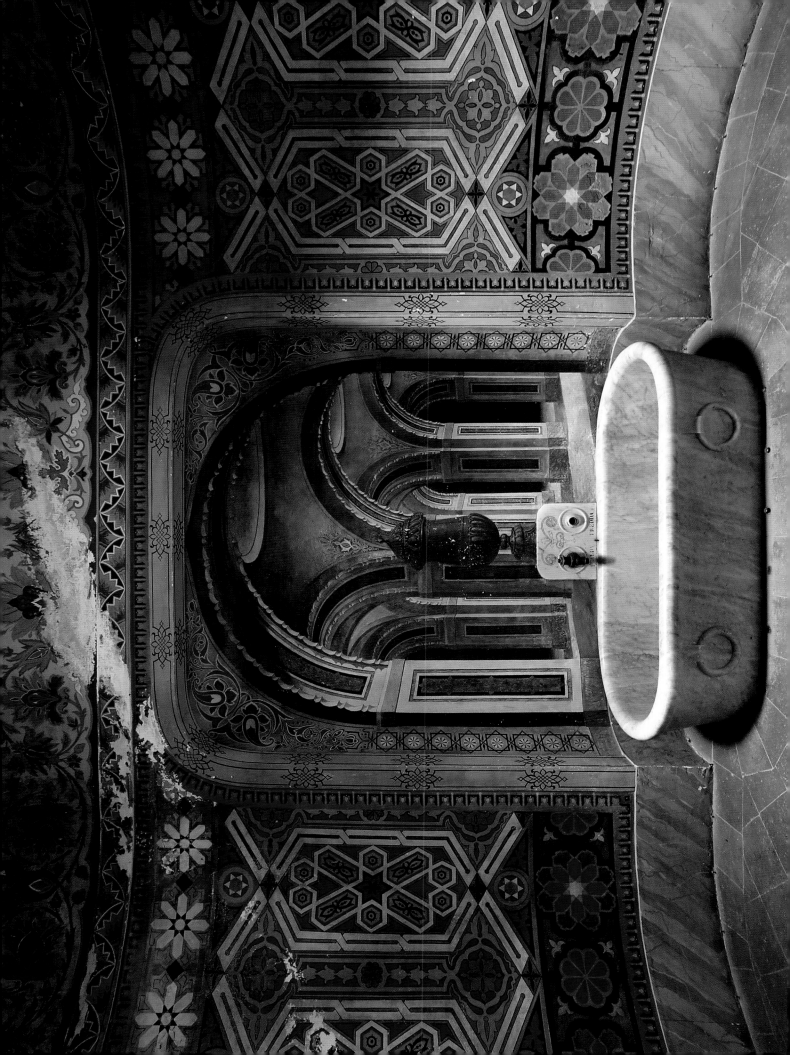

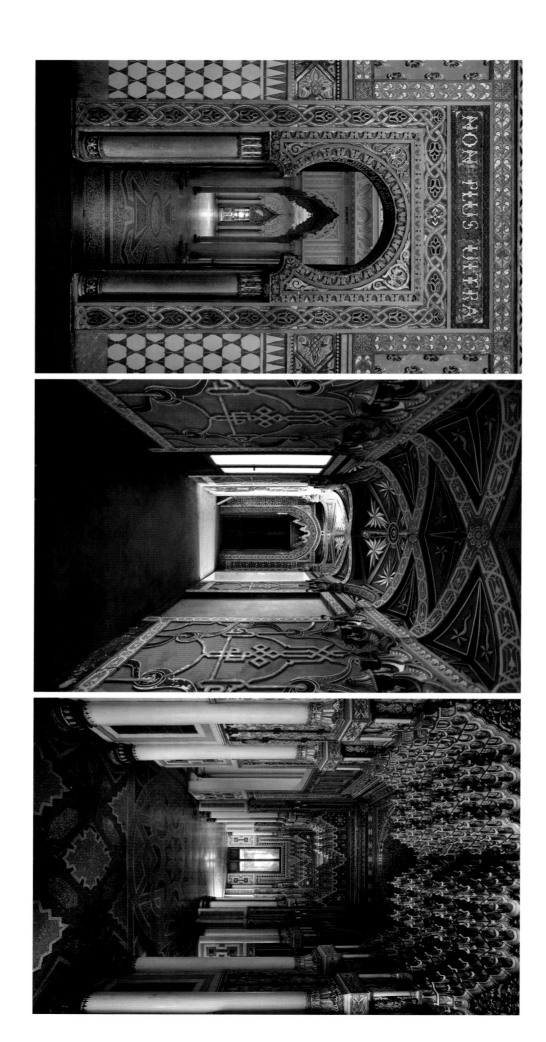

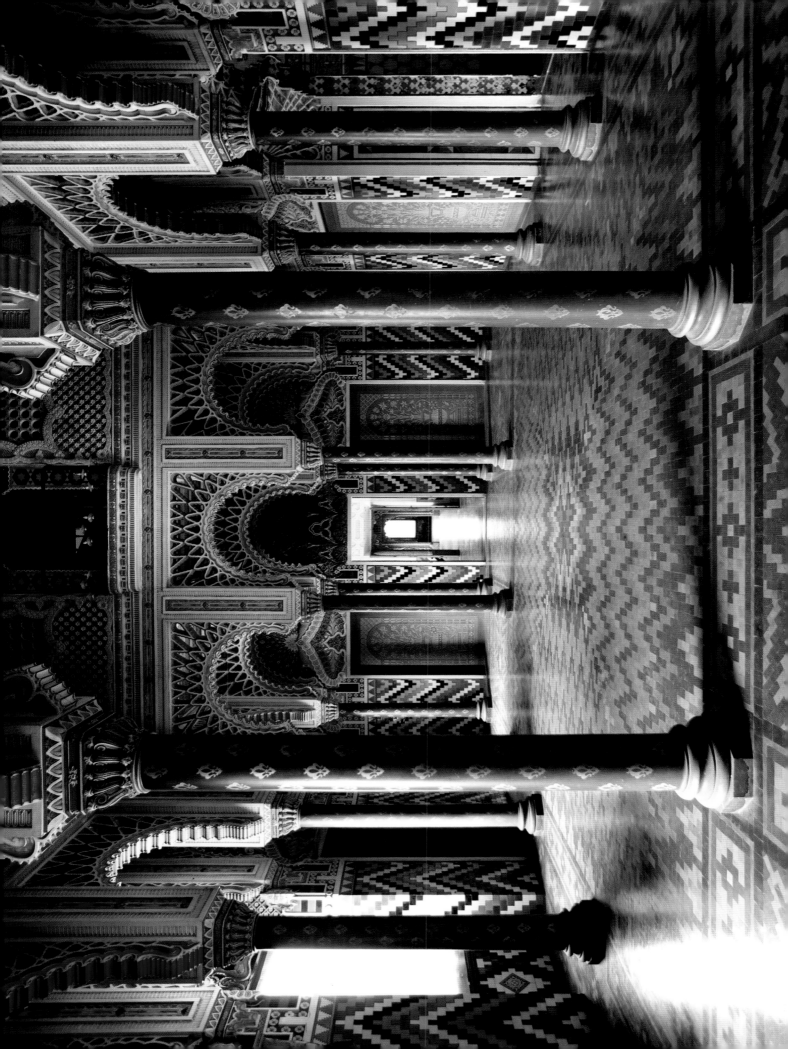

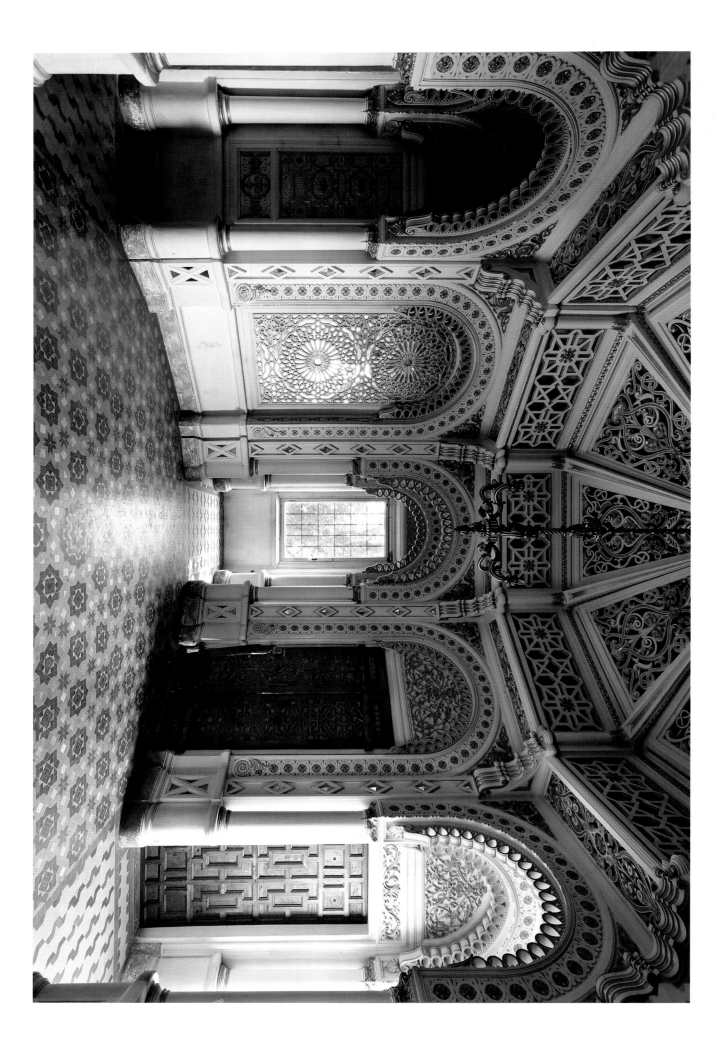

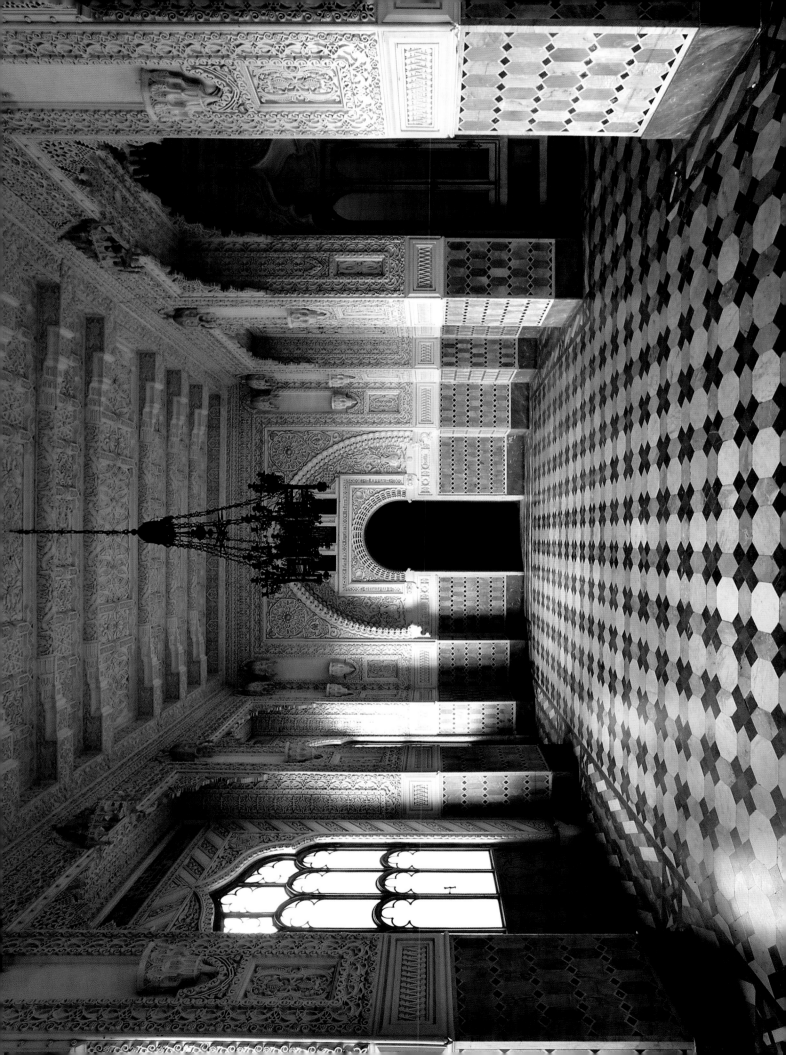

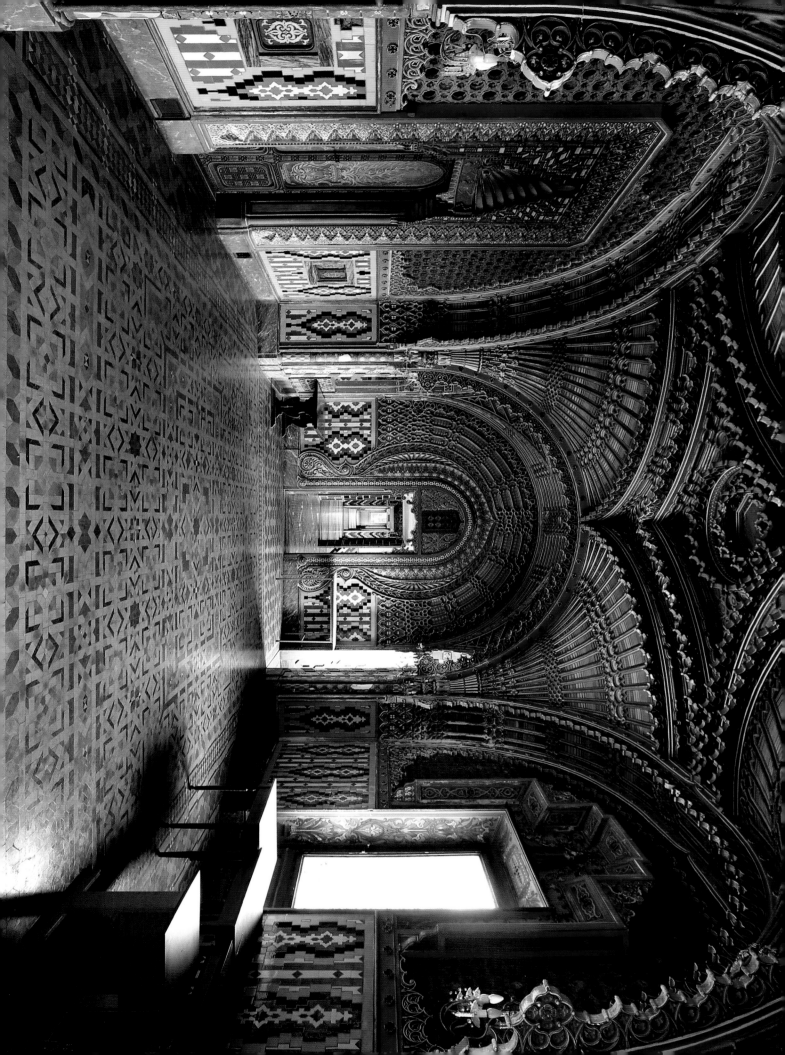

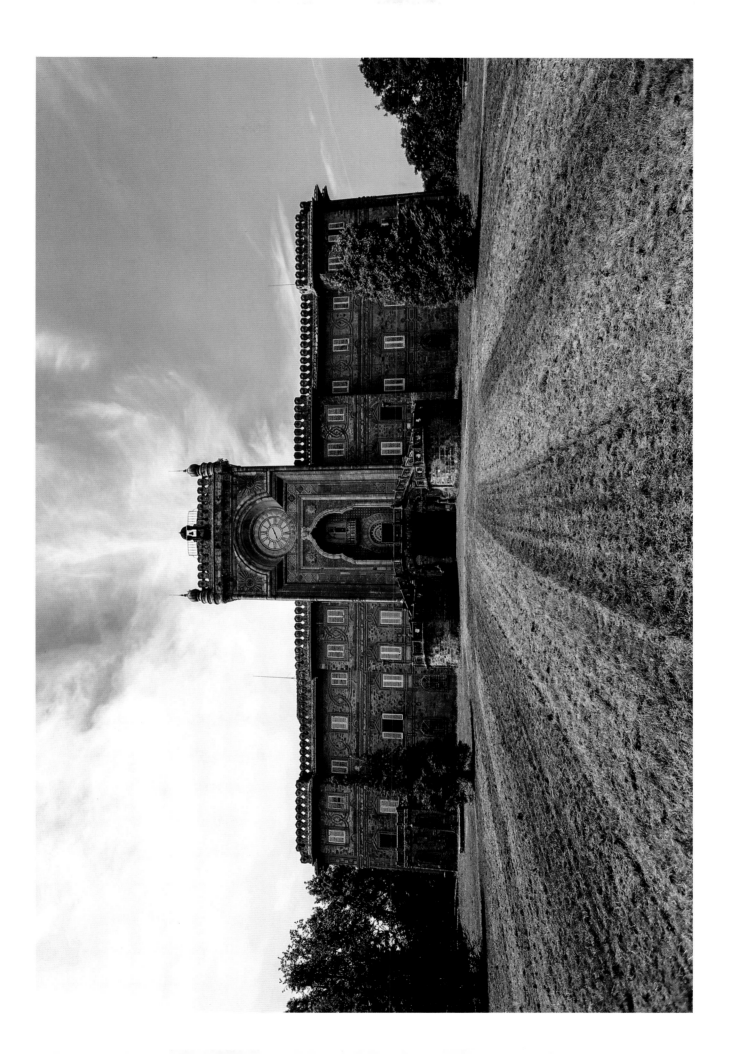

Villa della B – *Tuscany*

The villa, built on the ruins of an old military tower on the border of the influential areas of Florence and Pisa, was transformed into a Renaissance-style country house by the architects Michelozzo and Peruzzi.

Its successive owners were all born into famous rich families: the Pucci family, who had completed the defensive towers, as well as a large farm, a water mill and outbuildings to house workers; Count Fabio Orlandini; and finally Amadeo Del Vivo, a merchant from a family of aristocrats, who modernised the building and gave it its present appearance.

On the ground floor, the *trompe-l'œil*-themed rooms give the impression of Tuscan landscapes extending beyond the walls. The coat of arms of the Del Vivo family resides over the fireplace in the dining room. On the first floor the illusion continues with rural scenes incorporating Greek ruins. Frescoes can be seen in one room after another, sometimes hiding invisible doors leading to other rooms, all decorated with trompe-l'oeil draperies. On the walls of a large salon with a coffered ceiling are depictions of ancient games, perhaps the ancestors of tennis and golf. The farm and stables adjacent to the sumptuous villa have been converted into housing according to a detailed plan of recovery for the site, which could in turn be saved from abandonment.

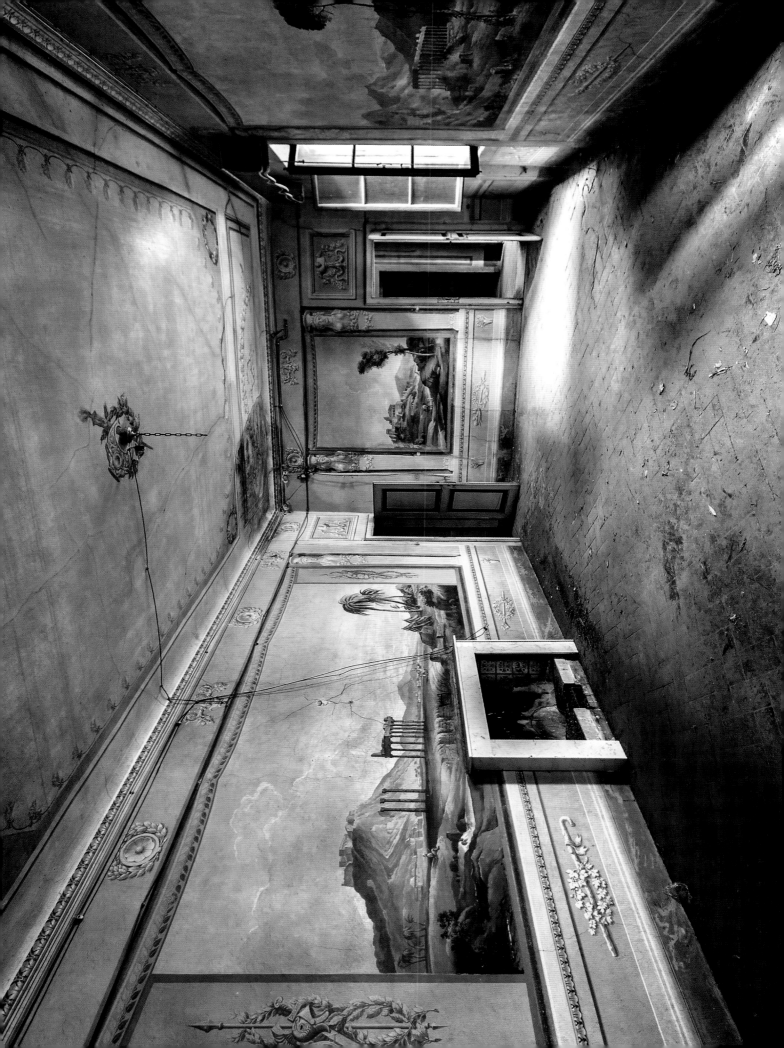

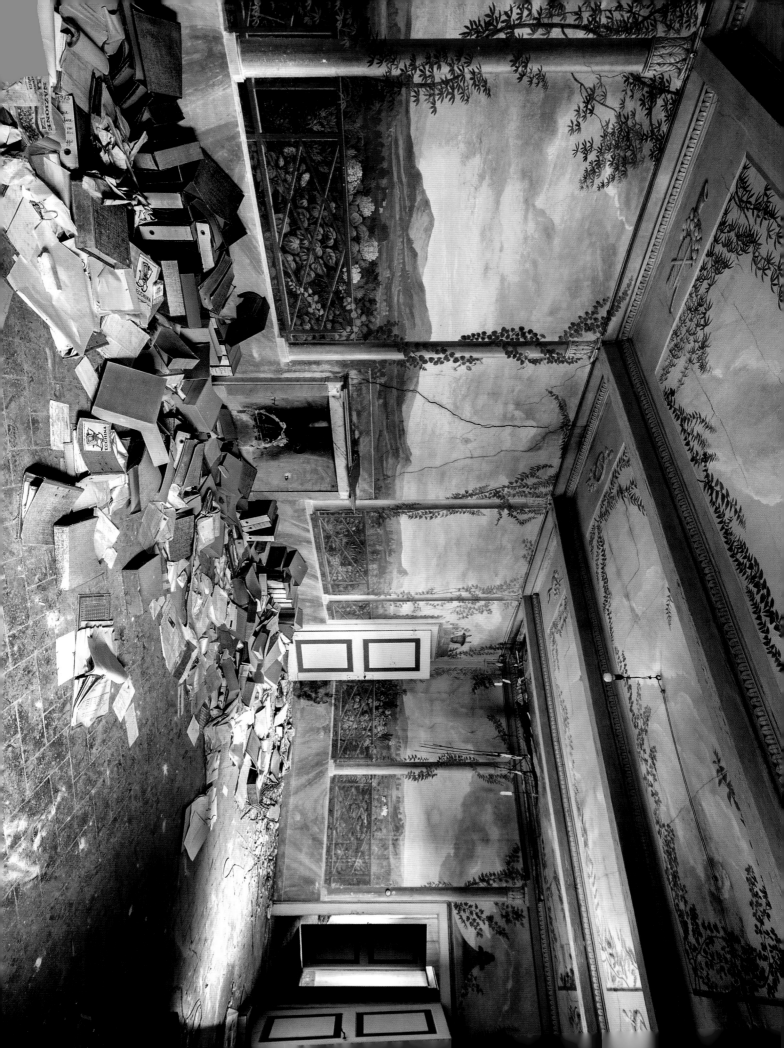

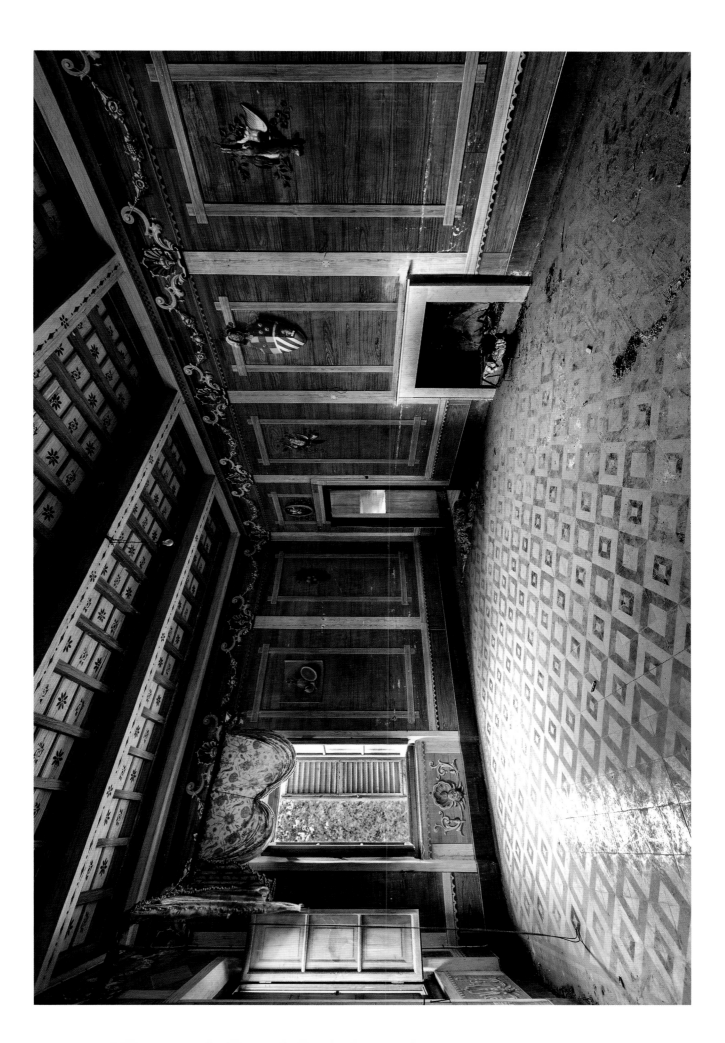

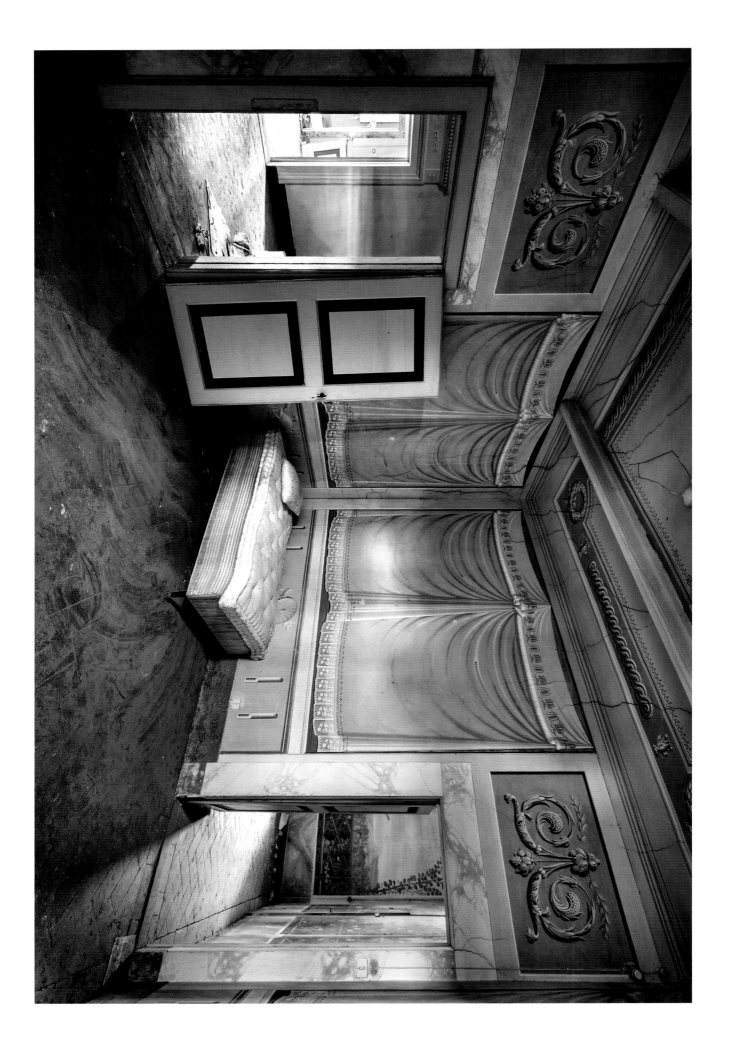

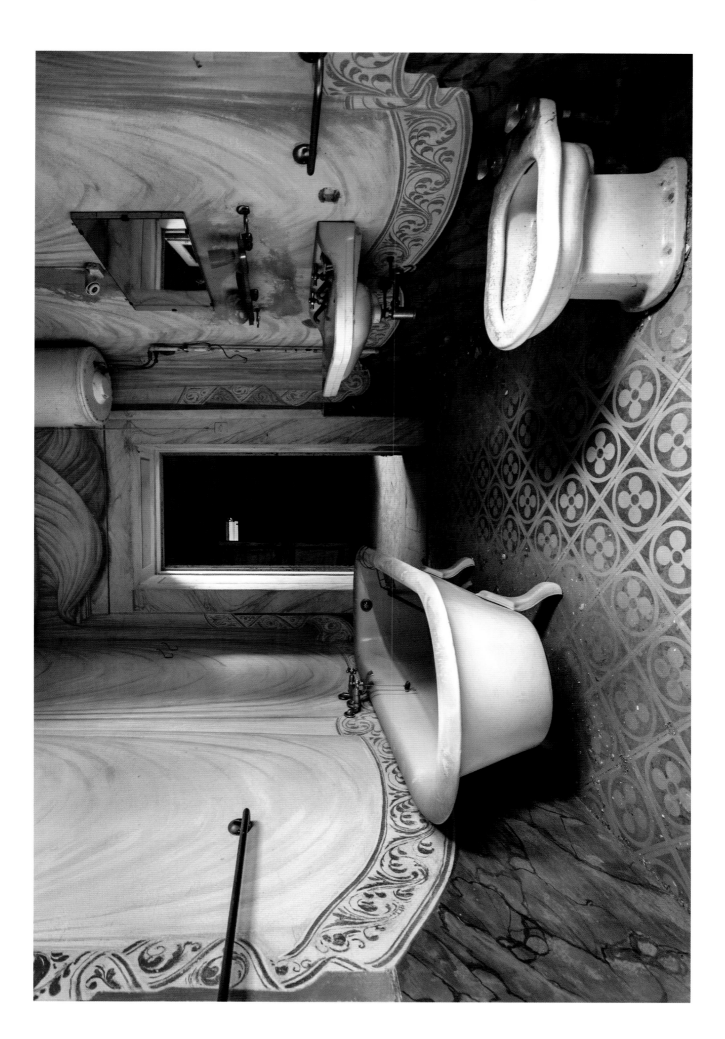

Villa di Sir Daniel d'Aragona – *Tuscany*

Built in 1900, this prestigious Liberty-style residence — an Italian interpretation of the fashionable Art Nouveau — extends over three floors. Beautiful red draperies meet elegant floral fabrics on a white background, very popular at the time for the refreshing touch they brought to an interior.

All the rooms bear the imprint of the family that has lived here for many years; from the pristine furniture to photographs and paintings that appear to follow the visitor who ventures in. The "limonaia" (a lemon treehouse) and the large garden seem ready to welcome the hosts and their guests.

How long will this beautiful and impressive villa remain as it is?

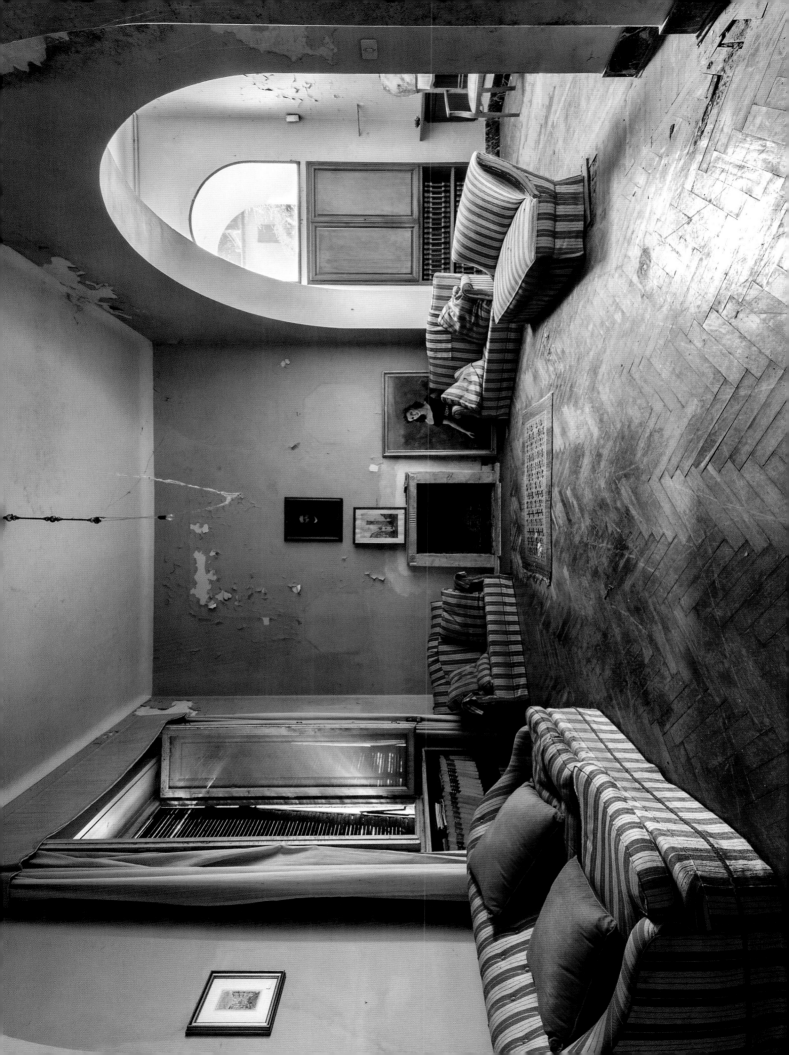

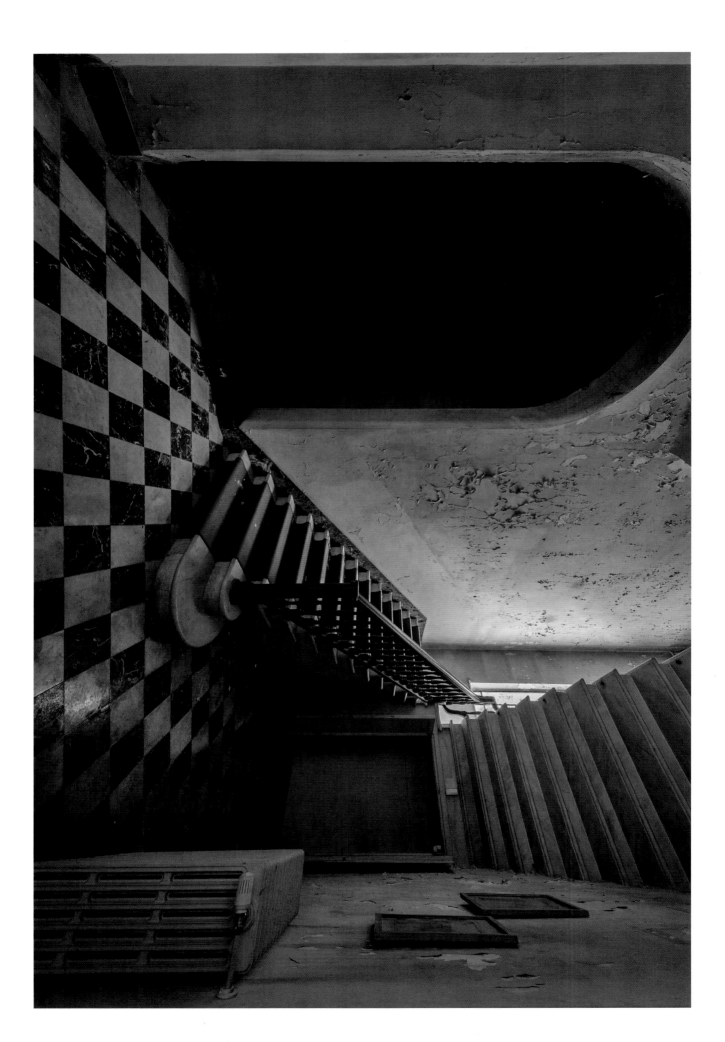

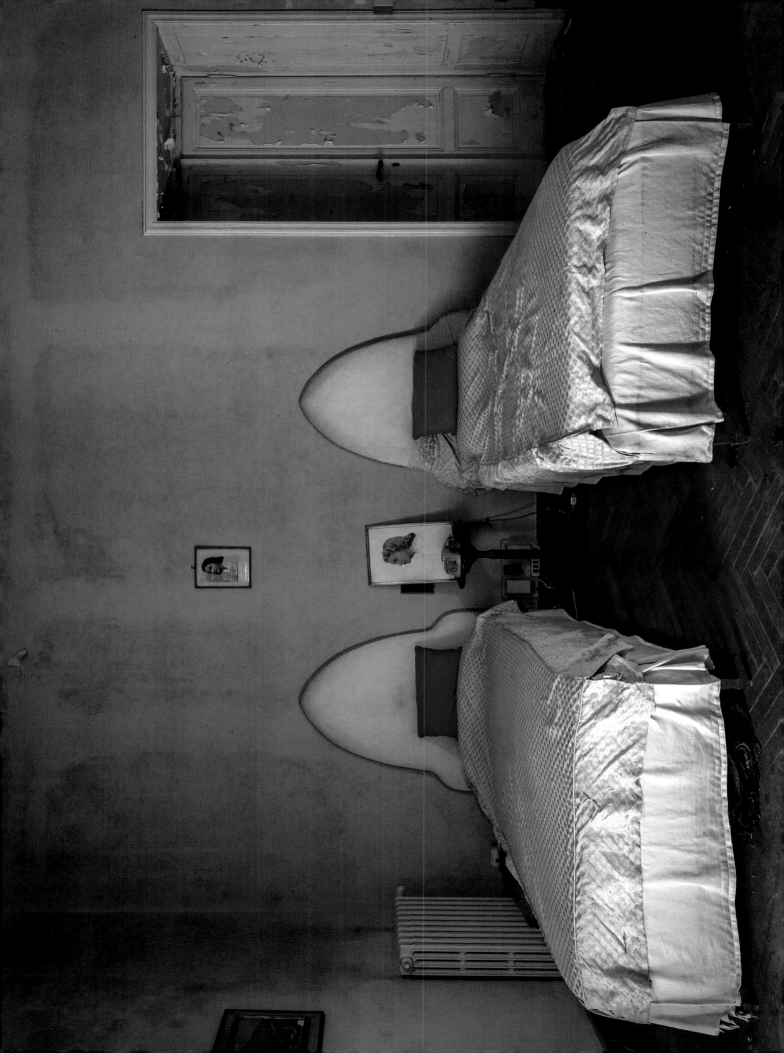

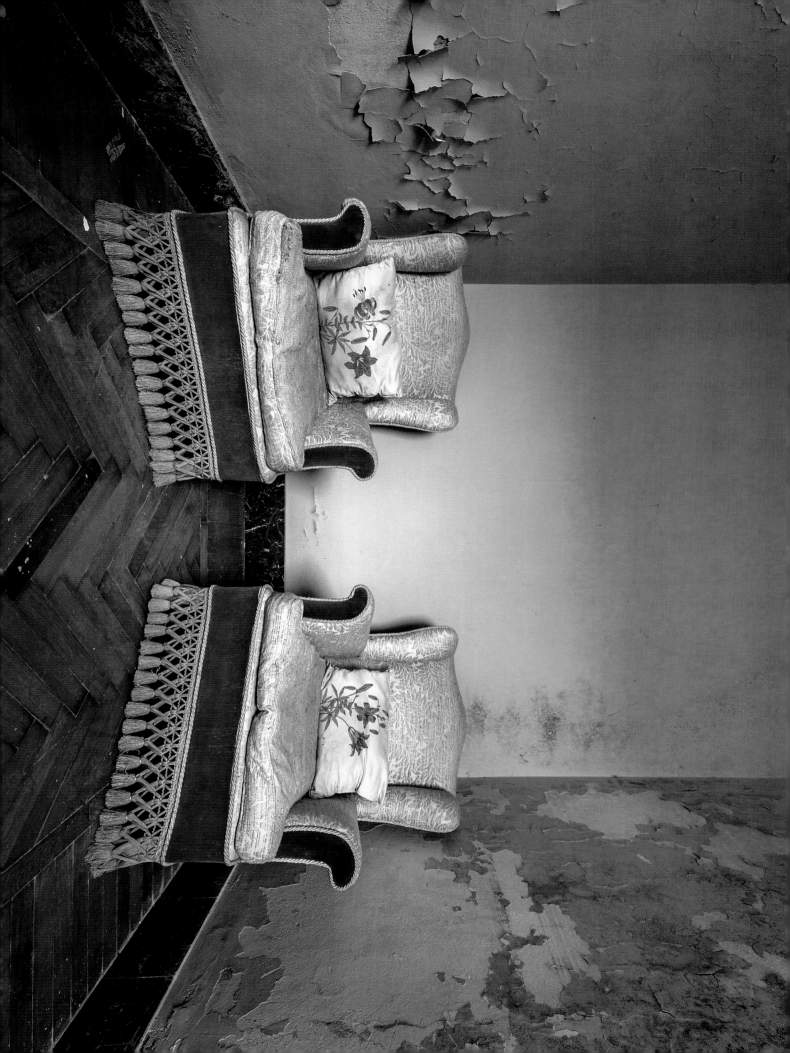

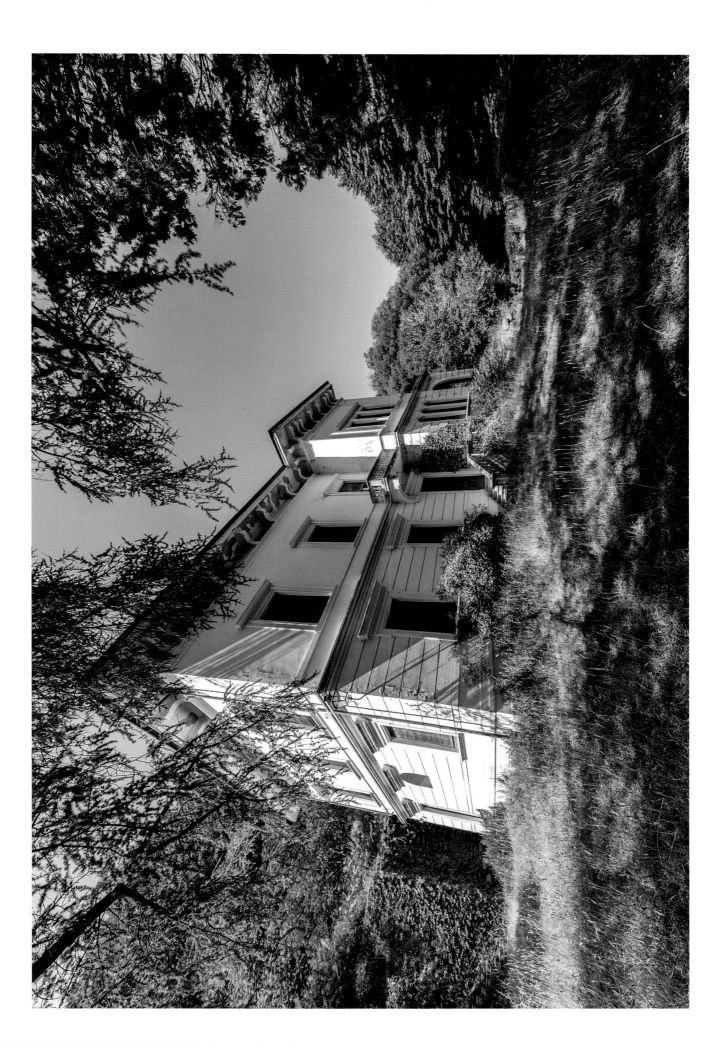

Villa F – *Tuscany*

It is surprising what people sometimes leave behind when they vacate their home. It is as if time had stopped and is now waiting patiently under a layer of dust for the inhabitants to come back and bring the place to life once more. In this beautiful villa, built in 1842, the luxurious furniture is still in place. And though the glassware and porcelain is gone, it is easy to imagine great refinement throughout the house.

However, it is on the walls that we find the most beautiful works of art. Once it was the paintings of the master Emilio Pisa Acerbi that hung here, but these were stolen by the German army during the Second World War (the paintings were later found and estimated to be worth a small fortune). Today it is the wonderful floral frescoes that attract attention and admiration. Typical Pisan landscapes are also represented, but, as in most wealthy Italian homes, flowers are valued more highly; not only are they a tribute to the beauty of nature, they also suggest the fortune of the owner — you must be rich to want to enjoy such an ephemeral pleasure!

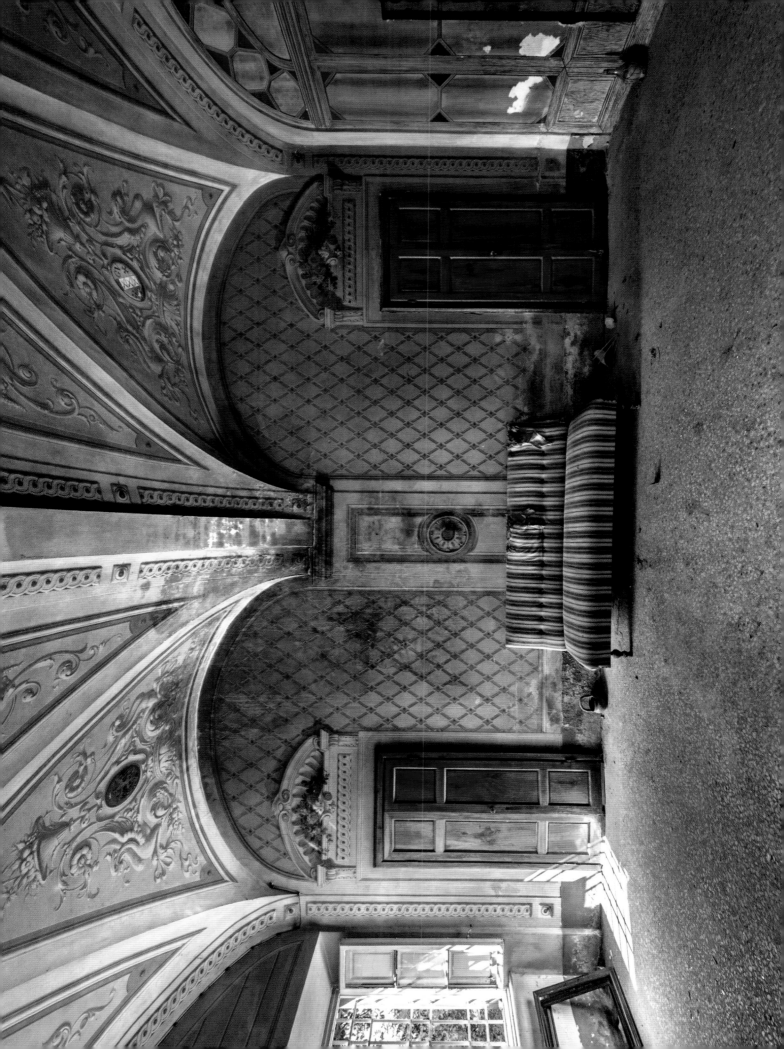

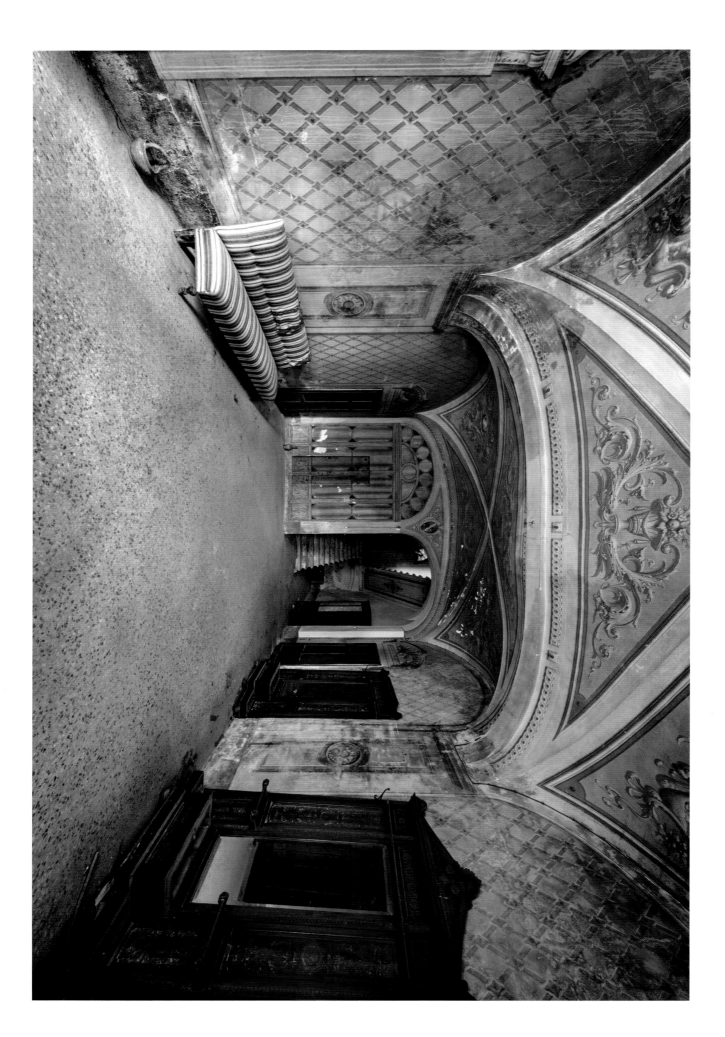

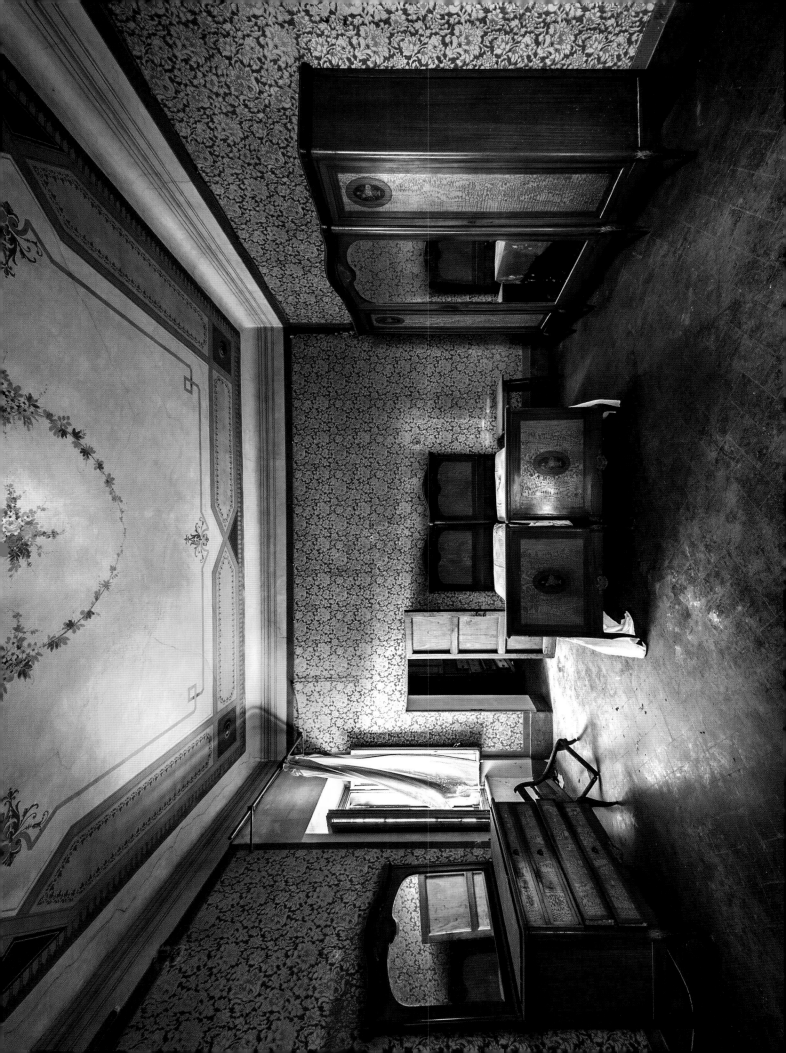

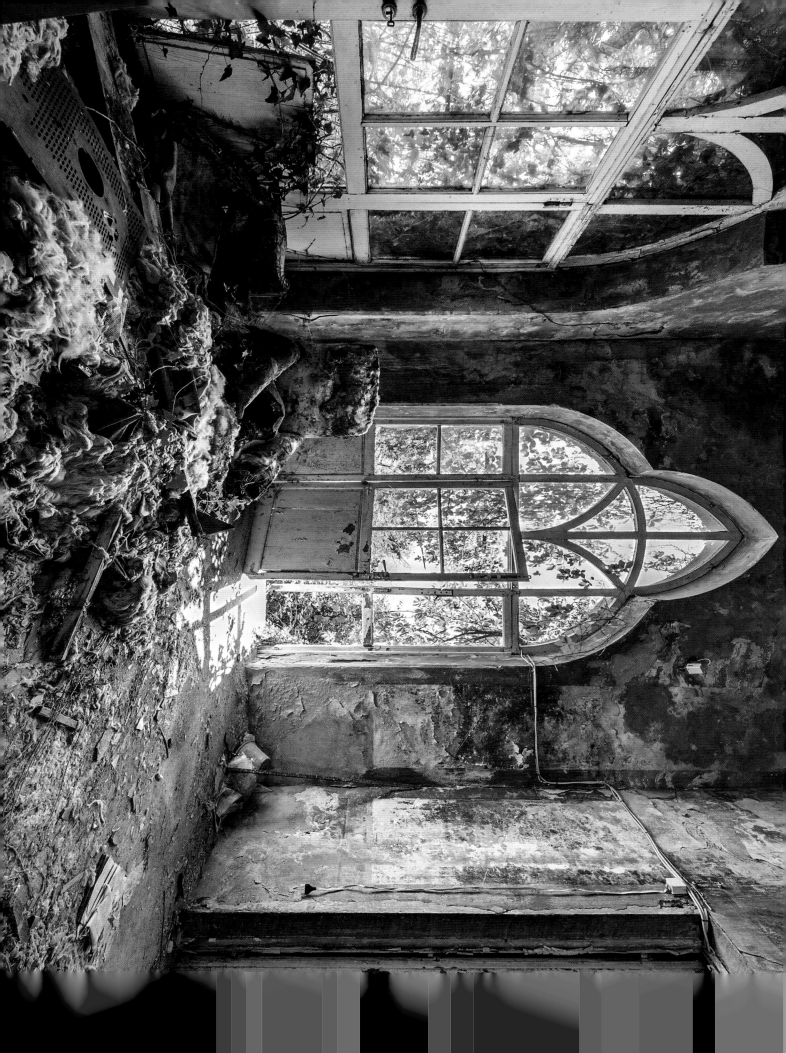

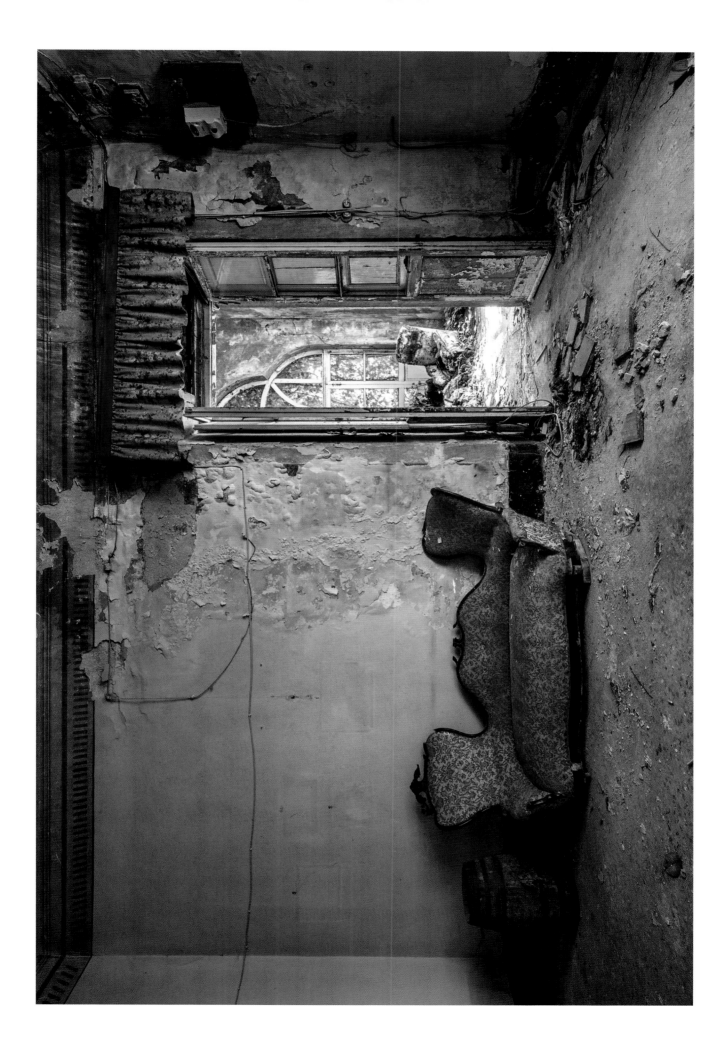

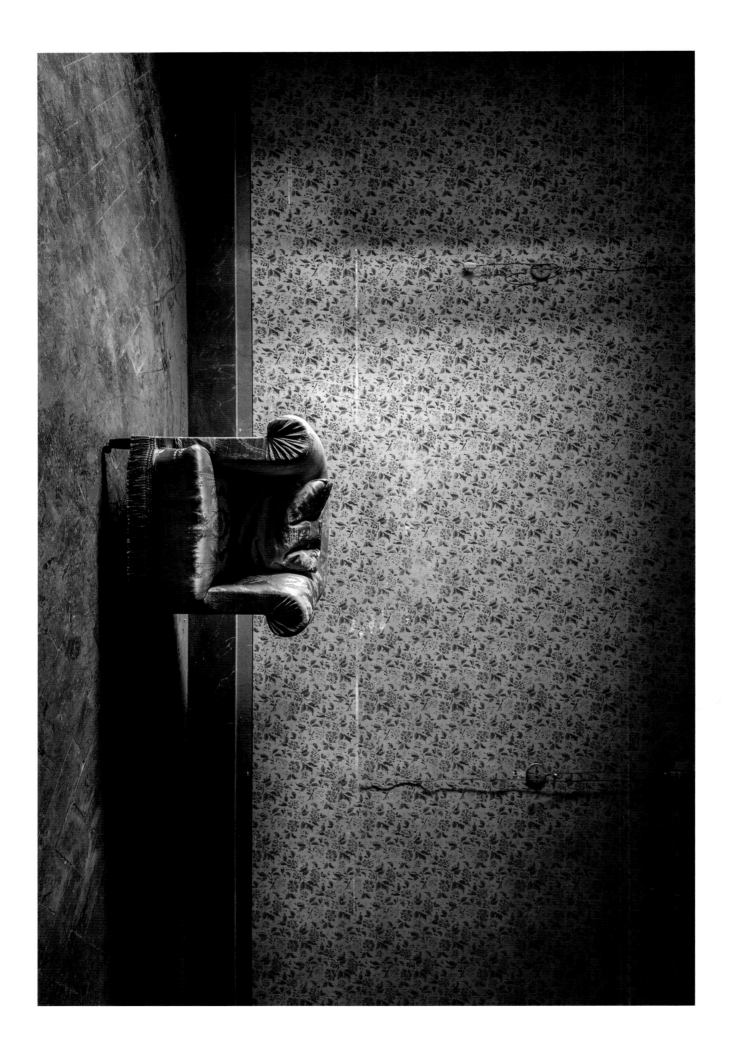

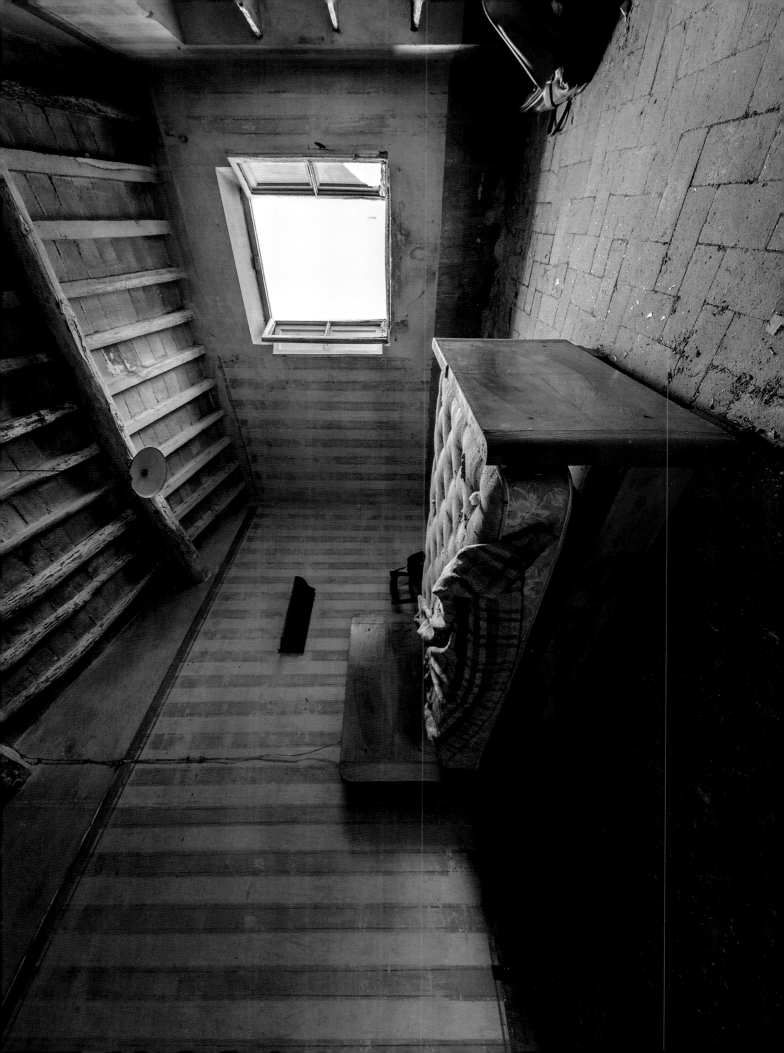

Villa Giovannina – *Tuscany*

On a hill stands an old seigneurial villa. Built in the 18th century by the Peruzzi, a very rich family of Florentine bankers and merchants, it was long the seat of a company specialising in the production of organic products in association with nearby farms.

The company produced grains, flour, pasta, extra virgin olive oil, beer and honey. And for several decades it even had classrooms installed in the villa where it hosted a detachment of the University of Agronomy of Florence.

However, the villa was eventually abandoned for more modern premises where it would be possible to fully invest in new technologies.

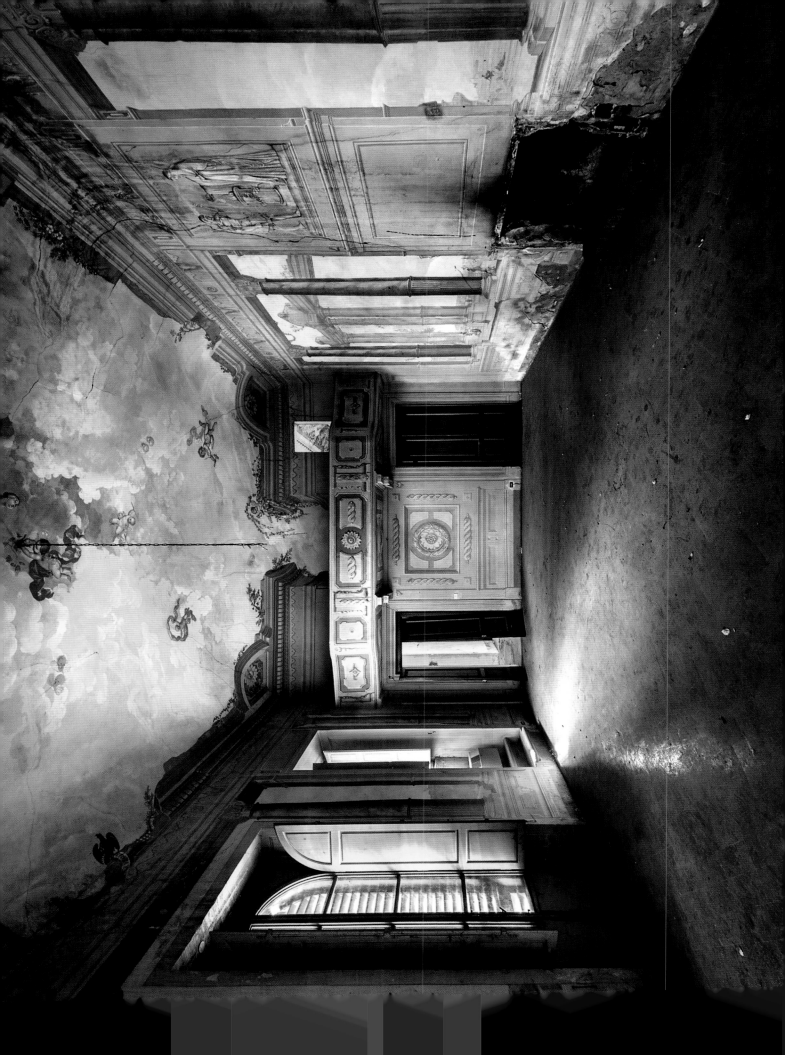

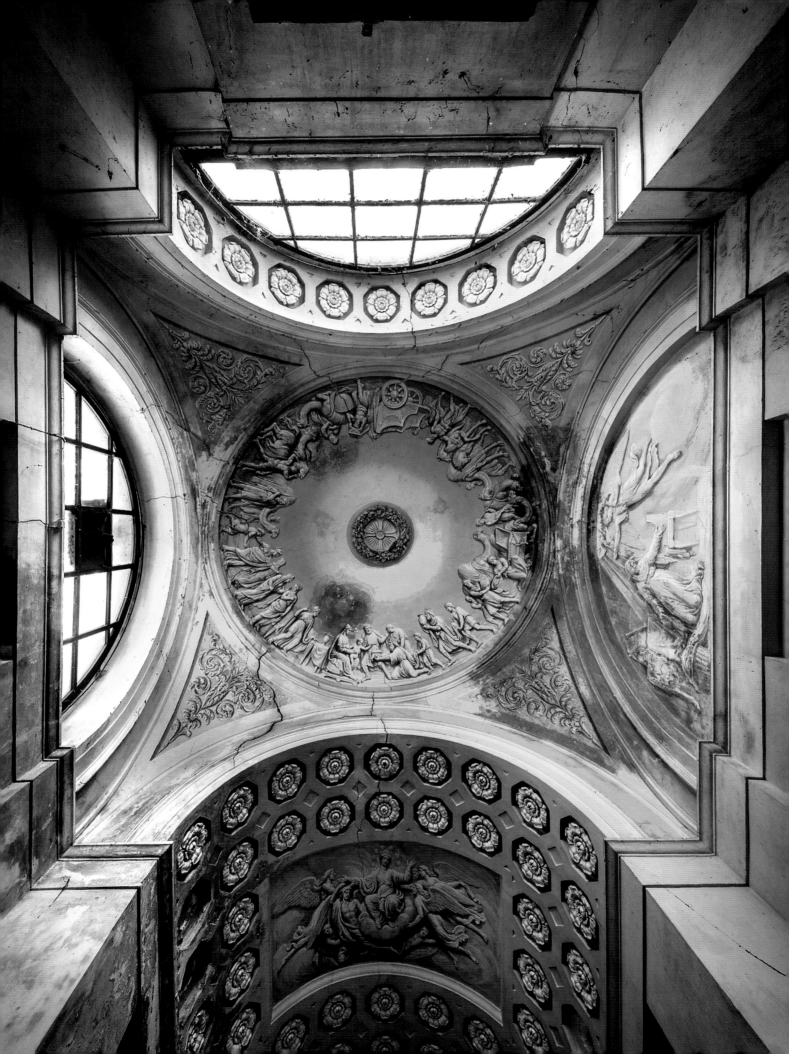

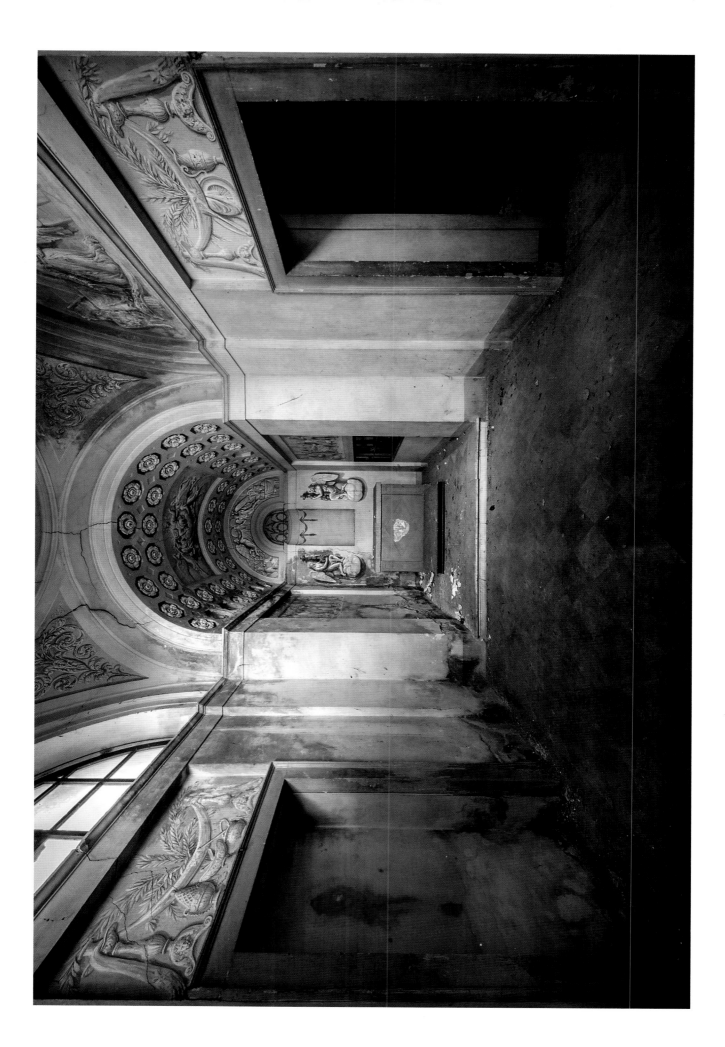

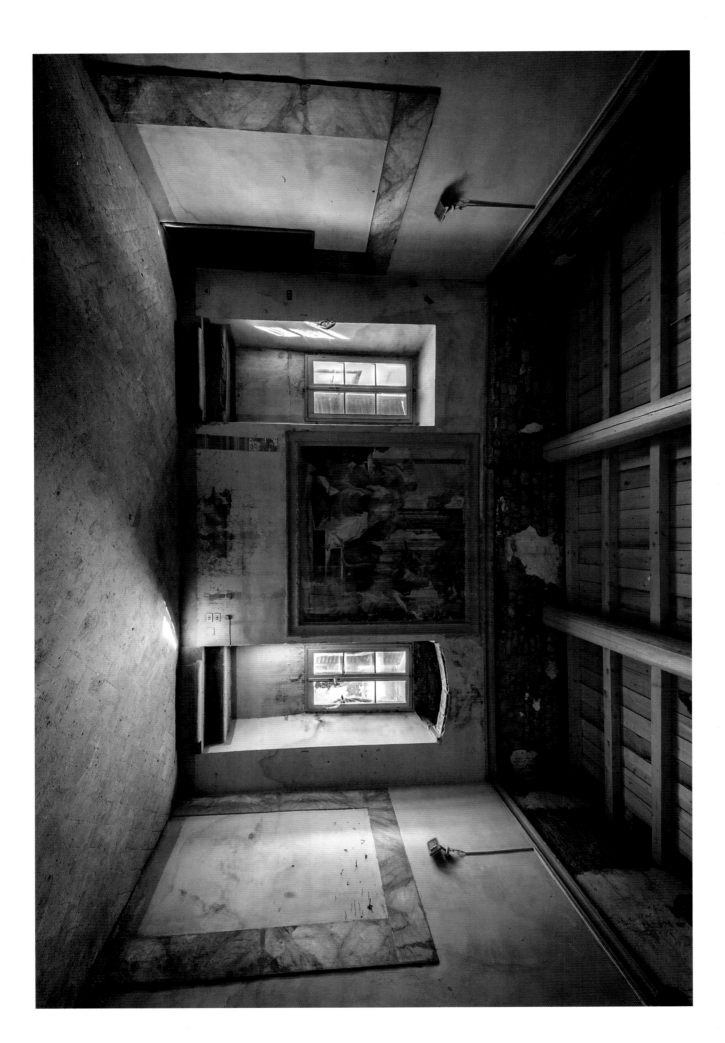

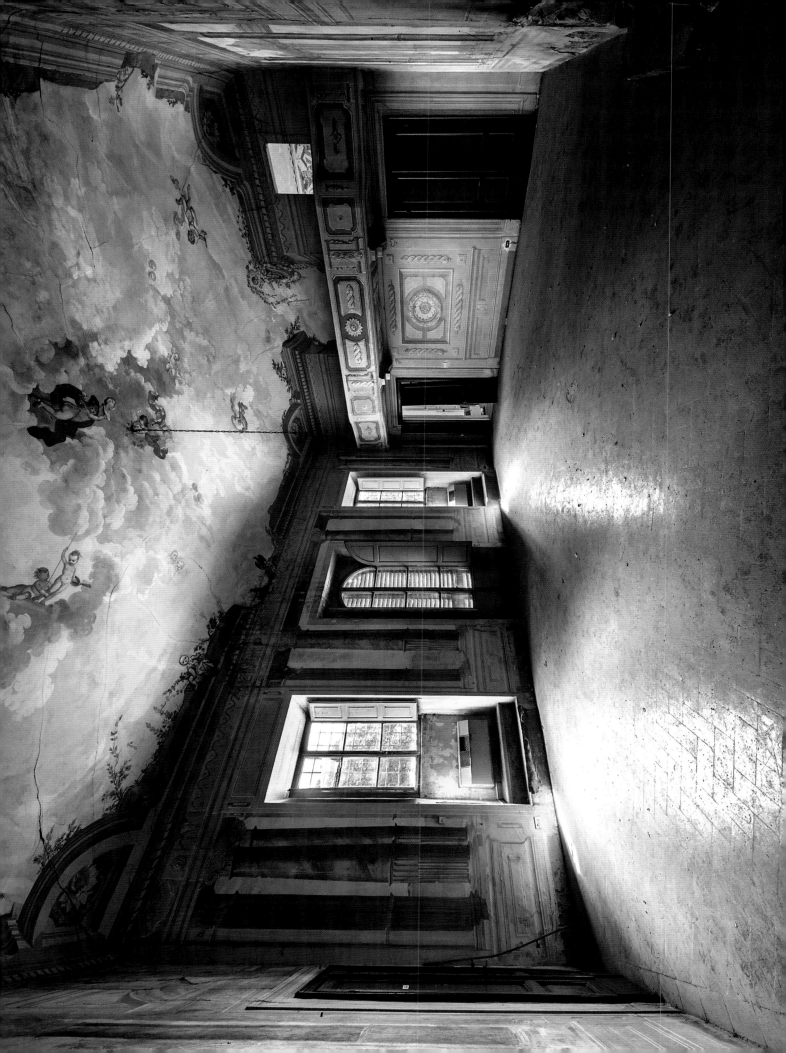

Villa Sbertoli – *Tuscany*

Purchased in 1868, this beautiful patrician residence, formerly known as "South Villa", was originally the family residence of a wealthy doctor working in the Pesaro asylum. However, it was transformed into a centre for the treatment of children suffering from psychiatric disorders. This transformation was undertaken, it is said, to allow one of the children of the family to be treated for a mental illness while remaining in an environment that was familiar to him, in the company of other children.

The large abandoned mansion bears the marks of this story. Though the architecture clearly suggests a luxury house, we still find telltale signs of its use as a hospital: bars at the windows, massive doors to close off the isolation rooms, etc.

However, we must remember that here, away from the nightmarish conditions of some asylums, children could enjoy the beautiful gardens maintained by the hostess, and play as much as they wished on a secure ground reserved solely for them.

During the Second World War, the house was used as a prison by the Nazis, and in the late 20th century the complex was bought by the province, which converted the villa into a provincial neuropsychiatric hospital.

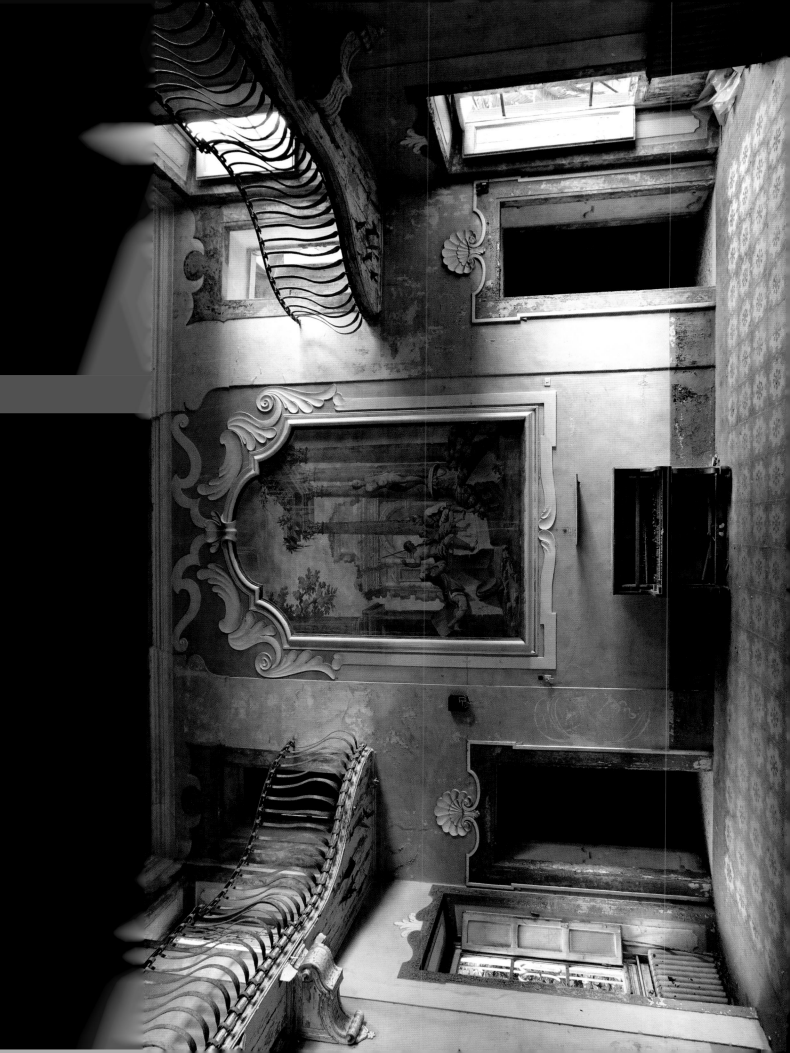

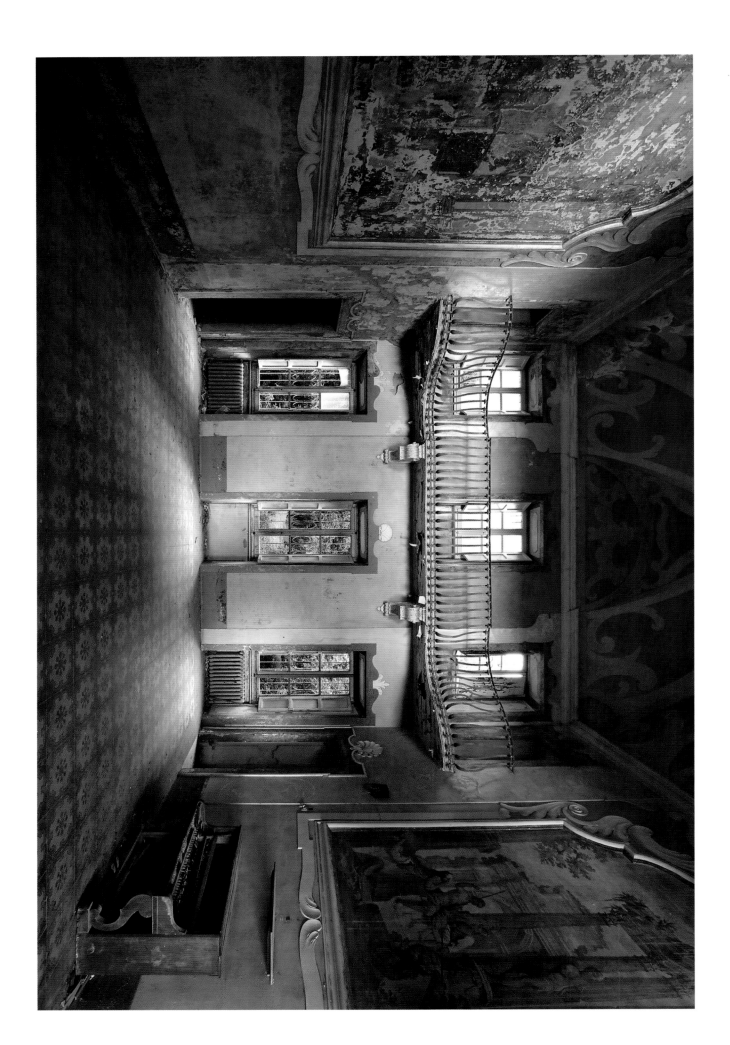

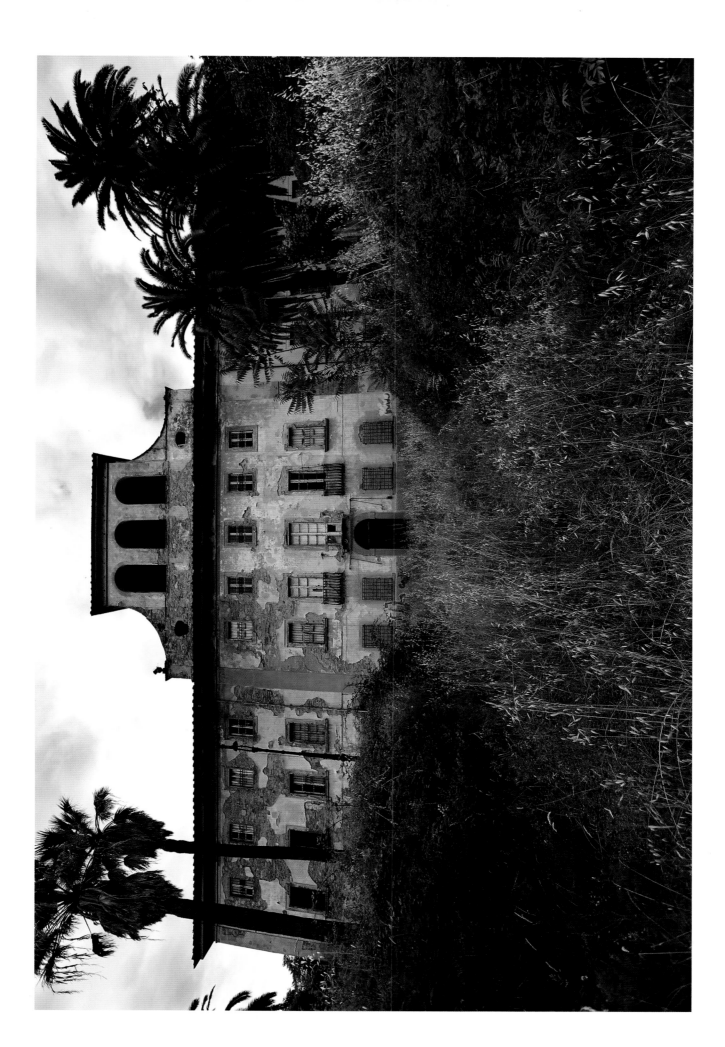

Castello M – *Umbria*

The castle, built on an island in the middle of a lake in the late 19th century, was commissioned as a summer residence by the Marquis of Vulci, a senator in Rome, administrator of the Roman railways, and a philanthropist who wanted a home worthy of a great lord.

Annexed to it is the existing medieval tower, the monastery and the huge church. The latter, with decrepit walls in blue tones, can even accommodate a condominium.

According to local rumours, the house had lounges hosting many art collections, a gallery featuring portraits of ancestors and armours, a salon decorated with tapestries and Murano chandeliers, and a billiard room where important issues were discussed. Beautiful paintings and delicate stucco decorations can still be seen on the walls of the salon, while carved woodworks also catch the eye … and the dust.

The Marquis's daughter taught the daughters of the local fishermen the secrets of the precious art of lace making, which still flourishes throughout the region. But in the second half of the 20th century, their heirs could no longer afford to live there and had to move.

The castle is seeking a buyer, in case you are interested!

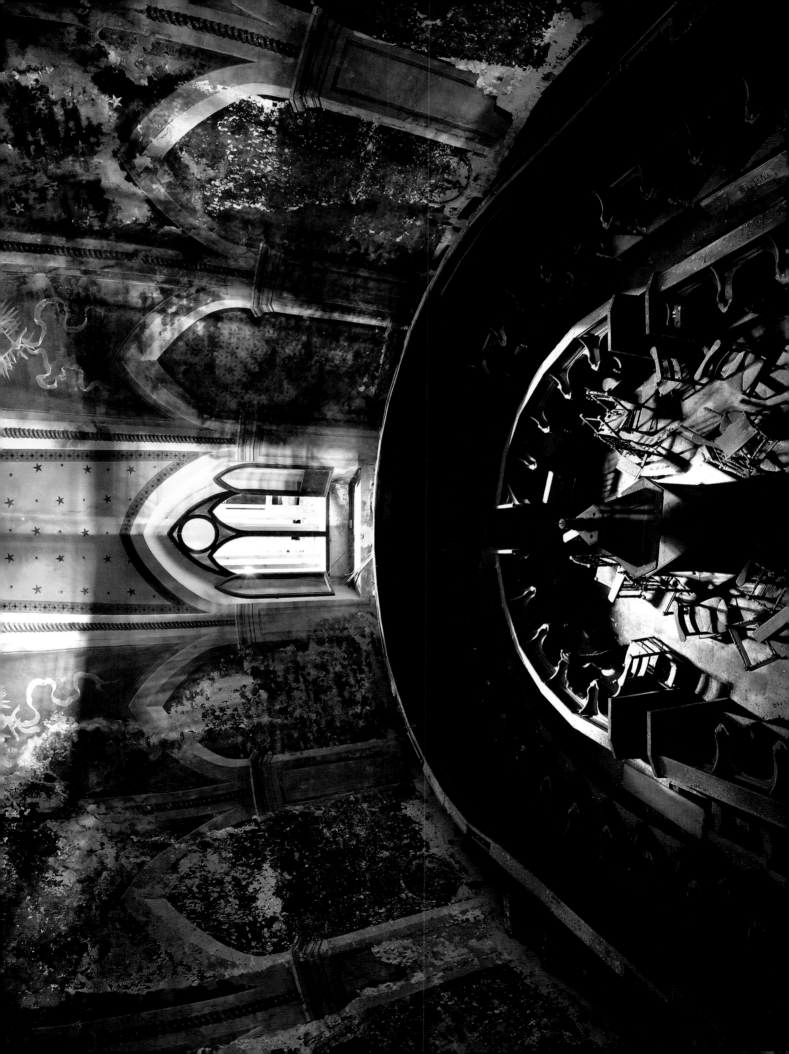

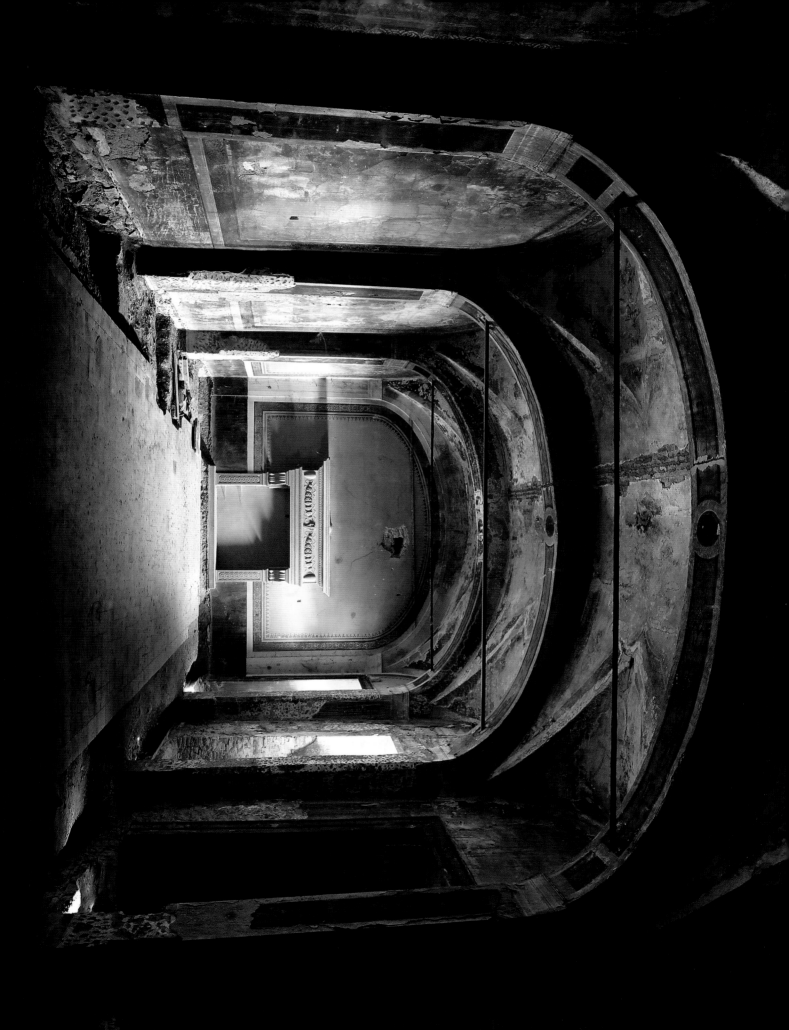

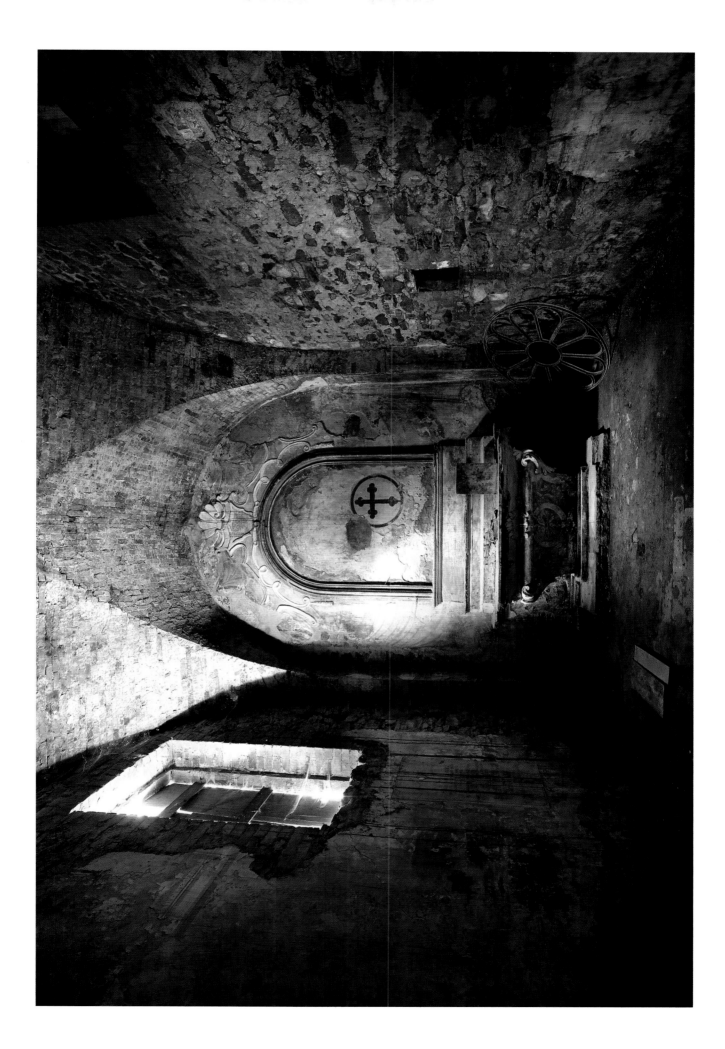

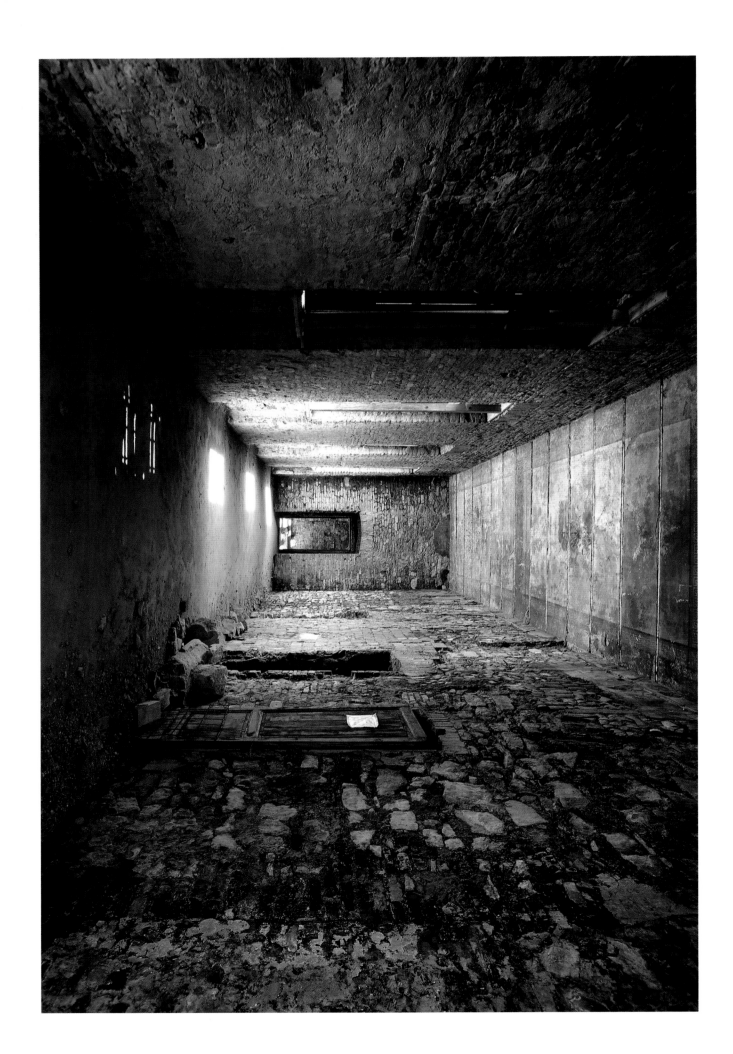

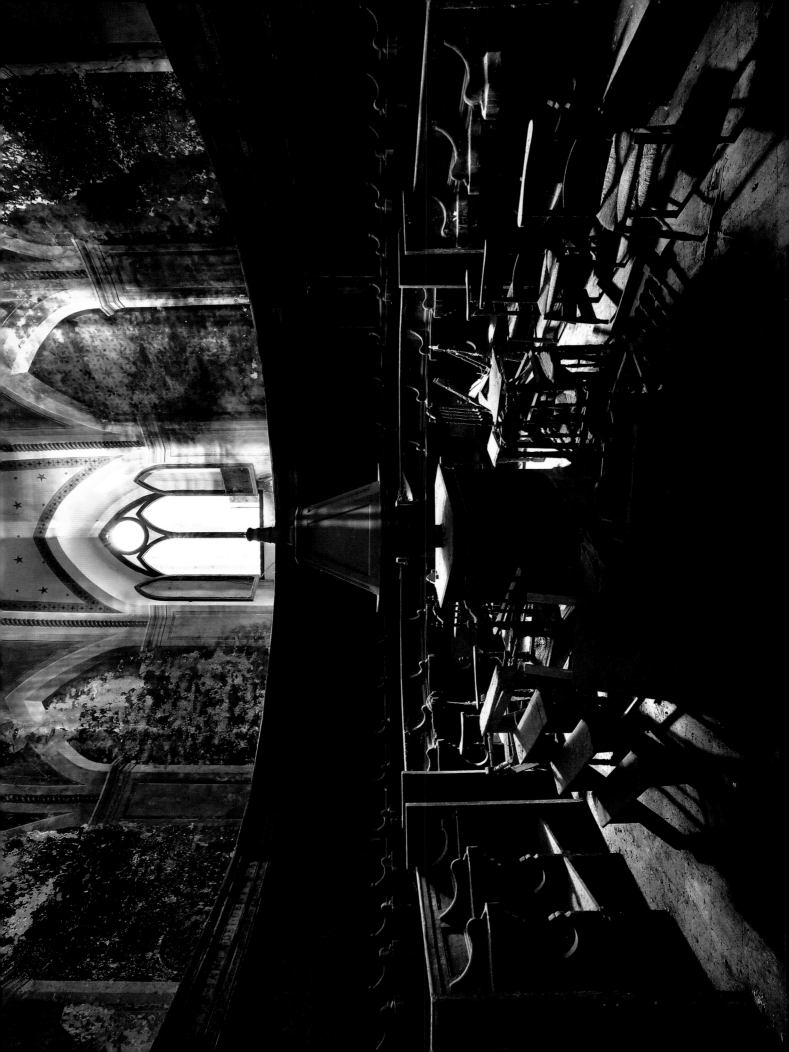

Power plant – *Umbria*

Italy is one of the pioneers in hydroelectric power generation. The first plants were built in the late 19th century, located mainly in the Alps and Apennines, near the major rivers.

In the 1950s, hydropower accounted for 20% of the energy produced throughout Italy.

Energy requirements increased considerably in the middle of the 20th century and other more efficient production units were created, including nuclear power plants. But with greater ecological awareness, and with Italy being located within a seismic zone, which drastically increases the risk of nuclear accidents, the government, under the pressure of a referendum held in 1987, decided to no longer build nuclear power plants and to close those in operation until then.

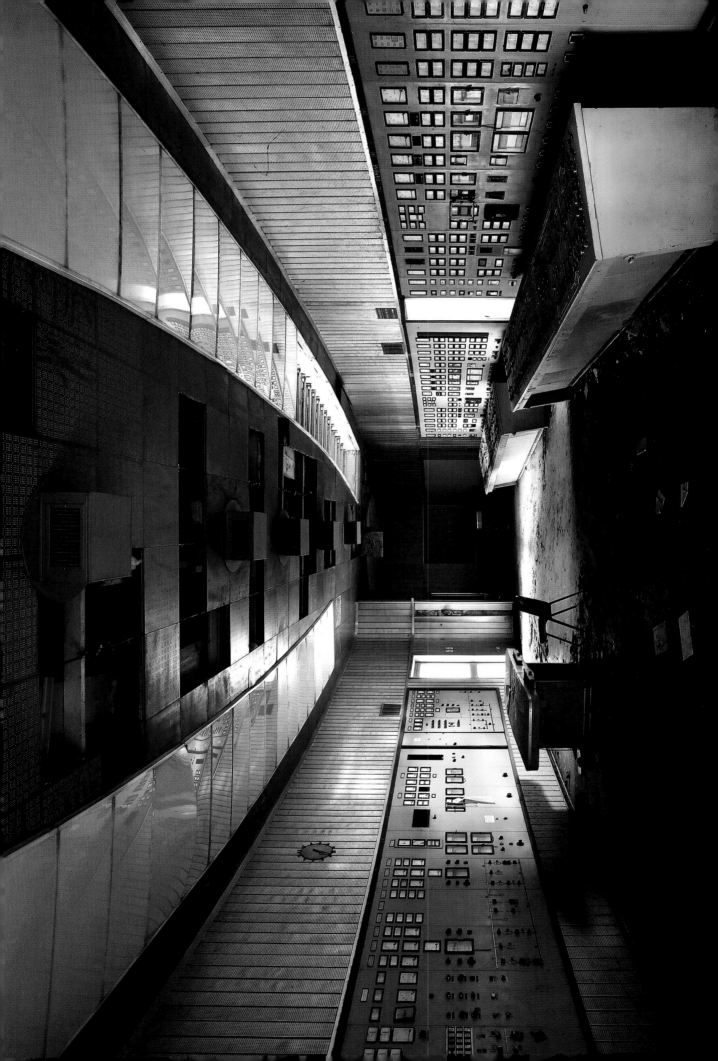

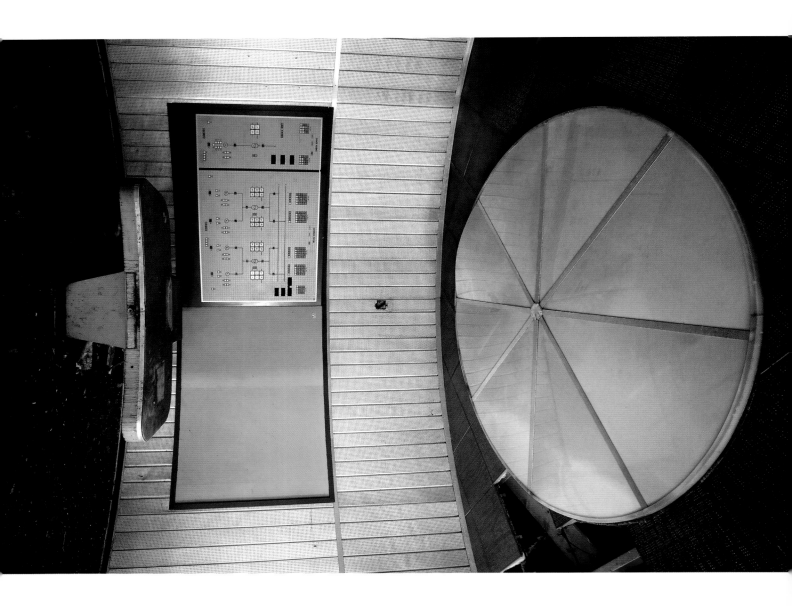

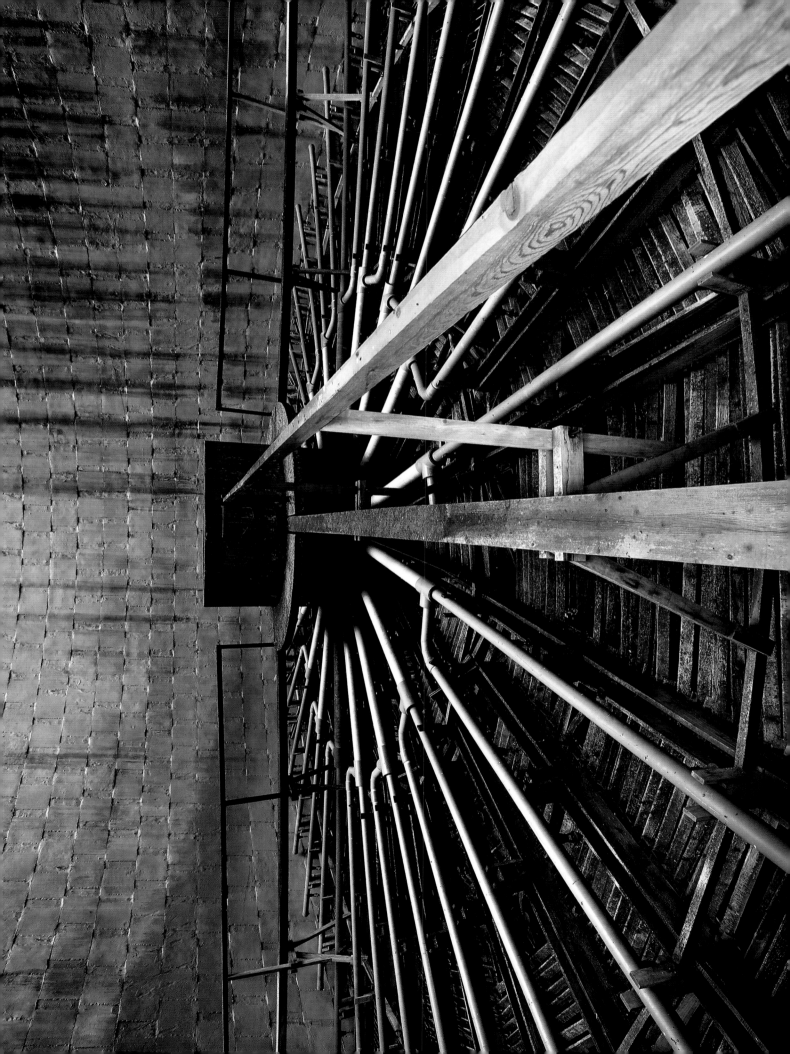

Galleto power plant – *Umbria*

The Galleto power plant, built between 1924 and 1925, was the first major construction of the national hydroelectric programme, and was of paramount importance in the industrialisation of Italy.

It was the exploitation of the waters of the Velino River that produced electricity, upstream of a mobile dam, connected to the nearby lake, which was inaugurated with great pomp in 1929. In 1931 the plant could supply up to 146,000 kW thanks to four groups of turbo-alternators.

During the Second World War, Allied forces tried more than once to destroy the plant. It was eventually the Germans who blew it up as they retreated, although by the end of 1945 the four production units had already been restored.

In 1962 the power plant was nationalised and was bought in 2001 by the ENDESA group to become a colossal enterprise.

Following the construction of a new and imposing modern power plant, the turbines, the V-shaped control room and the obsolete Galleto buildings were abandoned.

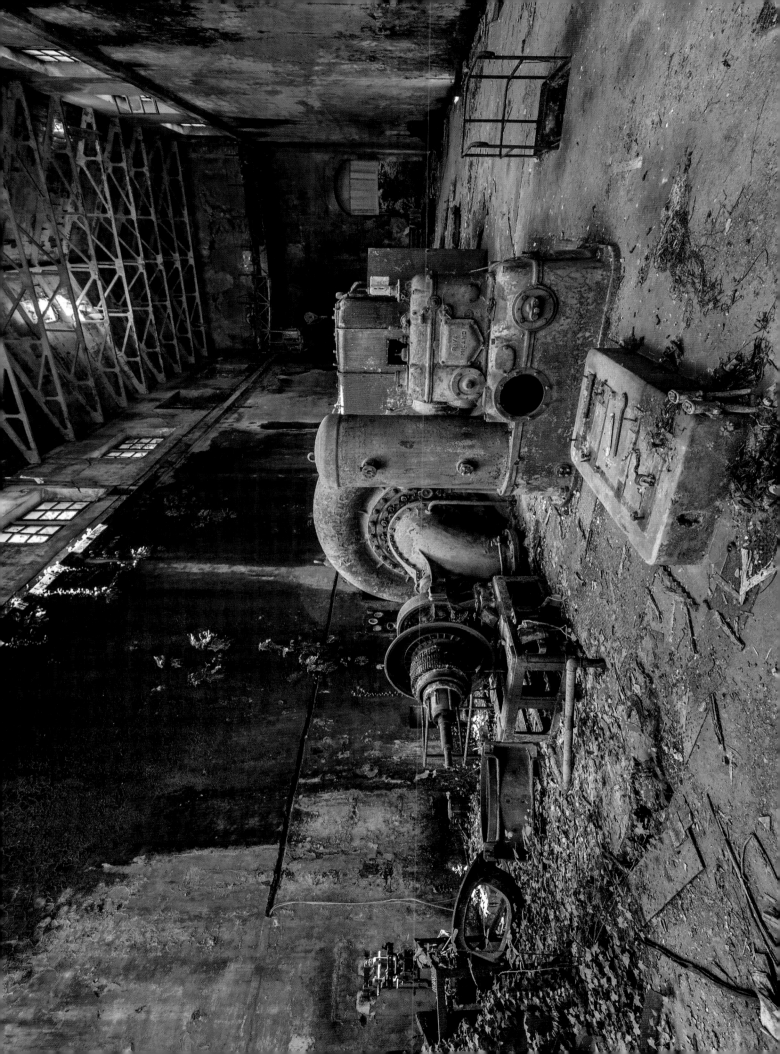

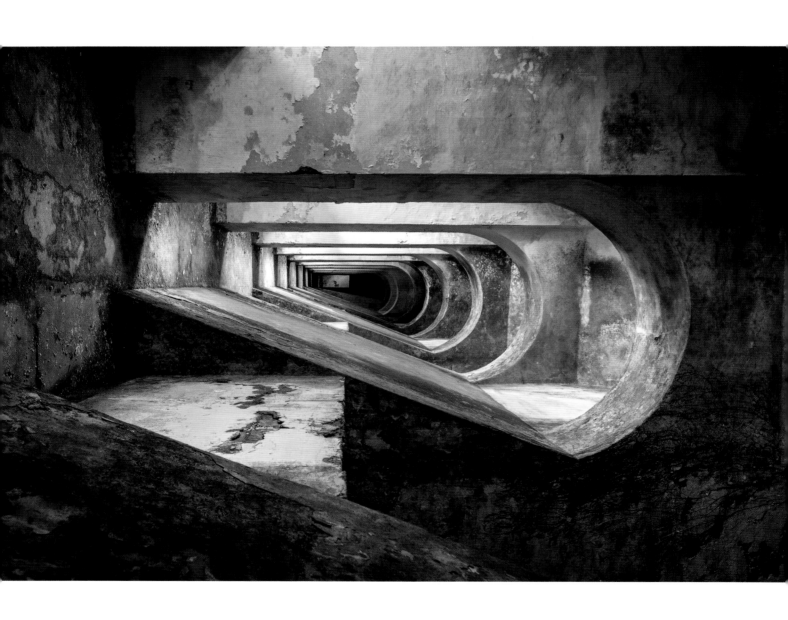

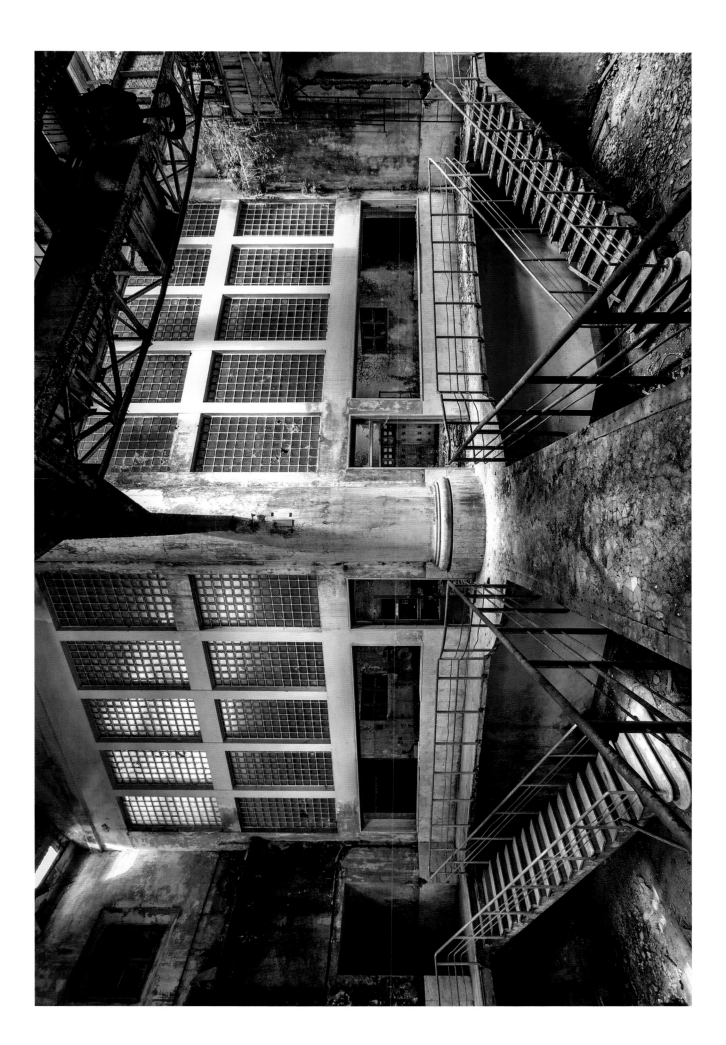

Studio Pinocchio – *Umbria*

Welcome to behind the scenes of a purely Italian work of art. This small village once hosted the studios for the film adaptation of a tale known around the world.

Pinocchio is the hero of the 1881 children's novel by the Italian journalist Carlo Collodi. The story tells of Geppetto, a poor Tuscan carpenter, who takes a piece of firewood and carves a puppet that laughs, cries and speaks like a child; a puppet he calls Pinocchio.

Tall hangars cover the sets that were built and stored here; through the windows, all kinds of strange things can be seen: manikins and models used in Roberto Benigni's 2003 movie.

Pinocchio has become an international star, recognisable by his long nose and still popular more than a hundred years after his creation.

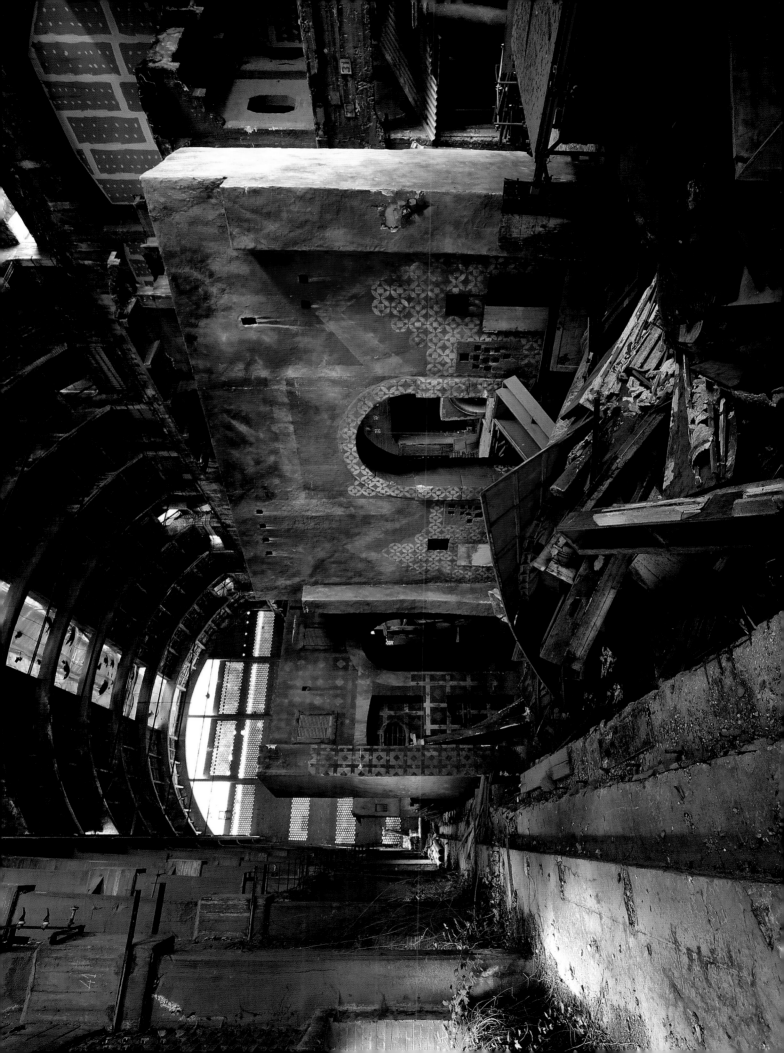

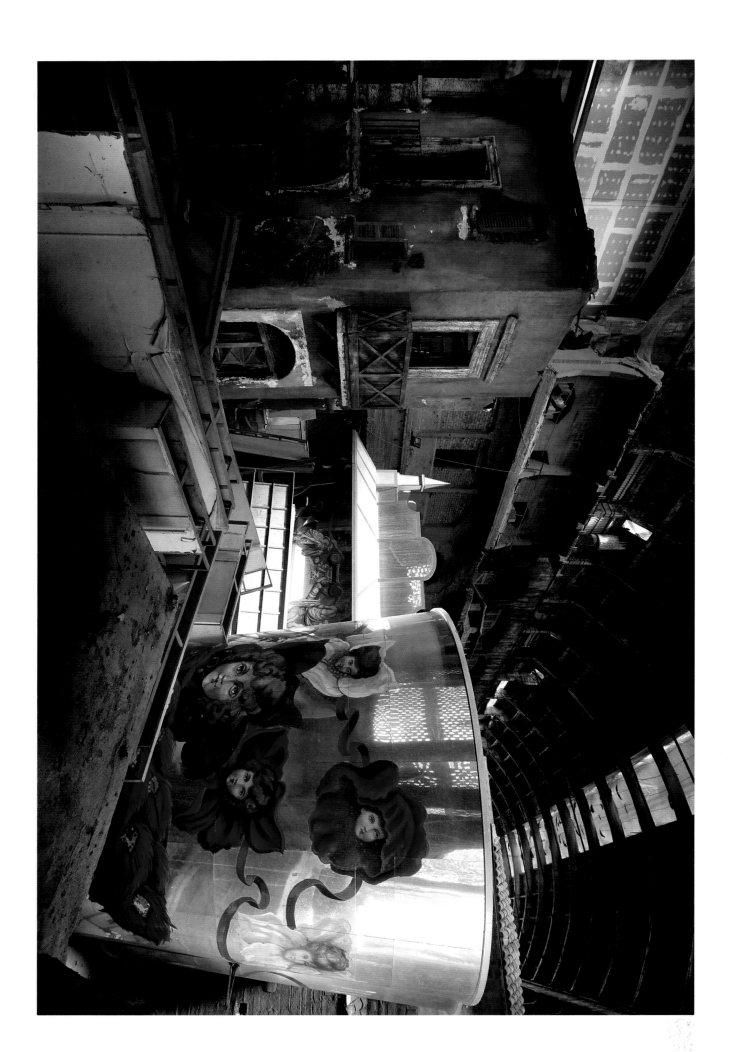

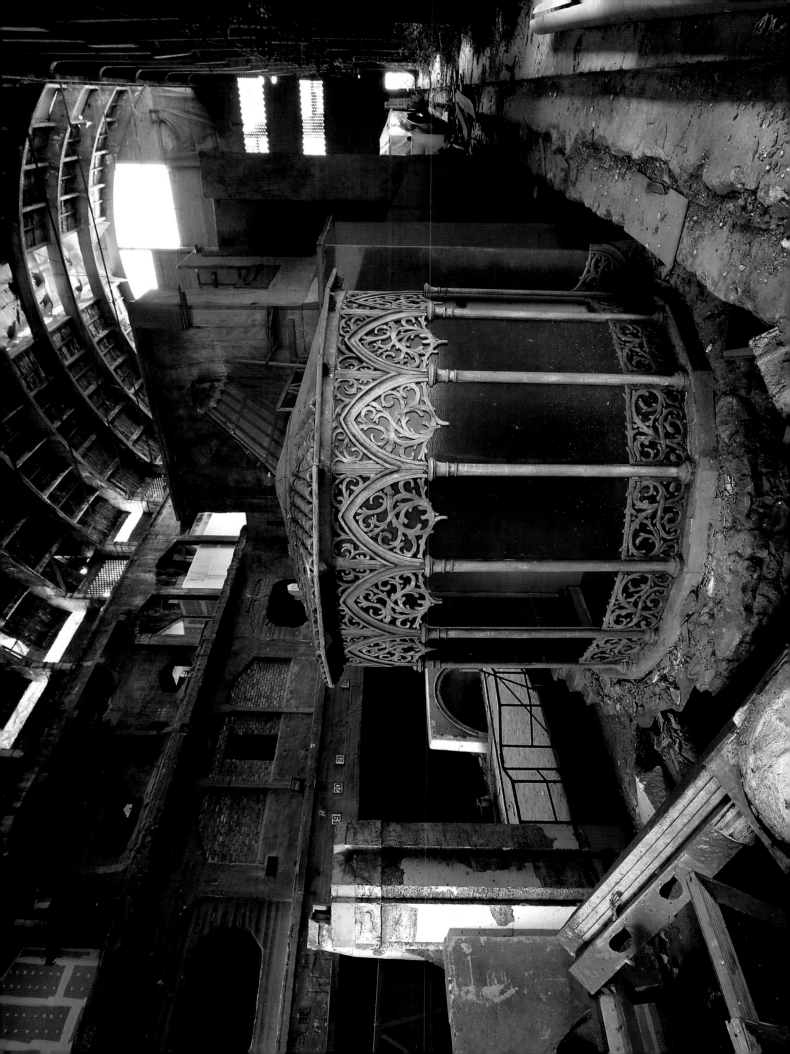

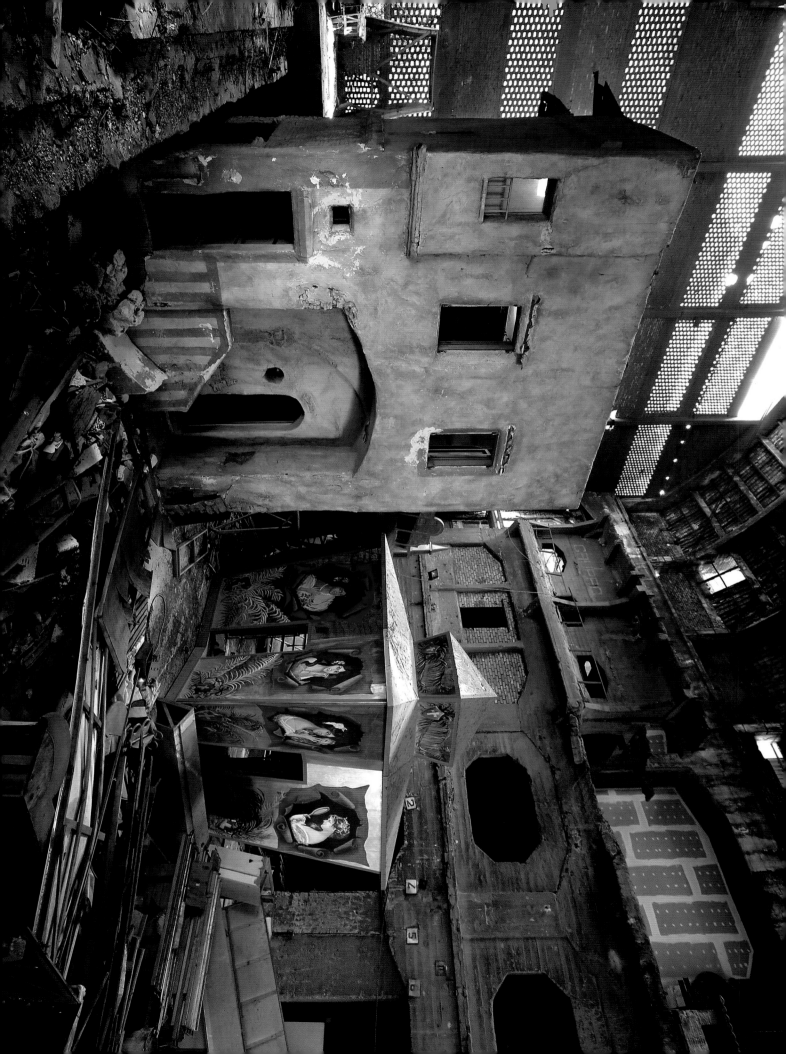

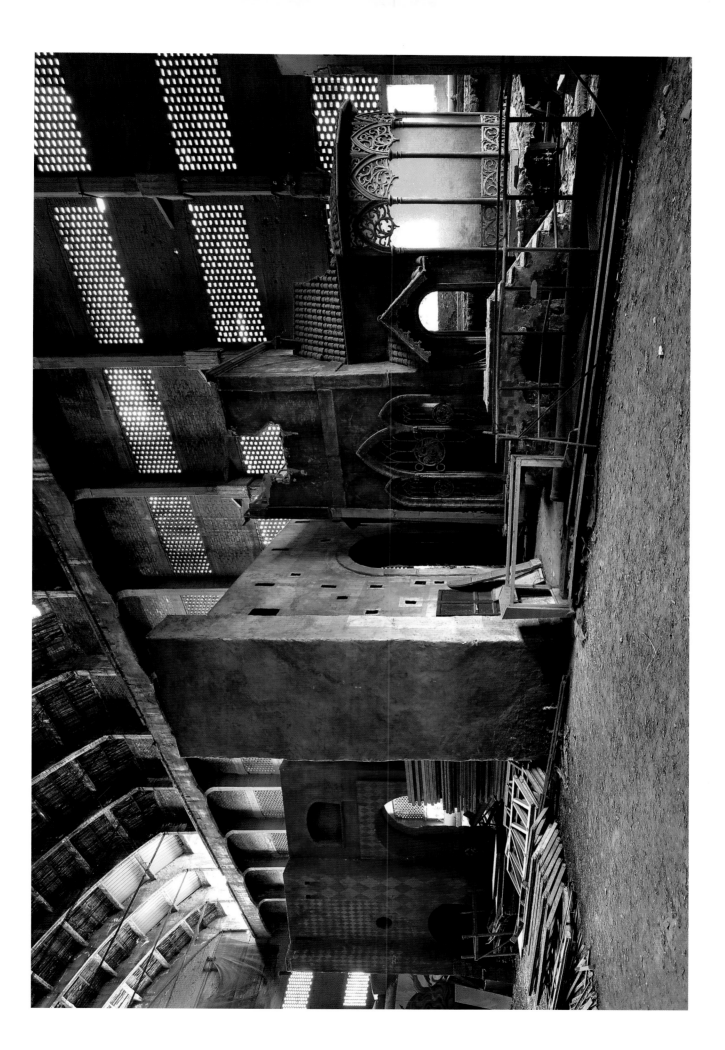

Villa Ponam – *Latium*

Remarkable villa seeks patron to recover former prestige …

The villa, built by the Ponam family in the early 18th century, is located on a hill near a historic hamlet, a former capital of the delegation of the Papal States. It is one of the finest examples of Late Baroque private architecture in the region.

Two rows of century-old cypress trees frame this beautiful house. On the front of the building there is an exedra with semicircular seats that has no doubt hosted many conversations. Elliptical oculi illuminate both the entrance hall on the ground floor and the attic rooms.

The main room on the first floor is magnificent. Its perimeter frame, from which the vault starts, rests on twin columns.

The subceiling is adorned with stucco relief decorations depicting allegorical figures and cherubs holding crowns.

Even the rear façade — more simple and linear — is beautifully crafted, with an upper central body.

Following the earthquake of 1997 the property suffered enough damage that its owners deserted the premises.

Despite this, it remains a splendid building.

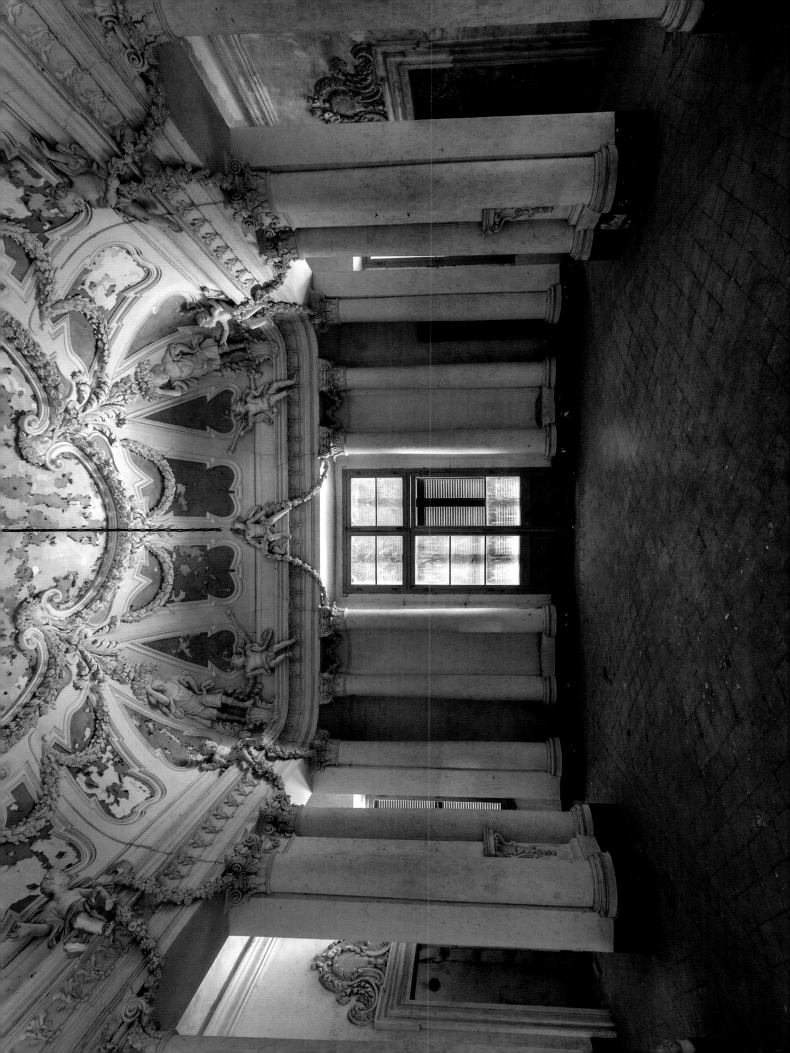

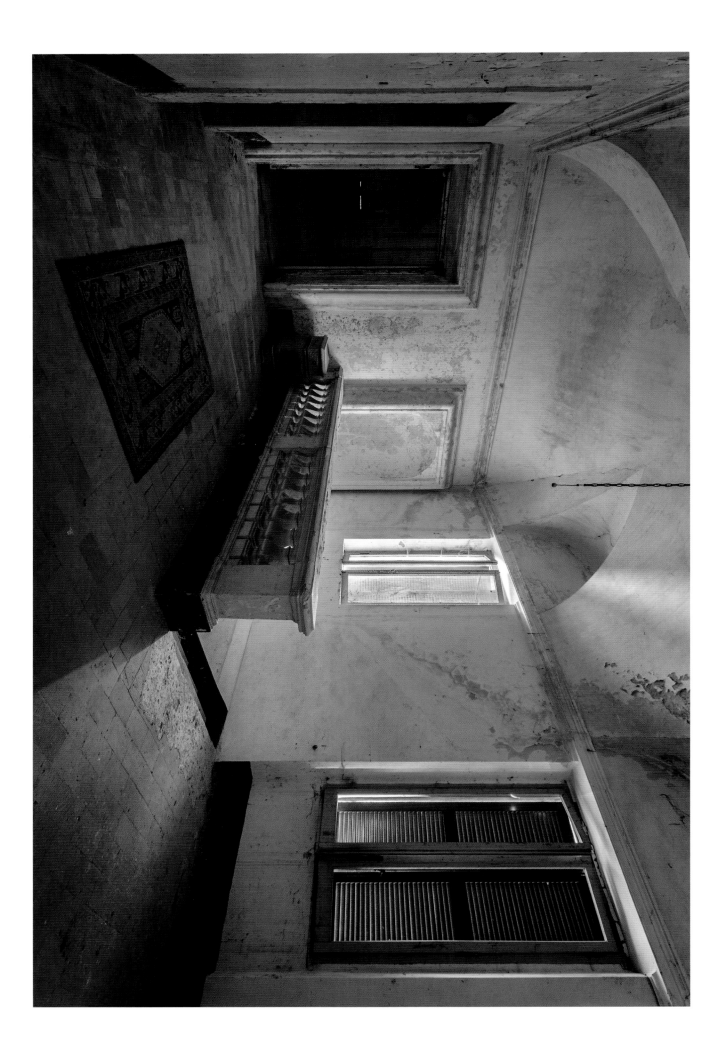

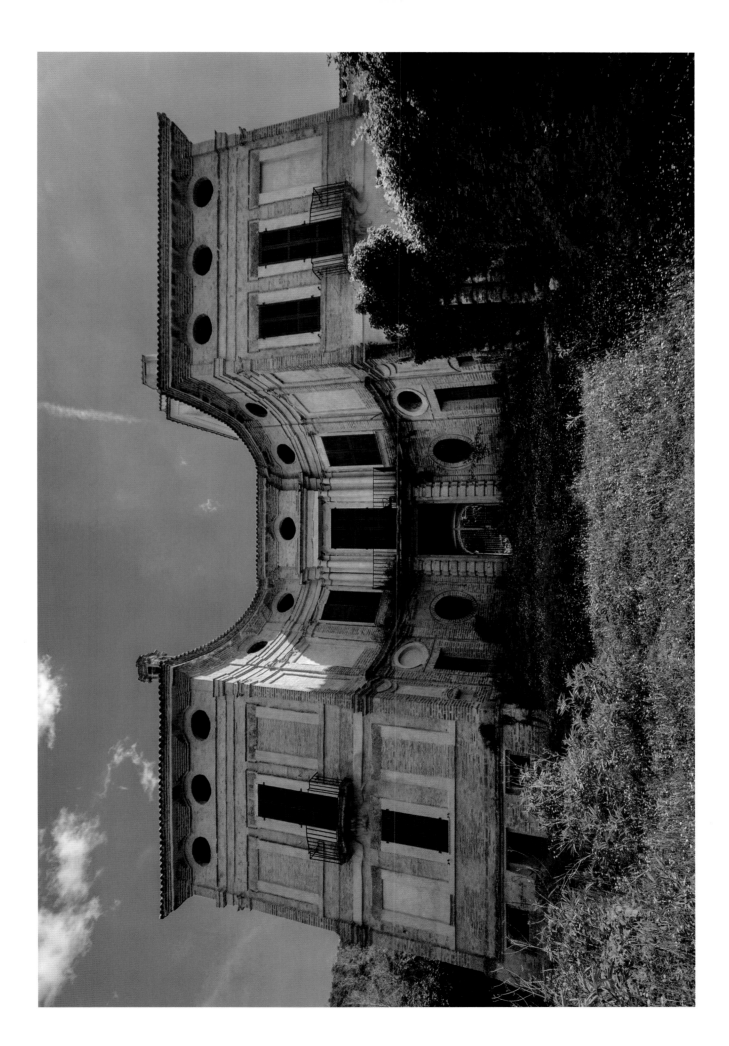

Jersey Textile factory – *Marches*

Located in a small picturesque village, the "Jersey Textile" spinning and knitting mill stands abandoned after becoming obsolete a few years ago.

Under the perforated roof of the shed, on a mouldy floor, are enormous coils soaked with water and balls of wool that may never fully dry. A little further in, ironing presses stand idle, while rows of sewing machines, which once made clothes of every colour, seem to brood over their redundancy.

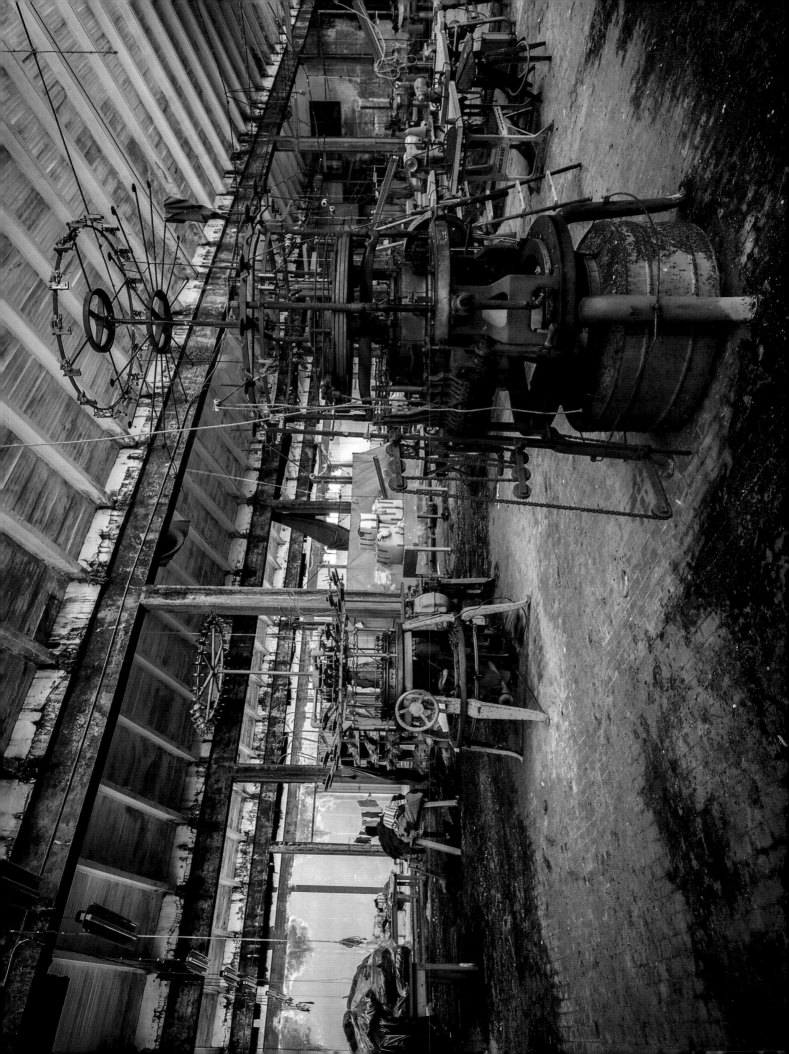

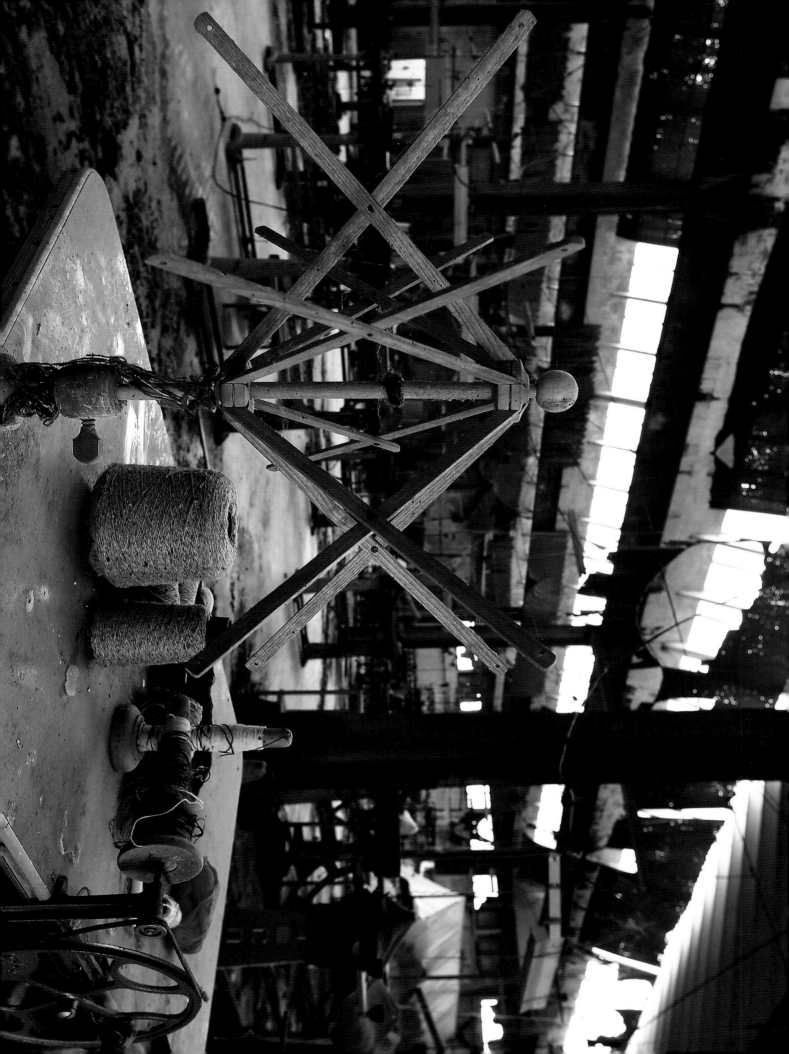

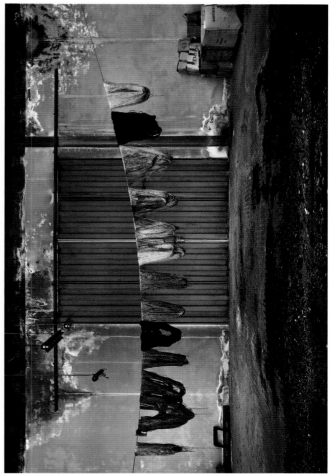
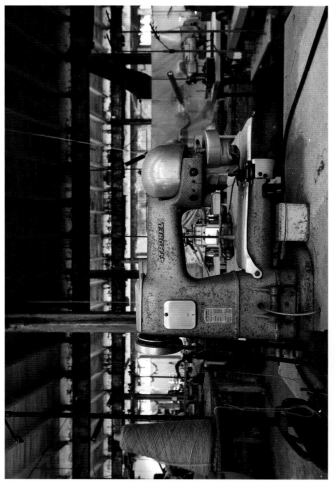

Villa Alba – *Marches*

Once upon a time, there was a wealthy industrialist from Marche who decided to build a splendid private villa right next to his factories on the Adriatic coast. At the beginning of the 1960s the shoe industry was booming in the region and fortune smiled on the Bertolis, who treated themselves to a home reflecting their success.

Alba Bertoli was a famous opera singer, highly acclaimed all over Europe for her interpretation of Verdi's Aida. She also practised on a Steinway and Sons piano in the salon of the villa, where she organised parties for high society.

The majestic crystal chandelier, still hanging in the main hall, would have cost more than 35 million lire, a small fortune for the time. The marble staircase, with its wrought iron railing, leads to a monumental wooden door, which leads in turn to what was once a magnificent bookshelf. The same standard of luxury can be found in every room, all with bathrooms completely furnished in marble.

The shoe brand "Lion" disappeared and the Macerata factory finally closed its site in Sant'Elpidio a Mare in 1996. Soon after the abandonment of the site and the villa, the premises were occupied by vagrants and thugs who devastated the place, even setting fire to the garage and part of the house. Today, threatened by bulldozers, the beautiful villa could soon disappear.

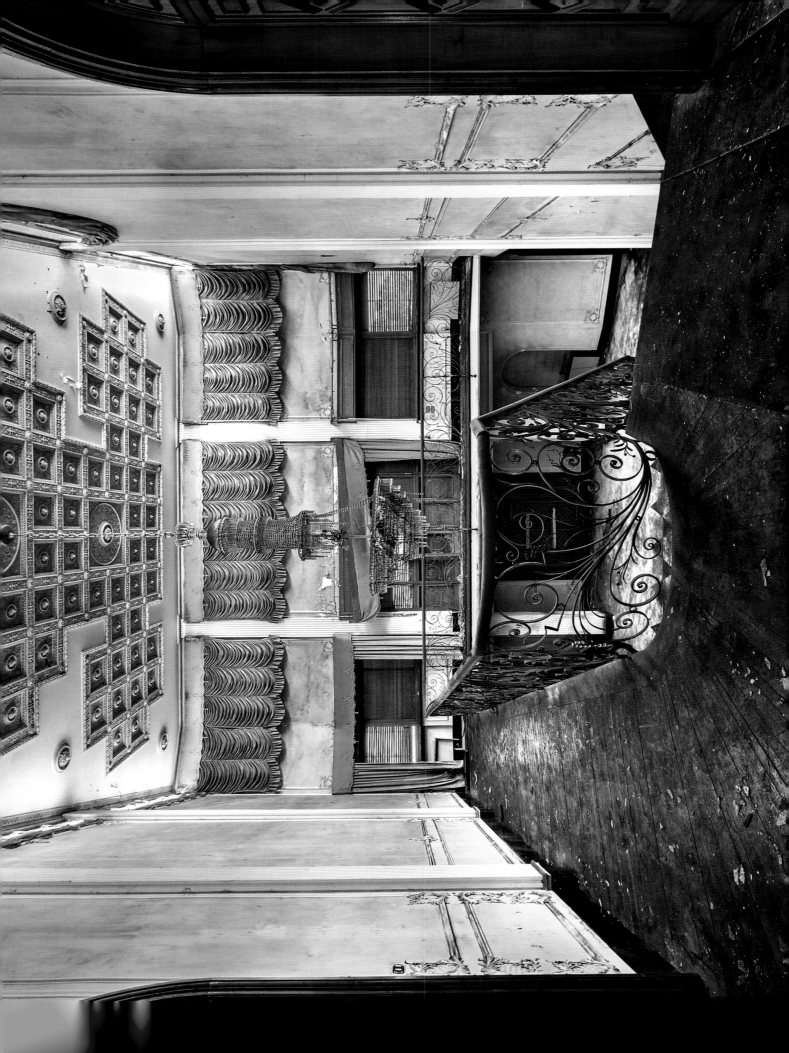

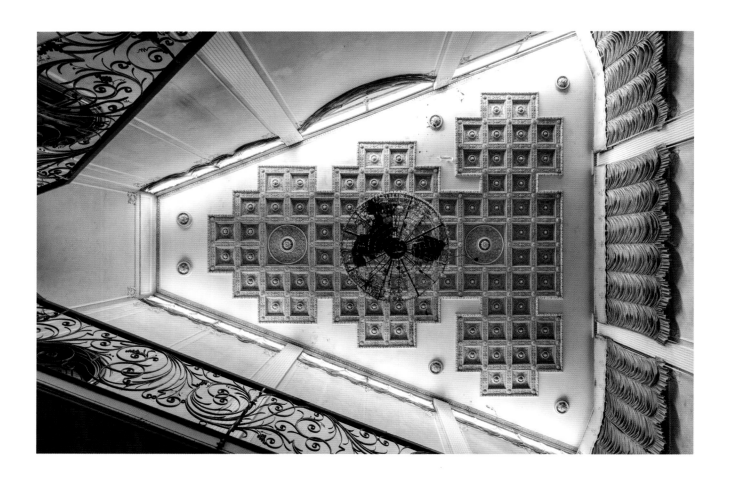

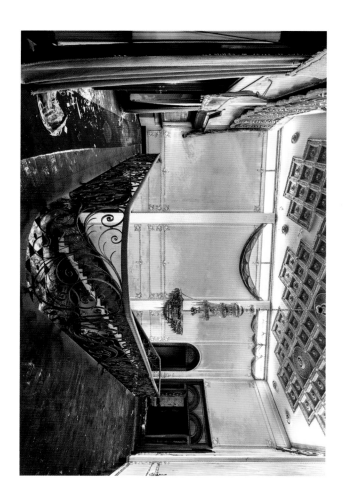

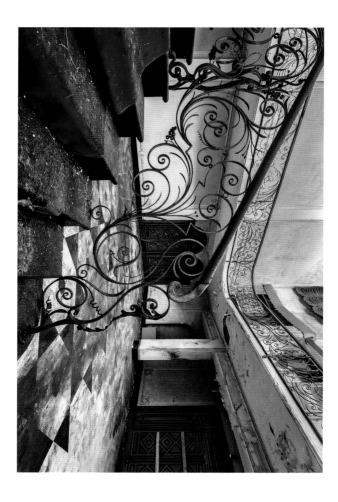

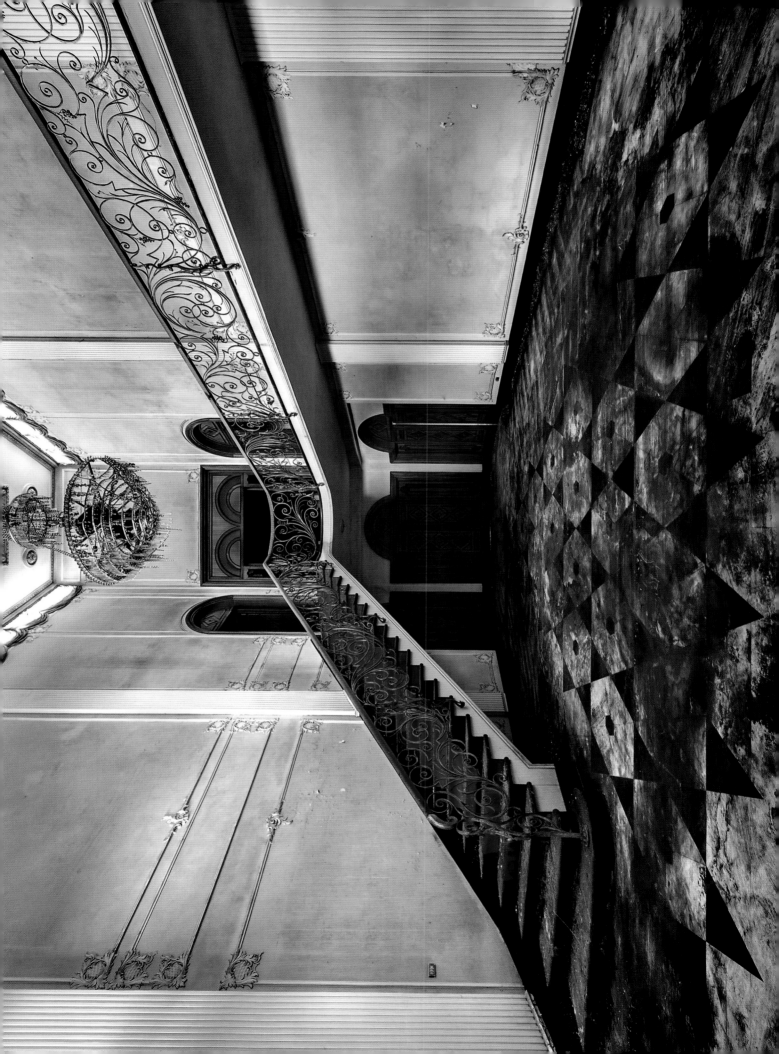

Villa G – *Marches*

This abandoned villa boasts an impressive pink marble staircase; the wrought iron railing depicting Afghan greyhounds frolicking along the ramp is breathtaking.

Upstairs, decorative styles flow from room to room; bedrooms and bathrooms range from the most classic to the most modern. In the master bedroom, hand-painted scenes show gentlemen in charming company.

On the vast expanse of land behind the villa, a large, empty pool invaded by wild grasses is desperate for new owners who don't seem ready to show up.

The house, located near a busy road, is struggling to attract potential buyers — a fact that has recently benefited shameless metal dealers, who have sawn up and stolen the ramp. It is a regrettable loss!

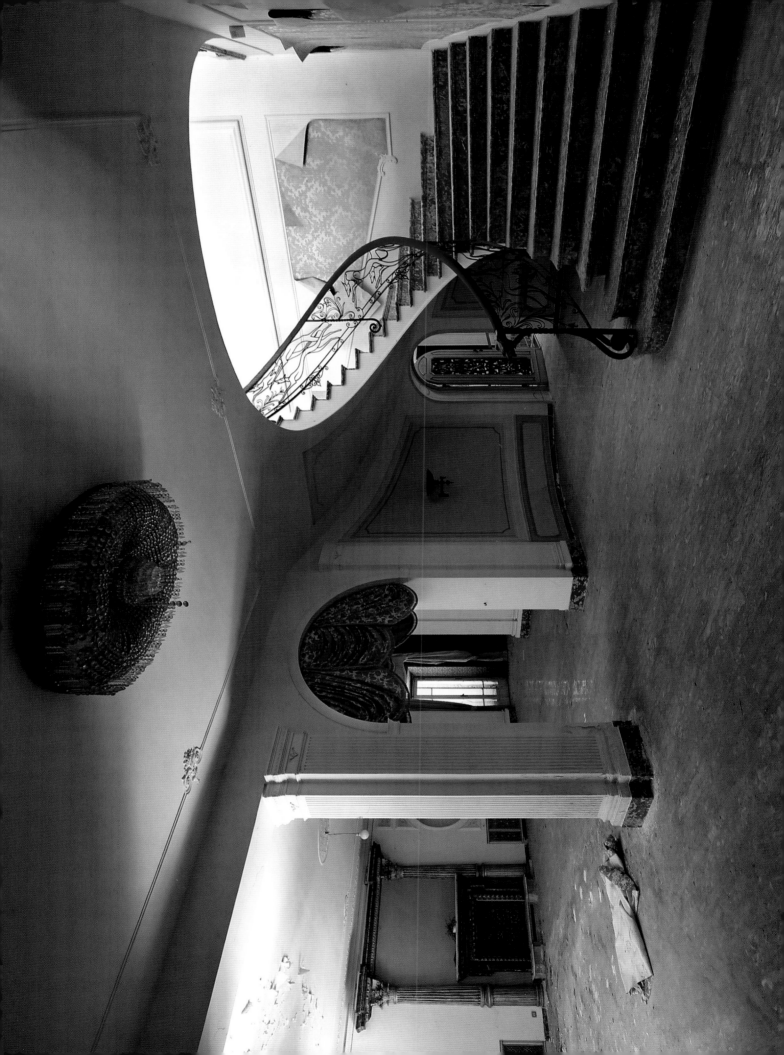

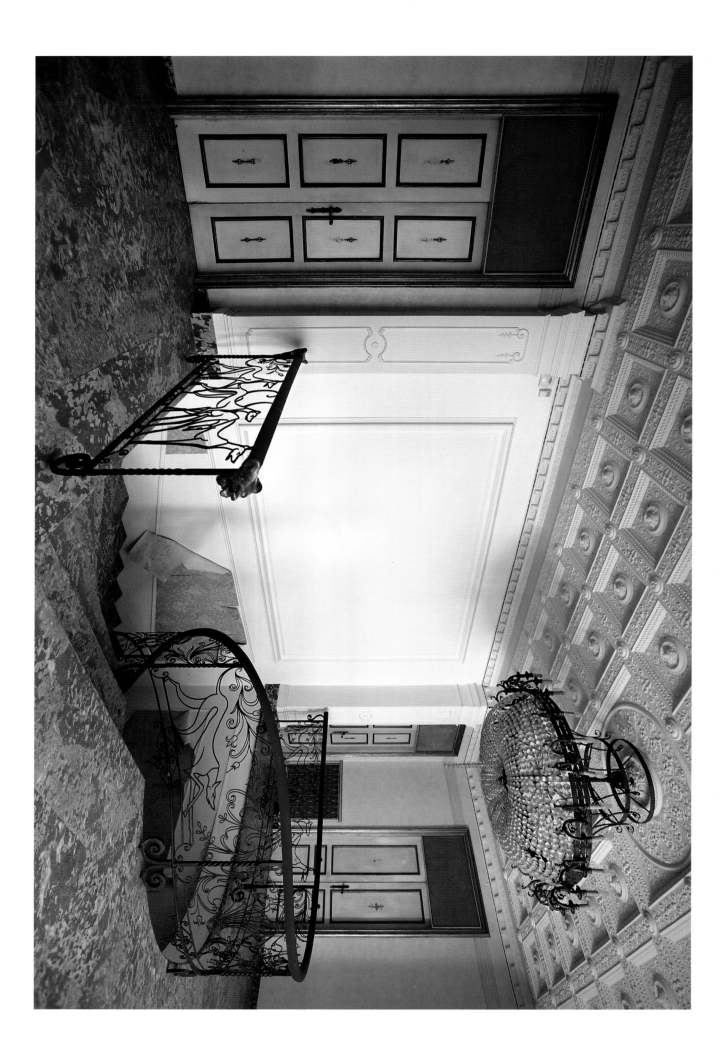

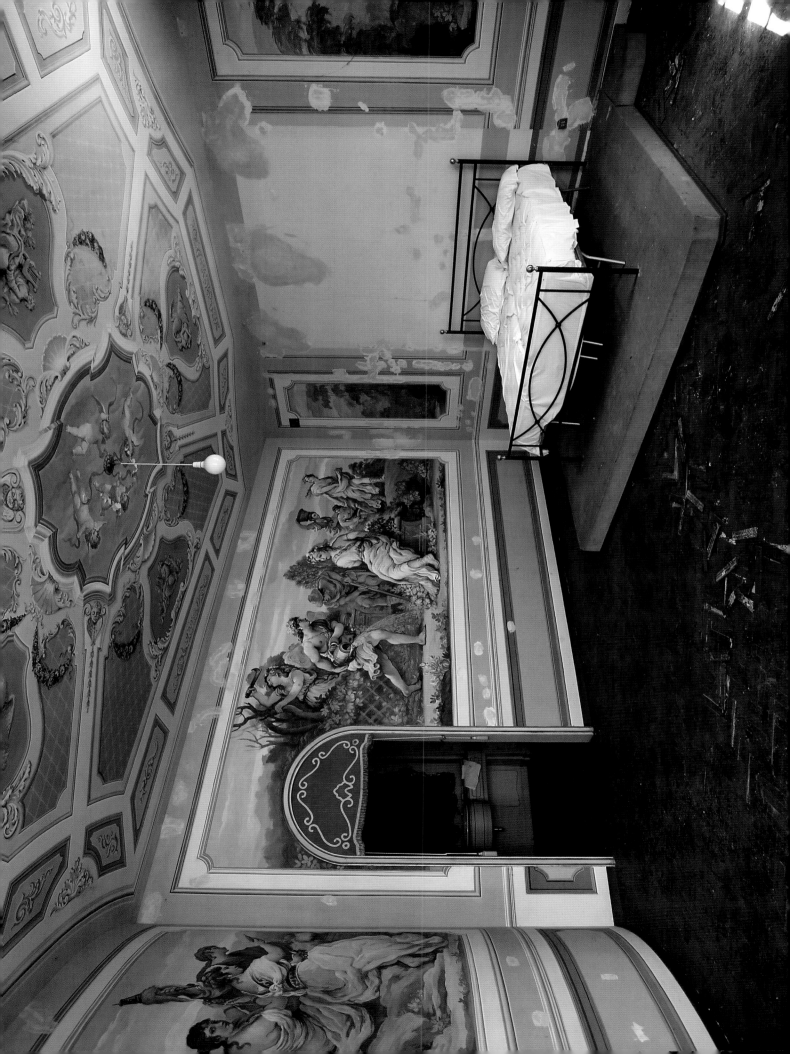

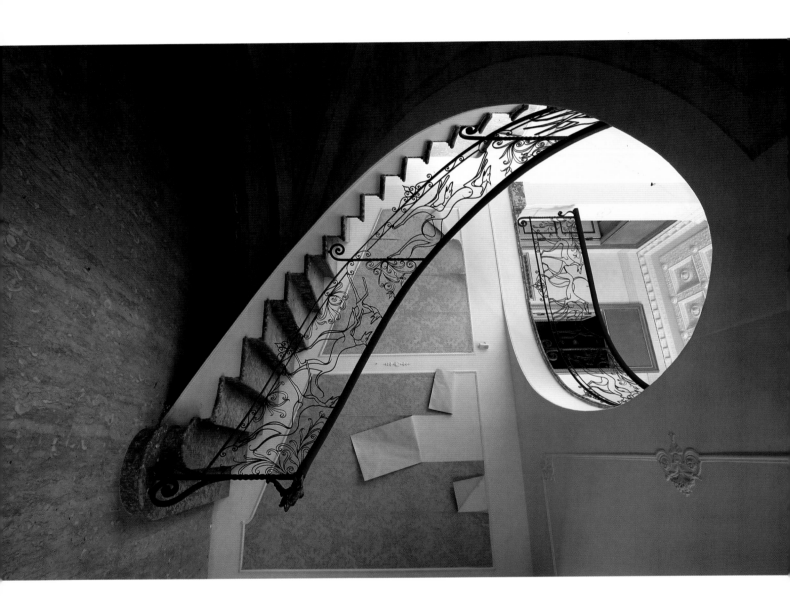

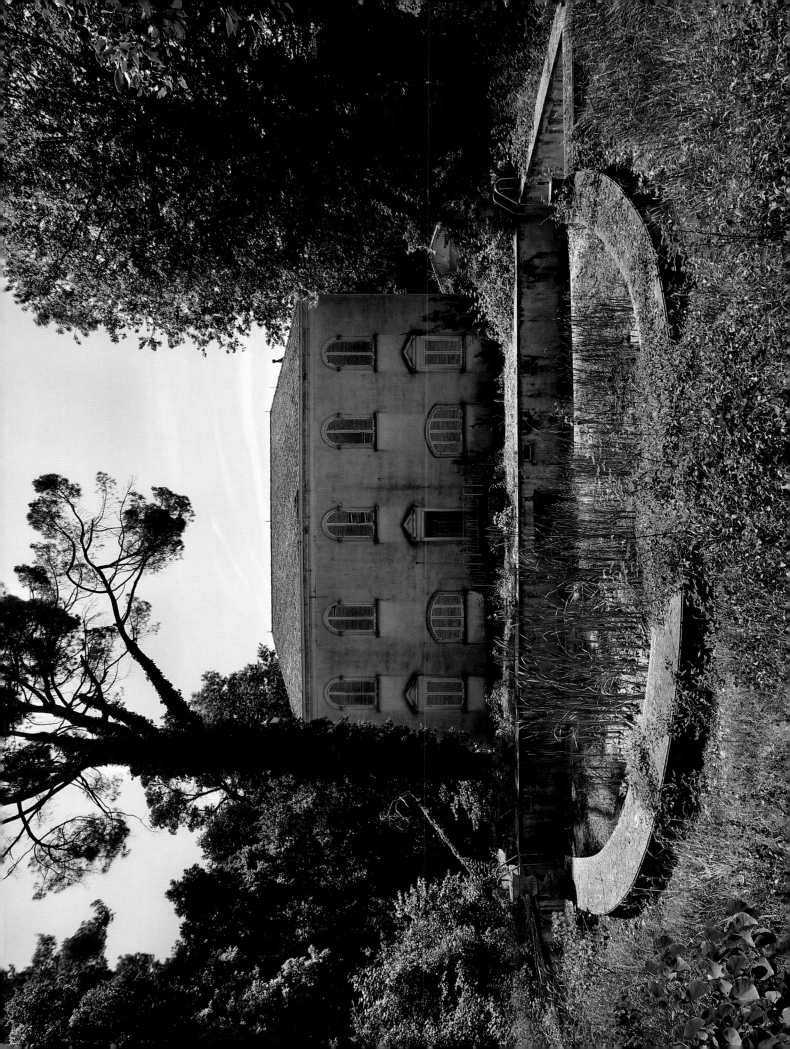

Villa La Quiete – *Marches*

This magnificent residence, perched on a small wooded hill, enjoys a beautiful view of the sea. It was conceived as a kind of Eden, and offered to Polish Countess Natalia Komar by her new husband, Lavinio de Medici Spada, a man of letters and sciences.

The villa was constructed on the ruins of an old convent in 1810, directed by the famous neoclassical architect Giuseppe Valadier. A greenhouse was added to the villa to accommodate the experiments of the master of the house, as well as his studies in botany and floriculture, for which he imported plants from America, Asia and India.

During the Second World War the property was initially used as a place of detention, before becoming the headquarters of Polish troops in support of the liberation operations. In the 1960s the property was converted into a kindergarten and it remained so for 20 years.

Though it has not been inhabited since then, it still offers some wonderful surprises; the atrium surrounded by many pillars, with vaults painted the colour of the sun, is still impressive.

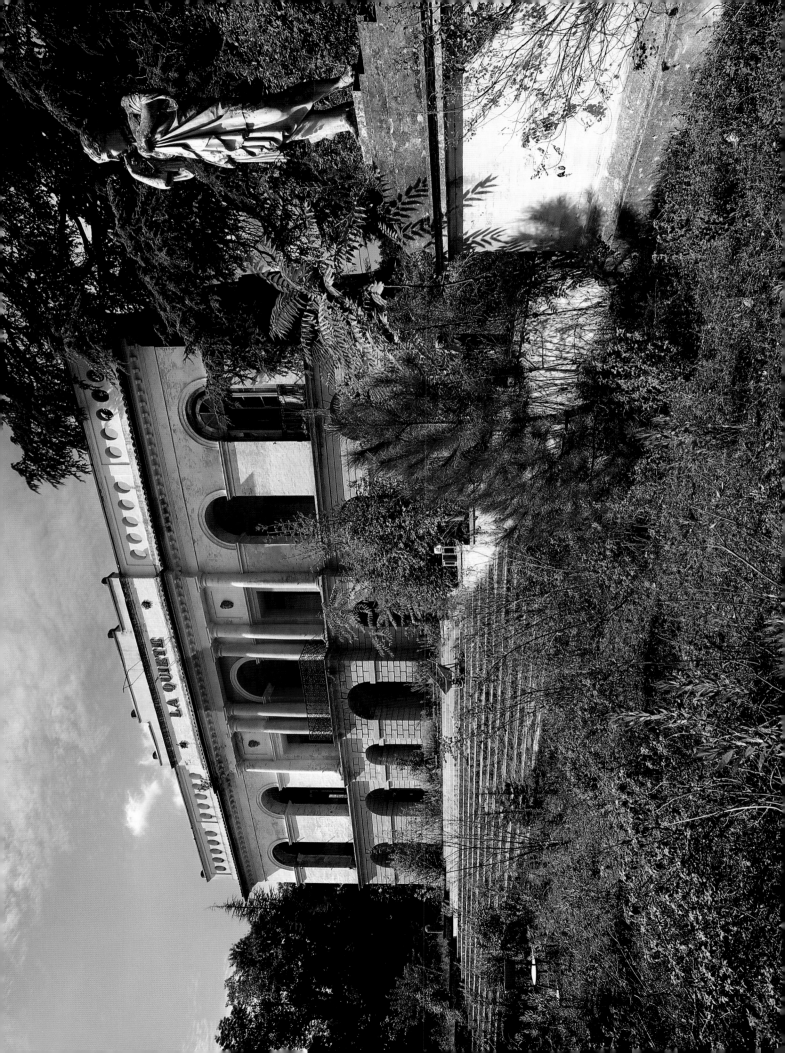

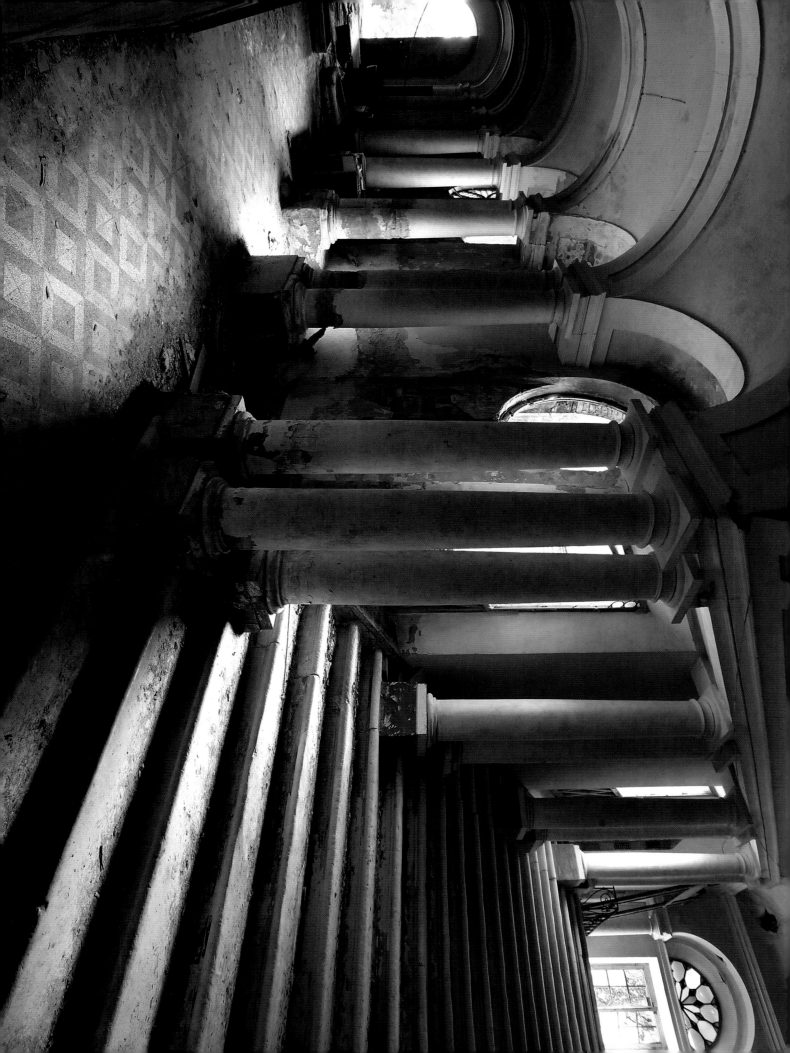

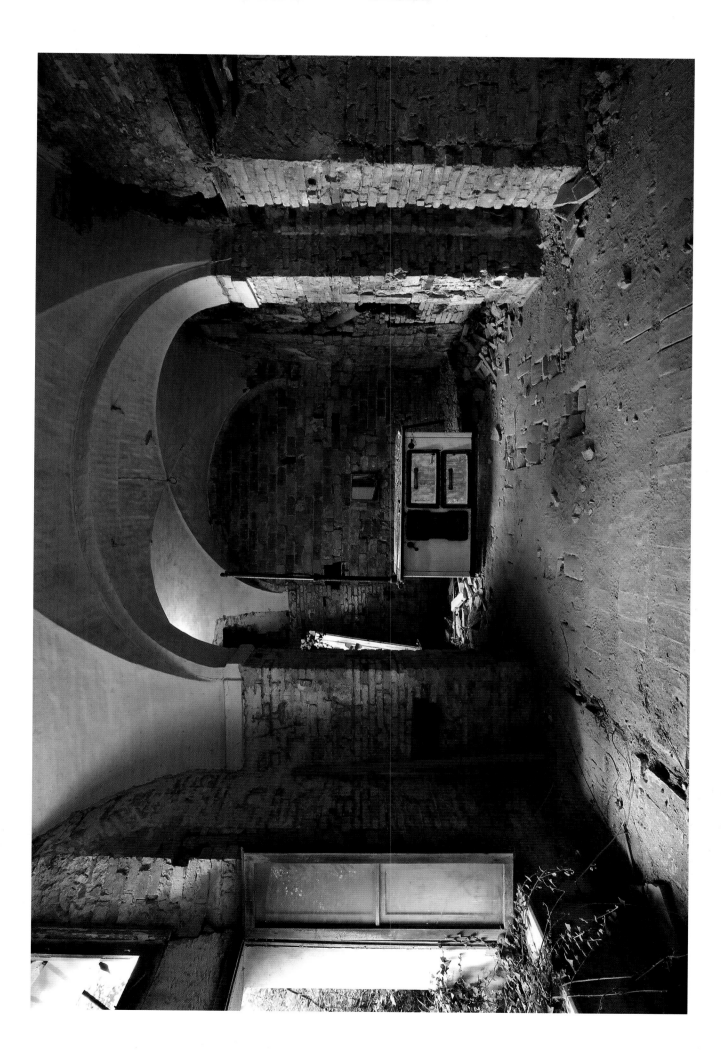

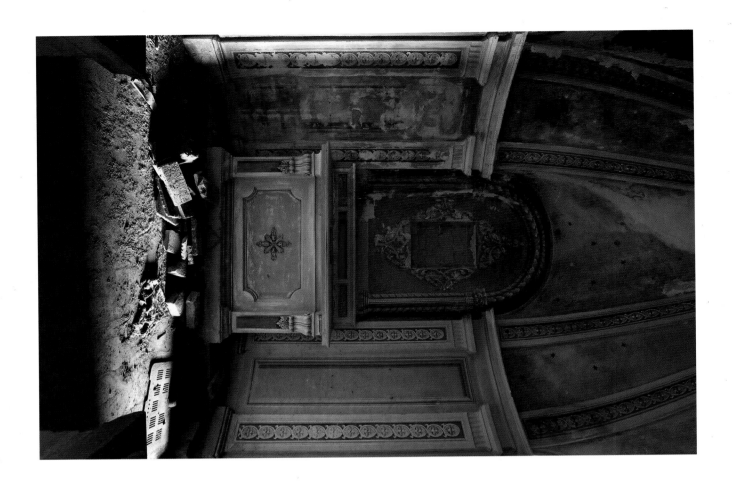

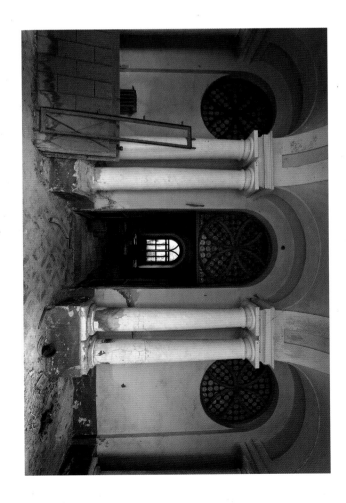

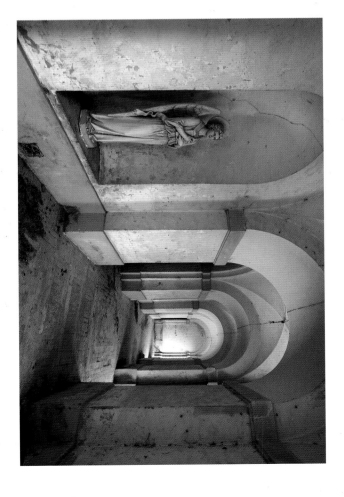

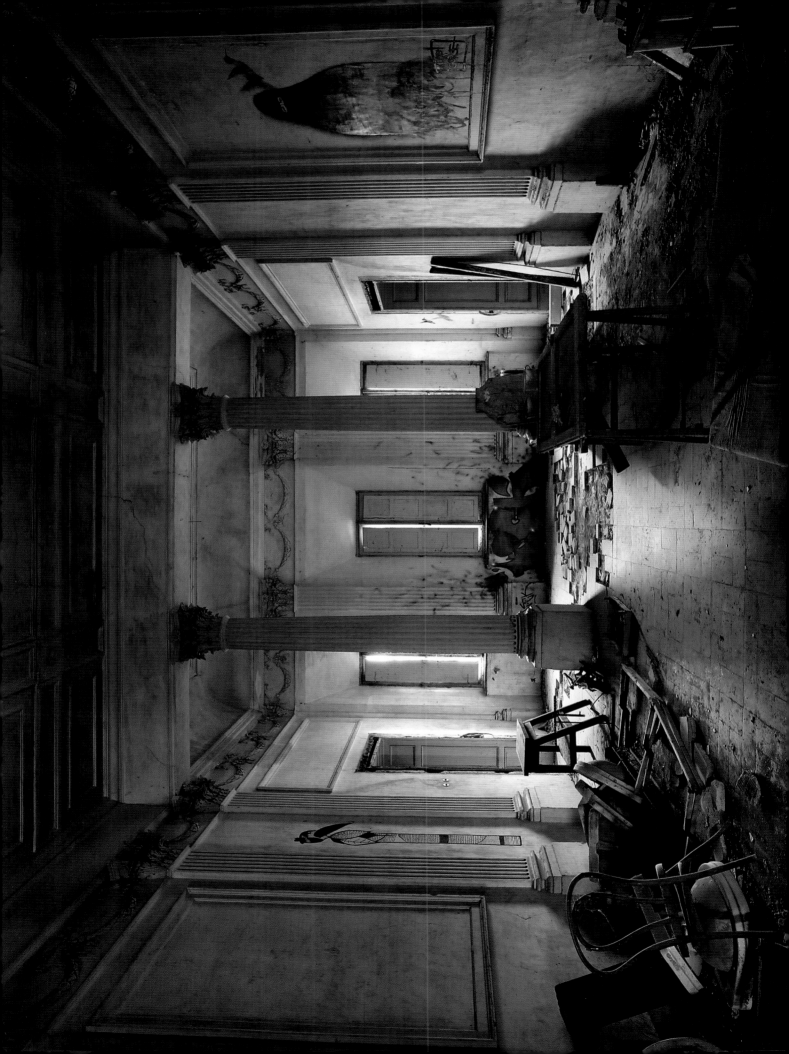

Villa Pontificia – *Marches*

In 1830 Count Mei Gentilucci, who was from a family of the Italian aristocracy in Ancona, built a large, traditional residence in a small village far from the bustle of the Adriatic coast. With precisely 99 rooms, the villa attracted the admiration of the whole region.

The paintings adorning the property are inspired by the papal colors (white and yellow), lending it a unique freshness. The entrance staircase, flanked by majestic columns, leads to a hall illuminated by frescoes by Ciasca, and to a gentilizia chapel (a private place of worship built by a family).

Village archives teach us that during the flight of the royal family from Savoy to Italy on the night of 8-9 September 1943, the house offered hospitality to Prince Umberto, the future Umberto II, the last king of Italy.

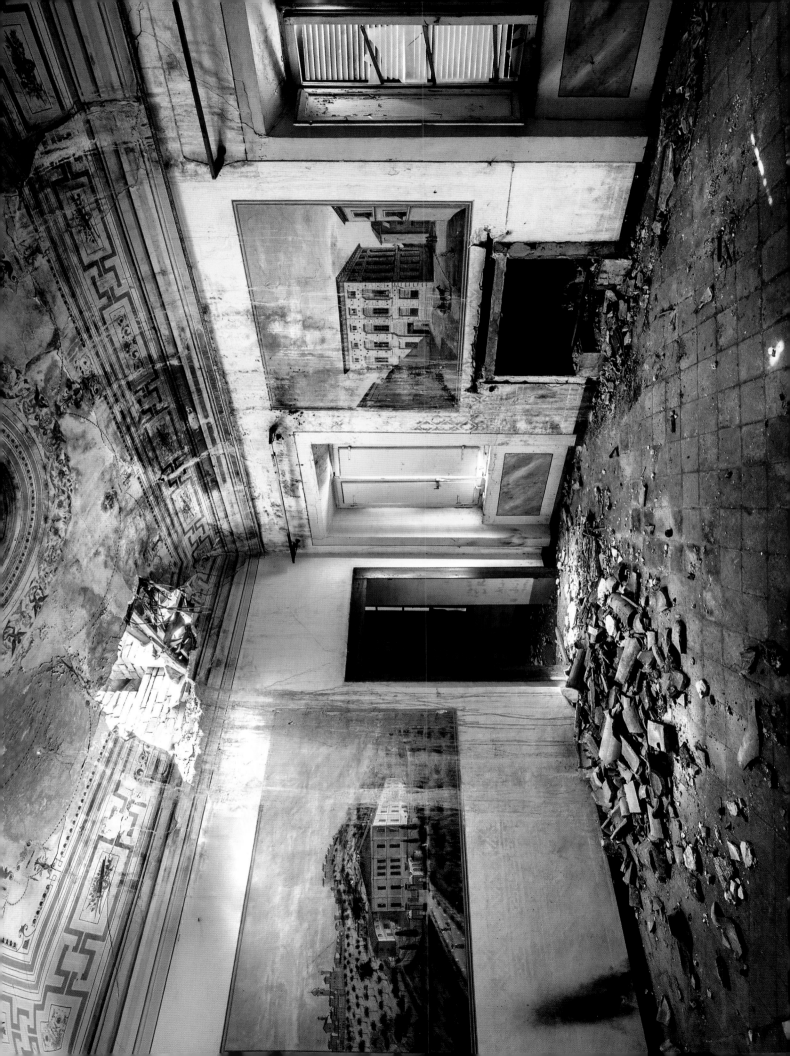

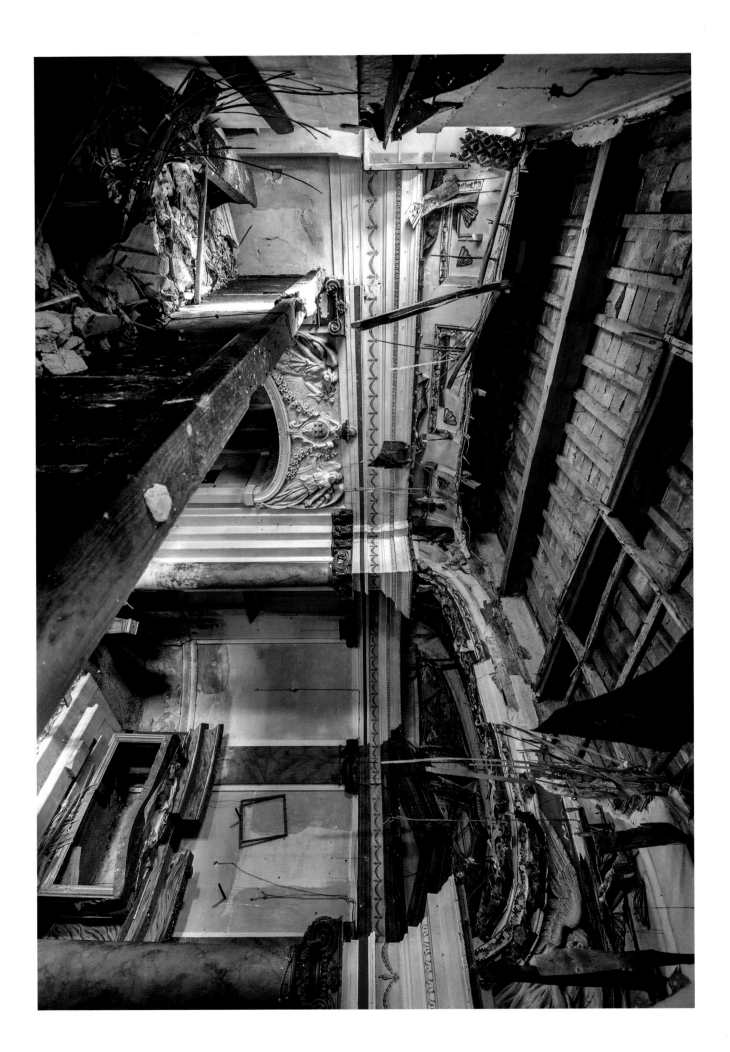

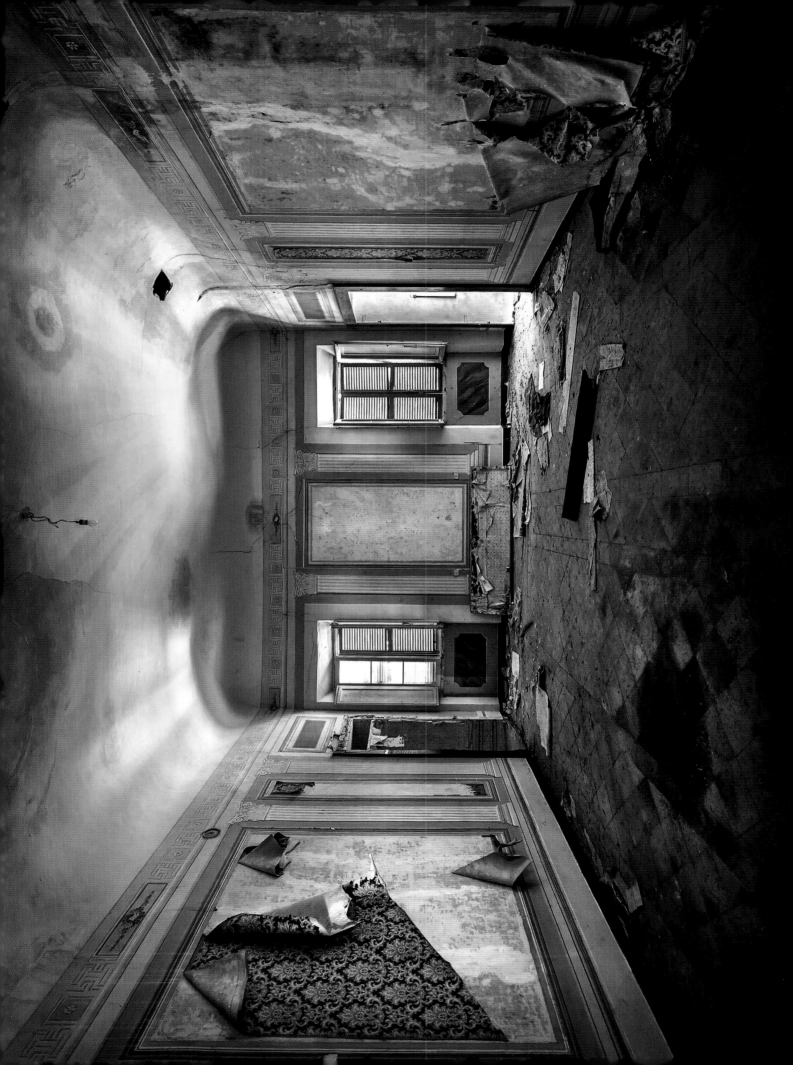

Villa Ponzio – *Marches*

Nestled in the green countryside of a small village, this prestigious Rococo-style palace — the only example known in Italy — was the former residence of the Marquis Pianetti. It is one of the most beautiful historical sites of regional aristocracy.

The house, which dates back to 1748, has three floors, plus a chapel and a crypt where the sepulchres of the family are located. The central building overlooks a typical Italian garden surrounded by terraced walls.

The most surprising thing about this palace is the exuberance of the ornamental motifs — including wreaths and medallions — that adorn it.

The city has entered into talks with a view to transforming this magnificent example of regional heritage into a contemporary art gallery. Unfortunately, budget restraints have prevented any progress.

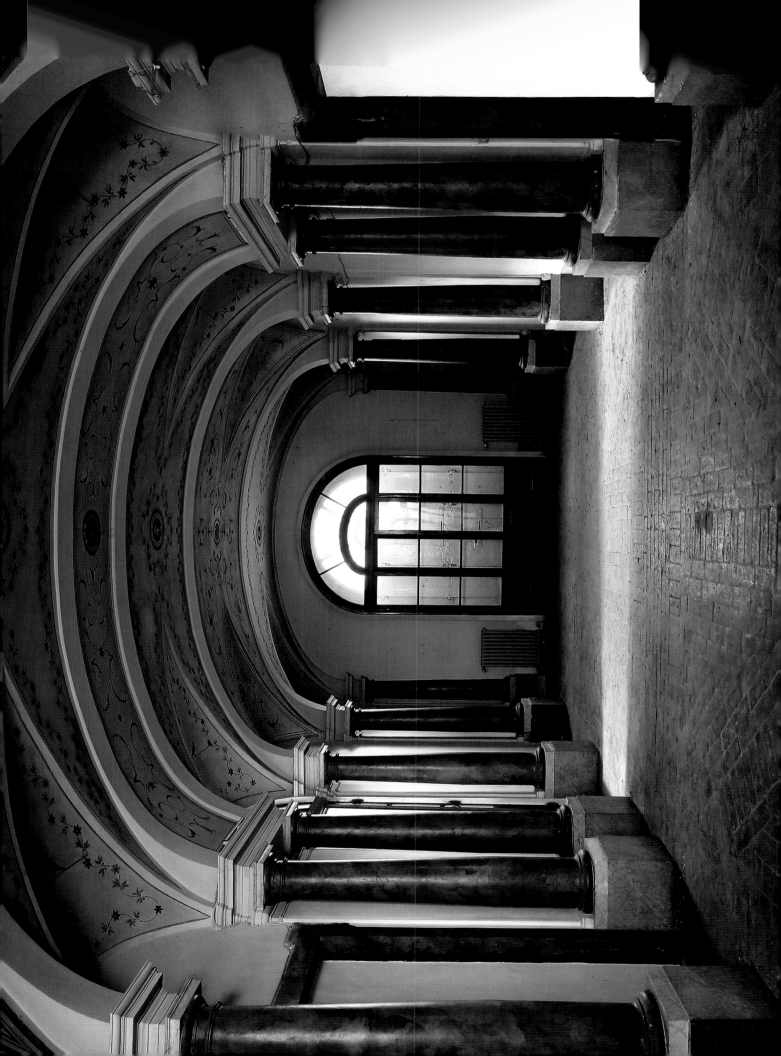

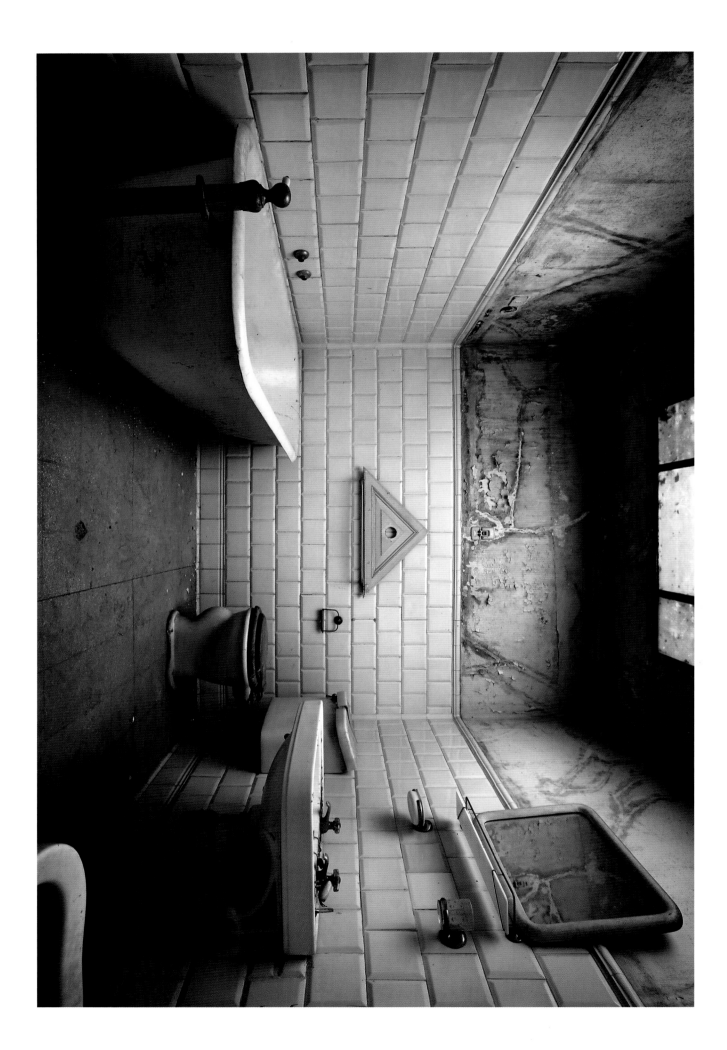

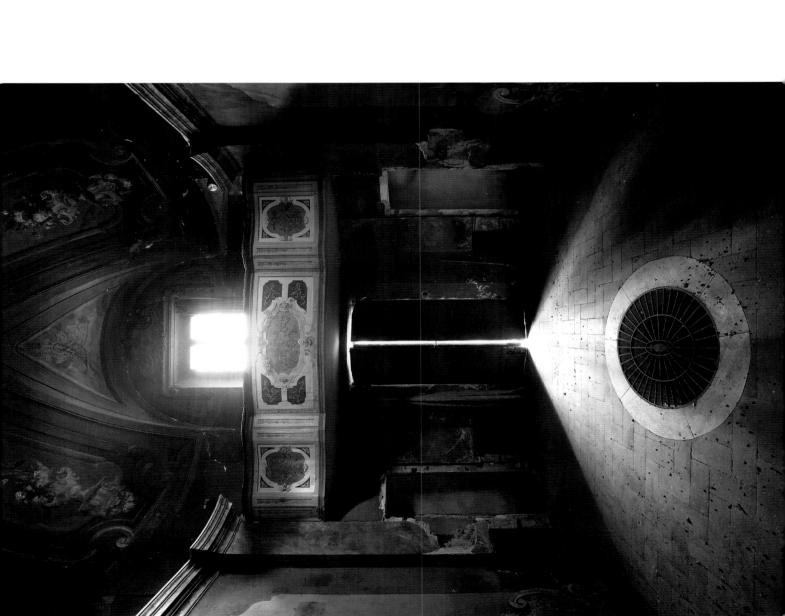

Chiesetta Don Colocci – *Marches*

Standing among the rolling countryside is the bell tower of a small private church built by Don Antonio Colocci in 1927. Attached to a farmhouse surrounded by olive trees, the church was designed and decorated by a master craftsman well known in the region.

The interior is covered with stuccoes in the shape of garlands interspersed with cherubs, and the bright colors that adorn the decorations are astounding.

Beautiful statues nestle in the niches, watching over this haven of peace that has no doubt comforted many visitors.

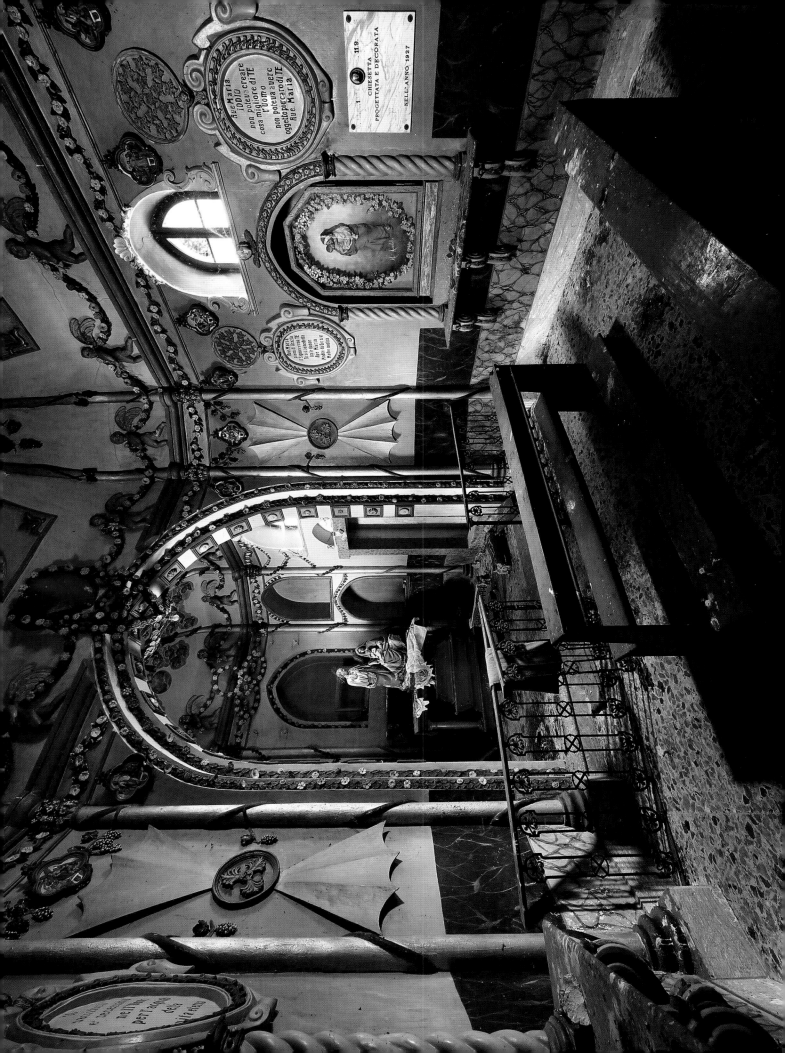

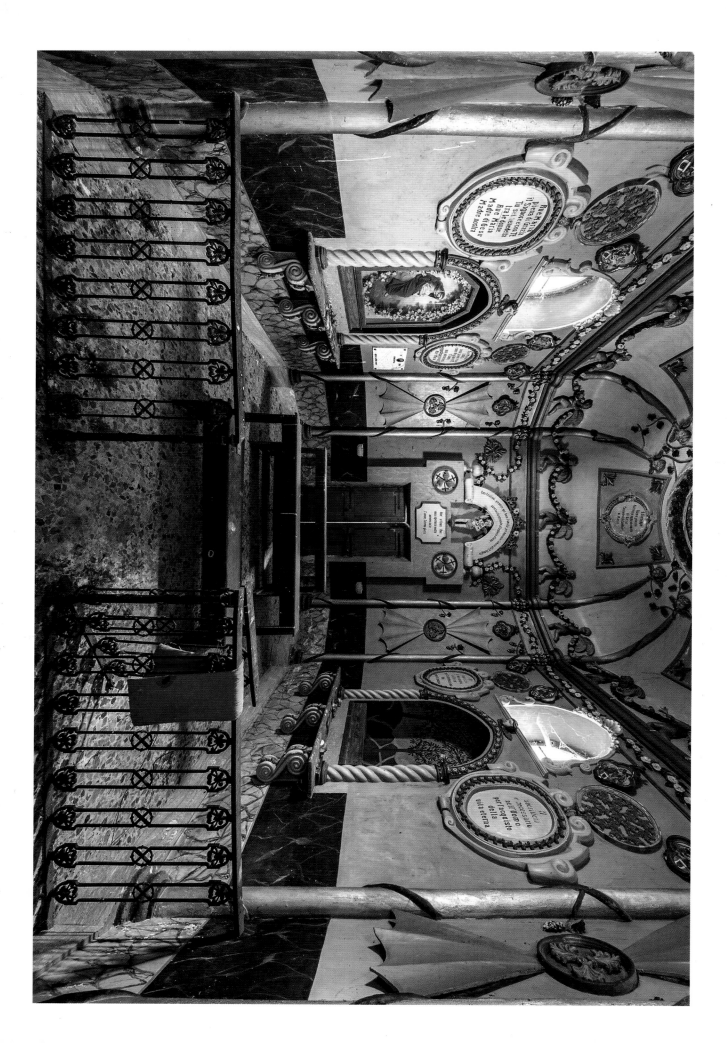

Acknowledgements

As it is customary to give thanks, I warmly thank my Italian friend for his hospitality, my faithful travel companion and colleague Jerome Michez, my friend Alyssia Roelandt, my father on the occasion of some of my escapades, and my mother for her secretarial work, her research and the writing of texts.

Please note: not all the places included in this book can be freely visited. It is necessary to inquire specifically for each venue for possible access.

Photos and texts: Robin Brinaert

Layout design and layout: Stéphanie Benoit - Translation: Laura Perreca - Proofreading: Eleni Salemi - Editing: Matt Gay - Publishing: Clémence Mathé

In accordance with jurisprudence (Toulouse 14-01-1887), the publisher is not to be held responsible for any involuntary errors or omissions that may appear in the guide despite the care taken by the editorial staff.
Any reproduction of this book in any format is prohibited without the express agreement of the publisher.

© JONGLEZ 2018

Registration of copyright: July 2018 – Edition: 01

ISBN: 978-2-36195-271-6

Printed in China by Toppan